REAL-WORLD FLASH GAME DEVELOPMENT

HOW TO FOLLOW BEST PRACTICES AND KEEP YOUR SANITY

CHRIS GRIFFITH

Focal Press is an imprint of Elsevier 30 Corporate Drive, Suite 400, Burlington, MA 01803, USA Linacre House, Jordan Hill, Oxford OX2 8DP, UK

© 2010 Elsevier Inc. All rights reserved.

No part of this publication may be reproduced, stored in a retrieval system, or transmitted in any form or by any means, electronic, mechanical, photocopying, recording, or otherwise, without the prior written permission of the publisher.

Permissions may be sought directly from Elsevier's Science & Technology Rights Department in Oxford, UK: phone: (+44) 1865 843830, fax: (+44) 1865 853333, E-mail: permissions@elsevier.com. You may also complete your request on-line via the Elsevier homepage (http://elsevier.com), by selecting "Support & Contact" then "Copyright and Permission" and then "Obtaining Permissions."

Library of Congress Cataloging-in-Publication Data

Griffith, Christopher, 1979-

Real-world Flash game development : how to follow best practices and keep your sanity/ Christopher Griffith.

p. cm.

Includes index.

ISBN 978-0-240-81178-9 (pbk.: alk. paper) 1. Computer games— Programming. 2. Computer animation. 3. Flash (Computer file) I. Title. QA76.76.C672G774 2009 794.8'1526–dc22

2009020027

British Library Cataloguing-in-Publication Data

A catalogue record for this book is available from the British Library.

ISBN: 978-0-240-81178-9

For information on all Focal Press publications visit our website at www.books.elsevier.com

09 10 11 5 4 3 2 1

Printed in Canada.

Working together to grow libraries in developing countries

www.elsevier.com | www.bookaid.org | www.sabre.org

ELSEVIER B

BOOK AID International

Sabre Foundation

CONTENTS

Acknowledgments	X
Introduction	.xi
Chapter 1 Computer Science Isn't for Everyone	1
A Little Groundwork	
Common Game Types	1
General Development Terms	5
Game-Specific Development Terms	8
Flash DevelopmentTerms	10
You Can Wake Back Up Now	12
Chapter 2 The Best Tool for the Job	13
Flash Back	
The Case For Flash	14
Nobody's Perfect	15
Stop Fighting It	20
Things Flash Was Built to Do	21
The Best Tool for the Job	23
Chapter 3 A Plan is Worth a Thousand Aspirin	25
Step 1. Be Able to Describe the Game from a Bird's-Eye View in One or Two Sentences	25
Step 2. Outline or Wireframe Out the Flow of All of the Game's Screens	. 26
Step 3. With Your Description and Basic Wireframe in Hand, It's Time to Outline the Core Mechanics That Your Game Will Utilize	. 27
Step 4. Build an Asset List	28
Step 5. Make a List of Technical Requirements for Your Game	30
Step 6 (Optional). Diagram Your Classes Using a UML Modeler	32
A Quick Review of the Planning Steps	33

hapter 4 //FTW!	35
Fair Warning	. 35
PART 1: Classes	. 35
Packages	. 36
Classes as Files	. 36
Constructors	. 37
Constants, Variables, and Methods	. 37
Getter/Setter Methods	. 39
Class Identifiers	. 40
Inheritance and Polymorphism	. 41
Interfaces	. 42
Linking Classes to Assets in Flash	. 45
Class vs. Base Class	. 46
Using Exported Symbols with No Class File	
getDefinitionByName and Casting	. 48
PART 2: Events	. 49
dispatchEvent	. 49
addEventListener, removeEventListener, and Event Phases	. 50
Event Propagation and Cancellation	. 53
Custom Events	. 54
PART 3: Errors	
try, catch, finally	. 56
Throwing Your Own Errors	
PART 4: Data Structures and Lists	. 58
Objects	. 59
Arrays	
Vectors	
Dictionaries	62
ByteArrays	
So What Should I Use For My Lists?	
Custom Data Structures	64

PART 5: Keep Your Comments to Everyone Else!	64
The Bottom Line	
PART 6: Why Does Flash Do That?	
Event Flow	
Frame Scripts	
Working with Multiple SWF Files	69
Garbage Collection	71
Conclusion	73
Chapter 5 Managing Your Assets/Working With Graphics	75
A Few Words About Organization	
Working with Graphics	
Raster Formats to Use	
Key Points to Remember	84
Chapter 6 Make It Move: ActionScript Animation	85
A Little Terminology	86
To Tween or Not to Tween? Is That a Question?	
A Simple Scripted Shooter	
Memory: Tweening Animation	
Summary	
Chapter 7 Turn It Up to 11: Working With Audio	97
Formats to Use	
Export Settings to Use	
Using External Files	
Tools for Working with Sounds	
Scripting Sounds	
Chapter 8 Put the Video Back in "Video Game"	115
Video Codecs	
External Video Uses: Cutscenes and Menus	116

The CutsceneManager	119
Video on the Timeline	123
Setting Up an Internal Video	125
Summary	128
Chapter 9 XML and Dynamic Content	129
Bringing Data In: Understanding the URLLoader Class	129
XML	130
E4X	130
The Crossword Puzzle	131
Content Is a Two-Way Street: A Crossword Builder	
Sending Data Back Out	
One More Example: XML vs. Flash Vars	
Summary	
Chapter 10 Four Letter Words: M-A-T-H	
The Math Class	
PART 1: Geometry and Trigonometry	
A Quick Explanation of Radians and Pi	
3D in Flash	
The SimpleTunnelShooter Example	
PART 2: Physics	
Scalar	
Vector	175
The Vector3D Class	175
Displacement	176
Velocity	176
Acceleration	176
Friction	177
Inertia	177
Simulation vs. Illusion	177
Reality vs. Expectations	178

Example: ATop-Down Driving Engine	178
Example: Top-Down Driving Game with Drift	
Review	
01 - 44 D - // 112 BE 1	400
Chapter 11 Don't Hit Me!	
What You Can Do vs. What You Need	
hitTestObject—The Most Basic Detection	
hitTestPoint—One Step Up	
Radius/Distance Testing — Great for Circles	
Rect Testing	
When All Else Fails, Mix 'n' Match	200
Chapter 12 I Always Wanted to Be An Architect	201
OOP Concepts	
Practical OOP in Game Development	
The Singleton: A Good Document Pattern	
Summary	
Chapter 13 We've All Been There	20 9
Basic Encapsulation—Classes and Containers	210
Store Relevant Values in Variables and Constants	
Don't Rely on Your Stage	212
Don't Use Frameworks or Patterns That You	
Don't Understand orThat Don't Apply	
Know When It's Okay to Phone It in and When It Definitely Isn't	213
Conclusion	213
Chapter 14 Mixtle A Cimple Engine	215
Chapter 14 MixUp—A Simple Engine	
The Main Document	
The MixUp Class	
The Title Class	
The RulesPanel Class	
The Game Class	22

The Interfaces	224
The GameBoard Class	226
The SourcelmageEmbedded Class	233
The GameHistory and Results Classes	234
The SourcelmageCamera Class	236
Review	238
Chapter 15 Bringing It All Together: A Platformer	239
The Platformer Genre	
Data Flow	
The Game Flow and Features	
The Level File Format and Asset Structure	
The Engine Classes	
The Game Class	
The Asset Classes	
Taking It Further	
Chantar 16 Dan't Play By Vourself: Multiplayer Daniel	004
RTMFP	281
RTMFPStratus	281
RTMFPStratusMixUp Multiplayer	281 282 282
RTMFPStratus	281 282 282
StratusMixUp Multiplayer	281 282 282 292
RTMFPStratusMixUp Multiplayer	281282282292
RTMFP Stratus MixUp Multiplayer Conclusion Chapter 17 Squash 'Em If You've Got 'Em: The Bug Hunt	281282292293
RTMFP Stratus MixUp Multiplayer Conclusion Chapter 17 Squash 'Em If You've Got 'Em: The Bug Hunt Bugs	281282292293293
RTMFP Stratus MixUp Multiplayer Conclusion Chapter 17 Squash 'Em If You've Got 'Em: The Bug Hunt Bugs Performance/Optimization Summary	
RTMFP Stratus MixUp Multiplayer Conclusion Chapter 17 Squash 'Em If You've Got 'Em: The Bug Hunt Bugs Performance/Optimization Summary Chapter 18 On Your Guard	281282292293293293293
RTMFP Stratus MixUp Multiplayer Conclusion Chapter 17 Squash 'Em If You've Got 'Em: The Bug Hunt Bugs Performance/Optimization Summary Chapter 18 On Your Guard Malicious Use	281282292293293298306307
RTMFP Stratus MixUp Multiplayer Conclusion Chapter 17 Squash 'Em If You've Got 'Em: The Bug Hunt Bugs Performance/Optimization Summary Chapter 18 On Your Guard Malicious Use Data Protection	
RTMFP Stratus MixUp Multiplayer Conclusion Chapter 17 Squash 'Em If You've Got 'Em: The Bug Hunt Bugs Performance/Optimization Summary Chapter 18 On Your Guard Malicious Use	

AFTERWORD	317
APPENDIX A Webcams and Microphones	A-1
INDEX	l-1
ONLINE CONTENTS	
APPENDIX B Localization	B-1
APPENDIX C JSFL is JavaScript For Lovers	C-1

ACKNOWLEDGMENTS

This book would never have been possible without the unending support and love from my wife, Delayna, and my daughter, Miriam. They are the best family that anyone could ever hope to have. In addition, I want to thank my extended family members for always being there for me:

Mom & Dad Meg & Leigha Andrew, Caleb, & Carson Delilah, Kurt, Vanessa, Isaac, & Virginia Daniel & Kelli Dottie & Charlie

I also would have never dreamed of writing a book if not for the support of my talented colleague and friend, Jason Fincanon.

For their professional support, I'd like to thank the following people (in no particular order):

Josh Dura

The whole Blockdot crew, especially: Paul Medcalf, Matt Schmulen, Bo Harris, Andrew Richards, Jim Montgomery, Curry McKnight, Stephen Hess, Mike Christian, Jon Stefaniak, Jack Dearnbarger, Dan Ferguson, Jason McMinn, and Mike Bielinski, Guy Stables, Matt Bugbee, Andrew Langley, Andy Brooks, Jack Doyle (and his amazing Tweening platform), Alessandro Crugnola, Grant Skinner, Allison Emerson and Marisa Murphy

The team at Focal/Elsevier: Laura Lewin, Chris Simpson, Dawnmarie Simpson, Anais Wheeler

Finally, I'd like to thank the fine team at Adobe who continues to push the Flash platform further. Please keep up the good work!

INTRODUCTION

Game development is a strange hybrid of many skills and styles merged together. One can argue that games are the most complicated form of entertainment to create. They not only require solid coding, attractive design, and sound user interface decisions, but the best games all share one particular aspect—they're fun to play. This "fun factor" can be especially elusive because it is so subjective. Different genres of games appeal to different people in different walks of life. Very few games, if any, are going to appeal to everyone, everywhere, all the time.

That said, the most popular type of game for players on the Internet are what have been termed "casual" games. If you're not familiar with this phrase, casual games are meant to appeal to a wide audience and focus on simplicity and approachability over depth and realism. This is not to say that some casual games are not deep and realistic, but the audience for a complicated tactical simulation on a console is very different from someone killing 10 minutes on their lunch break at work. Casual games can fall into any number of genres, from classic arcade-style games like Pac-Man to puzzle and logic games like Tetris. In fact, both of the titles I just mentioned have one thing in common; they are both products of an era in game development (the late 1970s to mid-1980s) when the focus was not on spectacle and movie-quality graphics and audio but rather on creating games that were first and foremost fun to play.

Games in Flash

Since you've picked up this book, I assume that you're not just interested in creating a game, but that you want to build it in Flash. Flash is an outstanding platform for developing games, particularly casual games for the web. The file size and power of the plugin, combined with the 98% install base around the world, make it a smart choice for getting your games seen by the largest possible audience. Historically, some Flash games have been thought of as glitchy, lacking in polish, and generally low end. That is quickly changing, however, as Flash games become more and more sophisticated and get closer to "traditional" computer and video games.

How to Get the Most Out of This Book

This book further assumes you either have at least intermediate experience with Flash (CS4 or a previous version) as an animation

or website creation tool or that you're entering Flash with game development experience on another platform. The purpose of this book is not to teach basic usage of the Flash environment from the ground up, as that has been done many times over by other skilled authors and instructors. Rather, I hope that by the time you finish reading this book you will feel totally comfortable tackling a game in Flash CS4.

The first part of this book covers a lot of the terminology and basic concepts you will need to understand about game development, as well as how to map out a game from start to finish on a single page. In the second part, I cover managing audio and visual assets in Flash, game logic (including dissecting an entire game script into its core components), and ways to architect your games to save you from headaches later. I'll share some best practices for both code and library organization.

A problem in Flash can usually be dissected any number of ways, and games are no exception. Sometimes external forces (clients, deadlines, etc.) will dictate one approach over another. Part three takes what you've learned from the first half of the book and applies it in a number of real-world scenarios, showing that you don't have to sacrifice the ideals of sound game development just because your timeline got cut in half.

The final part of the book wraps up with topics like sharing resources with a team of developers on larger games and ways you can optimize Flash to suit your workflow, and it provides some inspiration to get you pointed in the right direction.

Resources on the Website

On the companion website to this book, flashgamebook.com, you'll find a bevy of resources to assist you in following the examples later in the book and in creating your own original work. All the source code from the examples I share is available there, as well as other code snippets, scripts, and helpful utilities that should speed up game development. The site also provides a way for readers like you to ask questions and receive updates and clarifications as they become necessary. Be sure to check it out as you read and after you finish the book.

COMPUTER SCIENCE ISN'T FOR EVERYONE

A Little Groundwork

Before we get too far into Flash, it's important to lay a foundation for game development so we understand the terminology that will be used throughout the rest of the book. Refer back to this chapter when you forget what a term means or how it applies in a particular situation. If you start to feel a little overwhelmed by all the long words and abstract concepts, don't worry! Game development (particularly efficient, well-executed development) is complicated and there's nothing wrong in admitting it. Remember that anyone who has programmed a game has suffered the same anxieties and doubt. Like anything in life, it will take practice and real-world experience to feel proficient. So grab a cup of your favorite caffeine-infused beverage, and let's get started!

Common Game Types

There are many different types of games (and some games that pride themselves on being unable to be easily categorized), but most can be dropped into one of the following genres.

Adventure

Adventure-style games are typically story driven and have one or more central characters. These games feel the most like movies (some have been known to have the production budget of one) and can rely heavily on dialogue, exploration, and logical problem solving to move the player through the narrative. Adventure games were especially popular during the late 1980s and early 1990s, with LucasArts and Sierra producing some of the finest

examples of the genre. This game type has had a resurgence of sorts in Flash due to its very art-driven production pipeline and the typically lower system requirements.

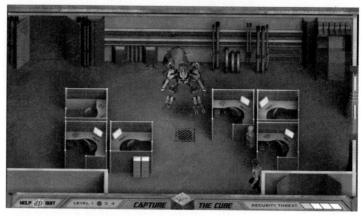

Figure 1.1 Mountain Dew Capture the Cube game.

Action

This category encompasses a large number of gameplay perspectives and subgenres, but usually action games consist of tests of player dexterity, reaction time, and quick-wittedness under pressure. First-person shooters, side- and vertically scrolling games, and fighting games all fall into the action genre. Flash lends itself very well to some of the subgenres of this category, particularly retrostyle action games like Space Invaders or Super Mario Brothers.

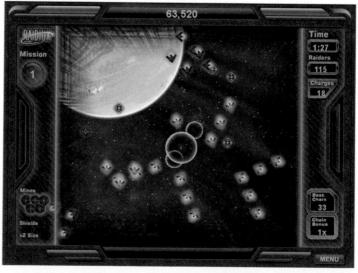

Figure 1.2 Raidiux. © 2009 Blockdot, Inc. All rights reserved.

Puzzle

Think Tetris, Bejeweled, Sudoku—the list goes on. Games that involve logic, problem solving, pattern matching, or all of the above fall into this game type. Flash thrives in this genre for a couple of reasons. First, there's generally a lower amount of art needed for a simple puzzle game, meaning individual developers can often do it themselves. Second, the core casual gaming audience on the web tends to be older and to appreciate the generally slower pace of puzzle games.

Word Games

This category could be considered a subgenre of puzzles, but the approach to building them can be different enough that I thought they deserved their own space. Word searches, crossword puzzles, spelling games, and anagrams all belong in this genre. Flash is a popular medium for games of this type, for the same reasons it is for other puzzle games.

Figure 1.3 JinkyPOP. © 2009 Blockdot, Inc. All rights reserved.

Strategy and Simulation

I'm cheating a little by combining these two genres into one, but they share a number of common traits. Careful planning, resource management, and decision making, such as city planning or the creation of a large army, characterize strategy games. The level of minutiae the player is expected to maintain usually defines a strategy or simulation game. Some games are so complex as to allow every possible option available to the player to be micro-managed. More casual strategy games, like most created in Flash, simplify gameplay by reducing the number of options available and focusing on a couple of main tasks. A popular

example of the casual strategy subgenre is tower-defense games, where players must stop enemies from getting past their defenses using a variety of different weapons strategically placed.

Figure 1.4 The Maid, Monk, and Ogre. © 2009 Blockdot, Inc. All rights reserved.

Role-Playing Games

Role-playing games (RPGs) are similar to adventure games but are normally defined more by the growth of the main character throughout the course of the game's story. Traditionally, RPGs take place in a fantasy setting and center around the player's statistical development, such as improving traits like strength, intelligence, or agility. The most popular recent incarnation of these games has been in massively multiplayer online RPGs, or MMORPGs, where players compete against and collaborate with each other to develop their characters. Because of the social and web-based aspects, a few Flash MMORPGs have begun to emerge; however, these games are typically costly and have long development cycles, making them riskier ventures for companies and infeasible for individual developers.

Vehicle Games

These games are pretty self-explanatory; they revolve around the operation of a vehicle on land, in water, in the air, or in space. Traditionally, these games are played from a first- or thirdperson perspective to achieve a sense of realism. Due to system requirements and the complexity of building a full three-dimensional (3D) environment in Flash, most casual games in this genre feature a two-dimensional game view.

Board- and Card-Based Games

Usually a digital incarnation of a real-world game, this category can consist of games like Chess, Checkers, Blackjack, and Poker. Due to the low system requirements, Flash is a great platform for creating most board and card games, as is evidenced by the large number of casino-style game sites on the web.

Figure 1.5 Tiki Freecell. © 2009 Blockdot, Inc. All rights reserved.

General Development Terms

Computer science is a difficult field of study and definitely not for everyone who simply wants to make games. However, a fundamental understanding of some of the core concepts of programming helps later when we're dissecting a game piece by piece. Yes, it's dry and occasionally tedious sounding, but I promise that fun stuff will follow!

Pseudo-Code

Pseudo-code is nothing more than a standard language explanation of a series of programmatic steps, sort of like a summary of your logic. Throughout some of the examples in this book, you'll find that I sometimes break down the logic in a game in pseudo-code before typing any actual ActionScript. It is easy to get too caught up in the syntax of programming and overlook a flaw in the logic, so it is almost always simpler to break down a problem in English before tackling it as actual code. Often my pseudo-code will become the foundation for the names of my functions and properties.

Algorithm

An algorithm is nothing more than a series of instructions and decisions that define the solution to a problem. They are not code or language specific and therefore make sense in plain English. For instance, an algorithm could be as straightforward as the process that takes place when a program sorts a list of words by their length. Here is what that might look like in pseudo-code:

```
for all in wordlist
  sort by length
sort by length (word A, word B)
  if A.length > B.length
   return B
  else
  return A
```

Procedural Programming

Many earlier programming languages, like BASIC or Pascal, were what are known as *procedural* languages. You can think of it in the abstract as programming a list of tasks, or subroutines. They can be executed in any order, but all the commands are driven by one main logic controller, sometimes referred to as the *main loop*. The examples in this book will be a combination of procedural programming techniques and the next kind, object-oriented.

Object-Oriented Programming

Unlike procedural programming, where the focus is on a set of tasks to be executed, object-oriented programming (OOP) is centered around the concept of "objects" interacting with each other. OOP can be a very complicated subject to understand fully, but suffice it to say that each object is a self-contained entity that has defining properties, can send and receive messages from other objects, and can process its own internal logic. For example, in OOP a person would be one object and a friend another. They will share some components, both being people, but they will also have characteristics unique to each. They communicate

to each other through messages in a common language. Some of the aspects of ActionScript work in an OOP manner, and we will cover those at length later on in this book.

Design Patterns

Much is talked about these days with regard to design patterns in software engineering. There are many lengthy explanations, with whole books devoted to the subject in abstract. For the purposes of this book, think of a design pattern as the template for your code. It is the blueprint by which you can structure a game as you program it, particularly from an object-oriented approach. There are many accepted design patterns in the industry, some of which work well for Flash game development and some that don't really have a place here. In Chapter 12, I'll discuss the most effective patterns I've found when working in Flash and how to implement them.

Classes

In OOP, classes are pieces of code that act as the building blocks of objects. You can think of them as templates from which all the objects used in an application are derived. A class defines all the properties and functions (known as *methods*) of an object. Using classes in Flash is important for a number of reasons. First of all, defining your code in classes requires you to put more planning into how you structure your game. This is a good thing; not having clearly defined blueprints leads to second guessing and duplication of work later on. If a carpenter went to build a house with no plans from the architect other than a single drawing, he would either quit or have to improvise continually along the way. The result would be a very inconsistent, possibly uninhabitable house. I'll cover class structure extensively later on, as most all of our development will be centered around their use. In the mean time, here is an example of a simple class defining a player in a game:

```
package {
  import flash.display.MovieClip;
  public class Player extends MovieClip {
    public const jumpHeight:Number=10; //pixels
    public const speed:Number=15; //pixels per second
    public var health:Number=100;//percent
    public var ammo:int=20;//units
    public function Player() {
        //initialization
    }
}
```

Not all the code may make sense at this point, but hopefully you can see that we've just defined a player character with a predefined jumping height and movement speed and variables for how much health and ammo he has. Granted, this little bit of code alone won't do anything, but it does create a foundation upon which to build more functionality and features.

Public, Protected, Private, and Internal

The four prefixes you can give the properties and functions inside your classes, also known as *attributes*, define what items are available from one class to the next. All of them are documented in Flash's Help files, but here's a quick summary:

- Public methods and variables are accessible from anywhere and are the foundation for how classes interact with each other; when one class extends another, all public methods and variables are inherited.
- Protected methods and variables are accessible only from inside their class and are inherited.
- Private methods and variables are accessible only from inside their class and are *not* inherited.
- Internal methods and variables are accessible from all classes within their package.

Techie Note

There is one other attribute, known as static, which can work with any of the other four listed above. When a method or variable is static, there is only one copy of that item ever created, and it is accessed through the class directly, not objects created from the class. In other words, a static property called *version* of the class Game would be accessed as Game.version. If you tried to access it from an instance of the Game class, you would get an error.

Game-Specific Development Terms

Now we move onto more interesting development terminology. This section covers concepts that we will be directly applying as we build games in future chapters.

Artificial Intelligence

Artificial intelligence (AI) refers generically to a set of logical decisions that a program can make to mimic human decision making. AI can be very simple (like having the computer move the paddle toward the ball in a game of Pong) or extremely

complex (like having enemies duck for cover, understand when they're in danger, and react accordingly in Halo 2). For our purposes in this book, and because Flash would not be able to handle it otherwise, most of the AI we develop will be relatively uncomplicated.

Game Loop (or Main Loop)

This term generally refers to the main segment of code that determines the next course of action for a game based on input, AI, or some other arbitrary logic. It usually is nothing more than function calls to other pieces of logic and checking to see if certain conditions have been met (such as whether or not a player has won).

Here is an example of pseudo-code describing a simple main loop from a game:

```
on enter frame
move player
move enemies
check for collisions
check for win or lose
```

In languages like C, a main loop is literally a coded loop (like a *while* or *for* loop) that runs until a condition is met. In some cases, this is also referred to as the *state machine*, because it is the logic that determines which "state" the game is in—pregame, in-game, post-game, etc.—and performs the corresponding functions. In ActionScript, it must be set up differently because a regular loop would lock up the Flash player waiting for the game to finish. Because of its animation heritage, Flash works in the context of frames, much like a movie. It has a frame rate, or number of frames per second, that can be defined. When a frame passes, Flash updates the screen, making it the perfect time to perform logic. This can seem odd to developers used to other languages, but it quickly becomes second nature. I'll discuss game loops further later, as they will be the driving force behind our game code.

Game View

A game can take place from any number of views—often the genre of a game defines which view to use, but not necessarily. Many modern action games are first- or third-person views, in which you see the game world from your character's perspective or from just behind them. More casual action and adventure games utilize views from the side. Other genres, such as strategy or racing, may view the action from above. Part of what makes a game compelling and fun to play is the view you choose to

employ. An action game with lots of fast movement and obstacles would be difficult and lackluster from a bird's-eye view, but from a first-person view it has an immediacy and intensity that suspend the player's disbelief. Some game views work better in Flash than others. Most any views involving a 3D environment won't work well given Flash's technological performance limitations, but there are tricks and techniques I'll discuss later that can be used to simulate 3D in a convincing manner.

Scrolling

Often a game's environment extends beyond its viewable area. For example, in Super Mario Brothers the game world stretches on for some distance but only a small portion can be seen at a time. Because of this, the game scrolls back and forth horizontally with the player kept within the main viewable area. This same affect can be used both horizontally and vertically for driving games or strategy games, for example.

One technique to give a scrolling game environment more depth and more of a 3D look is to have multiple layers of the environment scroll at different speeds. This technique is known as *parallax scrolling*. Much like in the real world, objects that appear to be in the distance, like mountains or buildings, can move at a slower speed than objects in the foreground. We'll dissect an example of side-scrolling animation in Chapter 6.

Tile-Based Games

Some game environments can be broken up into a grid, such as a maze or strategy game. The artwork for the game can then be created as *tiles* of a predetermined size. While it requires more work on the programming end to develop an efficient tile-mapping system, it opens up games to the creation of a level editor to allow end-users to create custom maps. Starcraft and Warcraft are two strategy games that feature very well-implemented tile systems with editors. We'll look at a tile-based game engine in Chapter 10.

Flash Development Terms

To finish out this chapter, here are a handful of terms that I'll continue to refer to throughout the book. Understanding the way each of these items works will be key to architecting sound game code down the road. In Chapter 4, we'll dig into these concepts in even more depth, but this will serve as a quick overview.

Stage

In Flash, the Stage is the main content area upon which everything is built. All other visual objects sit on top of the Stage once they have been added to it. Think of it as your game's canvas.

Display Objects

A display object is any object that has a visual representation and can be placed onto the Stage. There are many different types of display objects in Flash; those most familiar to experienced developers will be Buttons, Sprites, and MovieClips. Even the Stage itself is a special kind of display object. They all share some common traits; they all have an x, y, and z position on-screen, as well as scaling and rotation properties. Flash maintains lists of all the display objects on-screen at any given time, making them easy to access and manipulate.

Events and Listeners

Events are the primary means of communication between objects in ActionScript 3. They are simply messages that objects in Flash can broadcast or *dispatch*. Any object that has been set up to listen for them receives events. They can be notifications of user input, information about external data being loaded, etc. Flash has many built-in events for common tasks, and it is entirely possible (and encouraged) to create new ones for custom objects like games. Events can carry with them any amount of data pertinent to their type, but all of them contain a few basic properties:

- · A name or type
- A target—the object that dispatched the event
- A currentTarget—the object that is currently listening to or handling the event

Events are an extremely powerful tool that we will make extensive use of in later chapters.

Packages

A package is a collection of classes and functions used for organization purposes. Because there are so many different classes built into Flash, not to mention all the classes we will create, it is important to keep them grouped into logical collections. For example, any classes in Flash that deal directly with display objects are in a package called flash.display. Most events are found in the flash.events package. The standard naming convention

for a package is all lowercase. To use classes in a particular package, we use the *import* command to gain access to them:

```
package mypackage {
  import flash.display.MovieClip;
  public class MyClass() extends MovieClip {
  }
}
```

Author-Time, Compile-Time, and Runtime Events

These terms refer to the different stages when data in Flash is altered or verified. Throughout the book I will make reference to things that happen inside the Flash authoring environment—these are author-time events. Events or errors that occur during the process in which Flash creates a SWF file are known as compile-time events. Finally, runtime events occur once a SWF is running by itself.

You Can Wake Back Up Now

Whew. You made it! While you may not fully understand the concepts I've presented here, you will start to see them in context in later chapters, and they will start to click. Just think, soon you can drop words like "polymorphism" in casual conversation and sound like a full-fledged nerd, er ... software engineer!

THE BEST TOOL FOR THE JOB

Flash Back

Adobe Flash (formerly Macromedia, formerly FutureSplash) has been around for a long time now and come a long way from its humble beginnings. Starting in Flash 4 developers were given an impressive (at the time) set of scripting tools for what had previously been primarily a lightweight animation tool. The first games started to appear in Flash 4 and continued on into Flash 7 with the introduction of ActionScript 2 (AS2). Flash developers could now program in a fairly object-oriented way, albeit with some concessions and quirks.

Fast forward to the newest release, Flash CS4 (or Flash 10, if you prefer). Since the previous version, Flash users have had access to a powerful new version of the language: ActionScript 3 (AS3). Redesigned from the ground up, AS3 much more closely follows the standards and guidelines of modern programming languages (like Java or C#), with a well-defined roadmap for new functionality in later versions. Flash CS4 introduces even more amazing new features to exploit for games, such as basic three-dimensional (3D) transformations, inverse kinematics (for realistic character manipulation), and an all-new animation toolset.

Because Flash CS4 is our development environment of choice, AS3 is what we will cover in this book. If you're still making the transition from AS2 to AS3, or have yet to start, don't be discouraged. Where a programming convention or technique has changed significantly from AS2, I'll note it off to the side. AS3 can take some getting used to, as some of its syntax has changed dramatically over AS2; however, before long the changes will become second nature, and you'll wonder how you ever got along without some of the best features of AS3. If you've already got AS3 development experience, you're a step ahead and should feel right at home in the language. And, if you're coming from a game development

Figure 2.1 Flash logos from previous versions, all the way back to Flash 5.

background outside of Flash, you'll find some things familiar and some things very different than what you're used to.

The Case For Flash

The first thing to know about Flash is that it was never *designed* to develop games. There are a number of absent features that to this day frustrate even a fan of Flash like myself. I'll further outline these strikes against it shortly, but first let's see what Flash has going for itself.

Player Penetration

Roughly 98% of users on the Internet have some version of the Flash player, and usually within a year of a new version being released more than 80% have upgraded. The sheer size of the audience accessible to Flash developers is unprecedented in the games industry. Because it is available on machines running Windows, Mac OS, or Linux, it also bridges the gaps between all of the major consumer platforms. Most game designers and developers that produce big-budget, retail titles have to settle for a much smaller demographic and have to make the conscious (and often costly) decision to include platforms other than their main target.

Flexibility

Flash is capable of being many things at once. You can create cartoons, post-production effects, presentations, banner advertisements, all manner of websites, web- and desktop-based applications, and, of course, games. Developers use Flash for any and all of these functions, and some may only be familiar with the one task they've learned to do. Because it is a very visual environment, Flash is also much more approachable to novices than most development packages. Unfortunately, this immense flexibility comes with a price. By not being designed specifically to do any one thing, Flash tends to take a very generic approach to its toolset and includes functionality that is useful to a number of applications, not just one niche. You can create additional tools, scripts, workflows, etc., that will help you in your particular task, but that is all up to your individual ingenuity. I'll cover some of these additions in a later chapter.

Speed to Market

Flash makes many tasks that would require a great deal of code in other languages much easier. Tasks such as simple animation and basic playback of video and audio are very streamlined in Flash, which allows developers to get their products to market much faster than other solutions with arguably more power. For example, because of its animator heritage, Flash makes it very easy to display visuals on the screen. This may sound like an obvious statement, but compared to other development environments this is a big advantage. C++, Java, and other languages render everything to the screen programmatically, so drawing a simple rectangle on screen requires many, many lines worth of code. All it takes in Flash is selecting the rectangle tool and placing one on the Stage or writing a few lines of ActionScript. Flash takes care of rendering everything "under the hood" so you as the developer don't have to worry about it. Well, not too much anyway.

It Looks Good

While I'm sure we've all seen our share of hideous-looking Flash content over the years, some of the best-looking and most visually effective work I've ever seen on the web was created in Flash. Because Adobe is such a design-centric company, they are equally concerned with tools that allow your work to look nice as they are with tools that make it run well. This has a tendency to frustrate both designers and developers from the hardcore end of the spectrum, but it is exactly this marriage of technology and design that makes Flash unique.

Nobody's Perfect

For all that Flash has going for it, it is certainly not without its flaws when it comes to producing games. Don't get me wrong; the point of enumerating these flaws is so you as the developer will be aware of them, not to make a case against using Flash in the first place. The good news is that most of these downsides can be worked around, with the right tools.

Flaw: The Code Editor

While the Flash ActionScript editor has definitely evolved with the rest of the package over the years, it still lacks a handful of fundamental features that keep me from wholeheartedly recommending it as the coding tool of choice. The most aggravating omission is actually just a poor implementation: code hinting. As you write code, Flash tries to anticipate what you're going to want to type next and offers you a selectable list of options to try to speed up the process. The problem is that it only hints code when you get to the end of a word, so if you start to misspell a variable or function and don't receive a hint for it, you have no indicator of where you went wrong. It also won't give you hints for any classes

that aren't part of Flash's core library, which as you will see later, is a large portion of what we'll be using.

Figure 2.2 The built-in ActionScript editor in Flash CS4.

Solution: Use an Additional Tool

The simplest solution to this quandary (and the one I use) is to use an additional application to handle all your ActionScript writing and use Flash for everything else. The two best options out there as of this writing are FlashDevelop, a free open-source code editor, and Flex Builder, Adobe's coding application based on Eclipse (another open-source editor). If you're on a tight budget

```
Section of the sectio
```

Figure 2.3 The free code editor FlashDevelop.

or you don't intend to use the Flex framework to create Flash content, FlashDevelop is a great choice and what I use on a daily basis. If you want to create content in Flex, or you already own a copy of Flex Builder, it is an equally robust solution with some really great additional features such as bookmarking lines of code that you're actively working on. The extra step of switching back to CS4 to publish your SWF will pale in comparison to the amazingly good code hinting and other scripting enhancements these programs offer.

Flaw: Performance/Memory Management

As Flash games continue to grow in size and complexity, they require heftier hardware to run well. Most other modern development environments include tools for benchmarking a game's consumption of system resources like CPU power and memory. Flash does not have any features like this, so it is harder to predict without real-world testing how well a game will perform on a range of systems or what its minimum requirements should be.

Solution: Use a Third-Party Solution or Roll Your Own

The Task Manager in Windows and the Activity Monitor on a Mac are great system-level tools that everyone has for monitoring the memory and CPU allocation of a given application. Unfortunately, there's no real way of getting the exact CPU usage of a Flash game, because most ways of testing it involve running it inside another program, like Flash CS4 or a web browser. These programs can be running other tasks that consume system resources and it's hard to know where the container ends and the game begins. That said, sometimes a simpler approach to this problem is more effective. Flash content is set to run at a predefined frame rate. If the Flash Player gets too bogged down with either code or whatever it's trying to render to the screen, it will bring the frame rate down. It is very easy to use a small component in your games to monitor the frame rate a particular machine is getting. You can then use this information during testing to determine the minimum level of machine required to play your game. Simply set a tolerance level (usually 85% or higher of a game's designed frame rate is acceptable) and then note which machines fall below this tolerance. Memory is a little more exposed in Flash, and there are ways of determining choke points in your game where memory usage gets out of hand, though it does require writing your own utility. This is done using the Sampler package, and we will cover it, the FrameRate component, and other optimizations in Chapter 17.

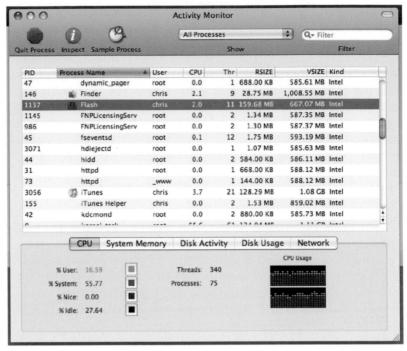

Figure 2.4 The Activity Monitor on a Mac.

Flaw: Debugging Content

Adobe greatly improved the debugger from AS2 to AS3, but it still has a number of flaws when it comes to working with larger projects. First of all, because SWFs do not store any breakpoint information by default, you can only step through code in the active SWF. Any subsequently loaded SWFs into your container cannot be debugged. As projects get larger and larger and rely on external files, this becomes exponentially more cumbersome. This problem also affects remote debugging, which is often even more important than when inside Flash. I've had content work fine within Flash and fall apart once it is on a web server, the results of which are a bug hunt in the dark and a lot of head scratching. Needless to say, this becomes even more frustrating with games, which rely so heavily on lots and lots of code.

Solution: Use Traces and Custom Tools

The single most helpful tool in debugging Flash content is the *trace* command; it has been around since Flash 4 and works essentially the same way it did those many years ago. All it does is display whatever information you tell it to at runtime. This becomes invaluable when attempting to watch something as complicated as a game execute in real time. You can have Flash trace out entire sequences of logic to determine where a bug is occurring, and you can use it to display messages to other developers who might be working with your code. Although traces work through the Output window in Flash, it is possible to capture them inside Firefox using an extension called FlashTracer and the debug version of the Flash Player. Links to both can be found on this book's website, flashgamebook.com. It works well for general debugging, but when a game works fine in Firefox but not other web browsers it won't be of any help. Another option is to create even more robust tools you can use in any environment. We'll explore how to create and implement these tools in Chapter 17.

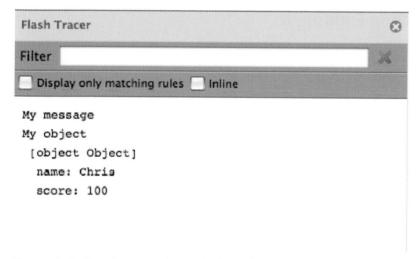

Figure 2.5 The FlashTracer extension running inside Firefox 3.

Flaw: Lack of Built-In Game Libraries

Up until this point, the shortcomings of Flash I've outlined are ones that affect developers of all kinds of Flash content. Because games tend to need more specific toolsets and lean towards the end of customized development, Flash lacks a number of code libraries that are readily available on other platforms. Examples of this type of library could be a physics simulator for doing realistic physical collisions or a sound manager that easily handles fading/panning sound effects in real time. These libraries must be written from scratch, which means they do not benefit from the speed boost of being implemented directly inside of Flash.

Solution: Write Your Own or Find Open-Source Implementations

Unfortunately, until Adobe adds game-specific libraries to the Flash Player we are stuck building our own. Luckily, many developers in the Flash community are working to either port libraries such as these from other languages or write them from the ground up in ActionScript. Many of them are open-source projects that anyone can contribute to and improve. There are links to a number of these on this book's website. To be fair to Adobe, some new classes have been created for Flash 10 that have previously had to be written from scratch, such as 3D manipulation of display objects, an inverse kinematics engine, and a new data type for dealing with vectors (see Chapter 10 on math and physics).

Stop Fighting It

Traditional game developers sometimes try to fight Flash's nature when they first make the transition, but often the best way to get the desired result out of Flash is to play to its strengths. Take, for example, a character in a game you want to animate depending on its state (idle, running, jumping, etc.). An artist has given you image sequences of each of these states. The character's state may be controlled by user input with the mouse or keyboard, or by AI. A conventional approach to this problem would be to write a script that updates the character with the correct frame of animation based on what the game is telling it to do. However, this requires the script to know how many animations there are, how many frames each animation is, and whether the animations loop or only play once. It also has to add the new image to the Stage and remove the old one. In addition, it adds overhead to any other code running in the game, which can become troublesome if you have many characters on-screen at once.

This is a perfect example of an area where Flash shines over other game development tools. Because the environment is built around the concept of timelines and animation, you have a tremendous amount of flexibility when it comes to controlling player states, game states, or any other objects in your game that are more than a still image. The trick is in knowing what Flash does best and where you need to alter its behavior.

The flip side of the game development coin is that games *do* take code—often lots of it. A game built entirely around animation and fancy art would not likely be very interesting or reusable at a later date. Users who have previously built content in Flash with very little scripting may find themselves panicking at the sight of the amount of code we will encounter in later chapters.

This is normal; take a deep breath. Development in Flash has always been a marriage of different disciplines, and games are possibly the ultimate example of this notion. Each task Flash has been designed to make easier has aspects that translate to game development.

Things Flash Was Built to Do

Animation vs. Games

Possibly Flash's strongest use out of the box is as an animation application. Much like post-production programs (like Adobe After Effects) or multimedia authoring tools (like Adobe Director), Flash is centered around the concept of a timeline. By default, events occur in a linear order, and objects on the timeline can have timelines nested within them. This allows for very complex animations to be built relatively quickly.

Consider for a moment an animation of a character walking. In order to look convincing, all the character's appendages would have to be separated and animated independently. Additionally, they must move across the Stage so the character is not just walking in place. To move all the parts at the right speed would be very cumbersome and time consuming. Instead, with nested timelines, the walking sequence can be contained inside a clip that is moved at a different rate across the Stage. While this concept is not at all new to anyone familiar with Flash, it speaks to a hierarchy that will prove very handy later.

Application vs. Games

Though it started as an animation tool, Flash has grown into a number of other uses. Since the last few versions of Flash, Adobe has started marketing it (along with Adobe Flex) to create what is referred to as *rich Internet applications* (RIAs). In brief, RIAs are applications that perform what were traditionally desktop-bound tasks from the web. They can be anything from shopping cart applications to billing software to a weather forecast widget. To provide flexibility and to make rapid development of this kind of software possible, Adobe includes a number of components—prebuilt pieces of code designed for easy reuse. These components include scrollbars, text boxes, radio buttons—devices you might see on a typical webpage in HTML. While these components are great for RIAs, they serve little use directly in games (though I will show later how they can be very useful in tools that aid game development).

Arguably, a game is an application, since it performs certain functions based on user input. However, an application in the

traditional sense is used to create something or deliver information; it receives input and gives output. The guidelines for producing an application like a word processor are very different from those used to create a game. This must be understood so as not to try to develop games like you would any number of other applications. While applications tend to be used for productivity, games are used for entertainment or, in some cases, education. Games are experiential; they set a tone and create an environment for the user to have fun (or occasionally teach a concept or make a point).

Flash vs. Flex

Adobe Flex is a tool for creating Flash content outside the CS4 environment, based on a preset framework of components and a layout language similar to HTML. It excels for rapidly creating RIAs. It was conceived to try to win over developers to Flash from platforms like Java or .NET. Where Flash CS4 stands out in terms of animation and motion graphics capabilities, Flex shines as a programmer tool. Its accompanying Flex Builder is an outstanding code editor and has many features that make traditional programmers feel right at home, as it is based on the popular Eclipse integrated development environment (IDE). The main reason I chose to cover Flash instead of Flex as my development environment of choice is that I feel Flash is simply a better environment for making most games. There is no equivalent to be found in Flex for Flash's animation toolset, but Flash can be augmented and used concurrently with other tools like Flex to make up for its code shortcomings. The other reason to use Flex is the Flex Framework (a set of classes for easily creating and skinning RIAs using a markup language called MXML), and it adds considerable bulk to your projects that in no way benefits game development. See above regarding alternative code editors for Flash.

Websites vs. Games

Another area where Flash has flourished is in website development. I started using it at an ad agency, building branded websites for clients. Flash includes many features for working on the web, including streaming support for content, the ability to load data from a variety of external sources, and, of course, its browser-based player that places Flash content alongside anything else in HTML. Much like games, websites tend to be experiential, but they are also usually meant to be informative. When they are intended purely for entertainment they can resemble a game on many levels, short of a score or accomplishment-based outcome. In fact, because of the similarities in how each type of

content is produced, the line between Flash websites and games nested inside them has become very blurred.

Flash vs. Traditional Game Development

Working with game developers coming from a background in C or Java, for example, has been an enlightening experience; many aspects of Flash's workflow that I take for granted are real stumbling blocks to outsiders. First of all, traditional game developers tend to keep all the code for a game and all the assets (art, sounds, video, etc.) separated completely. The code defines what assets are loaded and how they are used. In Flash, the standard way of managing assets is to import them into a single library file. To use an asset, you simply drag it onto the Stage and start working with it, or you give it a name that can be referenced later in the code. This interdependence of code and assets has often been a criticism leveled against Flash by more traditionalist developers, as too heavily tying code to specific assets can render it hard to reuse later. While there is some truth to this claim, there are ways (which we will cover later) to utilize the conveniences of Flash's asset management with largely reusable code.

The Best Tool for the Job

Perhaps one of Flash's greatest strengths is the fact that there are arguably so many ways to achieve the same end goal. There are definitely better and worse processes along the way, and in the chapters to come I will outline what I've found works consistently and what to avoid.

A PLAN IS WORTH A THOUSAND ASPIRIN

I've built a lot of games in Flash over the years. Some have taken less than a week, and some have stretched on for several months. Whether they had huge budgets or practically no budget at all, one common thread has come back over and over again: The projects that were well planned out and clearly defined went smoothly, and those that were not didn't. Planning a game thoroughly can feel like a tedious step, but it's much easier to change your mind or predict problems on paper than it is in the heat of development. How exactly you go about documenting and outlining your game is a matter of personal preference and a measure of just how anal retentive you're willing to be. Here are some strategies that work for me.

Step 1. Be Able to Describe the Game from a Bird's-Eye View in One or Two Sentences

Most any game idea, no matter how complex, can be summed up in this manner, even if it leaves out a lot of details. Being able to distill a game down to its most basic premise keeps you on track and acts as a "bigger picture" reminder of what you're building. If you work at a company building games for clients, you're likely dealing with marketing people, not gamers; they tend to appreciate this level of succinctness. For example, a summary of Pac-Man could be:

Move through a maze collecting food while avoiding ghosts that are trying to kill you.

A game I once built for Mountain Dew's MDX drink would have a description like this:

Drive a cab around the city at night and earn as much money as possible by delivering passengers to their destination in a timely manner. Pick up bottles of MDX for a speed boost.

Note the plug at the end outlining how the client's product will be showcased; that is very intentional.

Step 2. Outline or Wireframe Out the Flow of All of the Game's Screens

At its most basic, this includes the main menu, help panels, the core gameplay itself, and any results screens (client link, scoreboards, etc.). Note that this is not an outline of gameplay, but rather all the steps leading up to and surrounding it. Performing this step captures the user's progression through the game and helps identify touch-points between different screens that might be tricky to integrate if you don't plan for them in advance. Figure 3.1 is an example of how a simple game with relatively few screens might look. In this example, bolded text represents buttons or links that can be clicked to access the associated screen. A simple wireframe like this is also often helpful to artists, reminding them of any necessary buttons, call-outs, etc.

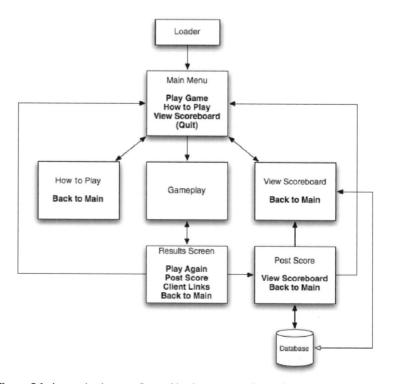

Figure 3.1 A very simple game flow, with a box representing each screen.

You might have noticed () around the Quit button. This indicates that a Quit button is optional. It makes sense for games that players will download to their computers, but for web games in a browser it doesn't really have a place. If you add the option to Quit from your game in a webpage, be sure you know where you're going to send them.

Step 3. With Your Description and Basic Wireframe in Hand, It's Time to Outline the Core Mechanics That Your Game Will Utilize

This is more or less a feature list and can simply be in bulleted form, but the more detail you cover the less surprises you'll run into once you're in production. It allows you to break down the gameplay into its main pieces of functionality. These include components like the game's rules, input mechanisms (keyboard or mouse), movement and collision, and how the player's score or progress is determined and recorded. Once again referring back to Pac-Man as an example, here's how a mechanics list might read:

- · Maze tile engine
 - Nothing can move through walls.
 - Any open space is filled with food, power-ups, or bonus items (fruit).
 - o One pass-through connects left and right sides.
 - Each tile has at least one and up to four possible connections to other tiles.
- · Collision management
 - Maze
 - Ghosts
 - Pick-ups
- Player
 - Keyboard input; directional arrows
 - Lives
 - Player has three lives at start of game.
 - Player loses a life every time he is hit by a ghost without a power-up.
 - When the player dies, his progress in the current level is maintained.
- AI
 - Normal behavior—chases player.
 - Power-up behavior—avoids player.
 - Starts from a central location at the beginning of a level and is sent back there when caught by the player in power-up mode.
 - Increased speed with each successive level.

• Pick-ups

- No pick-ups regenerate until the start of a new level or a new game.
- Food
 - * All food pick-ups must be collected to win a level.
 - Food contributes 10 points per item to the player's score.
- Power-ups
 - Each level of a game has four power-ups.
 - Eating a power-up makes player invincible for five seconds and allows player to eat ghosts.
- Bonus food items
 - Appear on a random interval, one at a time, and only stay in place for a few seconds before disappearing.
 - Contributes 100 points per item to the player's score.
- Scoring
 - Pick-ups and eating ghosts contribute to overall score.
 - Final score is used as ranking mechanism for scoreboards.
- · Winning criteria
 - o Player wins a level when he picks up all food.
 - Game continues until player runs out of lives, getting successively harder with each level (see AI).

As you can see, all the familiar features of Pac-Man have been outlined here, as well as their relationships to each other. Note that this list is not typically client facing, but in projects with a short timeline it can be wise to put it in front of a client to get sign-off *before* you begin production. This can give you leverage when that last-minute client change comes down the line and threatens to derail the project. It also makes the clients feel empowered and like they have a say in the process but at a point when a change in direction isn't catastrophic.

Step 4. Build an Asset List

Whether you're working with an artist or building the entire game yourself, it's best practice to make a list of all the art, sound, and copy (or text) assets you'll need. Working through this list after Step 3 is important because the game mechanics and any specific art pieces and animations you need should be fresh in your head. Following the Pac-Man theme, here is a sample asset list. You can reference your wireframe from Step 2 to help you remember what assets you'll need for the non-gameplay screens.

- · Game animations
 - Pac-Man
 - Movement

- · Power-up
- Death
- Ghosts
 - Movement
 - · Retreating movement
- Static game art
 - Maze walls
 - Food
 - o Power-ups
 - Bonus food
 - Point displays
- · Non-game screens
 - Loader artwork
 - Main Menu
 - . Title artwork
 - Play button (three states: up, over, and down)
 - How to Play button (three states: up, over, and down)
 - View Scoreboard button (three states: up, over, and down)
 - How to Play
 - · Rules copy
 - · Rules artwork
 - Back to Main Menu button (three states: up, over, and down)
 - View Scoreboard
 - Scoreboard table artwork
 - Back to Main Menu button (three states: up, over, and down)
 - Results screen
 - Score display artwork
 - Play Again button (three states: up, over, and down)
 - Post Score button (three states: up, over, and down)
 - Back to Main Menu button (three states: up, over, and down)
 - Post Score screen
 - Confirmation message
 - View Scoreboard button (three states: up, over, and down)
 - Back to Main Menu button (three states: up, over, and down)
- Audio
 - Sound effects
 - · Eating food
 - Eating power-up
 - Eating bonus food
 - Eating ghost
 - Ghost attacking Pac-Man/death
 - Level begin

- · Level end
- Game over
- Music
 - · None, it's Pac-Man!

You probably noticed that nothing in this list defines *how* any of these assets should look or sound, just the objects and events they are associated with. What the assets look like should largely be irrelevant to you as the developer, provided the assets meet you or your company's quality standards and any technical requirements, which leads us to the next step.

Step 5. Make a List of Technical Requirements for Your Game

This will include two sets of criteria: (1) the system requirements of the end user playing the game, and (2) any server-side requirements your game needs in order to function, such as a database and any scripts necessary to connect to it. For a simple game, these requirements should be fairly succinct, and if you are building the game for clients that are going to host the game themselves, this list may have been provided to you entirely.

Let's start with the system requirements for the game's audience. Unless the game is an exact copy of another title you've already released, you probably won't know the exact machine requirements necessary to run the game smoothly. Any estimates you make will be vetted for accuracy during the testing process. At the very least, you can set a screen resolution and minimum version of the Flash Player that is capable of running the game. One note about the Flash Player is that Adobe now periodically releases minor updates that add features in addition to fixing bugs. As a result, you must be cognizant of any cutting-edge features that might necessitate a particularly patched version of the player. Here is an example:

- Flash Player major version—10
- Flash Player minor version—10.0.2.13
- Screen resolution—1024 × 768 or higher
- Connection speed—DSL or higher
- RAM—512 MB+
- CPU—1.5 GHz+

These are fairly modest requirements for Flash games on the web. Obviously, during the testing and quality assurance (QA) process, you can adjust your initial numbers as necessitated by the game's feature set. Games with a lot of motion and many objects moving on the screen at once are obviously going to need more computing horsepower than a single screen with static game pieces. Sometimes a feature can be compelling enough to justify

a trade-off in higher system requirements and thus a reduced audience. This decision must not be made lightly, however. For instance, more robust AI that makes the game more enjoyable but taxes the CPU is more justifiable than a bunch of real-time special effects such as shadows or glows, which look nice but don't add any real gameplay value. You and your client's mileage may vary, but experience has shown me that the lower you set your technical barrier to entry, the more people will play your game.

Next come the server-side requirements for your game. For simple games with no data to be saved from session to session, this is probably as simple as having an HTML page to house your game's SWF file. More and more, however, players expect more robust functionality out of games on the web. The ability to save their high scores and even maintain a profile for larger games is very popular, as it gives players bragging rights when they do well and often affords some level of personalization.

Depending on whether you're doing the back-end integration (server-side scripts, database work, etc.) or you work with a team, this list of requirements may look very different. If you work at a company with a team that already has a database infrastructure in place, your requirements may look something like this:

- · Methods required
 - Save score
 - Parameters—score, number; initials, string; security hash, string
 - Returns 0 for success, -1 for error
 - Load score table
 - · Parameters—size, number
 - · Returns list of initials and scores, highest to lowest

Based on the wireframe example we have created throughout the previous steps, these two methods (or functions) are all you will need to post a player's score and load a table of high scores. The first method, saving the score, would receive the player's score, their initials, and a security hash (which we'll cover in depth in Chapter 17). The second method, used when viewing the high score table, would receive a table size (such as 10 or 20) for the number of results to return. Regardless of whether your team works in PHP, .NET, or some other back-end language, this simple listing will let them know what code they need to expose to Flash for the game to perform its operations.

If you will be building these scripts yourself and don't already have a system in place for doing so, you'll need to set up a database structure to house all of your game's data. If you are new to this area of development but want to learn, I recommend starting with PHP. It is free, it is fast, and it is relatively easy to pick up. There are also many resources in books and on the web for how to save data into a database with PHP.

Techie Note

If you're already familiar with PHP, I would highly recommend looking into AMFPHP. It allows you to send binary data in Flash's native format rather than name/value strings. Because of this, it allows you to send and receive typed results (i.e., a number comes back as a number, not a string), and the chunks of data are much smaller and faster.

Step 6 (Optional). Diagram Your Classes Using a UML Modeler

UML stands for Unified Modeling Language, and it is the standard for planning complex software through a visual process. Basically, it involves visually showing the hierarchy of the classes you intend to create alongside each other, with all the publicly available properties and methods listed along with what they accept and return. You may be wondering, "Why would I want to do that? Why can't I just get started typing code and build it as I go?" The answer is simple: A UML diagram takes your whole project into account in a single document. It is much easier to make changes and correct inconsistencies and confusion in naming conventions from this bird's-eye view than when you've got a dozen ActionScript files open and you're trying to remember the name of the method you're trying to call from one to the next. You can keep the diagram handy as you work, and there are programs available that will take your completed diagram and turn it into actual ActionScript class files, complete with all the methods and properties ready to be used!

Now you're probably wondering, "Well, if this step is so important and helpful, why do you have it listed at the end as optional?" There are a couple of reasons for this. One reason is that for very simple games on a tight timeline, a full-blown UML diagram may yield low returns on time that could be better spent just knocking out the code. If you're pretty certain your game will only rely on a couple of class files, UML is probably overkill. Second, while many UML tool options exist, including a large number of free offerings, I have yet to find one that I wholeheartedly recommend for Flash development. Well, I take that back. The best UML tool for ActionScript I've ever used is Grant Skinner's gModeler. It is streamlined especially for this use, it was created in Flash so it will run on any OS that supports the Flash Player, and it will generate code as well as documentation. Unfortunately, it is several years old and will only generate up to ActionScript 2 code, leaving AS3 developers like us in the cold. If you're still doing work in AS2 (and there's nothing wrong with that), I highly recommend using it to model your classes.

Though I haven't found my equivalent for gModeler for AS3, I've found the free StarUML (http://www.staruml.com) to be a solid title and fairly straightforward. Also, an Adobe employee has created a tutorial showing how to generate stub code from your diagrams much the same way gModeler did. These resources are available on http://flashgamebook.com.

I know this seems like a lot of steps just to get started if you're not used to this level of planning. Trust me, it will not only get easier and more natural as you figure out what works best for you, but you will find that fewer surprises pop up down the road. Now that you have your plan firmly in hand, it's time to open that copy of Flash.

A Quick Review of the Planning Steps

- One- to two-sentence description
- · Game screen wireframe and flow
- · List of game mechanics
- List of assets (art, animation, sound, video, and copy)
- · Technical requirements
- · UML class diagrams

4

//FTW!

In this chapter, we'll cover best practices to use when programming in ActionScript 3 (AS3). This includes smart class utilization, using the event model, error handling, and data structures. We'll also cover a number of Flash's idiosyncrasies that tend to trip up developers coming to Flash from other languages.

Fair Warning

It's worth mentioning that this chapter (like the rest of this book) assumes a familiarity with either ActionScript 1 or 2 or another programming language. If you have no idea what objects, variables, or functions are or have never used Flash at all, you will be lost very quickly. Some familiarity with ActionScript 3 is ideal, since we'll also be moving pretty quickly through a wide variety of topics, but it's not absolutely necessary. The documentation that comes with Flash expounds on all of these topics, so if you find yourself confused or want to learn more, you can check out those examples. You can also always ask questions on any chapter in this book at flashgamebook.com. If you're an experienced AS3 user, be patient—we'll get through the basics as quickly as possible and move on to the fun stuff!

PART 1 Classes

As we learned in Chapter 1, classes are essentially the blueprints for objects in ActionScript (and many other object-oriented programming languages). They define the properties that are inherent to that object as well as the methods that determine how that object functions on its own and as part of a larger context. When you create an object from a class, that object is known as an *instance* of that class. Every instance of a class may have different specific values for its properties, but they all share the common architecture, so Flash knows that all instances of a certain class will behave the same way. In its simplest form, *instantiation*, or creation, of an object looks like this in ActionScript:

```
var myObject:MyClass = new MyClass();
```

As a standard naming convention, classes should start with a capital letter and then use InterCaps (or "CamelCase") from then on, denoting the start of a word with a capital letter. CamelCase makes names in code much easier to read—take, for example, the longest class name currently used in the Flash CS4 code base:

```
{\it HTMLUncaughtScriptExceptionEvent}
```

While this is something of an extreme example, note that it is much easier to read than:

htmluncaughtscriptexceptionevent

Packages

A set of classes with categorically similar or related functionality can be grouped together in what are known as *packages*. Classes within the same package can reference each other without any special code, while classes in different packages must *import* each other with a line of code, similar to the following:

```
import flash.display.MovieClip:
```

Note that, in this case, the MovieClip class is inside the display package, which is part of the larger flash package. The standard naming convention for packages is all lowercase letters, which differentiates them from classes visually. Packages are represented in the file system as a series of nested folders. In the previous example, if the MovieClip class were not an included part of the Flash Player, you could find the MovieClip.as file inside a folder called *display*, inside another folder called *flash*.

Classes as Files

To create a class, you simply open Flash or a text editor like FlashDevelop and create a basic framework. All AS3 classes must have this minimal amount of code in order to function:

```
package flash.display {
  public class MovieClip {
  }
}
```

Note that the names in bold are the custom package and class names of your choice. All classes need is a class definition wrapped by a package definition, placed in a folder structure that matches the package hierarchy. This class won't do anything, however, so next we'll cover adding properties and methods.

Constructors

Every class has a *constructor*, even if it does nothing and is not explicitly defined. It is the function, with the same name as the class, that is called when a new instance of the class is created. In the case of our last example, even if we leave it out, Flash adds the following to the class:

```
package flash.display {
  public class MovieClip {
    public function MovieClip() {
    }
  }
}
```

The constructor allows us to run any initialization code that the new instance might need, or it can do nothing, depending on how your class is to be used.

Constants, Variables, and Methods

A class without any data or functionality inside it is not of very much use, so we can define variables, or properties, of the class that will store information, methods, or functions that will perform actions. I'm going to assume you already know how to use variables and methods, either from earlier versions of ActionScript or another language. Constants are entirely new to AS3 but are not a complicated concept. Essentially, they are variables that can only be assigned a value once. When you declare a constant or variable, it is best to give it a *type*, which tells Flash which class to use as the blueprint for that variable. Here are a few examples:

```
const myInt:int = -3; //WILL ALWAYS BE -3 AND CANNOT BE MODIFIED
var myBoolean:Boolean = true;
var myString:String = "Hello World";
var myObject:Object = new Object();
```

Giving a variable a type also saves memory, because Flash knows the maximum amount of memory it needs to store an instance of a specific class. If you don't type a variable, as in the following example, Flash must reserve a larger amount of memory to accommodate any possible value:

```
var myMystery:* = "?";
```

Once you assign a value to an untyped variable, it becomes typed from then on, so attempts to change its type (like you could in earlier versions of ActionScript) will result in runtime errors, such as the following example:

```
var myMystery:* = "?";
myMystery = 5; //WILL CAUSE A RUNTIME ERROR
```

What's worse, the above example *won't* be caught during compilation, so it might get missed until your game is deployed live for real users. Unless absolutely unavoidable (like an instance where you simply don't know what will be assigned to a variable), *always* type your variables. You'll create far fewer headaches down the road for yourself.

When you define methods, there are similar practices to follow. It is best practice to define what parameters a method will receive and what, if anything, it will return:

```
function myFunction (myParam:String):void {
  //COMMANDS HERE
}
```

In this example, the method accepts a single parameter, myParam, and returns nothing. If you have a case where a method needs to accept an unknown number of parameters, a slightly different syntax can be used:

```
function myFunction (... params):void {
  //COMMANDS HERE
}
```

Here, the single parameter, params, is prefixed by three dots. This signifies to Flash that it should be treated like an array of values, so getting to each parameter that was passed must be done through array syntax:

```
function myFunction (... params):void {
  trace(params[0]);
}
```

It's important to remember that, when accepting a variable number of parameters, type checking during compilation will not catch any attempts to pass invalid data to the method. In this case, it's best to do some type of manual checking and generate errors at runtime. We'll cover more on errors shortly.

```
function myFunction (... params):void {
  for (var i:int = 0; I < params.length; i++) {
    if (!(params[i] is DisplayObject)) {
      throw new ArgumentError("Only DisplayObjects can be used in myFunction.");
    }
}</pre>
```

The keyword *void* is used to denote a function that does not return anything (and will cause an error if it attempts to), and all other types that variables can use can also be used here. If you leave off the return value altogether, you can opt to return something or not, depending on some piece of internal logic. However, as a best practice, a method should always declare what it will return, as it helps catch errors and maintains consistency.

Getter/Setter Methods

There are two special types of methods you can create when you want to expose a variable outside its class but want to control how the variable is used. They are known as *accessor* or *getter/setter methods*, and they are called like normal variable assignments but act like functions underneath. You can use them to make read-only variables or to perform actions on a value before it is set as a variable. There are a few rules to follow when using these special methods. Getter methods never accept any parameters and must specify a return type, whereas setter methods may only have one parameter and never return anything. Let's look at a couple of examples in a single script:

```
package {
 public class MyClass {
   protected var maxNameLength:int = 8:
   protected var _name:String;
   protected var _lives:int = 3;
   public function get name(): String {
    return _name;
   public function set name(value:String):void {
    name = value.substr(0.maxNameLength):
   public function get lives():int {
     return _lives;
 }
//OUTSIDE CLASS
var myInstance:MyClass = new MyClass();
myInstance.name = "CHRISTOPHER";
trace(myInstance.name); //OUTPUTS "CHRISTOP":
trace(myInstance.lives); //OUTPUTS 3;
myInstance.lives = 10; //THROWS ERROR
```

The *name* getter/setter functions return the protected value of *_name*, which would otherwise be inaccessible, and the *name* setter function forces any attempts to assign a value to the *_name* property to a fixed length of eight characters. The *lives* getter is an example of a read-only property—there is no accompanying setter function. Any attempts to set the value will cause an error.

This is very useful when you need to use values inside the class but also want external classes to be able to read the value.

The standard convention for variable and method names is to start lowercase and then use CamelCase for all subsequent words in the name. There is some debate over how to delineate public variables from protected, private, or internal ones. My preference is to follow Adobe's convention, which is to use an underscore ("_") at the beginning of the name of any property that is not expressly public. Doing so allows you to use getter/setter methods like the previous example, where _name was the protected variable and name was used for the pair of methods. This yields continuity in your naming and makes your code easier for others (and yourself) to follow.

Class Identifiers

Classes can use a few different identifiers to determine how they are exposed to other classes. The four available are:

- *Public*—The public attribute defines that a class can be accessed or used from anywhere else.
- *Internal*—The internal attribute allows a class to only be accessed by other classes in the same package; by default, classes are internal unless specified public, so internal does not actually have to be used.
- Dynamic—If a class is dynamic, it can have properties and methods added to it at runtime; by default, classes are static and can only use the properties and methods defined inside themselves.
- *Final*—If a class is final, it cannot be extended by another class (more on this shortly when we cover inheritance); by default, classes can be extended and are *not* final.

All of these identifiers can be used with each other, except that public cannot be used with internal. Similarly, variables and methods can have their own set of identifiers used to define how they are exposed outside the class:

- Public—Like the class attribute, this denotes that a variable or method can be accessed from anywhere, including outside the class.
- Internal—Also similar to classes, this denotes that a variable or method can only be accessed from inside its package.
- *Private*—The private attribute prevents a variable or method from being accessed outside its individual class.
- Protected—A protected attribute is pretty much like private, except that protected variables and methods can also be accessed by classes that extend the current class (more on inheritance shortly).

• Static—If a method or variable is static, it is part of the class, not instances of the class, meaning that there is only ever one value or functionality defined, and it is accessed via the class name rather than an instance (e.g., MovieClip. staticVar rather than myMovieClip.staticVar); it is important to note that static properties and methods are not inherited by subclasses.

The first four attributes in this list cannot be used with each other, as they would conflict, but static can be used in combination with any one of them.

Inheritance and Polymorphism

When you need to create a class that has the same functionality as another class but requires some additional properties or methods, a good option to save time and coding is to extend the first class to a new class, known as a *subclass*. All public and protected methods and variables that are not static will be available to the new class. To clarify, any static properties of the parent, or *superclass*, must be prefaced with the class name (as in the example below). Additionally, any internal methods or variables will be available to the subclass if it is in the same package as its superclass. To illustrate, let's look at an example:

```
package {
  public class SuperClass {
    static public var className:String = "SuperClass";
  }
}
package {
  public class SubClass extends SuperClass {
    public function SubClass() {
      trace(SuperClass.className); //OUTPUTS "SuperClass"
      trace(className); //THROWS ERROR
    }
}
//FROM OUTSIDE EITHER CLASS
trace(SuperClass.className); //OUTPUTS "SuperClass"
trace(SuperClass.className); //OUTPUTS "SuperClass"
trace(SubClass.className); //THROWS ERROR
```

Occasionally, you'll need to change the functionality of a method in a subclass from the way it behaves in the superclass. This change in functionality through inheritance is known as *polymorphism*. You can do this using the *override* keyword before the beginning of the method, albeit with a number of caveats:

- Only methods may be overridden, no properties.
- Only public, protected, and internal methods may be overridden.

- Internal methods may only be overridden in subclasses in the same package as the superclass.
- The new overriding method must match the composition of the original method, with the same parameters and return value.

Let's look at an example:

```
package {
 class SuperClass {
   public var name:String = "SuperClass";
   protected var _number:Number = 5;
   internal var _packageNumber:Number = 7.5;
   private var _secretNumber:Number = 10;
   public function helloWorld():void {
     trace("HELLO WORLD"):
package {
 class SubClass extends SuperClass {
   public function SubClass() {
     trace(name); //OUTPUTS "SuperClass"
     trace( number); //OUTPUTS 5;
     trace( packageNumber): //OUTPUTS 7.5
     helloWorld(); //OUTPUTS "HI WORLD";
     super.helloWorld(); //OUTPUTS "HELLO WORLD";
     trace(_secretNumber); //THROWS ERROR;
   override public function helloWorld():void {
     trace("HI WORLD");
```

As you can see, when SubClass traces out properties it has inherited from SuperClass, they stay intact, with the exception of the private variable. Also, when helloWorld is run from SubClass, it traces a different message than when run from SuperClass. That said, there is a way to get at the SuperClass implementation of helloWorld through use of the *super* keyword, which returns a reference to the superclass of the current class, allowing you access to any methods you may have overridden.

Interfaces

One of the most commonly misunderstood (including by myself for a long time) aspects of object-oriented programming (OOP) is the concept of *interfaces*. It is confusing for a few reasons, not the least of which is the confusion of an OOP interface with a graphical user interface (like operating systems provide). An interface does not contain any code, outside of declaring

the public methods that a class will use and what each will accept as parameters and what each will return. If a class is like a blueprint of the specific directions for creating a new instance of that class, an interface is like a checklist for that blueprint to make sure it adheres to a certain specification. Perhaps the best way to understand how an interface is structured is to see one in code:

```
public interface IEventDispatcher {
  function addEventListener(type:String, listener:Function,
  useCapture:Boolean = false, priority:
  int = 0.useWeakReference:Boolean = false):void;
  function removeEventListener(type:String, listener:Function,
  useCapture:Boolean = false):void;
  function dispatchEvent(event:Event):Boolean;
  function hasEventListener(type:String):Boolean;
  function willTrigger(type:String):Boolean;
}
```

Notice the differences between an interface and a class. Interfaces are always public or internal, just like their class counterparts, but none of the methods has any attributes because they are all assumed to be public. Interfaces cannot include variables, but they can include getter/setter methods, which can substitute for variables.

At this point, you might very well be asking, "Why would I ever bother to use an interface when I can simply extend a class to make sure all the subclasses have the available methods?" The answer is that, unlike some other languages, classes in Flash cannot inherit from multiple superclasses. This poses a problem when you need to extend one class but include functionality from another class in a different inheritance hierarchy.

A good example of a situation like this is the *IBitmapDrawable* interface that is part of the Flash display package. When you want to draw something to a BitmapData object, you can use either another BitmapData object or a DisplayObject. In order to keep just any object from being passed to the draw method, both BitmapData and DisplayObject implement the IBitmapDrawable interface. The interface actually doesn't do anything but enforce this compatibility between two classes that have nothing to do with each other. The draw method can then look like this:

```
public function draw(source:IBitmapDrawable,
matrix:Matrix = null, colorTransform:ColorTransform = null,
blendMode:String = null, clipRect:Rectangle = null,
smoothing:Boolean = false):void
```

When an object is passed for the source parameter, Flash checks to see if the object implements the IBitmapDrawable interface and can throw an error to let the developer know. Here

is another example of a class implementing an interface while extending an unrelated class:

```
package {
 import flash.events.IEventDispatcher;
 import flash.events.EventDispatcher;
 import flash.events.Event;
 import flash.geom.Rectangle;
 public class RectangleDispatcher extends Rectangle
 implements IEventDispatcher {
   private var dispatcher: EventDispatcher;
   public function RectangleDispatcher() {
     _dispatcher = new EventDispatcher(this);
   override public function set width(value:Number) {
     super.width = value;
     dispatchEvent(new Event(Event.CHANGE));
   override public function set height(value:Number) {
     super.height = value;
     dispatchEvent(new Event(Event.CHANGE));
   public function addEventListener(type:String,
   listener:Function, useCapture:Boolean = false,
   priority:int = 0,useWeakReference:Boolean = false):void {
     _dispatcher.addEventListener(type, listener, useCapture,
     priority, useWeakReference);
   public function removeEventListener(type:String,
   listener:Function, useCapture:Boolean = false):void {
     _dispatcher.removeEventListener(type, listener,
     useCapture);
   public function dispatchEvent(event:Event):Boolean{
     _dispatcher.dispatchEvent(event);
   public function hasEventListener(type:String):Boolean{
     return _dispatcher.hasEventListener(type);
   public function willTrigger(type:String):Boolean{
     return _dispatcher.willTrigger(type);
```

In this example, the class being extended is Rectangle, which has no ties to the EventDispatcher hierarchy. By implementing the IEventDispatcher interface and creating an instance of the EventDispatcher class, we can enjoy both the functionality of a Rectangle and an EventDispatcher. When the width or height of this special rectangle changes, it will dispatch an event to anything listening. We will cover more on events in an upcoming section.

So the question now is probably "When should I use interfaces?" Unlike some OOP proponents who believe the answer is

"always," I believe it really depends on the breadth of the game or application you are building. Sometimes, in quick games where I am the sole developer, I prefer to use inheritance because I usually have the luxury of defining my entire inheritance chain and I don't have to work within a preexisting framework. I find interfaces most helpful when working with other developers (particularly those at other companies where we're not eager to share specific code with each other) because we can agree upon an interface for our common class elements and integration of our respective components is far more likely to work without a hitch as a result. Interfaces are also extremely useful in creating flexible, reusable game engines for more complex games, as we will see in Chapters 14 and 15. In the end, interfaces are just a tool and, like any tool, should be used when called for and left alone the rest of the time.

Linking Classes to Assets in Flash

A common staple of my game development (and arguably one of the biggest advantages of developing games in Flash) is the ease with which you can link a Flash class to an item in your FLA library. Any item in your library can have an associated class linked to it, but the ones you will probably use the most are the DisplayObject subclasses Sprite and MovieClip. First, it's important to understand how Flash creates classes for library items.

If you set the linkage property of a symbol in the library, it has a class created for it when the SWF is compiled, regardless of whether or not one was explicitly defined. For example, take a Sprite in an FLA library named "square," with a simple blue square inside it. Because the symbol is not a Sprite directly, but rather an extension of a Sprite, a new class with the name "square" will be created at compile-time that extends the Sprite and looks like this:

```
package {
  import flash.display.Sprite;
  public class square extends Sprite {}
}
```

The reason Flash does this is because it needs a point of reference to be able to instantiate that symbol on the Stage if it is used in script somewhere. To see the evidence of this, you can look at all the classes embedded in a compiled SWF inside of FlashDevelop. In Figure 4.1, you can see the Flash library on the left, with the symbol exported with the name "square," and reflected on the right is the FlashDevelop project panel with the classes used in the SWF.

Figure 4.1 FlashDevelop can reveal the classes used in a SWF.

If you had a class defined for the square, it would use that file rather than generating its own. To see the result of this, we can rename the linkage class for the symbol to uppercase "Square" to match the name of a class I have defined for it:

```
package {
  import flash.display.Sprite;

public class Square extends Sprite {
  public function Square() {
    rotation = 45;
  }
}
```

Now when the square is added to the Stage, it will be rotated 45 degrees.

Class vs. Base Class

When you open the linkage panel to assign a class to a symbol, there is an additional field that is used to define the *base class* for a symbol. The base class symbol is where you define what class you would like extended for that symbol. In the previous example, the Square class extended from Sprite, so the base class for that symbol was flash.display.Sprite, as shown in Figure 4.2.

Suppose, however, that we wanted to create multiple squares of different colors. They wouldn't need any additional functionality on top of what Square already provides, so making an individual class for each one would be tedious. Instead, we could make multiple clips of different colors and set each of their base classes to Square. Then the individual class names could be squareBlue, squareGreen, etc. An example is shown in Figure 4.3.

			Symbol I	Properties			
Name:	squar	e					ОК
Type:	Movie	Clip	•			(Cancel
					C 515	- c	
					(Edit		Basic)
	guides	for 9-slice	e scaling				
Linkage —		▼ Export	for ActionScr	ript			
		Export	in frame 1				
lde	ntifier:						
	Class:	Square				10	
Base	class:	flash.disp	play.Sprite			10]
Sharing —							
			for runtime s				
		_ Import	for runtime s	haring			
	URL:						
Source -				*******************************			
Browse)	File:					
Symbo	l)	Symbol na	ame: Symbol	1			
		Always	update befor	re nuhlishi	na		

Figure 4.2 The properties panel shows the linkage for the square Sprite.

	Symbol Properties	
Name: squar	eBlue	ОК
Type: Movie	e Clip 💠	Cancel
		(Edit Basic
Enable guides	for 9-slice scaling	
Linkage		
	Export for ActionScript	
	Export in frame 1	
Identifier:		
Class:	squareBlue	V 9
Base class:	Square	10
Sharing		
	Export for runtime sharing	
	Import for runtime sharing	
URL:		
Source		
Browse	File:	
Symbol	Symbol name: Symbol 1	

Figure 4.3 The base class can be set to use a class for multiple symbols with different assets.

Using Exported Symbols with No Class File

I try to make it a policy to explicitly write a class file for any symbol that I intend to export for ActionScript, because it is easier to keep track of which symbols are available to me, and it allows me to quickly add functionality as it becomes necessary. Sometimes, however, as in the case of the previous Square example, some of the symbols I'm using all derive from a basic class I've created and are only differentiated by the assets inside them. To use these classes in your code, you can simply refer to the class name like you would any other. If I had a document class for the previous example, it might look something like this:

```
package {
  import flash.display.Sprite;
  public class ClassesExample extends Sprite {
    public function ClassesExample() {
      var blue:Square = new squareBlue();
      addChild(blue);
      var green:Square = new squareGreen();
      addChild(green);
    }
}
```

You can use it like a normal class, because when Flash compiles the SWF, it *will* be a normal class, just as though you'd written it yourself.

getDefinitionByName and Casting

Suppose you needed to instantiate a series of symbols or classes that followed a numeric sequence—say, for the purposes of our example, "square1" through "square10." It would be very tedious to have to instantiate them one at a time and create a lot of extra code. It would probably look something like this:

```
var square:Square = new square1();
addChild(square);
square = new square2();
addChild(square);
...
square = new square10();
addChild(square);
```

Luckily, Flash gives us the ability to look up a class by its name. In the flash.utils package there is a method called *getDefinition-ByName*, which accepts said name as a string parameter.

```
for (var i:int = 1; i <= 10; i++) {
  var squareClass:Class = getDefinitionByName("square" + i) as Class;
  var square:Square = new squareClass();
  addChild(square);
}</pre>
```

It returns a generic object that is a reference to the class, if it exists. That object can then be converted to a class through an operation known as *casting*. Casting is the process of telling ActionScript to treat one object like a different kind of object. It is most often used to treat a subclass like its superclass, which is known as "safe" casting, because all of the functionality will be guaranteed to carry over from the superclass. An example of this would be with Sprite and MovieClip. MovieClip extends Sprite, so it is safe to cast a MovieClip as a Sprite because their public methods and variables will match. If we were to do the opposite, cast a Sprite as a MovieClip, it would be considered an "unsafe" casting, because a Sprite does not contain all of the methods and variables of a MovieClip. While Flash will let you cast either direction, it's generally a good idea to avoid casting to a subclass unless you know for certain that the methods and variables you want to call will be available. In the case of the above example, converting a base object to a class is technically an unsafe casting, but the Class class (a confusing nomenclature to be sure) contains no additional public methods or variables so there is no danger of causing an error. We'll use casting and getDefinition-ByName regularly later in game examples.

PART 2

Events

A core component of ActionScript 3 is the use of events. Event objects can be thought of as messages that are sent between objects to notify each other of, well, events. When an object is set up to receive events, it is known as *listening*. When an object sends an event, it is known as *dispatching*. In their most basic form, events contain a type (the name of the event being sent), a target (the object that dispatched the event), and a currentTarget (the object currently processing the event after having received it). A basic event is merely a notification that something happened, and you'll need to access the object that sent the event in order to get any more information. Events can be customized, however, to send any amount of data along with the message, but we'll get to that shortly. First let's look at how objects can send events.

dispatchEvent

Many of the core classes of AS3 dispatch events. To dispatch an event, an object must either extend the EventDispatcher class in some way or implement the IEventDispatcher interface (see the interface example in the previous section on classes). If it meets one of these two criteria, you simply call the <code>dispatchEvent</code> method and pass it an

event object. Event objects are created from the Event class, or a subclass of it. The basic Event class has a number of predefined names, or *enumerations*, of event types, but you can use any name you want:

```
var event:Event = new Event(Event.COMPLETE);
    or
var event:Event = new Event("myCustomEventName");
```

It is a good idea, however, to define your event names as constants somewhere so you avoid misspellings. For example, if my game class needed to tell another object when the game had started and ended, it would be wise for me to define these event names so they can be referenced later. The typical event naming scheme is to use all capital letters, with underscores between words, for the property name and CamelCase for the actual value, as in the next example:

```
package {
  import flash.display.Sprite;
  import flash.events.Event;
  public class Game extends Sprite {
    static public const GAME_START:String = "gameStart";
    static public const GAME_OVER:String = "gameOver";

    protected function startGame():void {
        //START GAME LOGIC
        dispatchEvent(new Event(GAME_START));
    }
    protected function gameOver():void {
        //GAME OVER LOGIC
        dispatchEvent(new Event(GAME_OVER));
    }
}
```

There are a few things to note about that example. First, the event names are not only public constants, but they're also static, which makes them easily accessible from anywhere. Next, the Sprite class extends EventDispatcher, so all my methods are ready for me to use without defining anything extra, which is *very* convenient. And, finally, I often create and dispatch my events in a single line. You'll rarely need to keep a reference to an event object after you create it, unless you're adding a bunch of extra data to it, so I prefer this method for basic events because it's one less line to type and one less variable to assign. Now let's look at how another class might listen to these events.

addEventListener, removeEventListener, and Event Phases

There are a couple of different ways to listen for events, and these depend on what *phase* an event is in. When a DisplayObject

on the Stage dispatches an event, it goes through three phases: capture, target, and bubble. In the *capture* phase, the event travels all the way from the Stage down through the display list chain to the DisplayObject that sent the event. Once the event reaches its "owner," it enters the *target* phase. Finally, the event travels back up the display list to the Stage in the *bubbling* phase. Any object along the path of the display list can listen for these types of events, assuming the event is created that way. The reason for this particular sequence is so objects in the display list can easily listen for events further down the chain, such as mouse or keyboard input. For non-DisplayObjects (or DisplayObjects that are not on the Stage), events have only one phase: the target phase. In other words, the only way to listen for these events is to listen to the object directly. Let's look at some examples to make this a little clearer.

We'll start with a generic object first, since their events are simpler and can only be listened to in one way. This is also the most common way to listen for messages—during the target phase. To listen for an object's events, you simply call its *addEventListener* method and pass it a number of parameters. We'll use the example of the Game class from above, assuming that there is an instance of this class in the document class of an FLA.

```
package {
  import flash.display.Sprite;
  import flash.events.Event;
  public class Document extends Sprite {
    public var qame:Game;
    public function Document() {
        game - new Game();
        game.addEventListener(Game.GAME_START, gameStart);
        game.addEventListener(Game.GAME_OVER, gameOver);
        addChild(game);
    }
    protected function gameStart(e:Event):void {
        trace(e);
    }
    protected function gameOver(e:Event):void {
        trace(e);
    }
}
```

The two required parameters of the addEventListener method are an *event type* (as a string) and a *method* to call when that event occurs. Note that I can use protected (or private, or internal) methods as my event listeners—this is the only time where something that occurs outside this class can access an otherwise off-limits method. A method that is set up to receive events must accept a single parameter, the event object. There are a few other parameters that are optional when setting up a listener,

and I actually like to assign them, control freak that I am. A third parameter is *useCapture*, which is false by default. We will cover it momentarily as it deals with event phases and the display list. Another parameter is the *listener priority*, which is 0 by default. The priority level tells Flash which listeners should get the event first—the higher the number, the higher the priority. If it is critical for one object to receive an event before another, this is the best way to ensure that. I usually leave it at 0.

The final parameter is *useWeakReference*, which might be the coolest feature of events and is false by default. To fully appreciate what it does, you first need to understand how Flash's garbage collector (the mechanism that removes unused objects from memory) works. We'll cover the garbage collector in more depth when we reach the section on Flash idiosyncrasies, but suffice it to say for the moment that by setting useWeakReference to true the listener will automatically be removed when the object it is listening to is deleted from memory. Unless you have a specific reason you do not want the listener to be removed automatically, I recommend always setting useWeakReference to true. The following is a modification of the two lines from the above example, written to use weak references:

```
game.addEventListener(Game.GAME_START, gameStart, false, 0, true);
game.addEventListener(Game.GAME_OVER, gameOver, false, 0, true);
```

When you no longer need to listen for an event (or if you are not using weakly referenced listeners), you can use the *removeEventListener* method with the same first three parameters you called in addEventListener to disengage a listener from an object. For the example above, when the Document class was done listening to the game for events, it could call these two lines:

```
game.removeEventListener(Game.GAME_START, gameStart, false);
game.removeEventListener(Game.GAME_OVER, gameOver, false);
```

Like addEventListener, the third parameter is optional, depending on whether you're using the capture phase, which we will cover now.

As I mentioned earlier, if you're passing events between DisplayObjects, you have a few different options available to you, depending on where your objects are in relation to each other. Suppose the object you want to listen to is a child object, either directly or through the display chain, of your current object. In this case, you can listen to the target object in all three phases. When you listen during the capture or bubbling phases, you don't add the listener to the object itself but rather the object that is listening, as the event will be broadcast to your object as it "passes through." By default, most events do not bubble unless explicitly told to do so. To be able to listen to the Game class's events from

all three phases, we would first have to modify the dispatchEvent calls to look like this:

```
dispatchEvent(new Event(GAME_START, true));
dispatchEvent(new Event(GAME_OVER, true));
```

The second parameter when creating a new event tells the event whether or not to bubble. Now that these events are bubbling, we can modify the listeners in the Document class to account for all three event phases:

```
//CAPTURE PHASE
addEventListener(Game.GAME_START, gameStart, true, 0, true);
//TARGET PHASE
game.addEventListener(Game.GAME_START, gameStart, false, 0, true);
//BUBBLE PHASE
addEventListener(Game.GAME_START, gameStart, false, 0, true);
```

Note the subtle differences between how the listeners are added. The capture and bubbling listeners are identical, except for the useCapture parameter, and the target listener is attached to the game object directly. There are few times when you'd probably use all of these listener types at once. I almost always listen at the target phase, because I usually know which objects I need to receive events and which don't matter. One scenario where it is very helpful, though, is when you need to stop an event from being broadcasted.

Event Propagation and Cancellation

By default, events, particularly those in DisplayObjects, will move through their hierarchy uninterrupted, notifying each listener in the chain as it reaches it; however, there might be some scenarios where you would want to stop certain events from reaching their destination. A common example is with mouse input. Say you had an application or a game with a side panel containing some buttons and other information. If you were displaying a message and wanted to disable input to the panel while the message was being shown, you could tell the panel to disable itself, which would in turn disable each of the buttons. However, this is a lot of code to write, and it is more easily handled by canceling events.

When one of the buttons in the panel is clicked on by the mouse, for example, it generates an event (specifically, a MouseEvent) that moves through each display list level until it reaches the object that was clicked. If you listen for that event during the capture phase in some parent object of the panel, you can stop that event from proceeding any further and ever reaching its destination. You do this through the use of a couple of methods of event objects: *stopPropagation* and *stopImmediatePropagation*.

They both do virtually the same thing but with minor differences. The former stops any objects further down the display chain from receiving the event. The latter stops those objects, as well as any other listeners in the current DisplayObject.

Custom Events

If you find during development that you need an event type that contains more information than a generic event, you can easily extend the Event class to make custom events. Let's look at one quick example:

```
package {
 import flash.events.Event;
 public class GameEvent
   static public const GAME_START:String = "gameStart";
   static public const GAME_WIN:String = "gameWin";
   static public const GAME_LOSE:String = "gameLose";
   public var score: Number:
   public var timeLeft: Number:
   public var level:int:
   public var difficulty:int;
   public function GameEvent(type:String,
       score:Number = 0.
       timeLeft:Number = 0.
       level:int = 1.
       difficulty:int = 1,
       bubbles:Boolean = false,
       cancelable:Boolean = false) {
     this.score = score;
     this.timeLeft = timeLeft:
     this.level = level;
     this.difficulty = difficulty;
     super(type, bubbles, cancelable);
   override public function clone():Event {
     return new GameEvent(type, score, timeLeft, level,
     difficulty, bubbles, cancelable);
```

Since we've created a custom event class, it makes more sense to keep the event type names here, rather than in the Game class. In this case, GAME_OVER has been split into GAME_WIN and GAME_LOSE, for more specific events. Also, we've included holder variables for the game's current score, time left, difficulty, and current level, if they were applicable. Obviously, you would tailor these properties to your specific game. In the Game class, we would now dispatch events like this:

```
dispatchEvent(new GameEvent(GameEvent.GAME_START));
```

There are a couple of things to remember when extending the Event class. One is that any additional properties you want stored must have variables created for them, so the constructor can assign them or they can be reassigned after the event object is created. Another point to keep in mind is that you need to explicitly call the Event superclass constructor through super() and pass it at least the first parameter (and preferably all of them). The final aspect of events to remember is that you should provide a clone method to override the original. The clone method is automatically called by Flash when events are redispatched from a listener object. If an override is not provided, it will return a generic event rather than your custom type. While it is not mandatory to provide it, it is a best practice and will prevent problems from cropping up down the road where your data gets lost along the way.

That completes this section on events. While there are even more aspects of the event model in Flash that we could explore, what we've learned represents the core functionality that you will likely use when developing games.

PART 3

Errors

No one likes errors in their code. In fact, no one likes their mistakes being pointed out by others, let alone a computer. It may sound like an absurd statement, but errors in Flash really are your friends. In ActionScript 1 and 2, errors were passive; if they occurred, things might break, but you wouldn't necessarily know where or why. When I first switched to AS3, I couldn't stand how many errors I got and it drove me nuts. Now that I've gotten used to it, I'm very appreciative when Flash presents me with a batch of errors. I would much rather know that something happened and be able to fix it than have it fail silently and have no idea why my application isn't running as expected. And, really, though my ego might not like to admit it, those errors were probably in my AS1 and AS2 code, I just didn't know it. As some of you may already know, errors in ActionScript 3 make themselves known by bringing your program (or at least method) to a screeching halt and displaying a message in the output window. Anyone first developing in AS3 is bound to cause quite a few errors. You'll also note quickly that the Flash documentation tends to refer to them in a couple of different ways. Sometimes errors are referred to as exceptions. Also, because errors are derived from the Error class, there are a number of subclasses that extend from it, like ReferenceError or ArgumentError. These subclasses give you more detailed information about what went wrong. There are two main kinds or errors you'll run into during development.

The first are compile-time errors, which crop up when you go to publish your SWF. These are my favorite errors, because they let you know immediately that you did something flat-out *wrong*. The SWF won't even work correctly as a result, so you're forced to go back and fix them. The most common errors are typographic: mistyped variable names, assigning the wrong type of value to a variable, calling a method that doesn't exist. While they can be annoying if there are many of them, it's always better to know about problems up front and fix them.

The other kind is a runtime error, which occurs while your SWF is running. These are equally helpful, but they have to be discovered and are most likely to crop up during testing. They'll only occur when you run the piece of code with the problem in it. The other trick with runtime errors is that they're not always mistakes *per se*. Sometimes an error occurs when certain events are dispatched and nothing is listening to them. In this case, the error acts as a notification that something went wrong and that you need to account for the scenario in which it took place.

Regardless of the type, errors should always be handled. There are a couple of ways to fix errors. Most of the time, the error is the result of a coding mistake or omission; however, sometimes an error can occur because a piece of functionality has other dependencies, like external files, which are not available during development. In this case, you can prevent the errors from bringing the rest of your code to a halt by *catching* them.

try, catch, finally

If you want to trap an error and keep it from halting the rest of your code, the best way to do that is to wrap the code inside a *try* statement block:

```
try {
  //ERROR-INDUCING CODE HERE
}
```

If an error occurs inside of a try block, it will attempt to be caught by an adjacent *catch* block:

```
try {
   //ERROR-INDUCING CODE HERE
} catch (error:Error) {
   //NOTIFY DEVELOPER OF ERROR
   trace(error);
```

If no error occurs, the code in the catch block will not execute. You can also use multiple catch blocks to catch different kinds of errors rather than catching all errors with one lump block:

```
try {
    //ERROR-INDUCING CODE HERE
} catch (error:ArgumentError) {
    //CATCHES JUST ARGUMENT ERRORS
    trace(error);
} catch (error:ReferenceError) {
    //CATCHES JUST REFERENCE ERRORS
    trace(error);
} catch (error:Error) {
    //CATCHES ALL OTHER ERRORS
    trace(error);
}
```

If you want some type of code to run regardless of whether an error occurs, you can put it in a *finally* block, which appears after all catches. If no error occurs, the sequence will be try > finally. If an error occurs, it will follow try > catch(es) > finally:

```
try {
   //ERROR-INDUCING CODE HERE
} catch (error:Error) {
   //NOTIFY DEVELOPER OF ERROR
   trace(error);
} finally {
   trace("MADE IT THROUGH TO THE END");
}
```

Throwing Your Own Errors

Sometimes you may want to cause errors yourself to let you or another developer using your code know that they're attempting to perform an illegal operation. Creating an error is known as *throwing*, to coincide with the *catch* metaphor. To throw an error, you simply use the throw statement, which is a core part of AS3:

```
throw new Error("This is a custom error message.");
```

You don't actually have to specify a message for your error, particularly if you intend to create your own Error subclass (where the message could be predetermined by the class), but I find it very helpful to do so. If you're working in a complex application that has a lot of opportunities for errors, you can also define error codes to provide differentiation as a second parameter to the Error constructor. I don't tend to throw errors as much in my game-specific classes, but I use them frequently when creating utility classes that may be shared among a number of projects or other developers.

Creating custom error classes is even more straightforward than custom event classes, so I'll give only a brief example of how to do so. I have found that the basic included error types are more than enough to handle the errors I need to create. Here is a quick example of a GameError class that you could use to hold a number of predefined error messages:

```
package {
  public class GameError extends Error {
    static public const INVALID_INPUT:String = "That is not a
    valid form of input for this game.";
    static public const GAME_NOT_READY:String = "The game
    object is not yet initialized. Run init() before starting
    game.";
    public function GameError(message:String = "") {
        super(message);
    }
}
//IN GAME CLASS
public function startGame():void {
    if (!initialized) throw new GameError(GameError.
        GAME_NOT_READY));
    //OTHER CODE
}
```

In this example, the GameError class (much like an Event subclass) predefines the error messages the game will use for easy access and syntax checking. If the game is not initialized when startGame is called, it will throw a GAME_NOT_READY error. We'll cover more on how to overcome Flash-created runtime errors in Chapter 17.

PART 4

Data Structures and Lists

One of the most important abilities in programming is being able to group similar objects together in lists for easier tracking; for example, a game might have a player, a number of different kinds of enemies, and a number of pick-up items. It is inefficient, or even impossible in some scenarios, to keep track of the enemies and pick-ups with individual variables, so we need more complex data structures to store them and make them easily accessible. AS3 gives us four main containers for this type of data and, depending on what type of information you're trying to store, a fifth one, as well. We'll look at each of these structures, their pros and cons, the best tasks for them, and how to *iterate*, or step through, each of them.

Objects

At the root of all the different classes in ActionScript are basic objects. They are the building blocks for every other more complex data type. They are also dynamic and therefore useful by themselves as lists. Every variable added to them is indexed by a string name. Here is an example that stores a Sprite in a list by its name:

```
var enemyList:Object = new Object();
var enemy:Sprite = new Sprite();
enemy.name = "BadGuy1";
enemyList [enemy.name] = enemy;
```

Now, let's say you have a whole batch of enemies. You could use a *for* loop to add them to the list:

```
var enemyList:Object = new Object();
for (var i:int = 0; i < 10; i++) {
  var enemy:Sprite = new Sprite();
  enemy.name = "BadGuy" + i;
  enemyList [enemy.name] = enemy;
}</pre>
```

Later on, if you need to perform an action on all your enemies, you could simply run another *for* loop, but this time a *for...in* loop:

```
for (var i:String in enemyList) {
  var enemy:Sprite = enemyList[i];
  //DO SOMETHING TO ENEMY SPRITE
}
```

It's worth noting that when you iterate through an object using a for...in loop it goes through the object in reverse order from newest item added to oldest, so you can't count on an object for your items to be in a particular order. However, when order doesn't matter in your list, this is a powerful tool because you can gain direct access to any item in the list. If you need to remove an item from an object list, you simply use the *delete* command along with the item's key. Items in objects are "keyed off" of a string value. In the example above, each enemy in the list is indexed by its name, and future attempts to access this enemy can only be done if you know its name or run through a loop to find it. Suppose when the user clicks on an enemy it should be destroyed and therefore be removed from the list. Once the enemy is clicked on, you have a reference to it through a MouseEvent. You could then remove it from the list, like in this example:

```
protected function enemyClicked(e:MouseEvent) {
  var enemy:Sprite = e.target as Sprite;
  delete enemyList[enemy.name];
  //REMOVE DISPLAY OBJECTS, ETC
}
```

Pros: Objects make it easy to access items, to iterate through quickly, and to garbage collect.

Cons: Objects are unordered; they must have a unique string property like a name associated with whatever you're storing (using the same string twice will override the first one).

When to use: Objects are best used when you're not interested in the order of a group of items and when you have a unique string identifier, such as a name, to use.

Arrays

Up until AS3, objects and arrays were the only two native types of data storage available in Flash. An array is an ordered list of items that are indexed by number, starting at 0. Arrays can have an unlimited number of items added to them using the *push*, *unshift*, and *splice* commands. When an item is removed using the *pop*, *shift*, or *splice* commands, the array size, or *length*, is reduced. Items in the list can be set to null values, but the null still occupies a slot in the array. Like objects, arrays are easy to set up and use. Once an array is created, the *push* command is used to add items to the end of it. Likewise, the *unshift* command can be used to insert items at the front:

```
var enemyList:Array = new Array();
for (var i:int = 0; i < 10; i++) {
  var enemy:Sprite = new Sprite();
  enemyList.push(enemy);
}</pre>
```

One big advantage of arrays is the ability to easily combine them. Say you had separate lists of enemies, obstacles, and pickups, and you needed to perform an operation on all of them but also keep them in their discrete lists. You can use the *concat* method to concatenate the arrays together into one list and only loop through one larger array:

```
var combinedList:Array = enemyList.concat(obstacleList,
pickupList);
for (var i:int = 0; i < combinedList.length; i++) {
  var item:Sprite = combinedList[i];
  //PERFORM SOME OPERATION ON EACH ITEM
}</pre>
```

Another advantage of using arrays is the sorting options available. Because it is an ordered list, the order can be changed dependent on almost any criteria you specify using the *sort* and *sortOn* commands. The *sortOn* method is particularly helpful when you have an array of DisplayObjects like Sprites. Say you wanted to sort the list by their *x* positions from left to right. The code would probably look something like this:

```
enemyList.sortOn("x");
```

There are also special constants built into the array class that allow you to specify sorting order. By default, arrays will sort in ascending order, meaning from smallest to largest. You can add a second parameter to the *sortOn* method to specify a different order:

```
enemyList.sortOn("x", Array.DESCENDING);
```

For all this flexibility in ordering, arrays are not without their shortcomings. Unlike the object example where we were able to pinpoint an item in the list based on its name, there is no safe way to do that with arrays. You could theoretically store each item's index in the array in the item itself, but that would assume that the array order would never change at all—a largely unsafe assumption to make. To find an item in an array, you must iterate through it, compare each item to the one you're looking up, and break out of the array once you've found it to minimize processing cycles:

```
protected function enemyClicked(e:MouseEvent) {
  var enemy:Sprite = e.target as Sprite;
  for (var i:int = 0; i < enemyList.length; i++) {
    if (enemyList[i] -= enemy) {
       enemyList.splice(i, 1);
       break;
    }
  }
}</pre>
```

The larger the array is, the longer this process takes, and it is obviously way less efficient than simply keying off of a value like in an object. AS3 added two methods that simplify the coding of this considerably: <code>indexOf</code> and <code>lastIndexOf</code>. These two methods basically do the search for you, simplifying your code to:

```
protected function enemyClicked(e:MouseEvent) {
  var enemy:Sprite = c.target as Sprite;
  var index:int = enemyList.indexOf(enemy);
  enemyList.splice(index, 1);
}
```

The *lastIndexOf* method does exactly the same search but starts at the end of the array and counts down. While there is definitely less to type and it is cleaner than a *for* loop, the underlying process is still the same and large arrays are still taxing on Flash.

Pros: Arrays are ordered and easy to combine, with lots of sorting options.

Cons: Accessing specific items in arrays is slower (requires iteration); arrays are slightly slower to iterate through than objects. When to use: The best time to use an array is when your items must be able to be sorted and the order matters. Arrays also do not have to store all of the same type of item, making them a little bit more flexible for general-purpose use (see vector discussion, below).

Vectors

A vector is simply a typed array, meaning that all items in the list must be of the same type. By enforcing typing, vectors are faster to iterate through and process and take up less memory. They also have the option of being a fixed length, meaning no more items can be added to them. They are declared slightly differently than arrays, but all of their other methods are the same:

```
var enemyList:Vector.<Sprite> = new Vector.<Sprite>();
for (var i:int = 0; i < 10; i++) {
  var enemy:Sprite = new Sprite();
  enemyList.push(enemy);
}</pre>
```

Pros: Vectors offer all of the pros of arrays except the ability to combine different types; they are faster to iterate through than arrays.

Cons: Vectors still requires iteration to access specific items so they are a little slower than objects; they require Flash Player 10 (not available if you're still publishing for Player 9).

When to use: If at all possible, you should always use vectors over arrays if all of your items are of the same type. Typically, in a game, your lists will already be homogeneous anyway, so switching to a vector buys you some extra performance.

Dictionaries

Just as the Vector object improved upon arrays for ordered storage, AS3 added a new class to improve on basic objects for storing unordered lists: the Dictionary object. Unlike regular objects, which require a string to be used as the key for an item, dictionaries can use any data type, including the item itself. This makes them even easier to use for complex data types because you don't have to have a unique string to identify items. The Dictionary constructor also contains one parameter, called *weakKeys*, which defaults to false. When a dictionary uses weak keys if an item in the list and its key are one and the same, and you remove the item from the list, the key is removed, as well. For this reason, I like to set weakKeys to true. Here is the enemyList example, using a Dictionary object:

```
var enemyList:Dictionary = new Dictionary(true);
for (var i:int = 0; i < 10; i++) {
  var enemy:Sprite = new Sprite();
  enemyList[enemy] = enemy;
}</pre>
```

As you can probably already tell, getting access to a specific item in a dictionary is also easier than with a traditional object. With Dictionary objects, it is necessary to use the new *for each* loop in AS3:

```
for each (var enemy:Sprite in enemyList) {
   //DO SOMETHING TO ENEMY SPRITE
}
```

The *delete* command applies here the same way it does with regular objects:

```
protected function enemyClicked(e:MouseEvent) {
  delete enemyList[e.target];
}
```

Pros: Dictionaries offer the ability to key off any value, including items themselves; they provide fast, direct access for an object to individual items and can store items of any type together.

Cons: Dictionaries are unordered; they are not as helpful for lists of primitive values like strings or numbers.

When to use: As much as possible! The Dictionary class is outstanding for storing all unordered lists of complex objects.

ByteArrays

Though not useful for storing lists of objects, the ByteArray class is designed to store raw binary data, making it a perfect (in fact, the only) candidate container for things like image or sound data. We won't really use ByteArrays in this book, but they are very fast and worth mentioning since they are often overlooked.

So What Should I Use For My Lists?

That answer, as with so many question, is "depends." I tend to like to use dictionaries to keep track of all my object lists in a game and then use arrays or vectors only when I need their sorting abilities. You really can't beat a dictionary for ease of use or speed. If I must have an ordered list, I would prefer a vector to an array due to its slight edge in speed. This is not to say that basic objects and arrays are no longer useful. Objects are still great containers for dynamic data, but not as fast for lists as dictionaries. Arrays are great to fall back on if you can't guarantee that all your list items will be of the same type or if you're working with older classes that aren't configured to handle vectors.

Custom Data Structures

In the event that you need even more functionality than these built-in classes afford, you can of course extend any of them to a new class. One important thing to remember about all of these classes is that they are *dynamic*, allowing them to have any properties added to them at runtime. In order for your subclasses to inherit this same functionality, they must also be dynamic. We'll look at an example of a custom data structure (though not an extension of any of these) in Chapter 15.

PART 5

Keep Your Comments to Everyone Else!

Probably the single-most overlooked task of any developer, particularly in crunch time, is commenting code. Comments are invaluable when handing code off to another developer or even just returning to it later. The convention is usually the more comments the better, but this can actually sometimes make code harder to read. Here are a few tips for commenting your code:

- Don't comment the obvious—If a line of code simply declares a variable called "player," it should be fairly self-explanatory what is happening; extra comments like "//CREATING PLAYER OBJECT" simply clutter up the code.
- Be thorough, but concise—Explain as much as you can
 in as few words as you can; if comments break onto multiple lines or trail off so the reader has to scroll sideways, it
 breaks the overall flow of the code.
- When possible, use the ASDoc formatting standards of commenting classes—This primarily means creating comment blocks in a specific format (established by Adobe) just prior to properties and methods; by creating your comments this way, documentation can easily be generated for your code, and many script editors such as FlashDevelop can use the comments in tooltips to help remind you of proper syntax (see below for example).
- Keep comments correct—This may sound like an unnecessary statement, but if you write your comments for a piece of functionality, and later that functionality has to change, then your comments must be updated, too.
- Use header comment blocks—Sometimes a simple, complete explanation in one place is more effective than a bunch of lines spread out over a file; if you can explain everything that a class does in a few sentences at the top of a file, don't hesitate to do so.

Here is an example of ASDoc formatting; more precise standards and style guides are available on Adobe's website. This is taken from a SoundEngine class we will look at in a later chapter:

```
/**
* Plays the sound specified by the name parameter. Checks
for the sound internally first, and then looks for it as an
external file.
* @param name String The name of the linked Sound in the
library, or the URL reference to an external sound.
* @param offset Number The number of seconds offset the sound
should start.
* @param loops int The number of times the sound should loop.
Use -1 for infinite looping.
* @param transform transform The initial sound transform to
use for the sound.
* @return SoundChannel The SoundChannel object created by
playing the sound. Can also be retrieved through getChannel
method.
public function playSound(name:String, offset:Number = 0,
loops:int = 0. transform:SoundTransform = null):SoundChannel
```

Note that the comment block is placed just before the method itself. It starts with a description of the method and then a list of the parameters it accepts and what it returns. When using an editor such as FlashDevelop or compiling documentation, the method itself will be used to define things like the default values of parameters and specific data types.

The Bottom Line

It is better to comment some than none at all, so even if you're pressed for time, you'll thank yourself later for having put *something* in, even if later on it takes you a minute to remember what you were thinking.

PART 6

Why Does Flash Do That?

Flash and ActionScript have a number of idiosyncrasies that can throw even seasoned developers off track. Some of these oddities are instances where the language breaks form with similarly constructed languages like Java or C#, much to the chagrin of developers coming to Flash from these languages. Others have to do with the processing order in which Flash performs commands; sometimes a bug is simply the result of a misunderstanding

of this "order of operations." We'll cover a number of these quirks in this section.

Event Flow

One of the common misunderstandings that I've witnessed with developers first utilizing Flash's event model is the difference between DisplayObject-generated events and all other events. As we discussed earlier, events in ActionScript have three phases: capture, target, and bubbling. Objects that dispatch events but are not in the display list (which can include DisplayObjects that have not been added to the Stage) generate events only at the target phase. In other words, other objects may listen for these events only by attaching themselves directly to the dispatching object.

DisplayObjects that are active somewhere in the display list are capable of dispatching events that pass through all three phases. When a DisplayObject that is on the Stage dispatches an event, it actually originates at the Stage level and progresses through each subsequent child to effectively tunnel down to the originating object—this is the capture phase. The event then enters the target phase, and any listeners attached directly to the DisplayObject will receive the event. Finally, if the event is set to bubble, it will reverse its direction back up the same display hierarchy it traversed in the capture phase.

Frame Scripts

Before I go any further, I should go ahead and state for the record that coding on the timeline should be avoided at all costs. There is basically nothing that you can't do with classes to control your DisplayObjects at this point, and forcing your code into classes imposes better architecture and less sloppy shortcuts that will later come back to bite you.

Now, I say "basically" because until AS3 (Flash CS3, specifically) you still had to put a stop() action on the last frame of any MovieClip you didn't want to loop. Since switching to all-class scripting architecture, I found it very frustrating to not be able to easily remove this last bit of straggling timeline code from my FLA once and for all. Then I discovered an undocumented method of MovieClips. It's called addFrameScript, and it is a complete mystery to me why Adobe hasn't documented it or encouraged its use, because it is a fantastic piece of code. Basically, it allows you to tell a particular function to run when a certain frame of a MovieClip is hit. Unlike all the other MovieClip functions, it is zero based, rather than one based, so you must subtract one from

the desired frame number to use it correctly. Here is its syntax in the context of a MovieClip class:

```
public function MyMovieClip() {
  addFrameScript(totalFrames-1, stop);
}
```

Now when the clip reaches the last frame, it will call its stop() method and not loop. Obviously this has further reaching implications and uses than simply stopping a MovieClip from playing. In fact, I have come up with a way to use this method to make up for what I see as a deficiency in ActionScript with regard to MovieClips and frame labels. Since early versions of Flash, you could put string labels on any frame in the timeline and use them as reference points for navigation. Starting in AS3, Adobe finally introduced the ability to see what label you're currently on in a clip (with the *currentLabel* property) as well as a list of all the labels in a clip (the *currentLabels* property). I've long thought that Flash should dispatch an event whenever a frame label is hit so you could trigger actions based on label markers. With *addFrame-Script*, you can! Let's look at an example.

Here is an architecture I like to use for my document class in a Flash file. It involves placing labels on the main timeline to denote sections of a game; they might be things like "loader," "titleScreen," "game," "resultsScreen," etc. Figure 4.4 illustrates this arrangement.

Figure 4.4 For my main timeline, I set up labels denoting each section of the game experience.

In my document class, I create constants to match these frame labels so I can reference them easily and don't risk misspelling them. I also import the FrameLabel class, as I will be using it shortly:

```
package {
  import flash.display.MovieClip;
  import flash.display.FrameLabel;

public class FrameScriptExample extends MovieClip {
  static public const FRAME_LOADER:String = "loader";
  static public const FRAME_TITLE:String = "title";
  static public const FRAME_GAME:String = "game";
  static public const FRAME_RESULTS:String = "results";
  public function FrameScriptExample() {
    stop();
  }
}
```

When I have all my labels established, I create two functions that will control my frame events:

```
private function enumerateFrameLabels():void {
  for each (var label:FrameLabel in currentLabels)
    addFrameScript(label.frame-1, dispatchFrameEvent);
}
private function dispatchFrameEvent():void {
  dispatchEvent(new Event(currentLabel));
}
```

The *enumerateFrameLabels* method iterates through the list of FrameLabel objects in the currentLabels array and adds a frame script to every frame that has a label. The function it adds is called *dispatchFrameEvent*, and all it does is generate a new event with the same name as the frame label. Now every time a frame label is hit, an event with that label name will be dispatched. By using events, any number of objects can listen for these frame events. The rewritten constructor for this class now looks something more like this:

```
public function FrameScriptExample() {
  stop();
  enumerateFrameLabels();
  addEventListener(FRAME_TITLE, setupTitle, false, 0, true);
}
protected function setupTitle(e:Event):void {
  //PERFORM TITLE FUNCTIONS
}
```

It is worth noting that only one function can be assigned to a frame at a time, so any subsequent addFrameScript calls to the same frame number will replace the existing script. If you're at all nervous about using undocumented features in your work, addFrameScript is a pretty safe bet—it's what the CS4 integrated development environment (IDE) uses internally when you place code on the timeline. Let's say you put a script on the last frame of the main timeline that called stop(). When you compile the SWF, Flash takes each of these frame scripts and converts them into functions with names like "frame30" to ensure they are unique. Then, in the constructors for any clips with frame scripts, Flash calls addFrameScript to attach these functions to their respective frames. It looks something like this:

```
addFrameScript(30, frame30);
```

I'm sure there are many other good applications of this method, so continue to explore it and let's collectively push Adobe to support and document it. If it's good enough for Flash, it should be good enough for you. One other minor sticking point is that very early versions of Flash Player 9 prior to Flash CS3's release (specifically, 9.0.28 and earlier) do not support addFrameScript.

The command is ignored entirely. Because of this issue, other security issues, bug fixes, and performance improvements, I recommend you only build for Flash Player 9.0.115 or higher. If you're building for Flash Player 10 (which is the default for CS4), you don't need to worry about it at all.

Working with Multiple SWF Files

At some point, you'll probably be in the position of using multiple SWF files to support a game. Perhaps you have multiple game levels, each in its own SWF, or you have externalized all your audio as a separate file. To load external SWF files in at runtime, you'll need to use a Loader object, which is part of the display package. The syntax looks like this:

```
package {
 import flash.display.Loader;
 import flash.display.Sprite:
 import flash.display.MovieClip:
 import flash.events.Event;
 import flash.net.URLRequest:
 public class LoaderExample extends Sprite {
   protected var resourceLoader:Loader;
   protected var resources: MovieClip:
   public function LoaderExample() {
     loadResources():
   protected function loadResources():void {
     if (!resourceLoader) resourceLoader = new Loader():
     resourceLoader.load(new URLRequest("resources.swf"));
   resourceLoader.contentLoaderInfo.addEventListener
   (Event.COMPLETE, resourcesComplete, false, 0, true);
   protected function resourcesComplete(e:Event):void {
     resources = e.target.content as MovieClip;
   protected function unloadResources():void {
     resourceLoader.unloadAndStop():
```

In the *loadResources* method of this example, a new Loader object is created (if one doesn't already exist) and is used to load a SWF named "resources.swf." A listener is then added to the Loader's *contentLoaderInfo* object, which will dispatch events about the Loader's progress. When the load has completed, the resources variable is assigned to the content of the Loader. If at some point the data needs to be unloaded, the method

unloadResources can be called to dump the SWF. Developers familiar with AS3 already will note that the new unloadAndStop method in CS4 is a big improvement over the previous (and still available) unload method. It makes sure that all listeners and sounds connected to the loaded content are properly removed and garbage collected to prevent any of the assets from lingering in memory.

One thing to note about classes in separate SWFs is that, by default, every SWF has its own "sandbox" to store classes known as its ApplicationDomain. This is to prevent classes in one SWF from colliding with those in another, which is helpful if two SWF files have similarly named classes that are actually completely different in their implementation. Most of the time, this is the behavior you will want, as it protects your class integrity and keeps you from having to think about how any other content may be built. Occasionally, however, you want to be able to merge a loaded SWF's ApplicationDomain with its container. A good example of this is a SWF that contains nothing but sounds exported in the library. In order to easily get access to the classes for these sounds, you would have to rely on a roundabout way of looking them up. If you know that none of the class names in your loaded SWF file will conflict with those in the container, you can tell Flash to merge the two when the SWF is loaded. Using the previous example, the *loadResources* method would have to change:

```
protected function loadResources():void {
  if (!resourceLoader) resourceLoader = new Loader();
  var loaderContext:LoaderContext = new LoaderContext(false,
  ApplicationDomain.currentDomain);
  resourceLoader.load(new URLRequest("resources.swf"),
  loaderContext);
  resourceLoader.contentLoaderInfo.addEventListener
  (Event.COMPLETE, resourcesComplete, false, 0, true);
}
```

The new code uses two classes from the system package: LoaderContext and ApplicationDomain. When you perform a load, you can specify the context under which the file is loaded. Inside that context, you can determine which ApplicationDomain the loaded file should use. By specifying the current domain, any class definitions in the loaded SWF file will be combined with and accessible to those in the container. In Chapter 15, we'll look at a variation on this process when loading a set of assets.

One point to remember about using Loader objects is that you *must* call unloadAndStop to fully unload any content you want to get rid of. Simply setting the Loader object to *null* will only eliminate the reference to it and there is no guarantee that is will be automatically garbage collected correctly. Fewer things are worse in Flash than a memory leak that can't be fixed because there is no attainable reference to the offending object.

Garbage Collection

The AS3 garbage collection (GC) system, or the mechanism that removes unused objects from memory, has some peculiarities that are likely to throw off AS2 developers, though they are likely nothing new to developers from other memory-managed languages. Ideally, a garbage collector is always keeping track of which objects are in use and which are not, freeing up as much memory as possible. In reality, it is not so perfect, but there are ways to make sure your code conforms to how the GC will work. First, it's important to understand in brief how the Flash GC performs its functions.

The AS3 GC uses two techniques to clean up your objects. The first is known as reference counting; all the objects in memory have a number representing how many references there are to that object. For example, the following code creates three different references to a single object:

```
var obj1:0bject = new Object;
var obj2:0bject = obj1;
var obj3:0bject = obj2;
```

Any time the number of references to an object changes, Flash checks to see if that number is zero. If it is, the object is purged from memory. In this case, as long as we set obj1, obj2, and obj3 to *null*, the original object will be deleted. Sounds easy and effective enough, right? Unfortunately, there are a number of scenarios where a parent object may no longer reference its child objects, but they reference each other instead, as in the following example:

```
var obj1:0bject = new Object();
var obj2:0bject = new Object();
nhj1.otherObject = obj2;
obj2.otherObject = obj1:
obj1 = null;
obj2 = null;
```

In this instance, while we've nulled out the references to obj1 and obj2, they now reference each other. As a result, the garbage collector will not purge them as it does not discriminate between *what* is referencing the objects, only that *something* is. This brings us to the second method the GC uses to get rid of unused objects. It is known as *mark sweeping*. In this process, Flash creates a tree hierarchy of how all objects are connected to each other that links back to what is essentially the root of the SWF. Any objects that are not connected to the main tree in some way, even if they are connected to each other, are marked for deletion from memory.

At this point you're probably thinking, "Okay, great. Sounds like Flash has it covered." Once again, it is not quite that simple.

The reference counting technique of the GC happens automatically and immediately when the number of references to an object changes. However, because mark sweeping requires running the entire length of the object tree in memory, it is a very intense effect on the system and is only run *periodically*. In my experience, this is usually pretty frequently on decent machines, but it cannot be counted on for split-second accuracy. Don't worry, though—there are a few things you can do to help the garbage collector run thoroughly and effectively:

Be diligent about removing your references to objects

If you have multiple references to objects in your classes, I suggest writing a function called *cleanUp* in classes that contain a lot of references. This function can perform such tasks as setting references to null and emptying arrays. By helping the reference counting mechanism of the GC, you'll make the entire process easier on Flash and therefore less taxing on your game.

Use weakly referenced listeners

Event listeners are a common place for memory leaks, because developers add them and then neglect to remove them. Any object that is dispatching events contains a list of all the objects listening to those events. Even if the listening object has all of its external references set to *null*, it will still be in this listener list. Luckily, when adding an event listener, there is an option to use what are known as *weak references*. Weak references are not counted as part of the reference counting mechanism of the GC, so if the only remaining references to an object are weak, it will be deleted. Simply set the fifth parameter of the *addEventListener* method to true to use weak references. I recommend *always* using them, as they will save you endless headaches and there is not a scenario I have come across yet where using weak references had a negative impact.

Avoid using dynamic objects other than for lists

As a best practice you should always use statically typed classes, as opposed to dynamic classes, which allow you to add new properties and methods at runtime. By forcing yourself to intentionally declare the variables and object references you want to use in your classes, you keep better track of them. Also, statically typed classes require less memory as instances because they do not require a lookup table to hold the dynamically created properties and methods. Dynamic objects are a common way references to other objects get lost so that they're not effectively garbage collected.

Use the new unloadAndStop method in Flash Player 10 and CS4

Like I mentioned a brief while before, in the section on loading external files, unless you're still developing Flash Player 9 content always use the unloadAndStop method for getting rid of loaded content. It does a far more effective job of preparing all the objects in the content for garbage collection and will save you a lot of time trying to manually purge all those references yourself.

The garbage collector in Flash has many nuances and Adobe will surely continue to improve it with each new version of the Flash Player, eventually giving developers the ability to delete an object outright without having to wait for the GC to do it.

Conclusion

This chapter has provided an effective rundown on all the basics you need to know about using AS3 in Flash. This foundation will allow us to explore new classes and features in later chapters as we begin to build games. If you're interested in learning more about the fundamentals of ActionScript, a good place to start is Adobe's documentation on Flash. It is very thorough and covers all of these subjects and more in detail. Many thanks to Grant Skinner for his blog posts on garbage collection—they were an invaluable resource.

MANAGING YOUR ASSETS/ WORKING WITH GRAPHICS

While code is certainly a huge part of most games, the assets the code manipulates (art, sounds, text) are usually equally important. Unlike most programming languages where such resources reside as individual files separate from the code, every Flash file has an associated library that contains all the assets that will get bundled into the SWF at compile time. Once you have imported an asset into your library, you no longer need the external file unless you make updates to it. This allows for easier access by multiple developers, since someone who needs to work on a Flash file only needs the FLA in most cases. While you could arguably create a SWF that was all code and loaded in all of its resources at runtime, that is working against Flash's nature and creates a lot of extra work for very little return in almost every situation. Flash can also add extra layers of compression to assets that cannot be achieved by accessing them externally, meaning a single SWF containing all of its resources will be smaller than all of those individual files put together. Throughout the rest of this chapter, I will discuss the different types of assets you will need to know how to work with when creating games in Flash.

One point I'll continue to make throughout this chapter is about the file size of assets. Conventional wisdom in some Flash circles is that all that matters is the end product—how small the resulting SWF file is. Consequently, I've seen many FLA source files hit anywhere from 30 to 50 MB for relatively simple games. This is problematic for a couple of reasons. One is that, if you're using any type of backup or version control system every time, a new version takes up a considerable chunk of space. Even more importantly, Flash likes smaller, less memory-hogging FLA files and will be far less prone to locking up or crashing. One simple step to periodically take during development is to perform a Save

Figure 5.1 The Save and Compact option in the File menu will remove deleted resources from your FLA file and reduce its size.

and Compact operation. As you make changes to assets in Flash (adding, updating, deleting), it stores a history to allow you to undo as many of these actions as possible. Over time, these "undo backups" can begin to bloat your file, storing assets that you deleted from the library several iterations ago. Save and Compact goes through the FLA and purges any of this undo data. I've seen libraries drop 75% in size just because of a long version history. Note that if your version control system consists of saving to a new file each time and incrementing the file name (not a system I recommend at all), Flash automatically compacts your file when you use Save As.

A Few Words About Organization

If you've worked in Flash for very long, you've probably had the opportunity to open someone else's FLA file from time to time. I've rarely found two developers who organize their library the same way. For a while, a popular convention was to sort library assets by type, so there would be folders called MovieClips, Buttons, Bitmaps, etc. Some prefer to sort by use, reflected in folder structures like those shown in Figure 5.2.

Figure 5.2 A library organized by use.

The important thing to remember is that any organization is better than none, and often the complexity of the project will dictate the best structure to use. I typically use a hybrid of the two aforementioned methods. I will keep my visual assets (MovieClips, Images, Video) sorted by use and then by type inside their respective folders. I then keep items like sounds and font symbols organized strictly by type. My reasoning behind this is that Flash CS4 finally introduces the ability to edit the properties of multiple items of the same type, and having the items physically near each other in the library makes it easier to select them.

Working with Graphics

We're long past the days of Pong; the bar has been raised. With few exceptions, games are expected to have good-looking graphics and animation that feels natural and smooth, and Flash games are no different. In this section, I will outline the best formats to use for graphics in games and use of the timeline for animation. I won't discuss creation of artwork, for a couple of reasons. First, I am not an artist. Second, as Flash games become more and more sophisticated, it is less likely that one individual will be responsible for both the artwork and code in a single game. If you work alone or you are interested in designing graphics for Flash games, I recommend checking out Robert Firebaugh's *Flash Professional & Game Graphics*. It's a couple of versions behind now, but it is still a great resource for learning how to design efficient artwork for use inside Flash.

Flash CS4 supports both vector and raster (bitmap) artwork. Each has its advantages and disadvantages when it comes to game development. Vector graphics are resizable without any quality loss, they usually have a much smaller file size than raster graphics, and they can be manipulated over the timeline to create seamless (if rather time-consuming) animations on the level of professional cartoons. However, vectors can be notoriously heavy on the CPU in large numbers or when used in large objects. Vector artwork is usually best created directly inside of Flash, though it can be done in a tool like Adobe Illustrator. The upside of the first option is that Flash will automatically optimize vectors as they are drawn to use the least number of points possible. In a program like Illustrator, where accuracy and pixel-perfect quality are valued over optimization, art tends to end up with bulkier vectors that must be cleaned up after they are imported into Flash. If you are working on a project with all vector artwork, fewer points translate to faster rendering and lower file size.

Most everyone will be familiar with and has used raster images, even if all you've ever done with them is set your computer's wall-paper. They have a few advantages over vectors. First, they offer photorealism on a level that would not be possible without overly complex vector shapes. Many different art programs, including most three-dimensional (3D) software, will render out images, whereas only a few will generate Flash-compatible vector files. They are also much less intense to render to the screen, as Flash sees them on the level of complexity of a vector rectangle. They are not without their drawbacks, unfortunately. Raster images become exponentially heavy in file size as they increase in pixel size and cannot be resized inside Flash without a certain level of quality loss. Also, images with transparency are more taxing on the Flash renderer than ones without.

At this point, you may be saying, "So, neither one is a clear winner. Which one should I use?" Once again, like library organization preferences, this is usually dictated by the project. There is no one right choice that will work across the board; very rarely will I use all one or the other. That said, I lean more heavily on raster images than I do vector when it comes to game development. Many games rely on the ability to render objects to the screen quickly to maintain a sense of excitement, and with a significant level of detail vectors become too slow to pull this off. As a general rule, the art for games I work on is usually about 80% raster, 20% vector. Characters, backgrounds, particle effects, etc., are all raster. Menus, in-game displays, and, of course, any text are vector.

Raster Formats to Use

The two best raster formats to use in Flash are JPEG and PNG. JPEGs are great when you don't need any transparency because the compression level and quality you can get out of external programs like Photoshop is better than what Flash will perform internally. Because of their lack of transparency, they also have a lower overhead on the Flash renderer. PNGs are the best solution when you need transparency in your images, but they cost more in file size and in processor power.

Most projects will be a blend of the two formats. Whenever possible, it's a good idea to use a JPEG for any assets that can function in a rectangular format without any transparency. This includes:

- · Game and menu screen backgrounds
- Images that are going to be used as a texture in a bitmap fill
- Art that is going to get masked inside of another shape

Figure 5.3 The background art for a game, saved as a JPEG file.

• Overlays that will be used for some type of graphical effect over the game, like static or interference

Portable network graphics (PNGs) are the best choice for clean transparency and are better for the smaller elements in a game, including:

- Characters, especially those that are animated
- In-game elements that need to be separated from the background
- User interface elements such as buttons and other irregular shapes
- Any image that has fine lines and requires pixel-perfect accuracy (JPEGs have a tendency to blur or muddy pixelfine details in an image)

Figure 5.4 Character sequence of individual PNG files, with Onion Skinning turned on in Flash.

Techie Note. 8-bit PNGs with an Alpha Channel

PNGs come in two flavors—32-bit (or 16 million colors with a full 8-bit alpha channel) and 8-bit (256 colors). A seemingly little known fact about Adobe Fireworks is that it can generate a special type of PNG that has an 8-bit color channel and an 8-bit alpha channel (sometimes called PNG8+8). If you're using artwork that has a fairly flat color palette or that won't degrade when the number of colors is reduced, this format is an outstanding option. It allows you to keep nice clean edges and transparency, thanks to a true alpha channel, while reducing the file size by over half. In fact, this format is often smaller than the compressed version of a 32-bit PNG inside of Flash, and the resulting images look better. Hopefully this format will eventually find its way into Photoshop's Save for Web feature. Until then, you can always use Fireworks to batch-process your 32-bit PNGs down to 8.

Figure 5.5 The result of saving a JPEG.

Figure 5.6 The result of saving a 32-bit PNG.

Of course these are just guidelines, not hard and fast rules, but using a combination of formats that take file size into account upfront will save you time in the optimization phase. Another aspect of dealing with raster images is how Flash will handle them when compiling the game. Flash has a couple of different options when it comes to exporting images that can have an impact on how your game looks. Simply double-click on an image in your

library to view its properties. You can also select multiple images at a time (a new feature in CS4) and adjust the properties of all of them at once (Figure 5.8).

Figure 5.7 The result of saving an 8-bit PNG from Fireworks.

Figure 5.8 The Bitmap Properties panel will let you adjust the properties of a specific image or multiple images.

Compression

When you import a JPEG file that has already been optimized in another application, Flash will use it "as is" by default. PNGs are a different matter. If the image has 256 colors or less, Flash will automatically downconvert it to an 8-bit PNG file and you get instant file size savings with no quality loss (also known as lossless compression). If the image has more than 256 colors, Flash will apply its own version of IPEG compression when your file is compiled. The level of this compression can be controlled at the document level in the Publish settings (where it defaults to 80%) and on a per-image basis. For any images that will be still on screen for any length of time, a setting of 70 to 80 is recommended to prevent too much degradation. For images that are used in a rapid sequence, like character animation, I've gotten away with a setting as low as 50 without it being noticeable. In fact, at 30 frames per second, the human eye cannot perceive enough detail, and the natural blurring effect of JPEG compression will create a nice sense of motion blur. Never use anything over 90 unless the game is going to be displayed on an enormous high-resolution display: you likely won't be able to tell the difference, and the file size will jump up dramatically.

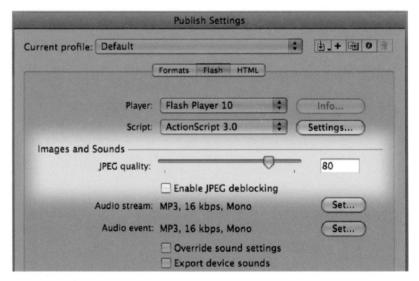

Figure 5.9 The Publish settings window allows you to set the default image quality.

Smoothing

By default, Flash does not re-render images when they are distorted in any way on the Stage, including skewing, scaling, or even rotating (at any angle not divisible by 90). This causes a jagged, blocky effect that is very noticeable on any images that are not moving rapidly. If you have any raster elements in your game that need to be able to rotate or resize from time to time, consider

checking the Allow Smoothing box in the Bitmap Properties panel. While it looks considerably cleaner, this does tax the processor a little bit more per image, so use it sparingly and consider disabling it for some images if your game begins to stutter later on in testing.

Figure 5.10 Bitmap smoothing (on the left) can make a big difference, particularly in images with fine details.

Deblocking

A new feature in CS4, enabling deblocking will apply extra some extra smoothing to improve images that are set to an extremely low JPEG quality, as in 30 or less. Unless you are using many heavily compressed images, deblocking is probably not a feature you will need much.

External Image Tools

The artists I work with typically use Adobe Photoshop and Adobe Fireworks raster game art. They produce very good JPEG compression and very clean PNG files. If you're on a tight budget and can't afford (or don't need all the high-end features of) Photoshop, Fireworks by itself is a very satisfactory application. As of this writing, it is \$300.

For vector art, I've known a number of artists who use the tools in Flash to great effect; they cost nothing extra and automatically optimize the vectors as they are created. Fireworks also has a very nice set of vector tools that export easily into Flash. Over the years, I've also worked with artists who like Adobe Illustrator, but I find it to be overkill for the level of detail needed in most games, and not all the effects (such as complex blends and gradients) will translate well to Flash.

Key Points to Remember

It's very easy when working with a lot of images in a game for them to get out of hand quickly, both in disorganization and file size. Remember:

- Be vigilant about keeping tabs on your images throughout the development process.
- Keep series of images organized in folders in your library.
- Keep images organized in the file system so you can do "Updates" in Flash rather than having to import them all over again if anything changes.
- Err on the side of smaller, both in dimension and file size, particularly with full-frame-rate animations.

Better to be a stickler and optimize upfront than to scramble to scrape file size off at the 11th hour by lowering the JPEG compression on everything until your game is one big blocky mess. In the end, your perseverance will pay off in peace of mind.

MAKE IT MOVE: ACTIONSCRIPT ANIMATION

No matter how good the artwork in a game looks, it can fall completely flat if it is unconvincingly animated. Players respond to motion and animation in a game, and it can mean the difference between a successful suspension of disbelief and a boring experience. Luckily for Flash game developers, animation is at the core of Flash's long history. It is what the product originally started out doing and has only continued to improve over the years. Flash CS4 introduces a number of new features that make the timeline amazingly more powerful to work with and which cut down on the time spent building animations. Some of these features include an entirely new way of assigning tweens to objects on the Stage, complete motion control over every property of a tween, and inverse kinematics for doing convincing joint-based character animation.

However, I should go ahead and get a disclaimer out of the way. We will not be covering standard Flash timeline animation in this chapter. I made this decision for a few reasons:

- If you're coming to this book from a Flash background, it's
 very likely you are already familiar with many aspects of
 Flash animation and will be able to pick up the new features quickly on your own.
- If you're coming to this book from another programming or game development background, I find discussions of timeline animation make people from these disciplines glaze over or hang their heads.
- In game development, timeline animation use is typically greatly reduced, and scripted animation is far more common.

The last of these points is really the most important. In game development, you want to have as much control as possible over the animations you use in your game, and the best way to achieve

this control is by creating the animations through ActionScript. That said, I still regularly use the timeline for things like title and menu screens, cutscenes between gameplay segments, and other incidental, non-game-related animation. If you are interested in learning more about timeline animation in Flash, I will have links to excellent learning resources on flashgamebook.com.

A Little Terminology

So we're all on the same page (literally and figuratively) over the course of this chapter, here are a handful of terms that will be used shortly, what they mean, and how they are relevant.

Easing

In real life, most motion does not occur in a rigid fashion. Unless you are a robot underneath, for example, your movement is not completely linear and always at the same rate of speed. When starting to walk from a stationary position, you gradually speed up and then slow down when you come to a stop again. In animation, this gradual acceleration and deceleration constitute the concept known as *easing*. Easing is a critical component in making animations look convincing and real. If a ball rolls across a surface, it shouldn't move at a fixed speed and then come to an abrupt stop. The friction between the ball and the surface causes it to come to a stop progressively. In scripted animation, easing is usually defined by an equation (in the case of Flash, a function) that determines how an animation plays out over a given time based on a starting and an ending point. It can also be used to create effects such as elasticity and bounciness.

Sequencing

Sequencing refers to the stacking of animations (usually of different objects) so they occur in a particular order rather than simultaneously. This concept becomes especially important when timing events within a game; when a player makes a move, you might want a short pause before an animation starts playing or you might have a series of animations that you want to play when a player does something.

To Tween or Not to Tween? Is That a Question?

When creating animation in a game, there are generally two methods to use. The first approach to creating scripted animation is to move objects based on the game's mechanic. An example of this would a top-down scrolling shooting game where the speeds, positions, and orientations of the background, player, and enemies are all determined by engine calculations and updated frame by frame. Another example would be any kind of physics simulation, which we'll look at in depth in Chapter 10.

The second method is to create what is commonly known as a tween. A tween is a set of instructions that change the properties of an object over time. For example, if I move a circle from (0, 0) to (10, 10) in two seconds, I have tweened that object's x and y properties. Since version 7, Flash has included some basic classes for creating tweens with code. These classes have changed very little all the way through version 10 where we are today. However, a number of Flash users in the community have taken it upon themselves to write elaborate tweening libraries that support things such as moving multiple objects in sync with each other; dispatching events when animations begin, change, and end; and sequencing entire virtual timelines of animation. Tweens are less useful when creating simulation-driven games but are extraordinarily helpful when you simply need to move or manipulate components of a game or create visual effects in a style you might have traditionally used the timeline for in earlier versions of Flash. While I've used a number of tweening libraries and each has its own merits, my favorite as of this writing is TweenMax by Jack Doyle of greensock.com. Jack goes to great lengths to incorporate feedback from the community and continues to update and improve the library on his own time. It is the tween engine we'll use in some upcoming examples, and I highly recommend downloading the latest version from his site and donating to the project if you end up using it in your own work.

A Simple Scripted Shooter

In the following example, we will look at a simple animated game mechanic involving a top-down, scrolling shooter. This game will employ a form of scripted animation to convey a sense of motion to the player. You can follow this example using the SimpleShooter.fla file in the Chapter 6 examples folder on the website. When exported, this example will create an environment with a two-tiered background that scrolls at different rates and a ship that moves with the mouse cursor and fires projectiles when the mouse button is clicked. There are just two classes for this example: SimpleShooter.as and Projectile.as. We'll look at the latter one first, since it's very simple.

The Projectile Class

The class controlling the projectiles fired in the game only has one main property: the projectile's speed. Arguably, for this example,

we could have stored the speed in the main game class to keep it in a single file. However, if a more advanced feature set were added to this game, it would require classes to control each of the objects in play, so going ahead and creating a sort of "stub" class gets some work out of the way. If we added enemies to this game that also fired projectiles, for example, we'd want those projectiles to have a different speed than those fired by the player. It also gets us into the practice of creating classes to control the feature sets of our game objects, even when they're not 100% necessary.

```
package {
  import flash.display.Sprite;
  public class Projectile extends Sprite {
    protected var _speed:Number;
    public function Projectile(speed:Number = 0) {
        this.speed = speed;
    }
    public function get speed():Number {
        return _speed;
    }
    public function set speed(value:Number):void {
        _speed = value;
    }
}
```

Like I said—*simple*. The speed variable will be the number of pixels the projectile will move on every frame cycle.

The SimpleShooter Class

This class handles all the logic behind the gameplay. It will control the player's position, the scrolling background, and creation, movement, and removal of projectiles. The background actually consists of two separate objects we're calling the *foreground* and *background*. We will move these two objects at different speeds to achieve a feeling of depth and sense of motion known as *parallax scrolling*.

```
public class SimpleShooter extends Sprite {
  public var background:Sprite, foreground:Sprite;
  public var player:Sprite;
  protected var _projectileList:Vector. <Projectile> ;
  protected var _speed:Number = 15;
  protected var _stageWidth:int, _stageHeight:int;
  protected var _projectileSpeed:Number = 20;
  public function SimpleShooter() {
   addEventListener(Event.ADDED_TO_STAGE, addedToStage, false, 0, true);
   addEventListener(Event.ENTER_FRAME, frameScript, false, 0, true);
   _projectileList = new Vector. <Projectile> ();
}
```

As you can see, there are three public variables representing the background, foreground, and player Sprites. Internally, it also stores a list of all active projectiles, the speed at which the foreground should move, the speed of any projectiles upon creation, and references to the Stage's width and height.

```
protected function addedToStage(e:Event):void {
   _stageWidth = stage.stageWidth;
   _stageHeight = stage.stageHeight;
   addEventListener(MouseEvent.MOUSE DOWN, createProjectile,
   false, 0, true);
}
protected function frameScript(e:Event):void {
   movePlayer();
   moveProjectiles();
   moveForeground();
   moveBackground();
}
```

Once added to the Stage, the game stores information about the Stage and adds a listener for when the mouse button is pressed that will call a method named *createProjectile*. We will look at this method shortly. The function that runs every frame, *frameScript*, does four things. It moves the player, moves all of the projectiles, and updates the position of both the foreground and background tiles.

```
protected function movePlayer():void {
  player.x = mouseX;
  player.y = mouseY;
  if (mouseX > 0 && mouseX < _stageWidth && mouseY > 0 && mousey < _stageHeight) {
    Mouse.hide();
  } else Mouse.show();
}
protected function moveProjectiles():void {
  for each (var projectile:Projectile in _projectile1st) {
    projectile.x += projectile.speed;
    if (projectile.x-projectile.width > _stageWidth) {
        removeProjectile(projectile);
    }
}
```

In the *movePlayer* function, the player's *x* and *y* position is updated to match that of the mouse. In addition, we check to make sure the mouse cursor is within the bounds of the stage. If it is, we hide the cursor so it does not cover up the player; otherwise, we show it. The *moveProjectiles* method iterates through the list of projectiles and updates each according to its speed. If the projectile has moved too far off the screen, it is removed.

```
protected function moveForeground():void {
  foreground.x -= _speed;
```

```
var right:int = foreground.getRect(this).right;
if (right <= _stageWidth) {
   foreground.x = right-_stageWidth;
}

protected function moveBackground():void {
   background.x -= _speed/3;
   var right:int = background.getRect(this).right;
   if (right <= _stageWidth) {
     background.x = right-_stageWidth;
}</pre>
```

These two functions are almost identical. The only real difference is that the background moves at 1/3 the rate of the foreground. This will give the impression that the background is much farther away from the player.

```
protected function createProjectile(e:MouseEvent):void {
   var projectile:Projectile = new
Projectile(_projectileSpeed);
   projectile.x = mouseX;
   projectile.y = mouseY;
   _projectileList.push(projectile);
   addChildAt(projectile, getChildIndex(player));
}
protected function removeProjectile(projectile:Projectile):void {
   if (projectile.parent == this) removeChild(projectile);
   _projectileList.splice(_projectileList.
indexOf(projectile),1);
}
```

The last two functions in this class control the creation and removal of projectiles. The *createProjectile* method is called when the mouse is pressed. It generates a new Projectile object, moves it to the mouse's position, adds it to the vector list, and places it on the Stage underneath the player. In *removeProjectile*, we simply pass any projectile instance as a parameter and it is removed from the stage and spliced from the list.

When you run this example, you can see that the animation behind it is very basic but effective. It conveys a continual sense of motion and gives the impression that we're traveling very quickly. It is also a good base upon which to add components such as enemies animating in the same direction as the foreground and background. In the next example, we will look at a very different kind of game where tweening is a more effective method of animation.

Memory: Tweening Animation

This next example is a simple memory game. There are six pairs of matching cards that have a gray back and one of six different colors on the front. The player clicks any two cards to flip them over; if they match, they stay face up. If they do not match, they are flipped back over. In this instance, the game mechanic involves no motion by default, so we'll need to add animation to liven up the experience. This is where a tweening library like TweenMax comes in. We'll use TweenMax, combined with the new 3D DisplayObject properties, to make the cards look like they're being flipped over. Like the last example, this game has two classes that control its functionality. The files can be found in the Chapter 6 examples folder; the main file is Memory. fla and the two class files are Memory.as and MemoryCard as. If you open the FLA file, you will see 12 instances of the MemoryCard class arranged on the Stage. We'll look at this file first.

The MemoryCard Class

Each MemoryCard object is a MovieClip derivative that contains the face-down state on the first frame and all the other faces on subsequent frames. Every card needs to know what its value is so it can display the correct frame and also so the game can compare any two cards to determine a match. The card numbers start at one and go up, in this case to six.

```
package {
  import flash.display.MovieClip;
  public class MemoryCard extends MovieClip {
    protected var _cardNumber:int;
    public function MemoryCard() {
       stop();
    }
    public function get cardNumber():int {
       return _cardNumber;
    }
    public function set cardNumber(value:int):void {
       _cardNumber = value;
    }
    public function show():void {
       gotoAndStop(_cardNumber + 1);
    }
    public function hide():void {
       gotoAndStop(1);
    }
}
```

Once the card has an assigned *cardNumber*, the *show* and *hide* methods are the two main functions in play. The *hide* method returns the card to its first frame, and the *show* method jumps to its respective cardNumber plus one. The rest of the functionality for this game is in the Memory class.

The Memory Class

```
package {
  import flash.display.Sprite;
  import flash.events.Event;
  import flash.events.MouseEvent;
  import gs.TweenMax;
  import gs.easing.*;
  public class Memory extends Sprite {
```

Because we're making use of the TweenMax classes here, we need to be sure to import them for our use. In this example, we import the main class, TweenMax, and the entire easing equation set. We won't use every equation, but it's helpful to have them all available so we can select just the right look and feel.

```
protected var _cardList:Vector. <MemoryCard> ;
protected var _selectedCards:Vector. <MemoryCard> ;
public function Memory() {
   addEventListener(Event.ADDED_TO_STAGE, addedToStage, false, 0, true);
}
protected function addedToStage(e:Event):void {
   _cardList = new Vector. <MemoryCard> ();
   _selectedCards = new Vector. <MemoryCard> (2);
   for (var i:int = 0; i < numChildren; i ++) {
      if (getChildAt(i) is MemoryCard) {
         _cardList.push(getChildAt(i) as MemoryCard);
   }
   shuffleCards();
   activateCards();
}</pre>
```

When the class is instantiated, it creates a list of all the cards on the Stage and stores them in a vector. It also creates another vector of length 2 that will store up to two cards that have been clicked. The game then shuffles and activates the cards, which we will look at next.

```
protected function shuffleCards():void {
  var shuffledList:Vector. <MemoryCard> = new Vector.
  <MemoryCard> ();
  while (_cardList.length > 0) {
    var rand:int = Math.round(Math.random()*(_cardList.length-1));
    var index:int = shuffledList.push(_cardList[rand])-1;
    _cardList[rand].cardNumber = Math.floor(index/2) +1;
    _cardList.splice(rand, 1);
  }
  _cardList = shuffledList;
}
protected function activateCards():void {
  for each (var card:MemoryCard in _cardList) {
     card.addEventListener(MouseEvent.CLICK, selectCard, false, 0, true);
     card.buttonMode = true;
}
```

```
}
protected function deactivateCards():void {
  for each (var card:MemoryCard in _cardList) {
    card.removeEventListener(MouseEvent.CLICK, selectCard);
    card.buttonMode = false;
  }
}
```

The *shuffledCards* method does very much what you would expect; it creates a new list having randomly pulled from the original list. The two activation methods enable and disable mouse input, respectively. This is so the game can manage user input more easily and prevent impatient clicking from breaking the game logic.

```
protected function selectCard(e:MouseEvent):void {
 deactivateCards():
 if ( selectedCards[0] == null) { //NO CARD SELECTED
   selectedCards[0] = e.target as MemoryCard;
   flipCard(_selectedCards[0]);
 } else if (_selectedCards[0] == e.target) { //SAME CARD SELECTED
   flipCard(_selectedCards[0], false);
   selectedCards[0] = null;
   activateCards():
  } else { //NEW CARD SELECTED
   _selectedCards[1] = e.target as MemoryCard;
   flipCard(e.target as MemoryCard);
protected function flipCard(card:MemoryCard, show:Boolean = true):
void (
 if (show) {
   TweenMax.to(card, .5, { onComplete:card.show, rotationY:90,
   ease:Back.easeIn });
   TweenMax.to(card, .4, { onComplete:checkCards, rotationY:0,
   ease:Quad.ease()ut, delay:.5 });
  } else {
   TweenMax.to(card, .4, { onComplete:card.hide, rotationX:90,
   ease:Quad.easeIn });
   TweenMax.to(card, .5, { rotationX:0, ease:Bounce.easeOut,
   delay:.4 });
```

When a card is clicked, the *selectCard* method is called. If no cards are selected, the clicked card becomes the first of a comparison pair. If the same card is selected again, it is flipped back over. Finally, if a second card is clicked, it is added to the pair and flipped. The *flipCard* method is the first place we use any TweenMax functionality. By default, this function will show the card face; if the second parameter is false, it will hide the card again. The most basic TweenMax syntax involves the two static methods *to* and *from*. The *to* method creates a TweenMax object that will be automatically disposed of when the tween finishes.

The first parameter is the object that you want to tween, and the second parameter is the amount of time you want it to take in seconds. The final parameter is an object containing all the properties you want the tween to change, as well as information about which easing equation to use and what function to call when the tween is finished. TweenMax also supports a full event listener model, but it's a little overkill in this very simple instance.

When a card is flipped to be shown, the game first animates its *rotationY* property to appear to flip horizontally. Note that the easing method for this first tween is part of the *Back* class. The card will appear to turn the opposite direction for a brief moment before snapping toward its intended direction. When this tween is complete, it calls the card's *show* method and begins a tween restoring it to its original state. Once this second tween is complete, the *checkCard* method is called, which we will examine next. If the card is being hidden, the tween animates the card's *rotationX* property to flip the card vertically. When the card finally returns to its hidden state, the tween animates it using the *Bounce* easing class. This will give the affect of the card hitting a rubber surface.

```
protected function checkCards():void {
 if (!_selectedCards[1]) {
   activateCards();
 } else {
   if (_selectedCards[0].cardNumber == _selectedCards[1].
   cardNumber) {
     _cardList.splice(_cardList.indexOf(_selectedCards[0]),1);
     _cardList.splice(_cardList.indexOf(_selectedCards[1]).1):
     TweenMax.to(_selectedCards[0], 1, { rotationZ:180, ease:
     Elastic.easeout }):
     TweenMax.to(_selectedCards[1], 1, { rotationZ:-180, ease:
     Elastic.easeout });
   } else {
     flipCard(_selectedCards[0], false);
     flipCard(_selectedCards[1], false);
     \_selectedCards[0] = null;
     _selectedCards[1] = null;
     activateCards():
 if (!_cardList.length) {
     trace("WON GAME"):
```

The final method in the Memory class is *checkCards*. It looks at the *_selectedCards* list and checks to see if they have the same card number. If the cards are not a match, it flips them back over. If they are a match, they are removed from the main card list and have a final tween run on them. This tween uses *Elastic* easing to spin the cards with a rubber-band-like motion. Once the entire card list vector is empty, the game has been won.

Obviously, the tweens I chose to use here are largely arbitrary. One of the great things about TweenMax is how easy it is to change values to experiment with different equations and timing. We are also not limited to simple position, rotation, and scale tweens. TweenMax has support for color and filter animation effects as well, so you can really go wild experimenting, and the syntax is still very straightforward. Feel free to explore the full library with this game example.

Summary

However you ultimately choose to execute animation in your game, make sure you consider how it affects gameplay and what is most appropriate for the subject matter. A game that is intended for older adults or those who have vision difficulties should have more subtle, smoother animation so as not to become distracting. On the other hand, a game intended for most kids can't really ever have enough animation, and the wackier the animation the better! Remember, the wrong kind of animation is almost as bad as not having any at all, because it breaks the tone you're trying to set. Just keep your theme in mind and tween away!

TURN IT UP TO 11: WORKING WITH AUDIO

Sound is the most sorely overlooked component in the world of Flash games. Because it can't be seen, it's very often tacked on at the end of a project when someone realizes "this game really needs sound." It can mean the difference between a completely flat experience and a very rich one. Most of the best Flash games I've played had excellent sound design. It's not just that they used sound effects or music, it's that they paid attention to how the sounds blended together in the final mix. In this chapter, I'll outline the best formats to use for audio in games and different approaches to controlling sound within a game.

Formats to Use

I've heard many schools of thought from different developers on what formats they prefer. Some like nothing but WAV or AIFF files, both uncompressed formats. Others prefer MP3s that have already been compressed and are ready for export. The source format for audio doesn't matter quite as much as it does for graphics, because audio is almost always re-encoded when Flash exports a SWF. The export settings, which I will outline shortly, become very important at this point, because they will determine how the audio ultimately sounds in a game. Much like graphic formats, I find that a blend of the two types based on how they're being used is the best way to make format decisions.

For sound effects, which I categorize as sounds that are event triggered (like a punch or an explosion) and last no more than a

few seconds, I prefer WAV files that have been saved with the following settings from a sound editor:

- Bit depth, 16
- Sample rate, 22 kHz
- Channels, mono

This combination keeps the file size of each sound effect down but also provides enough flexibility and quality for anyone but the most attentive audiophile.

For music or ambient sound (background sounds that provide atmosphere), I prefer MP3 files. There are a couple of reasons for this. First, music tracks for games should be fairly long (one minute or more) so as not to get too repetitive, and long sounds begin to create very large files. A one-minute music track at the settings I described above for sound effects would be 2.5 MB. This doesn't seem like very much in this day and age, but consider if you had multiple music tracks and they started to get longer than one minute. This would add up pretty quickly and become cumbersome to manage and taxing on Flash's memory footprint. I've found that the following settings for MP3 files yield good-sounding music tracks:

- Constant bit rate (Flash doesn't like variable bit rate)
- Bit rate of 64 kbps

Depending on how prominent the music is in a game, a higher quality setting might be more appropriate. The same audio that would have been 2.5 MB as a WAV is 480 k—less than 1/5 the size.

Voice-over audio is a case where the context should determine the format. A computer voice speaking the name of a button when the user rolls over it is akin to a sound effect, so treat it like one. Narration, or any extended dialogue, makes more sense to treat like music given its length.

Export Settings to Use

In the early days of Flash, when keeping SWF file size low was overwhelmingly important, developers got used to setting all their sounds to use the lowest possible quality. All the sounds were muddy and often indistinct, but no one seemed to care because everyone was doing it. Now, with ever-increasing audio and visual fidelity in games (both commercial and on the web), the lowest common denominator won't usually cut it. Let's examine the Sound Properties window for a clip inside an FLA.

In this case, I have opened a file that was imported as an MP3. Flash automatically chose MP3 compression as the best option to use and selected an option only available to MP3s: use imported MP3 quality. This is a great option and means that not only will the sound not experience any further quality loss, but the SWF will also export faster than if Flash had to recompress it.

You may be thinking at this point that it would simply make sense to use MP3 compression for every sound effect in a game

	Sound Properties	
- International annual international con-	sizetest.mp3	ОК
	/Users/chris/Desktop/sizetest.mp3	Cancel
	Saturday, October 18, 2008 9:55 AM	Update
adadas estatistici intelestatudos das lastatidos	44 kHz Mono 16 Bit 60.1 s 480.8 kB	[Import
Compression:	MP3	Test
	■ Use imported MP3 quality	Stop
	24 kbps Mono 180.2 kB, 37.5% of original	
Device sound:		Basic

Figure 7.1 The Sound Properties window allows you to set the export settings for each individual sound in your library.

and forego WAV files altogether. The problem with this approach is that it is taxing on the Flash Player to start the process of playing an MP3 file because it must be uncompressed in real time. A music track that only loops every one to two minutes isn't noticeable, but if you have many sound effects occurring in rapid succession this can bog down the processor and hurt the game's performance. This is where a different form of compression comes in very handy.

	Sound Properties	
	soundeffecttest.wav	OK)
hadra de branklas prodavne	/Users/chris/Desktop/soundeffecttest.wav	Cancel
statistystetatless had a fish a seed a	Saturday, October 18, 2008 10:17 AM	Update
	22 kHz Mono 16 Bit 1.0 s 44.1 kB	[Import
Compression: (ADPCM 💠	Test
		Stop
Preprocessing:	Convert stereo to mono	
Sample rate:	22kHz 💠	
ADPCM bits:	4 bit \$	
	88 kbps Mono 11.0 kB, 25.0% of original	
Device sound:		Basic

Figure 7.2 For sound effects, ADPCM is the best option for compression.

Adaptive Differential Pulse Code Modulation (ADPCM) is a lower level of compression and sounds much closer to the source audio than an MP3. As you can see from the screenshot in Figure 7.2, a one-second sound file that was 44k in size becomes just 11k using a sample rate of 22kHz and a bit depth of 4. Not only is this very small, but it will also cause far less overhead in the Flash Player.

Techie Note. Obsessing Over Sound Quality

I tend to like to tweak the sound properties throughout the course of a project. Sometimes a compressed sound will be noticeably garbled or distorted when played by itself but in the context of all the other sounds it works fine. The opposite is also sometimes true. I've often found that for short sound effects that exist within a specific frequency range (beeps, clicks, etc.), you can even get away with lowering the bit depth to 3 without a noticeable difference and eke out a few extra kilobytes. Your mileage may vary.

There is one other setting that is useful specifically for voiceover sounds: *speech*. It has no options to set other than a sample rate (22 kHz is usually fine), and is a special variant of MP3 compression designed by Adobe to work best with a human voice. It also exports relatively quickly and doesn't seem to carry quite the overhead of a regular MP3.

If you only have a few sounds in your game, or you know most of your sounds are of the same type and will use the same form of compression, you can leave the individual sound properties set to Default and change them globally in the Publish Settings window. You'll be most interested in the Audio Event settings; Audio Stream isn't commonly used within games (more on this later).

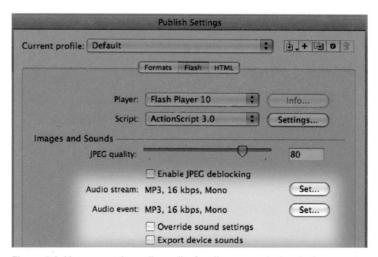

Figure 7.3 You can set the audio quality for all your sounds that don't use custom settings within the Publish Settings window.

Using External Files

Flash isn't limited to playing sounds that are embedded within the FLA. External MP3 files can be loaded in and played at runtime. While this feature doesn't really make sense for individual sound effects, music or other long sounds can work very well this way. The SWF isn't loaded down with the extra file size of the audio and can stream it in over time once the rest of the game is loaded. Because you don't have to worry about how it impacts your initial load, it also makes increasing the quality (and therefore the file size) of the sound less of a concern. Below is a simple bit of ActionScript that loads in an external sound:

```
var sound:Sound = new Sound(new URLRequest("mySound.mp3"));
sound.play();
```

The one main drawback to this method is that it exposes your MP3 file to anyone with an activity viewer in their browser. While you can copyright any assets of your game to prevent others from using them commercially, it does not prevent someone from stealing the individual files.

Tools for Working with Sounds

Probably the best choice for working with sound in Flash is Adobe's SoundBooth. It is cross-platform and, as of CS4, it supports multiple tracks for doing more complex mixing. It is reasonably priced and integrates nicely with Flash. Sony's SoundForge is another excellent application, but it is pricier and Windows only. If you are budget strapped (or on a Mac), HairerSoft's Amadeus Pro and Freeverse's Sound Studio are great options. Audacity is a free, cross-platform, open-source editor with a number of options, but if you need to do any level of sound manipulation greater than cropping and normalizing, it's really worth the money to spring for a higher end program. Links to the apps just mentioned are available on this book's website, flashgamebook.com.

Scripting Sounds

Sounds are handled differently from all other media in Flash because they have no visual representation. There are two ways you can add sound to your game: through script and by placing sounds directly on the timeline. This is the case with most elements in Flash, except that when you add a Button to the Stage, for example, you can also access it via script. The same is not true of sounds. A sound on the timeline is not accessible from ActionScript and therefore cannot be controlled. This forces developers to carefully choose how they are going to handle sounds.

At first, the obvious choice would be to always play sounds through script, as it provides the most flexibility and control, and for games this is almost always the case. The exception comes, however, when working with some animation. If a game has any segments that consist of long sequences of animation, like cutscenes, it makes more sense to play any accompanying sound effects on the timeline. This helps during sequencing to line up music or sound effects with the animation and it's also just plain easier.

Figure 7.4 When creating long sequences of animation, it makes sense to use sound effects played via the timeline.

The reason it's all right to use timeline sound effects this way is because sequences like this are linear and not interactive. The sounds are not likely to get stuck in a loop or linger around in memory because they weren't disposed of properly.

The rest of the time, scripting is the best way to control sounds. Because sounds don't need to adhere to the hierarchical structure of display objects, the best strategy is to create a generic sound controller that can play any type of sound and control its basic properties from anywhere in the game. To create this sound controller, we'll dive into some ActionScript.

Understanding the Sound Classes

Scripting sounds has gotten slightly more complicated in AS3 than it was in AS2. As with many aspects of AS3, the increased complexity is matched by increased flexibility, but it can initially be confusing. Objects of the *Sound* class are really just containers for the actual sound data. When played, they generate a *SoundChannel* object and any subsequent commands should be issued to this channel. As a result, you have to keep track of multiple objects to have any level of control over a sound you trigger.

Another way in which sounds are handled differently is that adjustable properties of sounds (such as volume and panning) are no longer individually assignable components. They are handled through a new class known as the *SoundTransform*. To set the volume and pan of a sound, you change its channel's SoundTransform object. The following code starts a sound playing and then creates a transform at 100% volume (1) and centered pan (0):

```
var soundChannel:SoundChannel = mySound.play();
soundChannel.soundTransform = new SoundTransform(1, 0);
```

The SoundEngine Class

We'll create a class called SoundEngine that will manage playing all the sounds we might need in a game and take care of storing all the pertinent objects. It will also provide us with easy methods to call for setting volume and pan without having to create new transforms manually. One other great feature it will afford us is the ability to call either internal sounds (found in the library) or external sound files. It will follow what is known as a Singleton design pattern, which you will learn more about in Chapter 10. Suffice it to say that there will only be one instance of the SoundEngine and it will be accessible from anywhere. This will make playing sounds as simple as a line or two of code.

There are two class files we'll need to establish to create this engine. The first is the engine itself, SoundEngine.as. Within this file will be the publicly exposed SoundEngine class, as well as an internal "helper" class called SoundEngineObject. This object will store information about each individual sound as it is created to keep track of them. Because there is no reason to expose this object outside the engine, we include it in the same file as the engine and Flash will automatically assume it is an internal class. We'll cover more about this class in a moment. The other file is a special type of event, SoundEngineEvent.as. This is the type of object the SoundEngine will dispatch when certain events occur within the engine, such as a sound reaching its end or an error in playing or loading a sound.

Here's a quick rundown of the functionality this class will contain:

- · Start sounds, both internal and external.
- Stop sounds.
- Pause/resume sounds.
- Mute/unmute sounds.
- Set and retrieve the volume of sounds.
- Set and retrieve the pan of sounds.
- Set and retrieve the entire active SoundTransform of sounds.
- Retrieve the SoundChannel object that an active sound is using.
- Add listeners that will be notified of events within the SoundEngine.
- Retrieve the current status of a sound, such as whether or not it is playing, paused, or muted.

All of this information can currently be retrieved from sounds, albeit with several lines of code. Our goal is to simplify this process and not have to rewrite this code every time we want to play a sound.

We'll begin in the SoundEngine.as file and set up the class definitions we'll be using:

```
package {
import flash.events.EventDispatcher;
import flash.events.IOErrorEvent;
import flash.media.SoundChannel;
import flash.media.SoundTransform;
import flash.media.Sound;
import flash.net.URLRequest;
import flash.utils.getDefinitionByName;
public class SoundEngine extends EventDispatcher {
}
import flash.events.Event;
import flash.events.EventDispatcher;
import flash.media.Sound;
import flash.media.SoundChannel;
import flash.media.SoundTransform;
internal class SoundEngineObject extends EventDispatcher {
}
```

Now the two classes we'll be using in this file have been defined in their most basic format. We'll need access to parts of the events package to be able to dispatch events, as well as the media package, where all the sound-related classes are stored. Finally, we'll need the URLRequest class to load external files and the getDefinitionByName method to look up sounds in the library. Note that we have to do all new imports for any classes we want to use internally, even if we already imported them in the package above.

Inside the SoundEngine class, we'll add some basic properties and the constructor for the class:

```
protected var _soundList:Object;
protected var _allMuted:Boolean = false;
static private var _instance:SoundEngine;
public function SoundEngine(validator:SoundEngineSingleton) {
  if (_instance) throw new Error("SoundEngine is a Singleton
  class. Use getInstance() to retrieve the existing instance.");
  _soundList = new Object();
}
static public function getInstance():SoundEngine {
  if (!_instance) _instance = new SoundEngine(new
  SoundEngineSingleton());
  return _instance;
}
```

The top three lines are variable declarations for the properties we are going store in the engine. The _soundList property will be used to keep track of all the SoundEngineObjects the engine creates. The _allMuted property will help us determine if the engine is currently muted so any new sounds played will be muted as well. Finally, the _instance property is static, meaning there is

only ever one instance of it created. It will be used to store the one SoundEngine object that gets created so we can always access it.

The constructor of a Singleton should technically be private so nothing outside the class can instantiate it; however, ActionScript does not support private constructors, so we have to use a workaround, which I will discuss momentarily. First, let's look at the getInstance method. It is static, so it will be accessible from anywhere as SoundEngine.getInstance(). If an instance of the engine has not yet been created, it stores a new one in the _instance property I mentioned earlier. It then simply returns the instance it has created. You probably noticed that both methods make use of a class called SoundEngineSingleton. This is an empty class that we will define internally to prevent any other class outside of the engine from creating a new one. Without access to this internal class, only the SoundEngine is capable of creating itself. We will accomplish this with one additional line at the bottom of the file:

```
internal class SoundEngineSingleton {}
```

That's it. Now anyone who uses the class has only one way of getting to the SoundEngine and is prevented from accidentally breaking some of its functionality or creating more than one engine. Think of it as the key to the engine; without it, the engine won't start.

Now that we've defined the basic properties of the engine and established a way to create and access it, we should jump down to the SoundEngineObject class to define exactly what each object will do when created:

```
public var name:String;
public var sound:Sound;
public var channel:SoundChannel;
protected var _transform:SoundTransform;
protected var _playing:Boolean = false;
protected var _muted:Boolean = false;
protected var _paused:Boolean = false;
protected var _pauseTime:Number;
protected var _loops:int;
protected var _offset:Number;
public function SoundEngineObject(name:String, sound:Sound) {
   this.name = name;
   this.sound = sound;
}
```

Each engine object stores the basic information about the sound it creates, such as the channel, transform, number of times it should loop, etc. Additionally, each object has a name property, which is how the engine will keep track of, or index, them. Now, we'll add some methods to the object so it can perform actions and give information:

```
public function play(offset:Number = 0, loops:int = 0,
transform:SoundTransform = null):SoundChannel {
```

```
offset = offset;
 if (channel) channel.removeEventListener(Event.SOUND_COMPLETE,
complete):
 channel = sound.play(_offset, 0, transform);
 channel.addEventListener(Event.SOUND_COMPLETE, complete, false, 0,
 transform = channel.soundTransform;
 loops = loops;
 _{playing} = true;
 return channel:
public function stop():void {
 channel.stop();
 _playing = false;
 dispatchEvent(new SoundEngineEvent(SoundEngineEvent.SOUND_STOPPED,
name)):
protected function complete(e:Event):void {
 if (_loops != 0) {
 play(_offset, _loops-, _transform);
 } else {
   _playing = false;
 dispatchEvent(new SoundEngineEvent(SoundEngineEvent.SOUND_
COMPLETE, name));
public function get playing():Boolean {
 return _playing;
```

The play and stop methods start and stop the sound object, respectively, and store information about how the sound is to be played. They also set up a listener for the SOUND_COMPLETE event, which is dispatched when the sound finishes. You'll probably notice I used a lot of the same syntax that Sound and SoundChannel objects use to stay consistent with ActionScript's conventions. I also don't tell the sound to loop at all but rather manually loop the sound each time it finishes. By keeping track of the number of loops this way, the sound can be paused and resumed and still know how many more times it must be played. Without this information, the sound might never reach its end. Also, if the same sound is called multiple times before it is able to finish, as might well be the case in a game where a player fires some type of projectile, any currently playing channel should be allowed to finish and then remove itself. Also, we allow the option for sound to loop endlessly by passing in a negative number (preferably -1). There is also one public "getter" that will return whether or not the sound is currently playing; this functionality does not exist in the basic Sound classes in ActionScript and is very helpful information to have in a game. If background music is already playing, for example, you don't want to accidentally start it a second time.

```
public function get volume():Number {
 return channel.soundTransform.volume:
public function set volume(value:Number):void {
 var tf:SoundTransform = _transform;
 tf.volume = value:
 _{transform} = tf:
 if (!_muted) channel.soundTransform = _transform;
public function get pan():Number {
 return channel.soundTransform.pan;
public function set pan(value:Number):void {
 var tf:SoundTransform = transform:
 tf.pan = value;
 transform = tf;
 if (!_muted) channel.soundTransform = _transform;
public function get transform():SoundTransform {
 return new SoundTransform(transform.volume, transform.pan);
public function set transform(tr:SoundTransform):void {
 transform = tr:
 if (!_muted) channel.soundTransform = _transform;
```

These six methods allow us to set the individual properties controlling volume and pan of the sound, as well as the raw transform object. Note that, if sounds are muted, the transforms are stored but not applied; when they are unmuted, they will reference this stored transform.

```
public function mute():void {
 if ( muted) {
   channel.soundTransform = transform;
   channel.soundTransform = new SoundTransform(0, 0):
 _muted = !_muted;
public function get muted():Boolean {
 return _muted;
}
public function pause():void {
 if (_paused) {
   var normalOffset:Number = _offset;
   play(_pauseTime, _loops, _transform);
   _offset = normalOffset;
 } else {
   _pauseTime = channel.position;
   channel.stop();
 _paused = !_paused;
```

```
public function get paused():Boolean {
  return _paused;
}
```

The final methods in the class control pausing and muting of the sound, as well as information about each. In the *pause* method, we store where the sound is when it is paused and stop it, using this information as the offset when we resume. In the *mute* method, we simply toggle between a zeroed-out SoundTransform object and the one stored in our _transform property.

Now that we have an understanding of how each object will work in the engine, we can return to the main class and see how each is accessed. Back in the SoundEngine class:

```
public function playSound(name:String, offset:Number = 0, loops:
int = 0. transform:SoundTransform = null):SoundChannel {
 if (! soundList[name]) { //SOUND DOES NOT EXIST
   var sound: Sound:
   var soundClass:Class:
   try {
     soundClass = getDefinitionByName(name) as Class;
   } catch (err:ReferenceError) {
     trace("SoundEngine Message: Could not find sound object
with name " + name + ". Attempting to load external file.");
   if (soundClass) { //INTERNAL REFERENCE FOUND-CREATING SOUND
OBJECT
    sound = new soundClass() as Sound;
   } else { //NO INTERNAL REFERENCE FOUND-WILL ATTEMPT TO
LOAD
     sound = new Sound(new URLRequest(name));
     sound.addEventListener(IOErrorEvent.IO_ERROR, ioError,
false, 0, true);
   soundList[name] = new SoundEngineObject(name, sound);
  _soundList[name].addEventListener(SoundEngineEvent.SOUND_
COMPLETE, soundEvent, false, 0, true);
  soundList[name].addEventListener(SoundEngineEvent.SOUND
STOPPED, soundEvent, false, 0, true);
 var channel:SoundChannel = _soundList[name].play(offset,
loops, transform);
  if ( allMuted) mute(name);
  return channel:
protected function ioError(e:IOErrorEvent):void {
  trace("SoundEngine Error Message: Failed to load sound:
  " + e.text);
  delete _soundList[e.target.url];
  dispatchEvent(new SoundEngineEvent(SoundEngineEvent.SOUND_ERROR,
e.target.url));
protected function soundEvent(e:SoundEngineEvent):void {
  dispatchEvent(e):
```

```
public function stopSound(name:String = null):void {
  if (name) {
    if (_soundList[name]) {
      _soundList[name].stop();
  } else {
      throw new Error("Sound " + name + " does not exist. You
must play a sound before you can stop it.");
  }
} else {
  for (var i:String in _soundList) {
    _soundList[i].stop();
  }
}
```

The playSound method is the largest and most important in the entire class. It checks to see if the sound requested has ever been played (created) before. If it hasn't, the getDefinitionBy-Name method is used to look up the sound by name in the library. If the sound cannot be found, the assumption is made that an external file was requested, and the sound uses the name as the URL to load the sound. Once the sound engine object has been created, listeners are attached to it to be notified when the sound completes or is stopped. An additional listener is also added if the sound is in an external file and loading it fails. The two additional protected methods, io Error and sound Event, are for dispatching events to anything listening to the engine. The *stopSound* method does what you would expect; it stops the sound passed in for the name parameter. However, we've added an extra feature—if no sound name is passed in, the engine will stop all the sounds. There are any number of times during a game when you might need to kill every sound that's playing, and this prevents you from having to name them individually.

Next we move on to the volume, pan, and transform methods:

```
public function setVolume(value:Number, name:String = null):
void {
  if (name) {
    if (_soundList[name]) {
        _soundList[name].volume = Math.max(0, Math.min(1, value));
    } else {
        throw new Error("Sound " + name + " does not exist.");
    }
} else {
    for (var i:String in _soundList) _soundList[i].
volume = Math.max(0, Math.min(1, value));
  }
}
public function getVolume(name:String):Number {
  if (_soundList[name]) {
    return _soundList[name].volume;
  } else {
```

```
throw new Error("Sound " + name + " does not exist.");
 return null;
}
public function setPan(value:Number, name:String = null):void {
 if (name) {
   if (_soundList[name]) {
    _soundList[name].pan = value;
   } else {
    throw new Error("Sound " + name + " does not exist.");
 } else {
   for (var i:String in _soundList) _soundList[i].
pan = value:
 }
public function getPan(name:String):Number {
 if (_soundList[name]) {
   return soundList[name].pan;
 } else {
   throw new Error("Sound " + name + " does not exist.");
 return null;
public function setTransform(transform:SoundTransform, name:
String = null):void {
 if (name) {
   if (_soundList[name]) {
     soundList[name].transform = transform;
   } else {
     throw new Error("Sound " + name + " does not exist.");
   }
 } else {
   for (var i:String in _soundList) _soundList[i].
transform = transform;
 }
public function getTransform(name:String):SoundTransform {
 if ( soundList[name]) {
  return _soundList[name].transform;
 } else {
   throw new Error("Sound " + name + " does not exist.");
 return null;
public function getChannel(name:String):SoundChannel {
 if (_soundList[name]) {
   return _soundList[name].channel;
   throw new Error("Sound " + name + " does not exist.");
  return null;
}
```

Note how each of the "setter" functions follows the form of the *stopSound* method; if no specific sound is passed in, the method runs on all of them. Also worth noting is that for all of these methods (except *isPlaying*) an error is thrown if the sound named doesn't exist:

```
public function mute(name:String = null):void {
  if (name) {
   if ( soundList[name]) {
     _soundList[name].mute():
     if (!_soundList[name].muted) _allMuted = false;
    } else {
     throw new Error("Sound " + name + " does not exist.");
  } else {
   for (var i:String in _soundList) _soundList[i].mute();
   _allMuted = ! allMuted:
}
public function pause(name:String = null):void {
  if (name) {
   if ( soundList[name]) {
     _soundList[name].pause():
   } else {
     throw new Error("Sound " + name + " does not exist.");
  } else {
   for (var i:String in _soundList) _soundList[i].pause();
public function isPlaying(name:String):Boolean {
 if (_soundList[name]) {
   return _soundList[name].playing;
 } else {
   trace("Sound", name, "does not exist."):
   return false;
public function isPaused(name:String):Boolean {
 if (_soundList[name]) {
   return _soundList[name].paused;
 } else throw new Error("Sound " + name + " does not exist."):
 return false:
public function isMuted(name:String = null):Boolean {
 if (name) {
   if (_soundList[name]) {
    return _soundList[name].muted;
   } else throw new Error("Sound " + name + " does not exist."):
   return false:
 } else {
   return _allMuted;
```

Following the same pattern, the *pause* and *mute* methods work the same way, with one minor exception. When *mute* is called on all the sounds, it is assumed that all sounds should stay muted until told otherwise. If any sounds attempt to play when _all-Muted is true, they are created and then immediately muted as well. The *isMuted* method reflects this as well.

You most likely noticed that the type of event dispatched by the SoundEngine was of the type SoundEngineEvent, referring to the file mentioned earlier. We'll now take a quick look at that custom event:

```
package {
import flash.events.Event;

public class SoundEngineEvent extends Event {
  static public const SOUND_COMPLETE:String = "soundComplete";
  static public const SOUND_STOPPED:String = "soundError";
  static public const SOUND_ERROR:String = "soundError";
  protected var _name:String;

  public function SoundEngineEvent( type:String, name:String,
  bubbles:Boolean = false, cancelable:Boolean = false ){
    _name = name;
    super(type, bubbles, cancelable);
  }
  override public function clone() : Event {
    return new SoundEngineEvent(type, name, bubbles, cancelable);
  }
  public function get name():String {
    return _name;
  }
}
```

The three constants defined at the top of the class are used to clearly define the types of events that the SoundEngine can dispatch. The SoundEngineEvent is just like a normal Event, except that it contains one extra piece of data: the name of the sound that generated the event. Without this, there would be no distinguishing one sound event from the next, especially when many were occurring at once.

Using the Class

Now that we have the class complete, we'll set up a test file to ensure that it is working. Create a new ActionScript 3 FLA. Import the test sound effect provided to the library. To set up the sound to be available to ActionScript, double-click it to pull up its properties panel. Under the Linkage area, select the checkbox Export for ActionScript. In the Class field, type "Explosion"; this is how you'll refer to this sound from this point on. Flash will automatically fill in the Base Class as an object of type Sound.

■ Export for ActionScript	
Export in frame 1	
Explosion	V 0
flash.media.Sound	

Figure 7.5 Use the Linkage proporties to set up a sound for export.

Save the FLA alongside the SoundEngine class file so Flash will know how to find it. Open the Actions panel and type the following in frame 1:

```
var se:SoundEngine = SoundEngine.getInstance();
se.playSound("Explosion");
```

When you test your SWF, you should hear the sound effect play. Note that we create a reference to the SoundEngine for convenience. If you were merely calling a single sound effect in a script and had no reason to store a reference, you could shorten the call this way:

```
SoundEngine.getInstance().playSound("Explosion");
```

Because this engine only exposes the existing functionality of the Sound classes in a simpler and more convenient way, there is plenty of other functionality that could be added in companion classes. For example, the ability to fade out sounds over time or being able to crossfade sounds to create musical transitions are both features that don't make sense in a basic sound engine but are very useful in games.

The SoundMixer Class

One other class worth mentioning in the audio section of Flash is the SoundMixer. It is the global sound controller for the Flash Player and has its own SoundTransform. If you need to do something basic like simply mute all the sounds in your game outside of the SoundEngine, you can accomplish it with a very simple script:

```
SoundMixer.soundTransform = new SoundTransform(0):
```

You can also use the SoundMixer to stop every sound that is playing inside of Flash, the descendant of *stopAllSounds()* from all the way back in Flash 3. While I recommend using a class like the SoundEngine to manage playback and control of your sounds, SoundMixer is a nice fallback if you are loading in content created by someone else and you need to control any rogue sounds.

Techie Note. Flash Hack: The Sound of Silence

At a conference I once heard a Flash cartoonist reveal a secret for how he made sure Flash could keep up with the set frame rate and slow down on older machines. While it applied to Flash 5, I've found it can still help in a pinch today. Basically, he would put a clip on the main timeline that had a one-second sound with total silence in it, set it to stream, and loop it 9 or 10 times. The way Flash is designed to work is that it will skip rendering frames to stay in synch with streaming sounds on the timeline. It will however, continue to process frame scripts, meaning any scripts that are reliant on the frame rate will still run. In essence, it may make gameplay choppier on slow computers, but it will play at the correct speed. The reason he looped it a number of times is that each time a streaming sound restarts the Flash Player will stutter momentarily if the processor is maxed out. The clip will play straight through and only have to restart the stream every 10 seconds or so. At this rate it is barely noticeable and makes a huge impact on the playability of complex games. Since the sound is made up of silence, you can use the highest compression settings possible that would turn any other sounds to utter garbage and it won't make a difference. It won't add more than a few kilobytes to your end file and is worth the peace of mind that the game will at least keep up on older machines.

The bottom line to remember with sounds is to not forget them. There is almost no game experience that cannot be enhanced by a well-implemented soundtrack. Make audio a priority and your game will be stronger as a result.

PUT THE VIDEO BACK IN "VIDEO GAME"

Video is probably used more than you might initially think in Flash games. It is a great format for non-interactive cutscenes because the performance is consistently satisfactory (Adobe has put a great deal of effort into making sure video plays smoothly in Flash), and it can be created and stored completely externally to a game. In this section, we'll see how it is also an excellent container for character animations, particle effects, and other small in-game animations. We'll also explore the Adobe Media Encoder that comes with Flash CS4 and the different settings to use for each type of video.

Video Codecs

Flash can handle a few different formats of video, all of which cater to different uses. The first, and oldest, is Sorenson Spark. While it is tends to show the most compression artifacts on higher resolution video, its processor requirements are modest and it requires the least horsepower of any of Flash's codecs. It works well for a game that needs to support older machines and where the video isn't going to get very large. In Flash 8, Flash introduced the On2 VP6 codec. The compression quality and file size is much improved over Spark, albeit at a higher cost of CPU overhead. The best feature about VP6 is that it can be encoded with an alpha channel so parts of the video can be transparent. Though for larger video an alpha channel can begin to drag down performance, at smaller dimensions it is a lifesaver for both performance and file size (which we will discuss momentarily). The final, and most recent, addition to Flash CS4 is the inclusion of H.264 (or MPEG-4-based) video. It is by far the best-looking video

available in Flash and rivals the quality of either QuickTime or Windows Media Player. The two drawbacks are that it is very processor intensive and it does not support an alpha channel, so you can think of it as more of an upgrade to Spark than a replacement for VP6. I would recommend it for cutscenes in games where the target machine is relatively new; the quality cannot be beat.

External Video Uses: Cutscenes and Menus

With console and commercial computer games reaching awe-inspiring levels of graphical sophistication, the bar is naturally raised on even simple web-based games to look polished and "modern." One way to achieve this feel is through the use of cutscenes in games that are story driven. When used wisely (and not overused), such as between levels or as a payoff at the end, they add a very cinematic quality to a game.

Figure 8.1 Video cutscenes can add a very immersive element to a game and can make Flash games look more on par with commercial games.

Another way of effectively incorporating video is in menus. Most players of Flash games are used to just static buttons and text on a menu screen. By utilizing even a simple video loop created in Adobe After Effects (or even created in Flash and then exported as a movie), a menu can feel much more dynamic and hold a player's visual interest enough to get them into the game. Because these two uses of video are passive, or non-interactive, it makes the most sense to load the video files in externally rather than embedding them in the game SWF. We'll now discuss how to encode the video and after that how we load in that video and play it as a cutscene using ActionScript.

Encoding a Cutscene

Adobe has replaced the Flash Video Encoder that came with previous versions of Flash with the far more robust and completely redesigned Media Encoder. It takes any video, audio, or image sources and converts them into one of the basic Flash-compatible video formats. It can be intimidating to use at first, as there are many options to consider. Luckily, most of the presets will work well for our needs, some with only minor modifications. We'll now walk through the process of encoding a couple of videos using different settings, based on how we would use the video in a game.

To walk through this example, you'll need the video support files for this chapter from this book's website, flashgame-book.com. Since it comes with Flash CS4, I'll assume you have the Media Encoder. Launch the program and drag the video file named *Cutscene.mov* into the program. This will add it to the list of media to be encoded.

Figure 8.2 The Adobe Media Encoder offers a wide range of presets so you don't have to tweak every setting by hand, unless you want to.

Once you have added your video, you'll see that there are a few columns of settings. Second from the left is the Format column. If it is not already set to FLV/F4V, toggle it to that setting now. To the right of the format is the Preset column. If you were using a standard preset for the video, you could select it from a list. In our case,

we want to select the very first option in the preset list, "F4V Same as Source." This setting will produce an H.264 Flash video file with the same dimensions and audio settings as the original file (in this case, 710×386 , $30\,\mathrm{fps}$). Because this cutscene would be used in a web game, we don't need that level of quality. Click just to the right of the drop-down arrow to customize the settings.

Figure 8.3 You can customize the presets for the video to suit your needs.

In the lower right quadrant of the window you will see a fivetabbed panel for adjusting the settings of the encoder. Select the Video tab and check Resize Video. A good rule of thumb for cutscenes (and video in general) in Flash is that you can very often get away with encoding it between one-half and two-thirds the size of the original and scale the video in Flash without drastic quality loss. Your tolerance of the compression may vary, but in this case we're going to set the dimensions to 470×255 . Scroll down in the video panel until you reach the Bitrate Settings. Select VBR, 2-Pass (meaning the encoder will double-check its work to deliver the highest possible quality) from the Bitrate Encoding drop-down. Set the Target Bitrate to .5 (or 500 kbps) and the Maximum Bitrate to .75 (or 750kbps). Because this clip has a lot of motion in certain parts, we want the encoder to be more generous with those frames but more conservative with others. Next select the Audio tab. From the Bitrate Settings drop-down, select 96 kbps. This will compress the audio cleanly and still provide ample quality for our needs. At this point, the encoder is estimating the file size at right about 1 MB, as you can see to the

left of the Cancel button. If you were encoding several videos, you could save these settings as a preset in the upper-right quadrant of the panel. For our purposes, just click OK and return to the main screen. With our video ready to encode, click Start Queue.

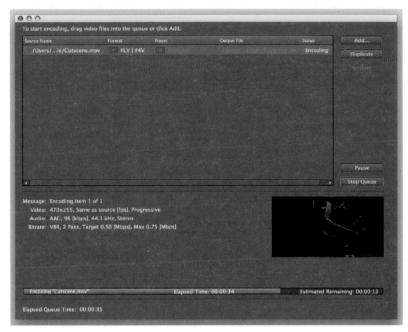

Figure 8.4 Once you've defined the settings for your video, click Start Queue to begin encoding.

What you should end up with, beside the original MOV file, is an approximately 1-MB F4V file. At roughly 15 seconds in length, this is probably still a little large for people on slower connections, so you'll want to take your audience into account when encoding. Now let's write some code to play what you've just encoded.

The CutsceneManager

I typically create a class to manage cutscenes that can sit on top of the gameplay and easily be called to play transition videos, so we'll set one up. There are a couple of reasons for using a custom class, first of which is the fact that just setting up and loading a video in Flash requires many lines of imports and code. Only having to type these lines once by containing them within a flexible wrapper is the essence of sound programming. Another reason to use a custom class is to be able to trigger custom notifications for events. Video playback in Flash generates a *lot* of events, some

purely informational and some error based, and having to filter through all the messages can be cumbersome when all you're trying to do is play a cutscene. Having the class listen for just the pertinent messages and distill them down into a couple of useful events simplifies the process even further.

This class isn't as involved as the SoundEngine we looked at earlier, and it is self-contained in one file.

```
package {
  import flash.display.Sprite;
  import flash.events.AsyncErrorEvent;
  import flash.events.Event;
  import flash.events.KeyboardEvent;
  import flash.events.NetStatusEvent;
  import flash.events.SecurityErrorEvent;
  import flash.media.Video;
  import flash.net.NetConnection;
  import flash.net.NetStream;
  import flash.ui.Keyboard;
  public class CutsceneManager extends Sprite{
  }
}
```

The CutsceneManager extends the Sprite class, so it can easily be added to the Stage like any other DisplayObject. Because it uses video, it needs not only the Video class but the NetConnection and NetStream classes, as well. Some examples I've seen import the entire events package (import flash.events.*), but for this example I've added each of the necessary events manually. Finally, we'll include the KeyboardEvent and Keyboard classes so we can bind a key to skip the video—a handy feature that prevents players from having to potentially sit through a video over and over again.

```
public var skipKey:uint = Keyboard.SPACE;
protected var _nc:NetConnection;
protected var _stream:NetStream;
protected var _video:Video;
protected var activeVideo:String;
```

We only need to keep track of a few variables for this class. The skipKey property is exposed publicly so you can set it to whatever keystroke you'd like; it defaults to the spacebar. The protected properties are all related to keeping track of the video.

```
public function CutsceneManager(width:int, height:int): void {
   setupConnection();
   _video = new Video (width, height);
   addChild(_video);
}

protected function setupConnection() :void {
   _nc = new NetConnection();
   _nc.addEventListener(NetStatusEvent.NET_STATUS, netStatus,
   false, 0, true);
```

```
_nc.addEventListener(SecurityErrorEvent.SECURITY_ERROR,
    securityError, false, 0, true);
    _nc.connect(null);
}
```

The constructor function creates a new CutsceneManager and sets up both the NetConnection and Video objects and prepares them for use. The NetConnection instance sets up a couple of listeners as well, which we'll look at next.

```
protected function netStatus(e:NetStatusEvent) {
    switch (e.info.code) {
        case "NetStream.Play.StreamNotFound":
            trace("Unable to locate video: " + _activeVideo);
            break;
        case "NetStream.Play.Start":
            dispatchEvent(new Event(Event.INIT));
            break;
        case "NetStream.Play.Stop":
            stopCutscene(Event.COMPLETE);
            break;
        }
}

protected function securityError(e:SecurityErrorEvent):void {
        trace(e);
}

protected function asyncError(e:AsyncErrorEvent):void {
        //IGNORE ASYNCHRONOUS ERRORS
}
```

NetStatusEvent messages are used for both NetConnection and NetStream objects. Any time anything happens to the connection or video stream, messages are broadcast and captured by one event. Using a switch statement we filter through them for the messages important to us. In this case, we want to know if the video fails to load, when the video actually starts playing, and when it finishes. There are two other events we need to set up listeners for, which are error based. It's not that we should be overly concerned with these errors, but without a listener attached to them they will throw real runtime errors that can break other parts of your code. Now that we've covered all the "under-the-hood" code, we'll take a look at the main methods used to control the manager:

```
public function playCutscene(url:String) : void {
   _activeVideo = url;
   _stream = new NetStream(_nc);
   _stream.addEventListener(NetStatusEvent.NET_STATUS,
   netStatus, false, 0, true);
   _stream.addEventListener(AsyncErrorEvent.ASYNC_ERROR,
   asyncError, false, 0, true);
   _video.attachNetStream(_stream);
   _stream.play(url);
```

```
if (stage) stage.addEventListener(KeyboardEvent.KEY_DOWN,
    skipCutscene, false, 0, true);
}

public function stopCutscene(eventType:String = Event.CANCEL)
: void {
    _stream.close();
    _video.clear();
    dispatchEvent(new Event(eventType));
    if (stage) stage.removeEventListener(KeyboardEvent.KEY_
    DOWN, skipCutscene);
}

public function get activeVideo():String {
    return _activeVideo;
}

protected function skipCutscene(e:KeyboardEvent) {
    if (e.keyCode == skipKey) stopCutscene();
}
```

The *playCutscene* method is the heart of this class. It accepts a URL string, sets up the stream, and links it to the video. It also adds a listener for keystrokes so you can define a key that will skip the cutscene. You probably noticed back in the *netStatus* method that upon the video finishing it calls *stopCutscene* and passes a parameter of Event.COMPLETE. By default, the *stopCutscene* method will assume that the video was terminated prematurely when it is called. This way you will be able to differentiate from outside of the class whether the video was able to finish playing or if it was skipped. In addition to dispatching a message about the status of the video, the *stopCutscene* method performs two other important functions. One is to the close out the NetStream object (whether or not video is still coming from it) and the other is to clear the video. Without the latter, the last frame of the video would stay in the Video object, covering up everything behind it.

Using the CutsceneManager

At this point we've written less than 100 lines of code, and it will allow us to easily call in a video for use as a cutscene in less than five lines. Open up a new FLA file in Flash and save it next to the CutsceneManager class. Set the dimensions of the FLA to 710×386 , the original size of the video we're going to load. If you followed the Adobe Media Encoder example earlier in this chapter, copy the Cutscene.f4v file you created next to the FLA. If not, you can find this same file in the support files for this chapter. Then, on the first frame of the FLA, add these lines:

```
var cm:CutsceneManager = new CutsceneManager(stage.
stageWidth, stage.stageHeight);
addChild(cm);
cm.playCutscene("Cutscene.f4v");
```

You should see the video start to play, filling up the whole Stage. Since we haven't specified another key, press the spacebar before the video finishes and you will see it go away quickly and cleanly. If we wanted to get information about when the video finishes playing, all we need is a few more lines:

```
cm.addEventListener(Event.COMPLETE, cutsceneFinished, false,
0, true);
function cutsceneFinished(e:Event) {
  trace(e);
}
```

That's it. This class will work with any format of Flash-compatible video and should save a lot of time when you're in a crunch. This class could also be modified pretty easily to work with a menu background loop, as well. Instead of clearing itself when the video reached the end, it would simply need to loop back to the beginning. You would also probably want to remove the skip functionality.

Video on the Timeline

Though an externally loaded file works great for non-interactive video, it's not the best option for video that is used in gameplay or when you need clips with alpha transparency. Image sequences like short character animations, particle effects, etc., tend to require a transparent background to integrate seamlessly with the background. Conventional thinking in Flash would dic tate using a series of portable network graphic (PNG) images that simply played back in order. Much of the time, however, the best option is actually to import the sequence as a video file directly into your library and use it on the timeline like a MovieClip. If all you have are image sequences to work with (not all animation programs produce video formats directly compatible with Flash), fear not! In an upcoming section on using the Adobe Media Encoder I'll show you how to use Flash as a video editing tool. There are a few reasons to consider using video instead of a sequence of PNG files.

File Size

Most of the time, a Flash video file (FLV) encoded with an alpha channel is going to be smaller than the equivalent PNG sequence, even with relatively high JPEG compression turned on in Flash. This is because the On2 VP6 codec is designed for handling motion and applies its compression more efficiently than JPEG. When an encoder compresses a video, it make decisions about what data will change from one frame to the next, stripping out anything

it doesn't need to duplicate. Single images only have their image data to work with and cannot benefit from the other images in a sequence. Video can also be encoded in what is known as variable bit rate (VBR). Instead of using the same compression across the board for every frame, the encoder determines which frames can benefit from extra compression and which ones need to stay higher quality. For example, if several frames of a video are all one color or have very little detail, the encoder will compress them heavily, whereas frames with a lot of motion and color data will receive lighter compression. While you could manually apply the same principle to all the images in a sequence, it would be much more time consuming and certainly tedious.

Ease of Use and Library Clutter

Say you have 10 different one-second character animations for a player in a game. At 30 frames per second, this would equal 300 images. Using a video in place of each of these sequences would result in only 10 library items—much more manageable and easy to update if changes are made. Simply replace one video instead of 30 images. This efficiency also translates to timeline management. Because a video is already treated as a single DisplayObject, sort of like a MovieClip of images, it's much easier to rearrange them on Stage and in the timeline without having to select multiple frames at once.

Performance

Even with the extra performance overhead an alpha-channel video clip brings, it is still more efficient than a series of images, particularly as the dimensions of the clip increase. This is because Adobe has put a lot of effort into making the video playback engine perform well even on modest machines. Also, in the context of Flash's timeline model, a PNG sequence requires the renderer to add and remove images on every frame, which is a more intensive task.

Free Motion Blur

The compression used on video tends to have a slight softening effect, depending on what settings were used in the encoder, and that effect can actually be helpful in creating a sense of motion blur on videos with a lot of movement. Since Flash cannot natively do directional motion blur, this effect would be much harder to produce with a series of images. Obviously, if the encoder is smudging the video *too much* you might want to change the compression settings.

Techie Note. When PNGs Still Win

Say you had an animation sequence of a character crouching. To be as efficient as possible, you would probably use the same animation for the character entering the crouch as coming out of it, just reversing the latter. This is possible with a sequence of images that you have complete control over but not so with video. You would have to create the second animation separately and at that point you will have lost any file size savings from using video in the first place. How you intend to use animation sequences in your game should dictate which format you use.

Setting Up an Internal Video

Let's walk through a practical example of setting up a timelinebased video and test the file size improvement. The support files for this exercise are can be found on this book's website, flashgamebook.com. In this example, I have a 15-frame running sequence for a character that will need to loop. It currently exists as an image sequence of PNG files. Open a new Flash authoring file (FLA) and save it as ImageSequence.fla. Set the Stage size to 200×200 . Import the first image from the sequence into Flash. It will prompt you if you would like to import the whole series; click Yes. You should now have the image sequence on the Stage. Test the SWF and you will see a running cycle animation that loops. It should be roughly 66 kb. You may be thinking "66k is nothing in this broadband age! How much could I possibly gain by using a video instead?" You'd probably be surprised just how much. This is just one video that is less than one second long. The game that employed this particular character had this same animation, as well as about nine others, from three other angles (left, right, and back) in order to make it feel like the character was moving in a three-dimensional space. That is over 2.5 MB for all those animations, and that's just for one character.

To turn this sequence into a video, select Export \rightarrow Export Movie from the File menu in Flash. Give the movie the name *ImageSequence* and select QuickTime from the Format dropdown. You will be presented with a QuickTime Export Settings window. Check the box to ignore stage color and generate an alpha channel. Tell it to store the temp data on disk, as it is more reliable for most image sequences. Click the QuickTime Settings button to bring up one more dialogue. The default settings should be correct, but just make sure the video is set to export at 200×200 , $24\,\mathrm{fps}$, using the Animation compressor and Millions of Colors+ . All this means is that it will create a movie file with an alpha channel that we can then encode as Flash video. Click OK and then click Export. Flash will let you know when it is finished, which should only be a matter of seconds.

Render width:	200 pixel
Render height:	200 pixels
	☑ Ignore stage color (generate alpha channel)
Stop exporting:	When last frame is reached
	After time elapsed: (hh:mm:ss.msec)
Store temp data:	O In memory (recommended for higher frame rates)
	On disk (recommended for longer movies)
	Select Folder /Users/chris/Library/Aph CS4/en/Configuration
QuickTime Settings	S Cancel Export

Figure 8.5 The Quicktime Export settings give you a number of options for exporting a Flash timeline animation to an MOV file.

At this point you should have a new MOV file ready to encode. Launch Adobe Media Encoder and drag the ImageSequence movie onto it. Select FLV/F4V as the format and select FLV – Same as Source (Flash 8) from the preset options. Then open up the settings to customize the preset. Under the Video tab, select

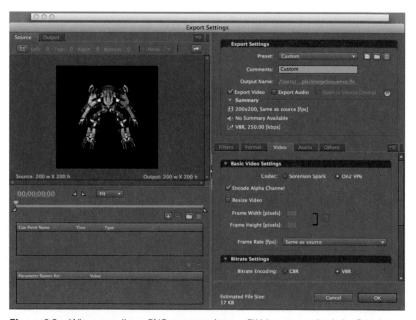

Figure 8.6 When encoding a PNG sequence into an FLV, be sure to check the Encode Alpha Channel box.

the Encode Alpha Channel box. Then scroll down to the Bitrate Settings and lower the bit rate to 250 kbps. This may seem small, especially after encoding an enormous cutscene file, but for small animations like this it is usually more than enough. This is the one option that I tend to change per project because I haven't found one setting that works across the board for every type of animation. At this point, the encoder should be estimating the FLV at 36 to 30 k less than the image sequence we created in Flash. Click OK and Start Queue to encode the video.

To do a true comparison of the two resulting SWF files, create a new FLA that is 200×200 . Save it as VideoSequence. Import the ImageSequence.flv file. It will bring up the Import Video window. Select the option to Embed FLV in SWF and click Continue twice. Click Finish on the summary screen, and the video will be added to your FLA on the Stage. If you test this SWF alongside the ImageSequence SWF, you'll notice that indeed the video version is $30\,\mathrm{k}$ smaller and looks almost identical. One could argue that

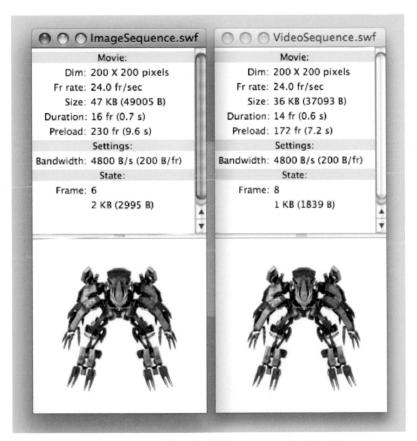

Figure 8.7 A side-by-side comparison of a PNG sequence and a video of the same sequence.

it is possible to lower the JPEG quality of the PNG sequence and that SWF will drop down to around 40 k. However, you still are left managing a bunch of images rather than just one video file, and now the image sequence will (usually) look worse than the video. Remember that, even though the savings in this example is small, most games will use far more assets than just a single character; always calculate the savings to the scale of your project to determine if using video is worth the extra few steps.

Summary

In this chapter we covered:

- The different formats of video that Flash will accept and when to use them
- How to use the Adobe Media Encoder to create both cutscene-style videos and alpha-channel clips
- How to create a CutsceneManager that handles loading external video files
- How to use video on the timeline in place of image sequences

XML AND DYNAMIC CONTENT

Many Flash games are self-contained SWF files. They don't load any additional files in and they don't send any type of data out; however, this closed architecture prohibits a number of scenarios, such as:

- Externalized content (such as puzzle data or even game copy)
- The ability to save to a public high-score table
- · Localization to other languages
- · Level editors and user-generated content

In this chapter, we'll explore how features like these can be implemented using a variety of features in ActionScript.

Bringing Data In: Understanding the URLLoader Class

The core component behind sending and loading basic text, XML, and binary data is the URLLoader class. It takes only a few lines of code to load some data and begin working with it. Consider this example:

```
var loader:URLLoader=new URLLoader(new URLRequest ("config.txt"));
loader.addEventListener(Event.COMPLETE, onTextLoad, false, 0, true);
function onTextLoad(e:Event) {
  trace("Text: " + e.target.data);
}
```

All this code does is load a text file and trace what is in it. In and of itself this is not especially useful until you consider what you could put inside the file. Maybe your game has a lot of text dialogue and you don't want it mixed in with your code, or it has a bunch of legal copy you don't want to mess with pasting inside a text field in Flash. Word-based, trivia, and many other puzzle games are also good candidates for loading in external content, allowing you to add new content without having to republish the game file. We'll look at an example of this type of game shortly.

XML

By default, a URLLoader simply loads in plain text, which is fine for most applications involving local files. By itself, however, text does not lend a great deal of flexibility. It needs to be organized into a format that has a structure. This is where XML comes in. If you're not already familiar with it, XML is, in brief, a markup language (similar in format to HTML) for organizing data into a structured format. Here is an example of some simple XML defining a quiz:

As you can see, XML is incredibly flexible, allowing you to define exactly how you want your data structured. XML structures can become extremely complex, particularly for large-scale applications, but this example also shows how simple it can be. In this case, we've defined that a quiz contains problems. Each problem has a question and three answers, the first of which is correct. By setting up your data with a logical hierarchy, we can access it easily from inside Flash.

E4X

If you worked with XML in ActionScript 1 or 2, you know how unwieldy it was to handle. Unless you used a very robust parser, most changes to the structure of the XML would break your code. A new feature in ActionScript 3 is the ability to parse through XML data just like any other object in Flash. This feature is known as E4X (ECMAScript for XML), and it makes XML a native data type in Flash, just like numbers or strings. Because of this, parsing XML is much faster and allows you to move through a structure like you would a set of objects and arrays. The following example uses a URLLoader to load the XML used in the previous example:

```
var quiz:XML;
var loader:URLLoader = new URLLoader(new URLRequest("quiz.xml"));
loader.addEventListener(Event.COMPLETE, onXMLLoad, false, 0, true);
function onXMLLoad(e:Event) {
  quiz = XML(e.target.data);
  trace(quiz.problem[0].question); // "What does this book cover?"
}
```

To use the data as XML once it is loaded, you simply use the XML conversion function and assign it to a variable. To learn

more about the more advanced features of E4X, such as filtering and searching, look to the Flash reference documentation on XML. For the purposes of this chapter, our use of XML will be more straightforward. Let's look at a practical example of how it can be used to store puzzle data for a game.

The Crossword Puzzle

One of the most popular types of word games in print or electronic media is the crossword puzzle. There are many variations of the crossword puzzle, but the traditional American square grid type is the style we will work with. It consists of overlapping horizontal and vertical words with unique numbers denoting the start of a word. Each word has a clue associated with it which can be another word or an entire phrase.

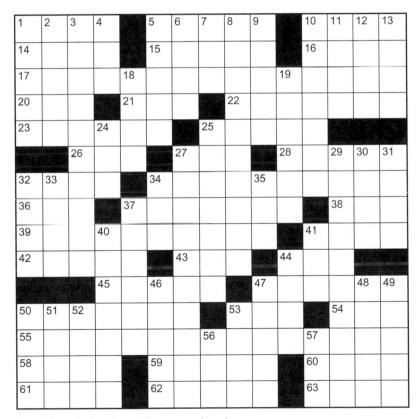

Figure 9.1 An American-style crossword puzzle.

In the following exercise, we will lay out the structure of a crossword puzzle in XML and then create a simple crossword engine that will display the puzzle and allow a player to fill it in.

Any XML to be used in Flash must have only one *root node*, which is the node that opens and closes the file. Any additional nodes will be ignored when the XML is parsed. We start with an opening node labeled "crossword," which will encase our entire puzzle. Inside an opening XML tag you can add parameters, called *attributes*, which allow you to add any pertinent information to the node. In this case, we define the width and height of the puzzle in question. Attribute values should be in quotes and do not need any type of separator between them:

```
<crossword width="13" height="13">
</crossword>
```

Now we can begin to break the crossword down into its core components: the grid layout (which we will call the "puzzle" in this case) and the clues. The grid squares either can have letters or can be blacked out so no letters can be entered. We'll break down the puzzle by rows and use a special character to denote the black spaces. For this example, we'll use the underscore ("_"). Each row will spell out one line of the puzzle in a single string:

As you can see, this structure is very readable and allows us to see basically what the puzzle will look like before it is even in a grid. It is important to remember that, while there are many standards in XML, there is no reason to overcomplicate the path to get to your data. Keeping it readable like this will also help us catch mistakes faster.

Next, we need to add the accompanying clues for this puzzle. We will do this by simply adding a clue node with two types of clues in it—down and across:

```
<clues>
  <across>Questions</across>
  <across>Harry Potter to Lily Evans</across>
  <across>Igloo, for example</across>
  <across>Emailed</across>
  <across>Lonely number</across>
  <across>Opposite of 60 Across</across></across></across></across></across></across></across></across></across></across></across></across></across></across></across></across></across></across></across></across></across></across></across></across></across></across></across></across></across></across></across></across></across></across></across></across></across></across></across></across></across></across></across></across></across></across></across></across></across></across></across></across></across></across></across></across></across></across></across></across></across></across></across></across></across></across></across></across></across></across></across></across></across></across></across></across></across></across></across></across></across></across></across></across></across></across></across></across></across></across></across></across></across></across></across></across></across></across></across></across></across></across></across></across></across></across></across></across></across></across></across></across></across></across></across></across></across></across></across></across></across></across></across></across></across></across></across></across></across></across></across></across></across></across></across></across></across></across></across></across></across></across></across></across></across></across></across></across></across></across></across></across></across></across></across></across></across></across></across></across></across></across></across></across></across></across></across></across></across></across></across></across></across></across></across></across></across></across></across></across></across></across></across></across></across></across></across></across></across></across></across></across></across></across></across></across></across></across></across></across></across></across></across></
```

```
<across>It grows on you</across>
<across>Cut grass</across>
<across>Fill a dog's dish</across>
<across>Look at intently</across>
<across>They have sleeves</across>
<across>Animal feet</across>
<across>With 41 Across, keen on</across>
<across>Fedora, e.g.</across>
<across>Spoke quietly</across>
<across>It's pumped in a gym</across>
<across>Social insect</across>
<across>"I __ ya!" (challenge)</across>
<across>Lounge in an airport</across>
<across>Lie in the sun</across>
<across>See 24 Across</across>
<across>Burn the surface of</across>
<across>Small trees</across>
<across>Come up</across>
<across>Take a trip around</across>
<across>Mighty tree</across>
<across>Uses a shovel</across>
<across>Famous singer Fitzgerald</across>
<across>Tell a tall tale</across>
<across>Rim</across>
<across>Open a banana</across>
<across>Opposite of 14 Across</across>
<across>Take five</across>
<down>Fire leftover</down>
<down>Oceans</down>
<down>Make a sweater, perhaps</down>
<down>Guitar holder</down>
<down>Sort of</down>
<down>Yoko __</down>
<down>Reporter's offering</down>
<down>Gave the meaning of a word</down>
<down>Above</down>
<down>Gct together</down>
<down>Finishes</down>
<down>Not cooked</down>
<down>___-Hop</down>
<down>Cavity in the head</down>
<down>With 50 Down, what one did for Easter, maybe</down>
<down>"___ we there yet?"</down>
<down>Apex</down>
<down>Made like a comet</down>
<down>Remy, the chef, is one</down>
<down>Period in history</down>
<down>Fox's home</down>
<down>Not synthetic</down>
<down>Steal</down>
<down>Hole in the head</down>
<down>Ghost _ (Johnny Blaze)</down>
<down>" on it!" (hurry up)</down>
<down>Golfer's target</down>
<down>Be king, say</down>
<down>Alone</down>
<down>Border</down>
```

```
<down>See 25 Down</down>
  <down>Band-__</down>
  <down>Sun__ (day's end)</down>
<clue>
```

Note that we are not interested in which clue is associated with which word in the puzzle, but rather put them in ascending order. This is because if we build our crossword engine correctly there will eventually be a one-to-one association between a word and its clue. Not hardcoding the number allows us to move clues around if a mistake was made or one was left out.

For this example, we'll break down the crossword engine into a few components. At its core, a crossword can be broken down into individual tiles, so we'll create a class to represent a tile. Together they make up the grid, or puzzle, so the main class driving the engine will be a puzzle class. At this point, one could argue the merits of creating a class to define a word, but in terms of practicality a word is nothing more than an array of tiles so for our purposes we'll keep it simple. Finally, we need a way to display the clue for a given word, so we'll make a class to handle that.

The CrosswordTile Class

The best way to solve a complex problem is to break it down into smaller, more manageable problems. Such is the case with the CrosswordTile class. This class will keep track of the correct letter for a given tile and whether or not that tile is active in gameplay. We'll discuss how a different class could handle rendering the tile in Chapter 10, but for now this class will control that as well. To start, we'll set up our class and package:

```
package {
  import flash.display.MovieClip;
  import flash.events.Event;
  import flash.events.KeyboardEvent;
  import flash.text.TextField;
  import flash.geom.Point;
  import flash.ui.Keyboard;
  public class CrosswordTile extends MovieClip {
  }
}
```

Because this class will handle display as well as the data in the tile, we'll extend it from MovieClip and use frames to store its different states.

Instead of starting with the constructor for the class, let's outline the different properties this tile should keep track of. This will consist of both basic public variables and protected variables with public getters and setters:

```
// PUBLIC DisplayObjects
public var letterField:TextField;
```

```
public var wordField:TextField;

// PUBLIC VARIABLES
public var letter:String;
public var acrossIndex:int= -1;
public var downIndex:int= -1;
public var tileIndex:Point;

// PROTECTED VARIABLES
protected var _wordIndex:uint;
protected var _answer:String;

// GETTER/SETTERS
public function get wordIndex():uint {
   return _wordIndex;
}

public function set wordIndex(value:uint):void {
   _wordIndex = value;
   wordField.text = (_wordIndex) ? _wordIndex.toString(): "";
}
```

First we declare two TextField objects that will be used to display the letter in the tile when it is entered and the number of the word if it is the first letter. The letter property will be used to store the letter that belongs in this square. Note that this is *not* the letter that will be used to store user input, but rather the correct answer from the XML. The acrossIndex and downIndex variables will store the tile's associations with any horizontal or vertical words. For the tileIndex, or the actual grid position in the puzzle, we use a Point object because it already has *x* and *y* properties.

Techie Note

You don't always have to use getters and setters for every publicly exposed property in your classes. If a variable is purely being stored, the extra overhead of a function to do so is unnecessary. Use getters and setters when some other action needs to take place when a value is set, but you want the simplicity of a simple variable assignment. As long as you keep to a standard convention (protected/private variables always begin with an underscore, for example), you can easily convert the public variable to a getter/setter property later on and not change more than a couple of lines of code. Getters also come in handy when you want a value to be readable but not writeable; simply omit the setter and you're done!

Next we have two protected variables, one of which has getter/ setter methods. The wordIndex property is used to store the word in the puzzle (horizontal or vertical) to which the tile belongs. The _answer property is what will store a player-inputted answer. We now move on to the publicly exposed methods, which can be called from outside the class:

```
public function setAnswer(e:KeyboardEvent):Boolean {
  if (e.keyCode >= String("A").charCodeAt(0) && e.keyCode <=
  String("Z").charCodeAt(0)) {</pre>
```

```
_answer = String.fromCharCode(e.keyCode);
letterField.text = _answer;
return true;
} else if (e.keyCode == Keyboard.BACKSPACE) {
    _answer="";
letterField.text=_answer;
}
return false;
}
public function deactivate() {
    gotoAndStop(2);
}
public function activate() {
    gotoAndStop(1);
}
```

When a user enters keyboard input on a tile, it will call *setAnswer*. This method is a combination of a normal function another class would call, but it accepts a KeyboardEvent as its parameter like an event handler. This allows another method elsewhere to pass along a received keyboard event for evaluation without having this method attached to a listener. Once it checks to see if the key pressed is an alphabetic character or Backspace it updates itself accordingly. It does not validate the answer further, but it does return *true* if a letter was entered and *false* if any other key was pressed. The *activate* and *deactivate* methods simply toggle between two different frames to show the tile as a usable square or a blank.

The constructor for the class will build the tile based on the character it is given to display. Remember how we denoted a blanked-out space with an underscore in the XML? We'll define a constant property named EMPTY for this character so we can easily reference it (and even change it later if need be):

```
static public const EMPTY:String = "_";
public function CrosswordTile(letter:String = EMPTY) {
    this.letter = letter;
    addEventListener(Event.ADDED_TO_STAGE, init, false, 0, true);
    if (letter == EMPTY) {
        deactivate();
    } else {
        activate();
    }
}

protected function init(e:Event) : void {
    if (letterField) {
        letterField.text="";
        letterField.mouseEnabled=false;
    }
    if (wordField) {
        wordField.text = (_wordIndex) ? _wordIndex.toString() :
    "";
        wordField.mouseEnabled = false;
    }
}
```

All the constructor does is store the letter passed in, set up a notification for when the tile is added to the display list, and toggle to the normal state or the blacked-out state. The init method handles setting up the text fields and disables mouse interaction on them. To some, these may seem like steps that could simply be accomplished in the constructor, but unfortunately this is not the case. If you tried to move them into the constructor, Flash would give you a runtime error. This is a point of confusion for many people and one we will explore further in Chapter 10. Suffice it to say that, while we've declared that there will be two text fields, we're going to create these objects inside of Flash. As long as we give the same name to our text field instances on the Stage, Flash will take care of linking the declared variable to the actual object. However, this step does not take place until after the constructor has completed, so the next best time to run these commands is when the tile is added to the Stage and ready to use.

Now that we have the class defining a tile created, we need to see the display object to which it will be linked. Open up the CrosswordPuzzle.fla file from the Chapter 9 Examples folder on the website. In the library you will find a symbol called CrosswordTile. If you open it you will see the two text fields (with the names of the variables in the class) and the two frames showing the different states a tile can use. If you bring up the properties panel for the symbol (right-click and choose Properties), you will see that it is set to export with the same name as the class we've just created. Now when a new CrosswordTile is constructed, this library asset will be used as the object to display.

Figure 9.2 The CrosswordTile symbol is made up of a square and two text fields

	Symbol Properties	Emarcal ancora de describir de la comisión
Name:	CrosswordTile	ОК
Type:	Movie Clip	Cancel
	1	Edit Basic
Enable	guides for 9-slice scaling	
Enable		
	guides for 9-slice scaling Export for ActionScript Export in frame 1	
Linkage —	■ Export for ActionScript	
Linkage —	✓ Export for ActionScript✓ Export in frame 1	

Figure 9.3 The CrosswordTile symbol is now linked to its class.

The CrosswordClue Class

Before we delve into building the puzzle itself, let's consider the clue component. It is a relatively simple class—all it needs to do is display the clue for the selected word. With no need for multiple frames, it is a good candidate to extend Sprite instead of MovieClip:

```
package {
  import flash.display.Sprite;
  import flash.text.TextField;
  public class CrosswordClue extends Sprite {
    static public const DEFAULT_VALUE:String="Clue";
    public var clueText:TextField;
    public function CrosswordClue(){
    }
    public function get text():String {
       return clueText.text;
    }
    public function set text(value:String):void {
       clueText.text=value;
    }
}
```

The class uses a TextField object and a getter/setter combination to assign text to it. You might wonder why we didn't simply use a standard text field instead of a custom class. You very well could for an example as straightforward as this, but there are a couple of reasons to encapsulate it as its own class. First is the ability to define constants, such as what the default value of the text field should be when no clue is shown. Another reason is expandability and flexibility; by already having a class set up to handle the clue, it will be easier to add animation and other features without adding a lot of code to the puzzle class. One other reason you might not expect is that it is easier to set up a text field inside Flash rather than code. Custom fonts (basically, anything other than system fonts) are clumsily handled through ActionScript and require more hassle than simply creating a symbol with a TextField object inside it and linking it to a class. In fact, spawning a new TextField from scratch in code and assigning it formatting objects and positioning involve as much or more code than the class we just created.

In the CrosswordPuzzle.fla file you'll find a symbol in the library named CrosswordClue. Inside it has the single TextField named clueText. It is set to export using the same class name, and is extending from the base class Sprite. You may have some cognitive dissonance when you see that the base class field says Sprite, but the type still says MovieClip. This has to do with the way the Flash authoring environment handles timeline-based elements and is a holdover from older versions, presumably for

consistency. To minimize confusion (or perhaps add to it), Flash CS4 now color-codes Sprites in the library as green instead of the MovieClip blue. Don't dwell too much on it—it's a quirk of Flash and while annoying does not cause any real problems.

Name:	CrosswordClue	OK OK
Туре: [Movie Clip 💠	Cancel
		Edit Basic
Enable g	uides for 9-slice scaling	
Enable gu		
	✓ Export for ActionScript	
inkage		
inkage —— Iden	✓ Export for ActionScript✓ Export in frame 1	

Figure 9.4 The CrosswordClue class extends Sprite, even though it says MovieClip in the Symbol Properties window.

The CrosswordPuzzle Class

With the individual tiles and the clue field ready to be used, it's time to set up the corc CrosswordPuzzle engine. Unlike the two previous components, we will not link this class to a symbol in the library. Because crossword puzzles can be any number of sizes, having any type of fixed layout defined in a symbol would make the class too rigid to deal with. Say, for instance, you wanted to support multiple dimensions of puzzles in a single game; if you tied the class to specific symbols, you would need to do so as the base class and have multiple subclasses that extend CrosswordPuzzle, which could get cumbersome quickly. It is easier to set up the puzzle dynamically based on the puzzle data. Like the CrosswordClue class, CrosswordPuzzle extends Sprite; since it is being generated dynamically it will not use frames.

```
package {
  import flash.display.Sprite;
  import flash.geom.ColorTransform;
  import flash.geom.Point;
  import flash.events.Event;
  import flash.events.MouseEvent;
  import flash.events.KeyboardEvent;
  import flash.ui.Keyboard;
```

```
public class CrosswordPuzzle extends Sprite {
    }
}
```

In the basic package definition, we will need to be able to listen for both Keyboard and Mouse events, and we will use the ColorTransform class (the code version of the Color properties drop-down on a timeline-based symbol) to tint tiles that are selected. Next we define the constants and properties of the class, as well as the constructor:

```
// CLASS CONSTANTS
static public const tileSelectedColor:ColorTransform = new
ColorTransform(0, 1, 1, 1, 0, 0, 0, 0);
static public const wordSelectedColor:ColorTransform = new
ColorTransform(.7, 1, 1, 1, 0, 0, 0, 0);
// PROTECTED VARIABLES
protected var _content:XML;
protected var _puzzleHeight:int;
protected var _puzzleWidth:int;
protected var _tileList:Array;
protected var _wordListAcross:Array;
protected var _wordListDown:Array;
protected var _selectedWord:Array;
protected var _selectedTile:CrosswordTile;
protected var crosswordClue:CrosswordClue;
public function CrosswordPuzzle(content:XML){
 _content = content;
 _tileList = new Array();
 _wordListAcross = new Array();
 _wordListDown = new Array();
 createPuzzle();
```

To tint a tile when it is selected, we create two color transforms (in this case, versions of light blue). One is used for the specific tile that was selected and a lighter one will be used for the word associated with that tile. The engine employs a number of variables to keep track of various pieces of data. The _content XML variable will store the puzzle data once it is loaded from an external file. It also keeps track of the width and height of the puzzle, a list of all the tiles in play (including blacked-out ones), lists of the horizontal and vertical words, references to the currently selected tile and word, and a reference to the CrosswordClue class we created earlier. Finally, the constructor accepts an XML object containing the puzzle content as a parameter. It then initializes the three lists and calls createPuzzle, which we will look at next:

```
protected function createPuzzle() {
    _puzzleWidth = _content.@width;
    _puzzleHeight = _content.@height;
    var totalWords:int = 1;
```

```
var tile:CrosswordTile;
  //SETUP TILES
  for (var i:int = 0; i < _puzzleHeight; i++) {
   for (var j:int=0; j<_puzzleWidth; j++) {</pre>
     var letter:String=_content.puzzle.row[i].charAt(j):
     tile=new CrosswordTile(letter);
     tile.name=j.toString() + "_" + i.toString();
     tile.tileIndex=new Point(j, i):
     if (letter != CrosswordTile.EMPTY) {
        var startofWord:Boolean=false:
        if (j = 0 \mid | \_content.puzzle.row[i].charAt(j-1) = = "") {
                tile.acrossIndex=_wordListAcross.push(new Array());
               _wordListAcross[tile.acrossIndex-1].push(tile):
               startofWord=true;
        if (i == 0 || _content.puzzle.row[i-1].charAt(j) == "_") {
               tile.downIndex=_wordListDown.push(new Array());
        _wordListDown[tile.downIndex-1].push(tile);
               startofWord=true:
        if (startofWord) {
               tile.wordIndex=totalWords++;
        if (tile.acrossIndex<0) {
               var previousAcrossTile:CrosswordTile=_
tileList[_tileList.length-1];
 _wordListAcross[previousAcrossTile.
acrossIndex-1].push(tile);
               tile.acrossIndex=previousAcrossTile.
acrossIndex:
       if (tile.downIndex<0) {</pre>
               if(i > 0) {
                       var previousDownTile:CrosswordTile=_
tileList[_tileList.length-_puzzleWidth];
                       if (previousDownTile.letter !-
(crosswordTile.EMPTY) {
 _wordListDown[previousDownTile.downIndex-1].push(tile);
                               tile.downIndex=previousDownTile
.downIndex:
     _tileList.push(tile);
     tile.x=j*tile.width;
     tile.y=i*tile.height;
     addChild(tile):
     tile.addEventListener(MouseEvent.CLICK, selectTile,
false, O, true):
 _crosswordClue=new CrosswordClue();
_crosswordClue.y=getRect(this).bottom + 20;
addChild(_crosswordClue);
```

There is a lot to the createPuzzle method, so we'll break it down into more manageable chunks.

```
_puzzleWidth=_content.@width;
_puzzleHeight=_content.@height;
var totalWords:int=1;
var tile:CrosswordTile:
```

The first few lines simply initialize the variables that will be used throughout the rest of the method. Note that the attributes we assigned to the crossword XML earlier are prefixed with the @ symbol. Another great feature of E4X is that it is smart enough to differentiate numbers from strings, so even though the values were in quotes in the XML file, Flash converted them to numbers for us.

```
for (var i:int=0; i<_puzzleHeight; i++) {
  for (var j:int=0; j<_puzzleWidth; j++) {
    var letter:String=_content.puzzle.row[i].charAt(j);
    tile=new CrosswordTile(letter);
    tile.name=j.toString()+"_"+i.toString();
    tile.tileIndex=new Point(j, i);</pre>
```

Next we begin two *for* loops that will run through the entire grid of the puzzle, row by row. Each iteration identifies the letter used at that space in the grid and creates a new CrosswordTile object for each one. As you can see, to get down to a specific row in the puzzle node of the XML, we simply use a combination of dot and array syntax. When you have multiple nodes on the same level with the same name, Flash converts it into an XMLList object, sort of like an XML array. To get at a particular item in the XMLList, we use a number from 0 up to the number of items minus 1.

```
if (letter != CrosswordTile.EMPTY) {
 var startofWord:Boolean=false:
 if (j == 0 \mid | \_content.puzzle.row[i].charAt(j-1) ==
CrosswordTile.EMPTY) {
   tile.acrossIndex=_wordListAcross.push(new Array());
   _wordListAcross[tile.acrossIndex-1].push(tile);
   startofWord=true:
 if (i == 0 || _content.puzzle.row[i-1].charAt(j) ==
CrosswordTile.EMPTY) {
   tile.downIndex=_wordListDown.push(new Array());
   _wordListDown[tile.downIndex-1].push(tile);
   startofWord=true;
 if (startOfWord) {
   tile.wordIndex=totalWords++;
 if (tile.acrossIndex<0) {
   var previousAcrossTile:CrosswordTile=_tileList[_tileList.
   length-1]:
   _wordListAcross[previousAcrossTile.acrossIndex-1].push(tile);
   tile.acrossIndex=previousAcrossTile.acrossIndex;
```

```
if (tile.downIndex<0) {
   var previousDownTile:CrosswordTile=_tileList[_tileList.
length-_puzzleWidth];
   _wordListDown[previousDownTile.downIndex-1].push(tile);
   tile.downIndex=previousDownTile.downIndex;
}
}</pre>
```

This section of the method performs a series of checks to determine the tile's current state (in-use or blacked-out) and the words with which it is associated. First we check whether or not the tile is supposed to be empty. If it is, we stop there and don't include it in any word lists. Next, we determine whether the tile is the starting letter of a word, either across or down. We ascertain this by checking if the tile immediately to the left or top of the current tile is a blank. If it is the start of a new word, we add it to the across list and/or the down list. We also increment the total number of words counter and set the tile's wordIndex to this number. If you recall from the CrosswordTile class, when the wordIndex is set, it adds this number to the upper-left-hand corner TextField. This is the number that will be used to match the tile to its corresponding clue. If the tile is not the start of a word, its acrossIndex and downIndex will still be the default value of -1. We then look up the previous tile to both the left and above the tile to use its same indices and add it to the across list, down list, or both. At this point the tile shares associations with words in the across word list, down word list, and the beginning letter of each word.

```
_tileList.push(tile);
tile.x=j*tile.width;
tile.y=i*tile.height;
addChild(tile);
tile.addEventListener(MouseEvent.CLICK, selectTile, false, 0, true);
}
_crosswordClue=new CrosswordClue();
_crosswordClue.y=getRect(this).bottom+20;
addChild(_crosswordClue);
```

Once all the logic has run to determine each tile's link to its neighbors, we add it to the master tile list, position it based on its location in the letter grid, add it to the Stage, and attach a listener for mouse clicks. To end this method after the loop has completed processing all the tiles, we add the previously created CrosswordClue component to the Stage and position it underneath the rest of the puzzle with a little bit of white space. A complete crossword puzzle should now exist on the Stage with all the proper squares blacked-out and certain tiles assigned clue numbers. You may have noticed that the method attached to

the mouse listener for each tile is called *selectTile*. We will examine it next:

```
protected function selectTile(e:MouseEvent):void {
 var tile:CrosswordTile=e.target as CrosswordTile;
 var acrossWord:Array= wordListAcross[tile.acrossIndex-1];
 var downWord:Array=_wordListDown[tile.downIndex-1];
 clearSelection():
 if (tile.letter == CrosswordTile.EMPTY) {
   crosswordClue.text=CrosswordClue.DEFAULT_VALUE;
   stage.removeEventListener(KeyboardEvent.KEY_DOWN,
keyDown);
   _selectedTile=null;
   return;
 if (! selectedTile) stage.addEventListener(KeyboardEvent.
KEY_DOWN, keyDown, false, 0, true);
 if ( selectedWord == acrossWord && _selectedTile == tile)
selectedWord=downWord;
   else if (_selectedWord == downWord && _selectedTile ==
tile) _selectedWord=acrossWord;
   else if ( selectedWord == acrossWord && _selectedTile !=
tile) selectedWord=acrossWord:
   else if (_selectedWord == downWord && _selectedTile !=
tile) _selectedWord=downWord;
   else _selectedWord=acrossWord;
  for (var i:int=0: i< selectedWord.length; i++) {
   if (_selectedWord[i] == tile) {
     selectedWord[i].transform.
colorTransform=tileSelectedColor;
   } else {
     _selectedWord[i].transform.
colorTransform=wordSelectedColor:
  _selectedTile=tile;
  var wordNumber:int=_selectedWord[0].wordIndex;
  if ( selectedWord == downWord) {
   _crosswordClue.text=String(wordNumber)+" Down: "+(_
content.clues.down[tile.downIndex-1] || "");
  } else {
   _crosswordClue.text=String(wordNumber)+" Across: "+(
content.clues.across[tile.acrossIndex-1] || "");
```

The *selectTile* method is called when the player clicks a tile. To provide the expected user feedback, this method needs to: (1) highlight the selected tile, (2) highlight the word the tile is a part of, and (3) display the hint associated with the tile. First, we look up the across and down words the tile is associated with and then call *clearSelection*, which we will look at shortly. Suffice it to say for now that *clearSelection* will nullify any other currently selected tiles. Next we check to see if the player clicked on a blacked-out

tile; if so, we clear the clue text, disable keyboard input if it is active, and exit the function. If the _selectedTile property is null, meaning no tile was previously selected, we add a listener for keyboard input so players can start to type letters once they click a tile. We now need to know whether to use the tile's associated across or down word. By default, if no previous word was selected, we use the tile's across word. We use many conditions to ensure that if a tile is selected as part of a down word, and another tile in that word is clicked, the game will keep the same word selected. We check to see if the same tile was clicked twice; if it was, we want to select the opposite type of the word that is currently selected. For example, if an across word is selected by its first letter, clicking the first letter again will highlight the down word.

Once we have determined the proper word to select, we run through a *for* loop that assigns the color transforms we created earlier to each of the tiles in the word. Now all that is left to do is display the clue for the word; to do this we grab the *wordIndex* of the first tile in the word. Finally, we concatenate a string together with the word descriptor ("1 Down," "30 Across," etc.) and the clue itself, pulled from the corresponding XMLList.

Now that we have the behavior defined for when the player selects a tile, we need some way of deselecting tiles and words, like when the player clicks on a blacked-out tile. That's where the *clearSelection* method comes into play:

```
protected function clearSelection():void {
  if (!_selectedWord) return;
  for (var i:int=0; i<_selectedWord.length; i++) {
    _selectedWord[i].transform.colorTransform=new ColorTransform();
  }
}</pre>
```

All this method does is reset the color transforms for the tiles in the currently selected word. If no word has been selected when the method is called, it exits. Note that we do not null out the variables <code>_selectedTile</code> and <code>_selectedWord</code>. This is because we may need to know what the previously selected word was. In fact, the <code>selectTile</code> method relies on knowing the previously selected word to fulfill all of its conditions. Now that we have methods to set up a puzzle and select specific tiles in it, we need one more method to insert letters into the tiles. If you recall in the <code>selectTile</code> method, we set up a keyboard event listener when a tile is successfully selected. This method, <code>keyDown</code>, is what we'll look at next:

```
protected function keyDown(e:KeyboardEvent):void {
  var selectedIndex:int=(_selectedTile.tileIndex.y * _puzzleWidth)+
  _selectedTile.tileIndex.x;
  var newIndex:int;
  switch (e.keyCode) {
```

```
case Keyboard.UP:
   newIndex=Math.max(0, selectedIndex-_puzzleWidth);
   if (_tileList[newIndex].letter != CrosswordTile.EMPTY)
_tileList[newIndex].dispatchEvent(new MouseEvent(MouseEvent.CLICK)):
   break:
   case Keyboard. DOWN:
   newIndex=Math.min(_tileList.length-1, selectedIndex +
puzzleWidth):
   if (_tileList[newIndex].letter != CrosswordTile.EMPTY)
tileList[newIndex].dispatchEvent(new MouseEvent(MouseEvent.CLICK));
   break:
   case Keyboard.LEFT:
   newIndex=Math.max(selectedIndex-1, (selectedTile.tileIndex.y
* _puzzleWidth));
   if (_tileList[newIndex].letter != CrosswordTile.EMPTY) _
tileList[newIndex].dispatchEvent(new MouseEvent(MouseEvent.CLICK));
   break:
   case Keyboard.RIGHT:
   newIndex==Math.min(selectedIndex+1,
((_selectedTile.tileIndex.y+1) * _puzzleWidth)-1);
   if (_tileList[newIndex].letter != CrosswordTile.EMPTY)
_tileList[newIndex].dispatchEvent(new MouseEvent(MouseEvent.CLICK));
   break:
   case Keyboard. SPACE:
   selectedTile.dispatchEvent(new MouseEvent(MouseEvent.CLICK));
   break:
   default:
   _selectedTile.setAnswer(e):
   break:
```

The keyDown method is responsible for handling a few different types of keyboard input. We employ a switch statement to filter through the possible values for the key that was pressed. In addition to responding to alphabetic key presses, we want to give the player the ability to move between different tiles with the arrow keys, as well as the ability to toggle between the across and down words of the selected tile. For the arrow key input, if a tile in the direction in which the player is attempting to move isn't blacked out, we simulate a mouse click by dispatching a new MouseEvent from the tile. The result is that it is as though the tile next to the selected tile was clicked with the mouse and selectTile is called to handle it. By simulating already existing functionality, we lessen the possibility for bugs, since the logic on how to select words based on tiles is centralized in one place. The same is true for the spacebar; when it is pressed it is as though the selected tile was simply clicked again. For all other keys, we send the event through to the setAnswer method of the tile. If you recall, that method knows how to filter for proper alphabetic input, so we don't have to worry about that here.

All of our classes for the crossword puzzle engine are now defined; let's try it out. If you open the CrosswordPuzzle.fla in

the Chapter 9 folder, you will find the following code on the first frame:

```
var loader:URLLoader=new URLLoader(new URLRequest("crossword.
xml"));
loader.addEventListener(Event.COMPLETE, createCrossword);
var cp:CrosswordPuzzle;
function createCrossword(e:Event) {
   cp=new CrosswordPuzzle(XML(e.target.data));
   cp.x=stage.stageWidth/2-cp.width/2;
   cp.y=cp.x;
   addChild(cp);
}
```

This little snippet of code handles loading in the XML file with all the crossword data and creates a new CrosswordPuzzle instance with it. Finally, it centers the puzzle horizontally on the Stage and adds it to the display list. This code could easily be integrated into a larger class that handles, for instance, the loading of multiple puzzles.

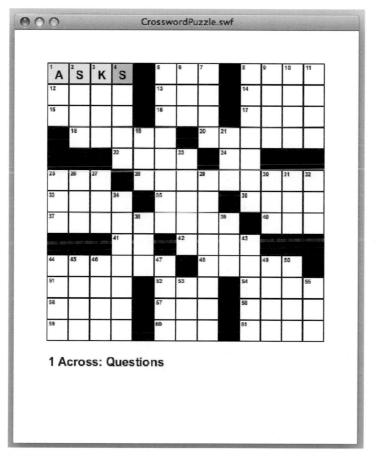

Figure 9.5 The finished crossword puzzle engine, running with the sample puzzle.

The resulting SWF for the whole crossword engine is just under 15 k—pretty small for a lot of functionality. Using a device, or system, font for the tiles would bring it down even further, because at least half of the file is font data.

Content Is a Two-Way Street: A Crossword Builder

While editing an XML file by hand is certainly not impossible, it would get grueling pretty quickly to have to create entire crossword puzzles that way. This is where an editor comes into play. Using the same core components, like the tile class and much of the puzzle class, you can take the crossword engine and write a second version of it that outputs the XML file and even saves it to a local file. While we won't build an entire editor here, this is what a *savePuzzle* method might look like for such an app:

```
protected function savePuzzle(e:Event=null) {
  _content=new XML(<crossword width={_puzzleWidth}
height={_puzzleHeight}><puzzle/><clues/></crossword>);
  for (var i:int=0; i<_tileList.length; i+= _puzzleWidth) {
   var slice:Array=_tileList.slice(i, i+_puzzleWidth-1);
   var str:String="";
   for (var j:int=0; j<slice.length; j++) {
     if (slice[j].letter == "") str += CrosswordTile.EMPTY;
     else str += slice[j].letter;
   var row:XML=new XML(<row>{str}</row>);
    _content.puzzle.appendChild(row);
  for (i=0; i<_acrossClues.length; i++) {</pre>
   var across:XML=new XML(<across>{_acrossClues[i]}</across>);
   _content.clues.appendChild(across);
  for (i=0; i<_downClues.length; i++) {</pre>
   var down:XML=new XML(<down>{_downClues[i]}</down>);
   _content.clues.appendChild(down);
  var file:FileReference=new FileReference();
  file.save( content. "crosssword.xml");
```

When creating XML within ActionScript, you don't have to enclose it in "{}" or convert it from a string. You simply start typing it, hence the one line to create the *_content* container for the XML. To insert ActionScript values in the midst of raw XML, simply use braces ({}) around whatever expression you need evaluated. In this case, the first line creates the main nodes with the puzzle width and height attributes and two child nodes: puzzle and clues. It then runs through the tile list and builds all the rows for the puzzle. The *appendChild* method is called, which adds each

row to the bottom of the puzzle XMLList, like a *push* to an array. After that, the across and down clues are iterated and appended, as well. Finally, a new feature in Flash CS4, the FileReference *save* method, is called. It brings up a system file dialogue window and saves the XML as text data to the file selected. The second parameter is only a suggestion; end users can select whatever file name they want.

Sending Data Back Out

While the local file saving abilities in the FileReference class are great, the real power comes from saving data to a remote destination, like a database. Data such as high-score leaderboards, user profiles, and more are all great candidates for XML formatting. To get the information to the database, it must get sent through some data processing (or *middleware*) layer, like WebServices, AMF (Remoting), or standard form posts. Here is a quick example of what the latter might look like, simply posting the raw XML to a receiving PHP page:

```
var myXML:XML=<crossword width="10"
height="10"><puzzle/><clues/></crossword>;
var request:URLRequest-new URLRequest("myservice.php");
request.contentType="text/xml";
request.data=myXML.toXMLString();
request.method=URLRequestMethod.POST;
var loader:URLLoader=new URLLoader(request);
```

Just as the URLL oader is the corc class for loading remote data into Flash, it is also the sending mechanism when combined with a data-laden URLR equest. In this example, we simply format the request to notify the receiving page that it contains incoming XML content. Of course, sending the XML in its raw form like this is not particularly secure—most any savvy hacker will be able to use any number of HTTP monitoring tools to see the XML being sent (or any being received for that matter). For some data, like public high-score tables, this won't matter; however, more sensitive data such as user information should be hidden. We'll explore ways to overcome this security deficiency in Chapter 18.

One More Example: XML vs. Flash Vars

A popular way of getting information into a SWF file from its containing HTML page is through the use of Flash Vars. If you're not familiar with them, Flash Vars are essentially name/value pairs that are passed into the SWF upon loading. Say you had a site where users could log in and you wanted to display a player's name inside the game. A traditional solution to this problem would be

to add the username to the object and embed tags in the HTML page. It would look something like this:

```
<object classid="clsid:d27cdb6e-ae6d-11cf-96b8-444553540000"</pre>
codebase="http://download.macromedia.com/pub/shockwave/cabs/
flash/swflash.cab#version=10,0,0,0" width="500" height="600"
id="CrosswordPuzzle" align="middle">
 <param name="allowScriptAccess" value="sameDomain" />
 <param name="allowFullScreen" value="false" />
 <param name="movie" value="CrosswordPuzzle.swf" />
 <param name="quality" value="high" />
 <param name="bgcolor" value="#ffffff" />
 <param name="flashvars" value="username==Chris" />
<embed src="CrosswordPuzzle.swf" quality="high"</pre>
bgcolor="#ffffff" width="500" height="600"
name="CrosswordPuzzle" align="middle" allowScriptAccess=
"sameDomain" allowFullScreen="false" type="application/
x-shockwave-flash" pluginspage=http://www.adobe.
com/go/getflashplayer
flashvars="username=Chris"/>
</object>
```

If you have multiple pieces of information you need to pass into Flash, they are separated by &'s, just like a URL in a browser. There are a couple of drawbacks to using this system that become very apparent when you start using more than one or two variables. One is that you're limited to only single name/value pairs; you can't store any type of complex data in a Flash Var. The other drawback is that it becomes tricky to manage them in the page and one typo or error processing them could render all of them unavailable. To add to their annoyance during troubleshooting, any special characters must be URL encoded, increasing their lack of readability.

A better option is to use a single Flash Var, maybe called something like *config*. The value of this variable is a path to either a static or dynamic XML file. It would probably look something like this:

```
<param name="flashvars" value="config=configuration.xml"/>
```

If the information contained within the XML file didn't need to change per user (like the links to various pages or media), it could simply be a file on the server beside your SWF that the SWF loads in upon launching. If the information was dynamic (like a username or preferences), it could point to a PHP (or other back-end service) file that returns XML:

```
<param name="flashvars" value="config=configuration.php"/>
```

The URLLoader will load in the data as plain text, regardless of file extension, so as long as the page renders out as XML you're good to go. This keeps your back-end developers (or you if you're a solo operation) from having to wrangle variables within a page of

already convoluted HTML. Here is an example of what a config file might look like:

Remember that you could put whatever information you wanted to in here and in whatever structure. As you can see, this much more readable option is also easier to parse, and thanks to E4X your basic data types (like strings and numbers) come through intact; Flash Vars are *all* strings.

Summary

In this chapter we've explored a few uses of XML in games. There are definitely many more. Some developers I've met are wary of using XML, feeling that doing so forces them to use an elaborate, complex setup or follow some "best practices" guide to formatting they read in a 500-page tome on XML in an enterprise setting. Nothing could be further from the truth; use XML where it makes sense, keep it simple, and try to follow a structure that lends itself to growth. The great thing about XML is that it is a standard in and of itself, and ActionScript 3 makes working with it a no-brainer.

FOUR LETTER WORDS: M-A-T-H

Few people I know, programmers included, don't groan a little when math and physics are brought up. While not all games utilize them, geometry, trigonometry, and basic physical mechanics are essential parts of game development. Don't worry, though; this isn't a physics and math book. There are many of those out in the marketplace already, some even written specifically for games. In fact, this isn't even going to be an in-depth exploration of those topics because they really aren't necessary for most casual games. In this chapter, we will cover the basic foundational concepts you must understand to be able to handle a wide variety of development challenges. We will accomplish this in two parts—geometry and trigonometry, and physics—each with a practical example illustrating the concepts. If, when you're done with this chapter, your appetite is whetted for a more in-depth look at these topics, I have provided links to further reading on this book's website, flashgamebook.com.

The Math Class

ActionScript includes a core library for performing a lot of the functions we're going to learn about in this chapter. It is the Math class, and it will quickly become invaluable as we get into more complicated problems later on in our code. It doesn't include everything we'll eventually need, but later we'll learn about some companion functions we can write to make it even more useful.

PART 1 Geometry and Trigonometry

Geometry, specifically Euclidian geometry, is the branch of mathematics that deals with, among other things, the relationship

between points, lines, and shapes in a space. From it we derive the formulas for getting the distance between two points, as well as the entire *x*,*y* coordinate system (known as the Cartesian coordinate system) upon which Flash's Stage is built. Figure 10.1 illustrates a typical two-dimensional coordinate system.

Flash's coordinate system is slightly different in that it is flipped over the *x*-axis, resulting in the *y* values being reversed. The upperleft corner of the Stage is at (0,0) and expands down and to the right from there, as shown in Figure 10.2. This is important to note because it is diametrically opposed to the notion that numbers decrease as they move "down" on a graph, and it can cause confusion later when we move into some of the concepts of physics.

Figure 10.1 A standard two-dimensional Cartesian, or *x*, *y*, coordinate system.

Figure 10.2 Flash's vertically inverted coordinate system.

Trigonometry (or "trig" for short) is a related, but more specific, branch that describes the relationships between the sides and angles of triangles, specifically right triangles (triangles with one angle of 90 degrees). All triangles have some fundamental properties:

- A triangle's interior angles always add up to 180 degrees.
- Any triangle (regardless of orientation and type) can be split into two right triangles.
- The relationships between any given side and angle of a triangle are defined by ratios that are known as the *trigo-nometric functions*.

You have probably heard of the three most common trig functions; they are sine (sin), cosine (cos), and tangent (tan). They each relate to different sides of a triangle. The longest side of the triangle (and, in a right triangle, the side opposite the right angle) is the *hypotenuse* (hyp). In Figure 10.3, we relate to the other two

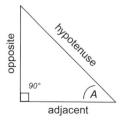

Figure 10.3 The three sides of a right triangle, related to angle *A*.

sides of the triangle based on the angle we're interested in—in this case, *A*. The vertical side of the triangle is *opposite* (opp) angle *A*, while the horizontal side is *adjacent* (adj) to it.

The aforementioned trig functions work with these sides as follows:

- The sine of an angle is equal to the opposite side's length divided by the hypotenuse's length; thus, $\sin A = \frac{\text{opp}}{\text{hyp.}}$
- The cosine of an angle is equal to the adjacent side's length divided by the hypotenuse's length; thus, $\cos A = \frac{\text{adj/hyp.}}{\text{divided}}$
- The tangent of an angle is equal to the opposite side divided by the adjacent site; thus, tan *A* = opp/adj.

As you can see, these functions are very helpful if you only know a little bit of information about a triangle and need to determine the other components. Let's look at a few examples. In Figure 10.4, we know the value of angle A is 50° (and, by extension, the other missing angle would then be 40°). We also know that the length of the hypotenuse is 30.

To find the lengths of the other two sides, we rewrite the sine and cosine equations as follows:

$$adj = \cos A^* \text{ hyp, or } adj = (\cos 50)^* 30$$

opp =
$$\sin A^*$$
 hyp, or opp = $(\sin 50)^* 30$

If you used a calculator with the trig functions on it, you would quickly determine that the value of the adjacent side is \sim 19.3 and the value of the opposite side is \sim 23.

In Figure 10.5, we can see that we now know one angle (45°) and the length of the side opposite that angle (20).

Once again, we simply manipulate the equations to determine the other two sides, this time using tangent instead of cosine, as cosine has nothing to do with the opposite side:

hyp = opp/sin A, or hyp =
$$20/(\sin 45)$$

$$adj = opp/tan A$$
, or $adj = 20/(tan 45)$

Using a calculator, this would reveal the hypotenuse to have a length of \sim 28.3 and the adjacent side to also be 20.

Now let's look at an example (Figure 10.6) with a triangle where we know the lengths of the two shorter sides but no angles and no hypotenuse.

Because we know the opposite and adjacent sides, the obvious choice would be to use the tangent equation to determine the value of angle *A* (and flip the two sides to find the value of *B*):

$$\tan A = 15/20$$

$$\tan B = 20/15$$

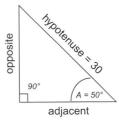

Figure 10.4 Using the information about one angle and one side, we can use the trig functions to find the values of the other two sides.

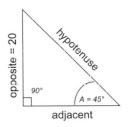

Figure 10.5 A triangle where we know one angle and one side.

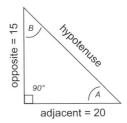

Figure 10.6 A triangle where we know just two of the sides, but no angles and no hypotenuse.

However, now we're stuck. We want *A* and *B*, not the tangent of *A* and *B*. Luckily, there is a way to reverse each trig equation using what are known as *inverse* trig functions. The names of these functions match their counterparts, but they are prefixed with the word *arc*. In this case, we need to use *arctangent* to find the value of each of these angles:

$$A = \arctan (15/20)$$

$$B = \arctan (20/15)$$

Based on these equations, angle A would be $\sim 37^{\circ}$ and B would equal $\sim 53^{\circ}$. If you add these together with the right angle of 90°, you can see that we indeed have a proper triangle of 180°.

For our final theoretical example, look back again to Figure 10.6. Suppose all you needed was the hypotenuse and you weren't interested in the angles at all. You could do what we did previously, using arctangent to get the values of the angles and then use those angles with either sine or cosine to determine the hypotenuse. However, as this is a multiple-step process, it is inefficient when we have a much quicker way. In addition to the standard trig functions, another equation, known as the Pythagorean theorem, can be used to determine the third side of a right triangle when you know the other two. It states that the hypotenuse of a triangle, squared, is equal to the sum of the squares of the other two sides. Let's look at this as an equation, calling the two shorter sides a and b and the hypotenuse c:

$$a^2 + b^2 = c^2$$

To find any one side when you know the other two is just a simple permutation of this equation, like the following:

$$c = \sqrt{(a^2 + b^2)}, \ b = \sqrt{(c^2 - a^2)}, \ a = \sqrt{(c^2 - b^2)}$$

For our purposes, we know sides a and b are 15 and 20 (or 20 and 15; it doesn't really matter). Based on these values, the hypotenuse would therefore be equal to:

$$\sqrt{(15^2 + 20^2)} = 25$$

Now that we have these functions defined and have seen how to use them, let's look at a couple of practical examples in Flash and how to apply the functions there.

A fairly common use of the trig functions is finding the angle of the mouse cursor relative to another point. This angle can then be applied to the rotation of a DisplayObject to make the object "look" at the mouse. If you open the MousePointer.fla file,

on the website, you'll find just such an example set up. It consists of a triangle MovieClip called "pointer" on the stage. One of the corners of the triangle has been colored differently to differentiate the direction it is pointing. For simplicity, the ActionScript to perform this math is on the timeline; if you were using this code as part of something larger, it would make sense to put it in a class. Let's look at this code now:

```
addEventListener(Event.ENTER_FRAME, updatePointer, false, 0,
true);
function updatePointer(e:Event) {
  var angle:Number = Math.atan2(mouseY-pointer.y, mouseX-
  pointer.x);
  pointer.rotation = angle * (180/Math.PI);
}
```

On every frame (30 times a second at our current frame rate), the angle of the pointer relative to the mouse position is updated. There is a fair amount going on in these two lines so let's look at them one at a time:

```
var angle:Number = Math.atan2(mouseY-pointer.y, mouseX-
pointer.x);
```

Remember how we learned that if we know two sides of the triangle we can use that information to find out any of the angles? In this case, we know the difference in *x* and *y* between the mouse cursor and the pointer clip. These constitute the two shorter sides of a right triangle—a straight line drawn between the pointer and mouse would represent the hypotenuse of this triangle. This is illustrated in Figure 10.7.

A represents the angle we're interested in, as we want the pointer to basically "look down" the imaginary hypotenuse. This makes the x distance the adjacent side to the angle and the y distance the opposite side. Recall the formula for the tangent of an angle: tan A = opp/adj. To determine A, we need to use the arctangent formula $A = \arctan(opp/adj)$. In ActionScript there are two ways to implement arctangent; they are the atan() and atan2() methods of the Math class. The first expects to receive one value, assuming you have already divided the opposite side by the adjacent. The second one performs this step for you and is thus more commonly used (at least by me); pass it the opposite side first, followed by the adjacent side. In our case, the opposite side is the y value of the mouse cursor minus the y position of the pointer. Likewise, the adjacent side is the difference in x values of the cursor and the pointer. We now have the angle represented in Figure 10.7 by A; however, this angle (and all angles returned by the arc functions in ActionScript) is in radians, not degrees. The rotation property of the pointer is assigned in degrees, so we need to understand how to convert one unit to the other.

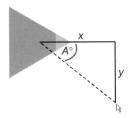

Figure 10.7 The distance between the mouse cursor and the registration point of the pointer clip form a triangle.

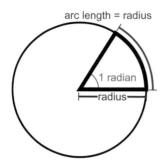

Figure 10.8 When the length of an arc on a circle is equal to the circle's radius, the value of the angle formed is one radian.

A Quick Explanation of Radians and Pi

You already know that a triangle is made up of 180 degrees and that a circle is made up of 360 degrees, exactly double. A single radian is the value of the angle created when a slice of the circumference of a circle is equal to the circle's radius; Figure 10.8 helps illustrate this.

If this explanation is confusing, don't worry. A full understanding of the use of radians is not necessary to perform the math we need. In fact, there is a very handy constant in math that will help us convert between radians and degrees. It is known as pi (pronounced "pie"); it is represented by the symbol π and is a nonrepeating decimal number approximately equivalent to 3.141. It represents the number of radians in a triangle, or half the number of radians in a circle; therefore, 180° is equal to π radians. To convert between radians and degrees, we simply multiply the number of radians by $180/\pi$ or the number of degrees by $\pi/180$. Returning to our ActionScript example from above, the next line of code does just that, using the Math.PI constant:

```
pointer.rotation = angle * (180/Math.PI);
```

If you test this FLA file you will see that the pointer consistently points in the direction of your cursor as you move it around the screen. Now that we have this piece of functionality in place, let's add a layer of complexity. Suppose in addition to "looking at" the mouse we wanted the pointer to also move toward the mouse until it reaches the mouse's x and y position. If you open the example MouseFollower.fla, you'll see how we can accomplish this.

Initially, this example looks very much like the last one, except for a few extra lines of code. Let's look at this additional ActionScript now:

```
var speed:Number = 5; //PIXELS PER FRAME
addEventListener(Event.ENTER_FRAME, updatePointer, false, 0, true);
function updatePointer(e:Event) {
  var angle:Number = Math.atan2(mouseY-pointer.y, mouseX-pointer.x);
  pointer.rotation = angle * (180/Math.PI);
  var xSpeed:Number = Math.cos(angle) * speed;
  var ySpeed:Number = Math.sin(angle) * speed;
  if (Math.abs(mouseX-pointer.x) > Math.abs(xSpeed))
pointer.x += xSpeed;
  if (Math.abs(mouseY-pointer.y) > Math.abs(ySpeed))
pointer.y += ySpeed;
}
```

The first line we've added is a speed component. This defines how many pixels the pointer should move per frame, in this case 5.

In the updatePointer function, we've also added a few lines to perform this move. Since the speed is how many pixels we want to move in a straight line, we need to convert it into the amount we need to move on the *x*-axis and the *y*-axis. In order to do this, we need to think of the speed as the hypotenuse of an imaginary triangle. We also already know the angle of the triangle we're interested in, because we just used arctangent to solve it. With this information in hand, we can use the sine and cosine functions to find the adjacent and opposite sides of this triangle, or the *x* and *y* components, respectively:

```
var xSpeed:Number = Math.cos(angle) * speed;
var ySpeed:Number = Math.sin(angle) * speed;
```

Once we have these two speeds, we can simply apply them to the *x* and *y* positions of the pointer to move it. In its simplest form, that code would look like this:

```
Pointer.x += xSpeed;
pointer.y += ySpeed;
```

However, if you were to leave the code like this, you would find that the pointer would start to move erratically when it got very close to the mouse. This is because, in trying to get as close to the cursor as possible, it continues to "jump over" its target and will appear to bounce back and forth endlessly. To circumvent this behavior, we need to check to see if the pointer is close enough to the mouse that it can stop moving. Doing so will employ another method of the Math class, abs(). This method is known in English as the absolute-value function. When given a number, either positive or negative, it returns the unsigned value of that number: Math.abs(4) = 4, Math.abs(-7) = 7, etc. In our example, we want to know if the distance between the cursor and the pointer is greater than the distance the pointer is trying to travel. Since we can't know whether or not the cursor's position minus the pointer's position will result in a negative number, we use the absolute value of the number for our calculation to ensure it is always positive. We also apply the function to the xSpeed and ySpeed variables because there are situations where they could be negative, as well:

```
if (Math.abs(mouseX-pointer.x) > Math.abs(xSpeed))
pointer.x += xSpeed;
if (Math.abs(mouseY-pointer.y) > Math.abs(ySpeed))
pointer.y += ySpeed;
```

If you compile the SWF you will see that this code causes the pointer to follow the mouse around the screen, always pointing toward it. While this logic is not what most people would consider *intelligence*, it is a form of artificial intelligence (AI).

Let's look at one more example that will give the pointer a little more personality. Open Mouse Follow Distance.fla to follow along. Continuing our previous examples, we once again have a clip named pointer and some code in the first frame. However, instead of constantly following the cursor, the pointer will only pursue the mouse when it is within a certain distance:

```
var speed:Number = 5; //PIXELS PER FRAME
var interestDistance:Number = 150; //PIXELS
addEventListener(Event.ENTER_FRAME, updatePointer, false, 0, true);
function updatePointer(e:Event) {
 if (getDistance(mouseX, mouseY, pointer.x, pointer.y) >
interestDistance) return:
 var angle:Number = Math.atan2(mouseY-pointer.y, mouseX-
pointer.x);
 pointer.rotation = angle * (180/Math.PI):
 var xSpeed:Number = Math.cos(angle) * speed;
 var ySpeed:Number = Math.sin(angle) * speed;
 if (Math.abs(mouseX-pointer.x) > Math.abs(xSpeed))
pointer.x += xSpeed;
 if (Math.abs(mouseY-pointer.y) > Math.abs(ySpeed))
pointer.y += ySpeed;
function getDistance(x1:Number, y1:Number, x2:Number, y2:
Number): Number {
 return Math.sqrt(Math.pow((x2-x1).2) + Math.
pow((y2-y1),2));
```

The first variable we add is *interestDistance*, or the number of pixels within which the pointer becomes "interested" in the mouse cursor. At the beginning of *updatePointer* we also add a condition to check if the distance between the two is greater than the amount we specified. We do this by introducing a new function we'll call *getDistance*. If you remember any basic geometry from school, you'll probably recognize this method as the *distance formula*; however, it is also a variation on the Pythagorean theorem. Recall from earlier in the chapter that:

$$c^2 = a^2 + b^2$$

where *a* and *b* are sides of a right triangle. To find *c*, we rewrite the function as:

$$c = \sqrt{(a^2 + b^2)}$$

In our case, a and b represent the differences in x and y, respectively. If we replace these variables with our actual values, it looks like this:

Distance =
$$\sqrt{[(x^2 - x^2)^2 + (y^2 - y^2)^2]}$$

Written in ActionScript, using the Math class methods for exponents, this same function results in:

```
Math.sqrt(Math.pow((x2-x1),2) + Math.pow((y2-y1),2));
```

Upon testing the SWF, you'll see that the pointer will only follow the cursor when the mouse is within 150 pixels of it. We have bestowed the pointer with a basic decision-making ability. So far these examples have been fairly abstract; they don't really constitute a game. We will use these examples as part of a larger piece of game code, but first we need to understand a little more about Flash CS4's coordinate system.

3D in Flash

A new feature in Flash CS4 is support for three-dimensional (3D) objects. This ability is sometimes misunderstood initially and requires a little clarification. Flash cannot natively make use of 3D models created in programs like Autodesk Maya or 3D Studio. Rather, you can now manipulate two-dimensional objects in 3D space, allowing for effects like true perspective skewing and distortion. One way to think about it is to imagine all your objects on the Stage like rigid pieces of paper; they have no perceivable depth, but you can tell their orientation in three-dimensional space. This new ability adds several new properties to DisplayObjects, not the least of which is the introduction of a third, or *z*, axis. Figure 10.9 illustrates how the *z*-axis is represented in the two-dimensional environment of the Stage; you can think of it as following the invisible line created from your eyes to the screen.

Figure 10.9 The new z-axis in Flash is perpendicular to both the x- and y-axes.

Position

On the z-axis, the value of 0 is at Stage level. Negative values for the z property of a DisplayObject would make the object appear larger and closer to the viewer. Positive values for z will increasingly shrink the object, making it look further away. Flash developers who have performed tricks with the x and y scale of objects in the

past to achieve the feeling of depth and 3D space will no doubt breathe a sigh of relief at the ease with which this effect can now be achieved with only a line or two of code. It should be noted that the z position of an object only tells Flash how to properly render the object in perspective; it does not affect the display list order. In other words, if you had two objects in a scene (let's say one with a z position of 30 while the other had a z position of 10), but the one with the higher z position was added to the Stage later, it would still appear to be on top in the display list.

Rotation

In addition to 3D positioning, you can also rotate DisplayObjects around any of the three axes. Figures 10.10, 10.11, and 10.12

Figure 10.10 A DisplayObject rotated 45° on its x-axis.

Figure 10.12 A DisplayObject rotated 45° on its z-axis.

Figure 10.11 A DisplayObject rotated 45° on its *y*-axis.

illustrate how a DisplayObject is rendered when its *rotationX*, *rotationY*, and *rotationZ* properties are each set to 45, respectively. You'll notice that the effect of *rotationZ* is not unlike the traditional *rotation* property from previous versions of Flash.

Perspective Projection

At this point it's important to understand how the 3D transformations are computed and applied to give the illusion of 3D space in a two-dimensional environment. Each DisplayObject in Flash has a vanishing point—that is, the point in 3D space where all parallel lines heading to the point appear to converge. The use of just one vanishing point is known as *one-point projection*. Figure 10.13 illustrates how four different objects look when using the same vanishing point.

Only being able to use a single vanishing point for all DisplayObjects would be rather limiting, so Flash allows us to assign each DisplayObject its own vanishing point. By default, every new object uses the center of the stage as its vanishing point. Unfortunately, multiple vanishing points cannot be assigned within the Flash authoring environment. This must be done through ActionScript using the transform property of DisplayObjects. In CS4, Transform objects now have a new property called *perspectiveProjection*. This object allows us to set the vanishing point for any given DisplayObject. Let's look at a few lines of script, applied to the same clips shown in Figure 10.13:

```
clip1.transform.perspectiveProjection = new PerspectiveProjection(); clip2.transform.perspectiveProjection = new PerspectiveProjection(); clip1.transform.perspectiveProjection.projectionCenter = new Point(0, 200); clip2.transform.perspectiveProjection.projectionCenter = new Point(550, 200); clip3.transform.perspectiveProjection = clip1.transform.perspectiveProjection; clip4.transform.perspectiveProjection \nabla clip2.transform.perspectiveProjection; clip4.transform.perspectiveProjection;
```

Figure 10.13 Four DisplayObjects rotating toward a single vanishing point.

Figure 10.14 Two pairs of DisplayObjects, each with its own vanishing point.

In this example, we create two new PerspectiveProjection objects, one positioned at the left-hand side of the screen and the other at the right. Figure 10.14 shows the result of this script; the two clips on the left skew to the left, while those on the right skew right.

With that basic overview of the 3D abilities in CS4, let's look at a practical example using the math covered earlier in this chapter. It is similar to the premise behind Atari's classic arcade game *Tempest*. The player controls a character at the mouth of a long tunnel that appears to start at the screen in first-person view and diminishes into the distance. We'll use the trig functions and some 3D manipulation to construct the game environment and move the various components of gameplay.

The SimpleTunnelShooter Example

The support files for this exercise are in the Chapter 10 folder on the website; the main file is SimpleTunnelShooter.fla. All the class files for it are in the *tunnelshooter* package. This is to eliminate any interference with other examples from this chapter, as well as to demonstrate the use of packages for keeping code isolated and organized.

The Basic Mechanics

The game will generate a tunnel in the shape of an octagon through a series of surface *tiles* positioned in 3D space. We must have enough tiles to create a sense of depth, as though the tunnel extends a long distance. The player will move the character around the edges; each side of the tunnel is a "step." Enemies will be generated at the far end of the tunnel and moved toward the player over time.

The Classes

We will utilize five classes for this example:

 Game.as—Controls the input and interaction with the other components; it is the main "engine."

- Tunnel.as—A DisplayObject that manages construction of the 3D tunnel and facilitates interaction with the tiles that make up the sides of the tunnel.
- TunnelTile.as—A DisplayObject that will be distorted in 3D space and used in conjunction with other tiles to simulate the 3D surface of the tunnel.
- Enemy.as—The class defining enemy objects that will be created at one end of the tunnel and moved toward the opening.
- Player.as—Actually just a *stub* class; it has no code for this example other than to establish a link between a symbol in the library and will be used later to bestow interactive abilities to the player object.

We'll work with these classes from the inside out, starting with the Tunnel, TunnelTile, and Enemy classes, and then pull all of them together in the Game class.

The Tunnel Class

To create the illusion of depth, we'll create a three-dimensional surface from multiple flat objects, or tiles. Because it doesn't need access to multiple frames, Tunnel extends the Sprite class:

```
public class Tunnel extends Sprite {
  protected var _radius:Number;
  protected var _sides:int, _depth:int;
  protected var _tileWidth:Number, _tileHeight:Number;
  protected var _tunnelTiles:Array;
  protected var _highlightIndex:int = -1;
```

There are some basic properties we will need to track during and after creation of the tunnel. Even though it is not a circle, the radius will keep track of the distance of each tile from the center of the tunnel. We also need to know the number of sides the tunnel has, as well as how many tiles deep it extends. The *_tunnelTiles* array will keep track of all the tiles so they can be referenced later. Finally, the *_highlightIndex* property will be used later when we want to light up a set of tiles.

```
public function Tunnel(radius:Number, depth:int=10,
sides:int=8){
   _radius = radius;
   _sides = sides;
   _depth = depth;
   createTunnel();
}
```

In the constructor, we pass the radius of the tunnel, as well as how many tiles deep and around the tunnel is. After that, we call *createTunnel* which we will look at next:

```
protected function createTunnel():void {
 _tunnelTiles = new Array();
 var tempTile:TunnelTile = new TunnelTile();
 _tileHeight = tempTile.height;
 _tileWidth = (_radius * Math.tan(Math.PI/_sides)) * 2;
 var angle:Number = (Math.PI * 2)/_sides;
 for (var j:int = 0; j < depth; j + +) {
   var tileSet:Array = new Array();
   for (var i:int = 0; i < \_sides; i + +) {
     tempTile = new TunnelTile();
     tempTile.width = _tileWidth;
     tempTile.x = Math.cos(i*angle) * _radius;
tempTile.y = Math.sin(i*angle) * _radius;
     tempTile.z = j * _tileHeight;
     tempTile.rotationX = 90;
     tempTile.rotationZ = i
Math.round(radiansToDegrees(angle)) + 90:
     var ct:ColorTransform = tempTile.transform.
colorTransform:
     ct.redMultiplier *= (_depth-j)/_depth;
     ct.greenMultiplier *= (_depth-j)/_depth;
     ct.blueMultiplier *= (_depth-j)/_depth;
     tempTile.transform.colorTransform = ct:
     tileSet.push(tempTile);
     addChild(tempTile);
   _tunnelTiles.push(tileSet);
```

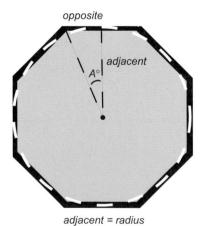

Figure 10.15 We can break the shape down into right triangles in order to use trig functions to determine missing values.

 $A = \pi / 8$ (number of sides)

This method is at the heart of this class. We start by determining the height and width each tile will have to be for the sides to meet all the way around the tunnel. We assume the artwork for each tile will dictate the height of the tile; in order to maintain the illusion of depth, the pieces will ultimately be taller than they are wide. To determine the width of each tile, we will need to refer back to the trig functions from earlier in this chapter. Since we are building our tunnel to have eight sides, we'll use that as our visual reference.

Look at Figure 10.15. Note the white dashed line that represents the virtual circle that touches the center points of all the sides of the octagon. The radius of this imaginary circle is the value passed into the Tunnel constructor. To learn the value of angle A, we divide π (which is half the angle value of a circle) by the number of sides. Since we now know an angle and one side, the best trig function to use is *tangent*. Recall from earlier in the chapter that:

tan A = opposite/adjacent

So, it follows that to find the opposite side's value, we rearrange the equation as:

```
opposite = adjacent* tan A
```

However, this will only give us half the width of a side, so we need to multiply it by 2, as well; thus, we have the line:

```
_tileWidth = (_radius * Math.tan(Math.PI/_sides)) * 2;
```

Before we start the loops that create the tiles, we need to know the angle value associated with each side so we can place the tiles. This is simply the entire angle value of the circle (2π) in radians, divided by the number of sides (8):

```
var angle:Number = (Math.PI * 2)/ sides:
```

Now that we have the information we need to place the tiles around the center of the tunnel, we need to run through two loops to create a multidimensional array. Each layer of eight tiles will be its own array, stored in a larger array:

Each time the outer loop runs, a new tile set is created that the inner loop will fill. That tile set is then added to the larger _tunnelTiles array:

```
tempTile = new TunnelTile();
tempTile.width = _tileWidth;
```

In the inner loop, we create a new TunnelTile object and set its width to the predetermined value. Next we need to position it around the center point. We can once again break a side down into right triangles. We know the hypotenuse to be the value of the radius and the angle is the value formed between the center points of any two connecting sides, as shown in Figure 10.16.

```
tempTile.x = Math.cos(i*angle) * _radius;
tempTile.y = Math.sin(i*angle) * _radius;
tempTile.z = j * _tileHeight;
```

The value of i is the current side of the tunnel we're dealing with, from 0 to 7. We multiply it by the angle value associated with each side and use the sine and cosine functions to position the tile's x and y coordinates. We then use the current depth level, represented by j, to position the tiles down the z-axis. Now the tile is positioned, but it would still

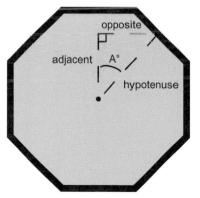

hypotenuse = radius

Figure 10.16 We know the value of the hypotenuse and the angle found between each side.

appear to be a flat shape on the Stage. We must rotate it in 3D space:

```
tempTile.rotationX = 90;
tempTile.rotationZ = i * Math.round(radiansToDegrees(angle)) + 90;
```

We rotate the tile along its *x*-axis to turn it parallel to the tunnel; one end of the tile will now appear closer than the other. Next we rotate it along the *z*-axis so each tile faces the center of the tunnel. We convert the angle from radians to degrees (using a function we'll cover momentarily) and add 90. This is to compensate for having rotated the tile along its *x*-axis already; without it, the tiles will align perfectly perpendicular to the stage and will disappear from view. Now the tile is ready to use:

```
tileSet.push(tempTile);
addChild(tempTile);
```

We add the tile to the tileSet array (which will get added to _tunnelTiles) and then to the display list. If we were to stop here, the tunnel would work just fine, but there's no real sense of depth, since Flash's 3D capabilities do not include any form of lighting. However, we can manually adjust this using a ColorTransform:

```
var ct:ColorTransform = tempTile.transform.colorTransform;
ct.redMultiplier *= (_depth-j)/_depth;
ct.greenMultiplier *= (_depth-j)/_depth;
ct.blueMultiplier *= (_depth-j)/_depth;
tempTile.transform.colorTransform = ct;
```

For the tunnel to look like it is truly diminishing from the player's point of view, the mouth of the tunnel should look like the main light source. The light should therefore fall off as the tunnel descends. We can achieve this effect by multiplying the red, green, and blue values of each tile's *colorTransform* object by how deep the tile is. Note that you can't operate directly on an object's colorTransform. You must assign it to a variable, which makes a copy, modify the copy, and assign it back to the object. All transforms in ActionScript work this way. We've now created the tunnel and its entire tile set. Let's look at a few of the other functions the tunnel uses, including one that was mentioned earlier:

```
protected function radiansToDegrees(value:Number):Number {
  return value * (180/Math.PI);
}
protected function degreesToRadians(value:Number):Number {
  return value * (Math.PI/180);
}
```

These two functions simply perform the conversion from radians to degrees and *vice versa* that we covered earlier in this chapter. For purposes of simplicity, they're included in this class, but

the smartest way to utilize them would be as static methods of a math utilities class:

```
public function get radius():Number {
  return _radius;
}

public function get sides():int {
  return _sides;
}

public function get depth():int {
  return _depth;
}

public function get tunnelTiles():Array {
  return _tunnelTiles;
}
```

Each of these getter functions provides easy access to various properties of the tunnel without making them writeable. One could argue that the tunnelTiles getter should return a copy of the tunnel array, not the original, but since you would also have to copy all the arrays inside it as well, it is not a very efficient way to manage the list. It is better to just be mindful that any edits made to the tunnelTiles list could break the tunnel's functionality of appearance.

```
public function highlightSide(angle:Number):void {
  if (angle < 0) angle - Math.PI*2 | angle;
  var index:int = Math.round((angle * _sides)/(Math.PI * 2));
  if (_highlightIndex == index) return;
  for (var i:int = 0; i < _tunnelTiles.length; i++) {
    if (_highlightIndex >= 0) _tunnelTiles[i]
  [_highlightIndex].deactivate();
    _tunnelTiles[i][index].activate();
  }
  _highlightIndex = index;
}
```

The final method in the Tunnel class is one that will be of particular use to the Game class. It allows an entire side (from the top to the bottom) to be highlighted, or lit up. This will be useful if we need to point out which side the player is currently on or if we need to notify the player of an enemy on a particular side. It accepts an angle as a parameter to match with its corresponding side. If the angle is negative, we convert it to its positive equivalent by adding 2π (or 360°). Once we know which side is correct, and if it is not already highlighted, we loop through the list from top to bottom to call the *activate* method of each tile and the *deactivate* method of any tiles that were previously highlighted. Afterwards, we set the value of *_highlightIndex* to the currently selected side for reference later.

Techie Note

You may have noticed that there is one method I didn't discuss. It is the getRandomColor method, and it does exactly that. It returns a randomly generated ColorTransform object that can be applied. I created it as an experiment when writing this class, and though it didn't produce the results I was looking for it is very interesting and might prove helpful if you want to do something with colored tiles or any other type of color generation.

Next, we'll look at the TunnelTile class, which the Tunnel class utilized to build itself. Since the class is pretty short, we'll look at it in its entirety and then explain each method:

```
public class TunnelTile extends MovieClip {
  private var _highlightedTransform:ColorTransform;
  private var _normalTransform:ColorTransform;

  public function TunnelTile() {
    if (!_normalTransform) _normalTransform = transform.

    colorTransform;
    if (!_highlightedTransform) createHighlight();
        transform.colorTransform = _highlightedTransform;
    }

  public function deactivate() {
        transform.colorTransform = _normalTransform;
    }

    private function createHighlight() {
        _highlightedTransform = transform.colorTransform;
        _highlightedTransform.redOffset = _highlightedTransform.
     greenOffset = _highlightedTransform.blueOffset = 50;
    }
}
```

The constructor for this class does nothing, as the Tunnel is responsible for placing and manipulating each tile. The methods here mainly deal with activating and deactivating the highlight effect for the tile, as evidenced by the method names *activate*, *deactivate*, and *createHighlight*. The first time a tile is activated, it stores its normal color transform (the one given to it by the Tunnel class) in a private variable for future reference. It also creates a highlighted version of that transform, which is done by offsetting all the color values by 50. This creates a tint effect, as though the tiles were overlaid with white. That way, when *activate* is called, the tint transform is used, and *deactivate* returns the transform to its previous state.

The last class to examine before we begin dissection of the gameplay is the Enemy class. It is also very simple, though further functionality could easily be added:

```
public class Enemy extends MovieClip {
  public var index:int;
  protected var _brightness:Number;

  public function Enemy(index:int) {
    this.index = index;
  }

  public function get brightness ():Number {
    return _brightness;
  }

  public function set brightness (value:Number):void {
    _brightness = value;
    var ct:ColorTransform = transform.colorTransform;
    ct.redMultiplier = ct.greenMultiplier = ct.
  blueMultiplier = _brightness;
    transform.colorTransform = ct;
  }
}
```

Since an enemy in this style of game generally sticks to one side of the tunnel, we keep track of which side through the *index* property, which is passed in when the enemy is created. The other method is a getter/setter combo that set the brightness value of the enemy's colorTransform. This has the opposite effect of the tint we used on the tiles. It will allow us to make the enemy darker the farther down the tunnel it is and make it brighter as it approaches the player.

We are now ready to look at the Game class, and the logic that will control the player and the enemies:

```
public class Game extends Sprite {
  static public var tunnelSize:Number = 175;
  static public var tunnelDepth:int = 8;
  static public var tunnelSides:int = 8;
  static public var enemyFrequency:Number = 3;
  static public var enemyTime:Number = 5;

  protected var _tunnel:Tunnel;
  protected var _player:Player;
  protected var _angleIncrement:Number;
  protected var _enemyFrequency:Number;
  protected var _enemyTime:Number;
  protected var _enemyCreator:Timer;
  protected var _enemyList:Dictionary;
```

The class starts out with some static variables; think of these as game settings. We use variables instead of constants because we might want to be able to change these values gradually at runtime. You'll probably recognize the first three as components of the Tunnel class, which the Game class will have to create. The next

two relate to the creation of enemies. The *enemyFrequency* is the rate in seconds at which enemies are created, and the *enemyTime* is the amount of time (also in seconds) it takes for an enemy to move from the bottom of the tunnel to the top. We also declare some protected variables we will use later on, such as references to the Tunnel, Player, and list of enemies. You'll notice we also duplicate two of the static variables as protected instance variables. This protects these values from changing in the middle of the game by an outside source. These values will be assigned in the constructor and then are only adjustable from inside the class. We'll look at the constructor next:

```
public function Game(){
    _tunnel = new Tunnel(tunnelSize, tunnelDepth, tunnelSides);
    addChild(_tunnel);
    _player = new Player();
    addChild(_player);
    _angleIncrement = 2 * Math.PI/tunnelSides;
    _enemyFrequency = enemyFrequency;
    _enemyTime = enemyTime;
    _enemyCreator = new Timer(_enemyFrequency*1000);
    _enemyCreator.addEventListener(TimerEvent.TIMER, addEnemy, false, 0, true);
    _enemyList = new Dictionary(true);
}
```

The constructor sets up a new Tunnel object, a Player object, and sets up the Timer object that will release new enemies using the *addEnemy* method. Now we'll look at the methods that start the game and control player movement:

```
public function startGame():void {
 _enemyCreator.start();
 addEventListener(Event.ENTER_FRAME, frameScript, false, 0,
true):
protected function frameScript(e:Event):void {
 movePlayer();
protected function movePlayer():void {
 var mouseAngle:Number = Math.atan2(mouseY, mouseX);
 var roundedAngle:Number = _angleIncrement
Math.round(mouseAngle/_angleIncrement);
 _player.x = _tunnel.radius * Math.cos(roundedAngle);
 _player.y = _tunnel.radius * Math.sin(roundedAngle);
 var oldRotation:Number = _player.rotation;
 _player.rotation = roundedAngle * (180/Math.PI) + 180;
 if (oldRotation != _player.rotation)
_tunnel.highlightSide(roundedAngle);
```

When *startGame* is called, the Timer object is started to create new enemies and a frame script is attached to the *enterFrame*

event. This *frameScript* method simply calls *movePlayer*, which reads the position of the mouse around the center of the tunnel and adjusts the Player's *x* and *y* position accordingly to stay along the outside edge. It also rotates the Player so it is always pointing inward toward the tunnel. If the player moves to a new side, that side of the tunnel is highlighted using the methods we looked at earlier.

```
protected function addEnemy(e:TimerFvent):void {
 var index:int = Math.round(Math.random()*(_tunnel.sides-1));
 var enemy:Enemy = new Enemy(index);
 enemy.x = _tunnel.tunnelTiles[0][index].x;
 enemy.y = _tunnel.tunnelTiles[0][index].y;
 enemy.z = _tunnel.tunnelTiles[_tunnel.depth-1][index].z;
 enemy.rotation = index * (360/_tunnel.sides)-180;
 enemy.brightness = .5;
 addChildAt(enemy, getChildIndex(_player));
 _enemyList[enemy] = enemy;
 var tween:TweenLite = TweenLite.to(enemy, _enemyTime,
{z:0, brightness:1, ease:Quad.easeIn, onComplete:
enemyMovementFinished, onCompleteParams:[enemy]});
protected function enemyMovementFinished(target:Enemy):void {
 removeChild(target):
 delete _enemyList[target];
```

The addEnemy function picks a side at random, creates a new Enemy object, and positions it on that side, at the bottom of the tunnel. It also sets the enemy to start out at half brightness so it will be visible but blend in much more with the tiles. Once the enemy has been added, a new tween is created using TweenLite (covered in Chapter 6), which will animate the enemy from bottom to top over the time we specified earlier. Once the tween is complete, enemy-MovementFinished is called. At the moment, all it does is remove the enemy from memory, but in a full game it would contain additional logic to cause damage when it hit if the player was not on that side or deduct points from the player's score. The enemy motion could also be handled by a *moveEnemies* method that decrements the enemy's z position over time, but the current technique has two big plusses going for it. First, it is *much* easier to implement—one line of code vs. several. Second, and even more importantly, using a tween gives much greater motion control. Notice that the tween uses an easeIn function on the animation, which will make the enemy slowly accelerate as it moves. This effect would be much more troublesome to write manually and with very little return.

All of the necessary classes for this iteration of the game have been completed. Now it is time to implement with actual assets. If you open the SimpleTunnelShooter.fla file, you'll find some clips in the library that will be used by the classes. These include the Enemy clip, the Player clip, and the TunnelTile clip. There is also a bitmap used for the tile texture. I chose a brick because it has a nice effect along the seams, but most any texture would work for the tunnel and some might even stitch together more cleanly.

The only thing on the timeline is the script necessary to instantiate a game and start it. This could also be done with a document class for the FLA, but for simplicity and since this isn't a full game the timeline suffices just fine:

```
import tunnelshooter.*;
var game:Game = new Game();
game.x = 275;
game.y = 200;
addChild(game);
game.startGame();
```

That's it! We're done with this example. When published, the end result should look something like Figure 10.17.

Figure 10.17 The completed tunnel shooter example.

Although this is by no means a complete game, it contains numerous examples of how the trig functions can be used to manipulate objects in two- and three-dimensional space. Here are some ideas on functionality that would enhance this game:

- Continually increasing the speed of enemy creation
- Players being able to either catch enemies or shoot at them
- Subtle rotation or distortion of the entire tunnel over time to create player disorientation
- Multiple types of enemies
- Other shapes of tunnels (eight sides work well for performance reasons, but many more could be used)

This concludes Part 1 of this chapter. We will continue to apply these concepts moving forward into our discussion of physics, as well as in upcoming chapters as we delve into more complex game mechanics.

PART 2 Physics

The correct name for this half of the chapter really should be two-dimensional, algebraic physics, since that's all we're going to cover for our purposes. Physics is, among other definitions, the science of the behavior and interaction of objects in the universe around us. These include concepts such as force, mass, and energy. The field of physics is a vast area of study, and this chapter will focus on one specific branch of it known as *mechanics*. Even more specifically, we will be looking at *classical mechanics*, which, among other things, deals with the interactions between objects in our visible, physical world. In the upcoming section, we will cover the concepts behind basic mechanics and how to apply them in games. To start out, we need to establish some standardized vocabulary.

Scalar

A scalar is simply a number in traditional mathematical terms. In physics applications, it can represent a magnitude such as speed—for example, 4 miles per hour (4 mph). There is no information about the direction or orientation of an object traveling at that speed.

Vector

In contrast to a scalar, a vector contains information about both the magnitude of a physical element as well as its direction. The direction component is a numeric angle value, but in conversation it is often referred to in looser terminology. For instance, the vector form of the scalar example above could be something like "4 miles per hour, heading northwest," although we would not necessarily be able to do any calculations with that information until we assigned it a number.

The Vector3D Class

Among the new classes in Flash CS4 for handling complex math more efficiently is the new Vector3D class. It is the code

representation of the *vector* concept we learned about earlier. It contains x, y, and z values to determine its magnitude and a fourth value, w, which stores information about the vector's direction, such as an angle. We will look at an example shortly where we will use the Vector3D class to simplify some vector math.

Techie Note. Vector vs. Vector3D

There is another new class in Flash CS4 known as Vector. It has nothing to do with vectors in physics terms. Rather, it is a special type of array that stores only one type of value and uses less memory than an array by doing so. For example, if you used arrays of numbers in previous versions of Flash, you can now use a vector instead. It has all the same methods and properties of arrays but is faster to navigate and more efficient. The name "vector" comes from the C programming language, but really you can just think of it as a *typed* array.

Displacement

Displacement is most easily thought of as the distance between any two points in space when connected by a straight line. Though technically a vector, we generally think of displacement in terms of a scalar. That is to say, we don't usually consider the direction of one object relative to another when computing their distance apart from each other. It would be odd to refer to the distance from one's self to a nearby table as "4 feet, 30 degrees from my facing direction." We simply say "4 feet."

Velocity

Displacement over a period of time results in what we know as *speed*. For example, if it takes me an hour to walk 5 miles, my speed is 5 miles per hour (5 mph). However, as discussed above, this is merely a scalar value, as it has no directional information. If we add a direction, such as 90°, we get the vector of *velocity*. The formula for determining velocity, where v = v velocity, d = displacement, and t = time, is:

$$v = d/t$$

Acceleration

If we change the velocity of an object over time (whether increasing or decreasing), we create that object's *acceleration*. For the sake of clarity, acceleration can be either a positive or negative change, but we usually refer to an acceleration that results

in a lower velocity, or slowing down, as a *deceleration*. The formula for acceleration, where a = acceleration, v = velocity, and t = time is:

a = v/t

A naturally occurring example of acceleration that we are all familiar with is that of gravity, the force pulling us downward toward the Earth's center. The magnitude of gravity on Earth is approximately 9.8 meters per second.

Friction

When two surfaces are in contact with each other, the resistance between the two is known as friction. Each surface has a property unique to it known as the coefficient of friction. Simply put, it describes the smoothness or roughness of a surface—the higher the number, the more friction that surface generates. Sandpaper, for example, would have a much higher coefficient of friction than a material like ice. The energy that is lost due to friction is converted to heat, which explains why rubbing your hands together eventually warms them. However, for our purposes, all you really need to understand about friction is its degrading affect on velocity and acceleration. An object's coefficient of friction often has to be determined through trial and error when programming. For example, the value for the friction of a rolling ball in the real world might not work effectively in a game. The important thing to remember is that none of the values must be set in stone—you can change them as needed to suit gameplay.

Inertia

The counterpart to friction, inertia is an object's resistance to change that causes it to either want to stay at rest or keep moving. Without friction, static objects would never be able to gain traction, thus remaining still, and moving objects would never be able to come to a stop. You can feel the sensation of inertia when inside an elevator or vehicle that comes to a sudden stop; your body can feel for a moment like it is still moving.

Simulation vs. Illusion

It's important to remember that as fast as ActionScript 3 and the Flash Player are, they still are not powerful enough to run a truly realistic physics simulation. Some open-source implementations of simple physics engines have been written, but most have severe limitations compared to what is possible in software that is written much closer to the hardware level than Flash. However, this is not to say that these engines, or even the relatively simple code we will write shortly in this chapter, are not effective at conveying the *illusion* of physical reactions. Indeed, we will see that even a bare-bones implementation of physics can be effective at suspending disbelief for the purposes of a game.

Reality vs. Expectations

Another point that some developers get hung up on when trying to emulate physics in Flash is striving for real-world values and reactions. While this is admirable, it often yields unsatisfactory gameplay. Take, for example, a platform game with multiple levels the player can move between by jumping and dropping. If you were to apply the rather harsh realities of the effects of gravity and friction on moving bodies, the game would become impossibly hard. This is because a realistic simulation factors out human response time. It is hard for people to stop themselves from falling over in real life once the process begins—it would be practically impossible using a keyboard and mouse. Characters in games have often jumped farther, run faster, and controlled themselves in mid-air unlike how real humans would ever be able to maneuver. This is okay; as I mentioned before, it only takes so much to suspend a player's disbelief. Part of achieving effective physics in games is knowing what the player will expect to happen, rather than simply trying to mimic the world precisely. We will explore this more through the following examples.

Example: A Top-Down Driving Engine

Modern driving games for computers and consoles employ a *lot* of physics. All sorts of aspects, such as road conditions, gear ratios, tire materials, and chassis weights, factor into the math behind these simulations, and the result (depending on the game) is a fairly accurate representation of real-world physics. For the purposes of most Flash games, however, what we are about to create will suffice for a very satisfactory driving experience. This example is divided into two classes: the Vehicle class, which defines the properties of the car, and the Game class, which handles input and manipulates the car's position and rotation. There is also an additional utility class called Time that will prove handy both here and elsewhere in later examples. The files for this example are in the Chapter 10 folder: DrivingSim and the drivingsim package. The end result will use the arrow keys to steer, accelerate, and reverse and the space bar to do a hard brake stop.

The Vehicle Class

This class will define all the basic properties of the car we'll see on screen. It starts with a number of constant and variable declarations:

```
static public const maxAcceleration:Number = 100;
static public const maxSpeed:Number = 350;
static public const maxSteering:Number = Math.PI/40;
static public const accelerationRate:Number = 50;
static public const handBrakeFriction:Number = .75;
static public const stoppingThreshold:Number = 0.1;
```

The first values set are the maximum acceleration and speed per second, followed by the maximum turning radius. Adjusting these three values yields a very different experience, and you could easily make them instance variables instead of static constants, thereby allowing different cars to have different behavior. We also define the rate of acceleration, meaning how many units we can increase our acceleration per second. Next we set the amount of friction the hand brake applies to the speed of the car. In this case, as long as the hand brake is being held, the car will slow to 75% of its current speed. The last constant is called the *stoppingThreshold*, which is the value below which the game will round the speed down to zero. This is present because, when multiplying a number between 0 and 1, the result will gradually get closer to zero, but never reach it.

```
protected var _speed:Number = 0; //PIXELS PER SECOND
protected var _acceleration:Number = 0; //PIXELS PER SECOND
protected var _angle:Number = 0; //ANGLE IN RADIANS
```

Next come three protected variables for speed, acceleration, and the angle of the car, all initially set to zero. Our constructor is empty for this example, so we'll skip it and move on to the three getter/setter function pairs that will complete this class:

```
public function get angle():Number {
  return _angle;
}

public function set angle(value:Number):void {
  _angle = value;
  rotation = _angle * (180/Math.PI);
}
```

These functions expose the protected *_angle* variable and also set the visible rotation of the car sprite on screen:

```
public function get speed():Number {
  return _speed;
}

public function set speed(value:Number):void {
  _speed = Math.max(Math.min(value,maxSpeed),-maxSpeed);
  if (Math.abs(_speed) < stoppingThreshold) _speed = 0;
}</pre>
```

For the speed property, because it can be negative or positive, we use the Math min() and max() methods to force restrictions on how high or low the speed can go. This is also where we employ the stoppingThreshold property to truncate the speed if it becomes infinitesimally small:

```
public function get acceleration():Number {
  return _acceleration;
}

public function set acceleration(value:Number):void {
  _acceleration = Math.max(Math.min(value,maxAcceleration),
  -maxAcceleration);
}
```

Much like the speed methods, we use min() and max() again to set the limits for the acceleration property. That is all that is required in the Vehicle class for now.

The Time Class

Before we move on to the Game class, we should take a quick look at a helpful utility class that the game will use. Since Flash is a frame-based environment and therefore dependent on the machine it is running on maintaining a consistent frame rate, it's a good idea to have a way to enforce accuracy in our calculations regardless of the number of frames actually being processed. It is also often easier to think of units like speed and acceleration in terms of seconds rather than frames. To gain this accuracy, we need to know how much actual time has transpired between frames. This change in time is often referred to as *delta time*. This value can be obtained within a couple of lines using the *getTimer* method in the flash.utils package. We could have just written these lines into the Game class, but because it has so many applications it's better to write it once in a class and reference it there from now on.

Techie Note. getTimer

This method has been around since Flash 4 and still proves its usefulness to this day. It returns the number of milliseconds that have passed since the Flash Player started running. It is perfect for calculating time spent between frames or any other pair of events. It should be noted that you cannot rely on the method to return a specific number or always start from 0. If multiple instances of the Flash Player are open, they all share the same value, and whichever one opened first started at 0.

We'll look at this class in a single pass, as it is relatively short:

```
package drivingsim {
 import flash.display.Sprite:
 import flash.events.Event;
 import flash.utils.getTimer;
 public class Time extends Sprite {
   static private var _instance:Time = new Time();
   static private var _currentTime:int;
   static private var _previousTime:int;
   public function Time() {
    if (instance) throw new Error("The Time class cannot be
instantiated."):
    addEventListener(Event.ENTER_FRAME, updateTime, false,
0. true):
       _currentTime = getTimer();
   private function updateTime(e:Event):void {
       _previousTime = _currentTime;
       _currentTime = getTimer();
   static public function get deltaTime():Number {
       return (_currentTime-_previousTime)/1000;
```

This class instantiates a single instance of itself in memory and prevents any other instantiations. The one static, public method it has is a getter for *deltaTime*. Every frame cycle, the class updates the current and previous times so at any moment it is ready to return an accurate delta. Since I like to work in seconds rather than milliseconds, I divide the difference by 1000 when I return it. This could easily be modified to return milliseconds instead, if that's what you prefer. It's mainly important to pick a convention and stick with it. We'll now look at how this class is used in the Game class.

The Game Class

Now we've come to the core of the functionality and the math that we'll need to employ. The Game class also functions as the document class for the accompanying FLA. The class starts out with just a few declarations:

```
protected var _leftPressed:Boolean;
protected var _rightPressed:Boolean;
protected var _upPressed:Boolean;
protected var _downPressed:Boolean;
protected var _spacePressed:Boolean;
protected var _friction:Number = .95;
```

There are Boolean values for each key we'll use so we can know whether or not that key is being pressed. There is also a value for friction or, rather, the coefficient of friction of the surface the vehicle will be driving on. This value will cause the vehicle to slow down when it is not accelerating:

```
public function Game() {
   addEventListener(Event.ADDED_TO_STAGE, addedToStage, false,
0, true);
}
private function addedToStage(e:Event):void {
   startGame();
}

public function startGame():void {
   addEventListener(KeyboardEvent.KEY_DOWN, keyDown, false, 0,
   true);
   addEventListener(KeyboardEvent.KEY_UP, keyUp, false, 0,
   true);
   addEventListener(Event.ENTER_FRAME, gameLoop, false, 0,
   true);
}
```

When the game is added to the Stage, it triggers startGame. This method sets up listeners for both keyboard input and the enterFrame cycle. We'll look at the keyDown and keyUp methods next:

```
protected function keyDown(e:KeyboardEvent):void {
  if (e.keyCode == Keyboard.LEFT) _leftPressed = true;
  if (e.keyCode == Keyboard.RIGHT) _rightPressed = true;
  if (e.keyCode == Keyboard.UP) _upPressed = true;
  if (e.keyCode == Keyboard.DOWN) _downPressed = true;
  if (e.keyCode == Keyboard.SPACE) _spacePressed = true;
}

protected function keyUp(e:KeyboardEvent):void {
  if (e.keyCode == Keyboard.LEFT) _leftPressed = false;
  if (e.keyCode == Keyboard.RIGHT) _rightPressed = false;
  if (e.keyCode == Keyboard.UP) _upPressed = false;
  if (e.keyCode == Keyboard.DOWN) _downPressed = false;
  if (e.keyCode == Keyboard.SPACE) _spacePressed = false;
}
```

These two functions simply toggle the different Boolean values to either true or false as keyboard input is received:

```
protected function gameLoop(e:Event):void {
  if (stage.focus != this) stage.focus = this;
  readInput();
  moveVehicle();
}
```

Because we're dealing with keyboard input, which automatically focuses on the Stage, on each frame cycle we make sure that the game still has focus, even if the player were to click somewhere

else on the screen. The class then calls *readInput* and *moveVehi-cle*, both of which we'll look at next:

```
protected function readInput():void {
  if (_upPressed) vehicle.acceleration += Vehicle.
accelerationRate * Time.deltaTime;
  if (_downPressed) vehicle.acceleration -= Vehicle.
accelerationRate * Time.deltaTime;
  if (!_upPressed && !_downPressed) vehicle.acceleration = 0;
  if (_rightPressed) vehicle.angle += (Vehicle.maxSteering *
  (vehicle.speed/Vehicle.maxSpeed));
  if (_leftPressed) vehicle.angle -= (Vehicle.maxSteering *
  (vehicle.speed/Vehicle.maxSpeed));
  if (_spacePressed) {
    vehicle.speed *= Vehicle.handBrakeFriction;
    vehicle.acceleration = 0;
  }
}
```

This method runs through all the key-related Boolean values. If the up or down arrows are pressed, it applies acceleration. If the right and left arrows are pressed, it applies steering based on the speed of the vehicle. Finally, if the space bar is pressed, it applies the hand brake friction to the vehicle's speed and resets any acceleration:

```
protected function moveVehicle():void {
  if (!vehicle.acceleration) vehicle.speed *= _friction;
  vehicle.speed += vehicle.acceleration;
  vehicle.x += Math.cos(vehicle.angle) * (vehicle.speed *
Time.deltaTime);
  vehicle.y += Math.sin(vehicle.angle) * (vehicle.speed *
Time.deltaTime);
}
```

Although only four lines, this method does a great deal. First, it applies friction to the vehicle's speed if it is not accelerating; not doing so would cause the vehicle to continue moving as though it were on a very slick surface. The vehicle's speed is then increased by its acceleration. The last two lines then compute the vehicle's new *x* and *y* coordinates based on the angle the car is facing and the speed at which it is traveling. Note that both this method and the readInput method make use of the Time.deltaTime property to only apply the speed that is necessary for the amount of time that has passed. By using this method, the frame rate of the SWF can now change, either deliberately or accidentally, without consequence to the responsiveness of the simulation.

If you open the FLA file associated with this example and run it, you will see the vehicle instance on the Stage is now controllable with the arrow keys and space bar. This is just the foundation for a game—it has no collision detection, computer AI, or even goals. One other thing to note about this example is that the car moves like it has the best tires ever made and can turn on a dime.

While this is okay and might work perfectly for certain scenarios, the simulation could be a little more realistic with the addition of the ability to drift the car, essentially making the motion of the car continue in the direction it was previously traveling. Let's look at how we could achieve that now.

Example: Top-Down Driving Game with Drift

In the previous example, we applied the acceleration directly to the speed of the car without taking into account the *direction* of the acceleration. Remember earlier how we learned that vectors have both a magnitude and a direction? If we make both the acceleration and velocity of the car into vectors, we'll gain more realistic behavior when we combine them. Since this is just a modification of the previous example, I won't cover any sections of the code that haven't changed. The files for this example are in the Chapter 10 folder; the FLA is DrivingSimDrift, and the associated package is called drivingsimdrift. Let's start by looking at the changes to the Vehicle class:

```
static public const maxSpeed:Number = 350;
static public const maxSteering:Number = Math.PI/30;
static public const maxAcceleration:Number = 400;
static public const handBrakeFriction:Number = .75;
static public const stoppingThreshold:Number = 0.1;
protected var _velocity:Vector3D = new Vector3D();
protected var _acceleration:Vector3D = new Vector3D();
protected var _angle:Number = 0;
```

We still have the maxAcceleration, maxSpeed, and maxSteering constants, but the values have changed some. Like the previous example, these values are determined through experimentation and are completely subject to change depending on what kind of handling you want the car to have. The two other major changes are that the speed value has been replaced by velocity and is now of type Vector3D. Acceleration keeps its name but is also a Vector3D. These changes obviously affect their getter/setter functions:

```
public function get velocity():Vector3D {
   return _velocity;
}

public function set velocity(value:Vector3D):void {
   _velocity = value;
   if (_velocity.length > maxSpeed) {
     var overage:Number = (_velocity.length-maxSpeed)/maxSpeed;
   _velocity.scaleBy(1/(1 + overage));
}

if (_velocity.length < stoppingThreshold) {
   _velocity.x = _velocity.y = 0;
}
</pre>
```

```
public function get acceleration():Vector3D {
  return _acceleration;
}

public function set acceleration(value:Vector3D):void {
  _acceleration = value;
}
```

While the acceleration functions are not much different than you would expect, the velocity setter has changed significantly. To enforce a top speed and the stopping threshold, we must measure the *length* of the vector, which is another term for its magnitude. If the length property is greater than the top speed, we scale the entire vector by the amount of the overage. This will adjust the *x* and *y* properties of the vector in a single line instead of having to do them separately. If the length property is less than the stopping threshold, we also set the *x* and *y* properties to 0. We could have also scaled the vector by 0, but a simple variable assignment is less overhead than performing calculations on all the properties of the vector. Next let's look at the changes to the Game class. Only the readInput and moveVehicle methods have changed, so that's all we'll address here:

```
protected function readInput():void {
 vehicle.acceleration = new Vector3D();
 if (_upPressed) {
   vehicle.acceleration.x += Math.cos(vehicle.angle) *
Vehicle.maxAcceleration * Time.deltaTime
   vehicle.acceleration.y += Math.sin(vehicle.angle) *
Vehicle.maxAcceleration * Time.deltaTime;
 if (_downPressed) {
   vehicle.acceleration.x += -Math.cos(vehicle.angle) *
Vehicle.maxAcceleration * Time.deltaTime
   vehicle.acceleration.y += -Math.sin(vehicle.angle) *
Vehicle.maxAcceleration * Time.deltaTime;
 if (_rightPressed) vehicle.angle += (Vehicle.maxSteering *
(vehicle.velocity.length/Vehicle.maxSpeed));
 if (_leftPressed) vehicle.angle -= (Vehicle.maxSteering *
(vehicle.velocity.length/Vehicle.maxSpeed));
 if (_spacePressed) {
   vehicle.velocity.scaleBy(Vehicle.handBrakeFriction);
```

At the onset of the readInput method, we create a new, empty vector object for acceleration. If the up or down arrows are pressed, the vector's *x* and *y* components are adjusted accordingly. If neither is pressed, the acceleration is empty and will have no effect when combined with the velocity. If the space bar

is pressed, the velocity is scaled down by the amount of vehicle hand brake friction:

```
protected function moveVehicle():void {
  vehicle.velocity.scaleBy(_friction);
  vehicle.velocity = vehicle.velocity.add(vehicle.acceleration);
  vehicle.x += vehicle.velocity.x * Time.deltaTime;
  vehicle.y += vehicle.velocity.y * Time.deltaTime;
}
```

When moving the vehicle, we use the friction property to scale the velocity down. We then combine the existing velocity vector with the new acceleration vector. Another way to combine the two would have been the Vector3D incrementBy method, which adds the two relevant vectors without returning a new object. However, in our case, by assigning the result back to the velocity property of the vehicle, it forces it through the maxSpeed check we looked at earlier. If we used incrementBy we would have to do that check manually here. Finally, to adjust the *x* and *y* positions of the vehicle, we increment it by the velocity's *x* and *y* components and the deltaTime property.

If you export this example and test it, you'll notice immediately that the car handles very differently, almost as if it were on ice. When you turn at high speed, the car continues in its original direction for a time before eventually aligning itself with the new direction. This is because by adding the vectors together with discrete x and y values, it takes a few passes of friction scaling to reduce the effect of previous accelerations. Naturally, most cars don't drift the way this one does. With some additional complexity, you could factor in the weight of the car to determine when the car's velocity overcomes its downward force (essentially, the car's traction) and so get the best of both examples.

Review

We've covered a lot of material in this chapter, so let's run through a high-level reminder of everything we've learned:

- The relationship of triangles to angle and distance problems
- The trigonometric functions (sine, cosine, and tangent) and their uses
- The coordinate system inside of Flash, including the new 3D system in Flash CS4
- How to manipulate objects in Flash's 3D space
- How to use perspective projection to create vanishing points
- The difference between scalar and vector values in physics
- The basics of classical mechanics in motion—velocity, acceleration, friction, and inertia

- How to apply simple two-dimensional physics in ActionScript
- How to use the new Vector3D class to simplify the process of combining vectors

There is considerably more material about physics in books and on the Internet to read if you're interested in doing more robust simulations. There are also links to a number of resources on this book's website, flashgamebook.com.

DON'T HIT ME!

If you do much game development, you'll eventually need to determine when two objects on screen are colliding with one another. While Flash does not automatically notify you of this, there are a number of different methods that can be used to detect it. In this chapter, we'll look at several types of collision detection and the scenarios in which they work best. We'll also look at the strategies that can be used with different styles of detection to achieve the desired results.

What You Can Do vs. What You Need

A temptation by some developers, particularly those coming from other game development backgrounds, is to always use the most precise, robust collision detection in all situations. The problem with this approach is the same that we discussed about physics in the last chapter—using more than you need to create an illusion is a waste of effort and computing power that could be used clsewhere. The trick with collision detection is to identify the minimum accuracy you need to achieve a particular effect and then implement a system that works for that scenario. One good reason not to try to develop the end-all collision detection system is that there really isn't one that works best in every possible situation. It's rare that I've used the same technique twice in two games that weren't extremely similar; for example, what works well in a driving game might not make sense in a pinball game. The next several sections outline the different types of detection you can achieve in AS3, with some examples.

hitTestObject—The Most Basic Detection

AS3 provides two methods to developers to detect when DisplayObjects are colliding. The first, and simplest, is *hitTest*

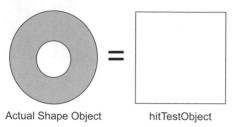

Figure 11.1 A shape object like a circle is still seen as a rectangle with its maximum dimensions by Flash's hit detection engine.

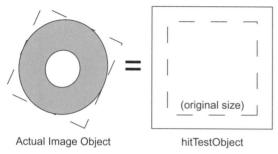

Figure 11.2 Once rotated, an image actually takes up a larger space during collision detection than its actual dimensions.

Object. You can call it on one DisplayObject and pass it another DisplayObject to test against, regardless of location or parental hierarchy. Flash will resolve any differences in coordinate systems. If the two objects are touching, it returns true, otherwise false. Sounds great, right? Unfortunately, there is one big catch. To keep this calculation fast, Flash resolves the two DisplayObjects down to their basic bounding boxes. In other words, even if a shape is very intricate and has large parts that are transparent or void of any data, Flash will see it as a single

rectangle. This is shown in Figure 11.1.

To make matters worse, the bounding box will adjust to whatever size it needs to be to encompass all of the DisplayObject data. If that circle from Figure 11.1 were a bitmap instead of a shape, it would actually be a square because of the transparent parts of the image. If you were to rotate this circle, the bitmap square is now at an angle. Figure 11.2 shows the larger bounding box that Flash will now use to fit this rotated shape.

As a result of these limitations, *hitTestO-bject* is generally the least accurate method of determining a collision. That said, it is

very fast and definitely has its uses. When all you need to know is whether or not two Sprites are overlapping into each other's display space, *hitTestObject* is very effective. If your game has DisplayObjects that can change their distance from the player (i.e., move closer or further away from the player's perspective), you're likely going to have to deal with managing the indices of these objects. If you detect that two objects are touching, you have a great opportunity to check their positions and display indices.

hitTestPoint—One Step Up

In earlier versions of Flash, *hitTestObject* and its counterpart, *hitTestPoint*, were both part of the same method *hitTest*. In AS3, Adobe broke the two up into discrete methods, both for speed and for accurate type checking. Unlike the object version of this method, *hitTextPoint* accepts *x* and *y* coordinates to check if the DisplayObject is overlapping a particular pixel. In fact, when testing against objects that have empty space (not transparent image data like an alpha channel but actually void of data), this method

has the option of accurately telling you if the shape is overlapping the point. Obviously, this method is considerably more accurate than *hitTestObject*, but it only does a single point in space. To test a complex shape against another, you'd need to do this test many times at points all around the shape's outer border. This would quickly become taxing for the processor, particularly if multiple objects are colliding on-screen. It is most commonly used when determining whether or not the mouse coordinates are overlapping a particular shape.

One thing that is important to note about this method is that it expects to receive its coordinates as they would appear on the Stage. If you are testing against a point embedded several DisplayObjects deep in the display list and their coordinate systems do not line up with the Stage, you'll need to convert the coordinates to the Stage's system. Luckily, all DisplayObjects give you a method to do this, called *localToGlobal*. It accepts a Point object and converts it numerically to the Stage coordinate system:

```
var clip1:Sprite = new Sprite();
clip1.x = clip1.y = 50;
var testPoint:Point = new Point(0, 0);
testPoint = clip1.localToGlobal(testPoint);
trace(testPoint); //OUTPUTS X = 50, Y = 50
```

In this short snippet, a Sprite is created on the Stage that has its coordinates set to (50,50). According to the Sprite's coordinate system, its center is at (0,0). By running *localToGlobal* on the Point object, we can see that according to the Stage the center is actually at (50,50).

Another good use for this method is when doing hit tests for vehicles against scenery. You can use a pair of points for the two front bumper ends and a pair for the rear.

As Figure 11.3 illustrates, you can use Sprites to visually mark the points on the car where you want to do a hit test. All you need to do then is to have an identifier separating the front ones from those in the back. If the car backs into something solid, you want it to be able to drive forward to pull away from it but not to be able to back up any farther.

Let's look at a simple example of how this test can be used in practice. You can follow along in the HitTestPoint.fla file in the Chapter 11 examples folder. When you open up the FLA you'll find two objects on the Stage: a square and two long rectangles. The square represents our player character (and is named as such) and the rectangles are part of the same clip called "barriers." Note that the square clip has a number of dots along its outer border; these dots represent collision test points. When the SWF is run, the square will move toward the mouse at a given speed but will not be able to move past the barriers. The code for this example

Figure 11.3 This car has two hit points in the front and two in the rear.

is in three different classes: HitTestPoint.as, HitTestCoordinate.as, and Player.as. We'll start with the Player class:

```
public class Player extends Sprite {
   private var _speed:int = 50;
   private var _hitPointList:Vector.<HitTestCoordinate>;
   public function Player() {
     addEventListener(Event.ADDED_TO_STAGE, addedToStage,
   false, 0, true);
   }
   private function addedToStage(e:Event):void {
     _hitPointList = new Vector.<HitTestCoordinate>();
     for (var i:int = 0; i < numChildren; i++) {
      var child:DisplayObject = getChildAt(i);
      if (child is HitTestCoordinate)
        _hitPointList.push(child);
   }
   public function get hitPointList():Vector.<HitTestCoordinate> {
      return _hitPointList;
   }
   public function get speed():int { return _speed; }
}
```

This class represents the square on the Stage. It has a given speed at which it will move per second (50 pixels) and a vector list of its collision test points. When it is added to the Stage, it enumerates these points in the list. Other than this basic functionality, this class does nothing. Now we'll look at the class behind the collision points:

```
public class HitTestCoordinate extends Sprite {
  private var _point:Point;
  public function HitTestCoordinate() {
    visible = false;
    _point = new Point(x, y);
  }
  public function get point():Point {
    updatePoint();
    return _point;
  }
  public function get pointGlobal():Point {
    return parent.localToGlobal(point);
  }
  private function updatePoint():void {
    _point.x = x;
    _point.y = y;
  }
}
```

This class is designed to be a visual tool for placing collision points so they don't have to be placed manually in code. Any shape could be used to represent them; I chose a circle because it is small and unobtrusive; the shape is ultimately irrelevant because the Sprite hides itself upon creation. It stores a point within itself representing its position. In addition to providing

access to this point, it provides an accessor method to return the point already converted to the global coordinate space, which is how we'll need to measure the point for the hit test. Now that we have the player Sprite and its test points, we'll look at the document class driving this example. Note that this class makes use of the Time class we created back in Chapter 10; if you skipped ahead to this chapter, all you need to know is that it has a method to return the time elapsed between frame cycles:

```
public class HitTestPoint extends Sprite {
 public var barriers: Sprite;
 public var player: Player;
 public function HitTestPoint() {
   addEventListener(Event.ADDED_TO_STAGE, addedToStage,
false, 0, true);
 private function addedToStage(e:Event):void {
   addEventListener(Event.ENTER_FRAME, enterFrame, false, 0,
true):
 }
 private function enterFrame(e:Event):void {
   //CHECK DISTANCE AND PERFORM MOVES
   var distance:Number = Math.sqrt(Math.pow(player.x-mouseX,
2) + Math.pow(player.y-mouseY, 2));
   var tempPoint:Point = new Point(mouseX, mouseY);
   var dx:Number = 0;
   var dy:Number = 0;
   if (distance > player.speed * Time.deltaTime) {
     var angle:Number = Math.atan2(mouseY-player.y, mouseX-
player.x):
     dx = (player.speed * Time.deltaTime) * Math.cos(angle);
     dy = (player.speed * Time.deltaTime) * Math.sin(angle);
     tempPoint.x = player.x + dx;
     tempPoint.y - player.y + dy;
   //DO CHECKS
   for each (var coordinate: HitTestCoordinate in player.
hitPointList) {
     if (barriers.hitTestPoint(coordinate.pointGlobal.x + dx,
coordinate.pointGlobal.y + dy, true)) {
      if (barriers.hitTestPoint(coordinate.pointGlobal.
x + dx, coordinate.pointGlobal.y, true)) {
          tempPoint.x = player.x;
       if (barriers.hitTestPoint(coordinate.pointGlobal.x,
coordinate.pointGlobal.y + dy, true)) {
          tempPoint.y = player.y;
     }
   //RE-ASSIGN VALUES
   player.x = tempPoint.x;
   player.y = tempPoint.y;
```

Really the only code happening in this class is in the *enterFrame* method. It measures the distance between the mouse and the player. If it is less than the speed of the player in a single frame, the player attempts to move to the mouse's exact position (this is to prevent the player from eternally jumping back and forth over the mouse). If it is farther away, the player will calculate its angle relative to the mouse and then move at its given speed in that direction. However, before the new coordinates are assigned, they are stored in a Point object, *tempPoint*. A *for each* loop then iterates through every coordinate in the player's list. It checks these coordinates, adjusted for the change in position, against the barriers clip. If it detects a collision, it then checks individual *x* and *y* values to determine in which direction the collision is occurring.

If you noticed the position of the test points in the player Sprite, you noted there are a total of eight: one for each side and one for each corner. The distance between them is such that you can actually coerce the square onto the barrier walls, as they are thin enough to fit between the points. Though it looks like a bug, I left this behavior in to make a point (no pun intended). Even if you find a technique that works for you, you will probably have to make some adjustments as you test. In this case, because we're dealing with such thin barriers, we need to position the collision points closer together and probably have more of them. By making these essentially little components, it is very easy to adjust the number and positioning of these points; remember that they only need to be slightly closer together than the smallest object you're testing against. That said, you might have a game where you need to wrap one object around another, in which case the current behavior would be ideal.

Radius/Distance Testing—Great for Circles

Though not an actual method of DisplayObjects, a very accurate way of detecting collision between two circular objects (or a circular object and a point) is simply by using the distance formula. If you know the radius of each object you want to test against each other, you can add the two radii together to see if the sum

is greater than the distance between them. In addition to flat, two-dimensional circles, this method works very well for characters on an isometric, or angled, playfield.

In Figure 11.4, two characters each have a radius of "personal space." A traditional *hitTestObject* would not work here because the objects will visually overlap when one passes in front of another. Instead, we need

Figure 11.4 These two players each have a radius around them constituting their hit area.

to measure the distance between the two players and determine if they are close enough to be touching. In this case, we also need to correct for the perspective skew of the field. The best way to make this adjustment would be to have the game engine store their coordinates as though they were being viewed from the top down. Then the engine can test against traditional circles but render out the view by applying the perspective correction. We'll look at a real example of this later in Chapter 15.

Another nice feature of this type of testing is that it is easy to have multiple testing radii, since the only real criterion is a number in pixels. Perhaps when two players get a certain distance from each other they gain the ability to talk to each other but only at a closer distance can they fight, exchange inventory, cuddle, etc.

One more example of where this type of detection is ideal is a billiards simulation. In a top-down pool game, for instance, you need to be able to accurately tell when two objects are colliding. The easiest way to do this type of test is to measure the distance between their edges. This scenario is illustrated in Figure 11.5.

Ball 2 (x_2, y_2) $d = \sqrt{(x_2 - x_1) + (y_2 - y_1)}$ (x_1, y_1)

Figure 11.5 A distance collision check applied to two balls on a pool table.

If you recall back to Chapter 10, the distance formula between two points is $d = \sqrt{((x^2 - x^1) + (y^2 - y^1))}$. As you can see in Figure 11.5, the value of d is the distance between the two center points of the balls. However, this isn't the value that will tell us when the balls are colliding, because by the time the distance between them is 0 they will be on top of each other. To find the distance between their edges, we have to calculate d minus the two radii. If we use the value of r for the radius and assume that the two balls are the same size (which they would be in billiards), we can then say that the distance between the two edges is:

$$d = \sqrt{((x^2 - x^1) + (y^2 - y^1))} - 2r.$$

When the value of d is 0, the two balls are touching. If it is less than 0, they are overlapping and must have their positions corrected.

Rect Testing

Another method similar to the basic *hitTestObject* is what is known as *rect testing*. It involves getting the bounding box rectangle of any two DisplayObjects (using the *getRect* method) and doing comparisons of intersection, overlap, etc. While this doesn't seem like it would be any better than the *hitTestObject* method, it has a number of advantages. The first is what I like to call *predictive* testing; basically, once you have the rect of an object, you can move

it around, scale it, and perform point tests against it without any effect on the original object. To test if two objects are *about* to hit with the *hitTestObject* method, you must actually move the objects around, which can occasionally cause glitches in the renderer. This is because when you update the position, scale, or rotation of a DisplayObject on the Stage, Flash will put it in the queue to redraw. By extracting the rectangle first, you can do tests on it that don't involve the display list at all and save the performance.

Another reason rect tests are a generally superior method of detection is greater flexibility. You can easily have multiple hit areas on an object or determine how much two rectangles are overlapping to determine the force of a collision. Let's say you have a vehicle that has multiple places in which it can take damage. You could place Sprites (that would make themselves invisible at runtime) to act as hit sensors, so to speak. When you needed to perform collision tests, you would iterate through these sensors to get their rects. Once you have a set of rectangles, you can test them individually or test them in combinations using the *union* method.

This next example demonstrates rect testing by expanding on a lesson from Chapter 6. Remember the SimpleShooter scolling example? We'll take that base code and add enemies and collision detection using rects. You can follow the example in the SimpleShooterCollisions.fla file and associated classes. There are two main additions that have been made to the file since we last looked at it: the new Enemy class and some method additions to the SimpleShooter class (now called the SimpleShooterCollisions class).

The Enemy Class

```
public class Enemy extends MovieClip {
  static public const FRAME_DESTROY:String = "destroy";
  protected var _speed:Number;
  protected var _alive:Boolean = true;
  public function Enemy(speed:Number = 0) {
    this.speed = speed;
    stop();
  }
  public function destroy() {
    _alive = false;
    gotoAndStop(FRAME_DESTROY);
  }
  public function get speed():Number {
    return _speed;
  }
  public function set speed(value:Number):void {
    _speed = value;
  }
  public function get alive():Boolean {
```

```
return _alive;
}
```

Like the Projectile class, Enemy objects have a speed parameter assigned to them upon creation. They also have a Boolean value specifying whether or not they are alive or dead. Finally, they have a *destroy* method that toggles the *alive* value and plays a destruction animation. In the FLA file, you can see an item in the library named Enemy that is linked to this class. It is a MovieClip with two frames: the static flying position and the destruction animation. Next we'll look at the additional methods that are now part of the main Game class.

The SimpleShooterCollisions Class Additions

In the code below, the sections in bold are new to this iteration of the game; refer to Chapter 6 for explanations on the other methods:

```
protected var _enemyList:Vector.<Enemy>;
protected var _enemySpeed:Number = -10;
protected var _enemyGenerator:Timer;
protected var _enemyFrequency:int = 2000;
public function SimpleShooterCollisions() {
 addEventListener(Event.ADDED_TO_STAGE, addedToStage, false,
0, true):
 addEventListener(Event.ENTER FRAME, frameScript, false, 0,
 projectileList = new Vector.<Projectile>();
   _enemyList = new Vector.<Enemy>();
   _enemyGenerator = new Timer(_enemyFrequency);
   _enemyGenerator.addEventListener(TimerEvent.TIMER,
createEnemy, false, 0, true);
protected function addedToStage(e:Event):void {
 _stageWidth = stage.stageWidth;
 _stageHeight = stage.stageHeight:
 addEventListener(MouseEvent.MOUSE_DOWN, createProjectile,
false. O. true):
  enemyGenerator.start():
protected function frameScript(e:Event):void {
 movePlayer();
 moveProjectiles();
 moveEnemies():
 checkCollisions():
 moveForeground();
 moveBackground();
```

In the initialization functions, there are now variables for how frequently enemies are generated, how fast they move, and Timer objects to create them. In the frame loop, two new methods are called which we will look at next:

```
protected function moveEnemies():void {
 for each (var enemy:Enemy in _enemyList) {
   enemy.x += enemy.speed;
   if (enemy.x + enemy.width < 0) {
     removeEnemy(enemy);
protected function createEnemy(e:TimerEvent = null):void {
 var enemy:Enemy = new Enemy( enemySpeed):
 enemy.x = _stageWidth + enemy.width;
 enemy.y = Math.random() * (_stageHeight-enemy.
height) + (enemy.height/2);
 addChild(enemy):
 _enemyList.push(enemy);
protected function removeEnemy(enemy:Enemy):void {
 if (enemy.parent == this) removeChild(enemy);
 _enemyList.splice(_enemyList.indexOf(enemy),1);
protected function checkCollisions():void {
 var enemyRect:Rectangle;
 var projectileRect:Rectangle:
 for each (var enemy: Enemy in _enemyList) {
   if (!enemy.alive) continue:
   enemyRect = enemy.getRect(this);
   for each (var projectile:Projectile in _projectileList) {
     projectileRect = projectile.getRect(this);
     if (enemyRect.intersects(projectileRect)) {
      removeProjectile(projectile);
      enemy.destroy();
```

You'll likely notice some similarities between how the projectiles and enemies are each moved. The *createEnemy* method, called by the Timer, places new Enemy objects at the right side of the Stage and they gradually travel across to the opposite side in the *moveEnemies* function. Once everything has been moved, the *checkCollisions* method runs. It loops through the two lists of projectiles and enemies and tests rects against each other. If a projectile hits an enemy that is still alive, the enemy will be destroyed. Note that at this point we don't remove the enemy. We rely on the *destroy* method of the Enemy class to display the destruction, and the object will get removed once it reaches the left side of the Stage. When you test this SWF you will see that when a projectile from the player hits an enemy, it explodes. Add

a scoring mechanism to the number of ships destroyed and a way for the player to be hurt, and you've got yourself a really simple but complete game!

Weaknesses of This Method

Even though this type of checking is overall pretty thorough, it will also break down in certain scenarios. If you were to increase the speed of the ships and the projectiles enough, they would eventually reach a point where they would jump over each other. In a single frame, they would go from facing each other to passing each other without a collision being recorded. Granted, they would have to be traveling *very* fast—faster than would probably be practical for this type of game—but that doesn't keep the underlying detection from being fundamentally flawed on some level. Because the detection is tied to the game's frame cycle, it also means that lowering the frame rate will lower the frequency of detection, effectively creating the same problem I just mentioned.

Luckily, there is a solution to this problem: iterative testing. Essentially, we want to test the space between a Sprite's new position and its previous position to see if a collision occurred between frames. In our shooter example, if the distance traveled between frame cycles is less than the width of either the projectile or enemy rects, then our current test is sufficient. However, when their speed exceeds their width, both Sprites need to iterate over their traveled distance to determine if they collided with anything in the dead space. This is where using rectangles for the tests are particularly helpful, because you can use a loop to move them at a certain interval and perform checks each time. Here's an example of how you could perform this loop:

```
for each (var enemy: Enemy in _enemyList) {
 if (!enemy.alive) continue;
 enemyRect = enemy.getRect(this);
 if (enemyRect.width <= Math.abs(enemy.speed)) {</pre>
   //"LITE" CHECK SUFFICIENT
   for each (var projectile:Projectile in _projectileList) {
    projectileRect = projectile.getRect(this);
     if (enemyRect.intersects(projectileRect)) {
      removeProjectile(projectile):
      enemy.destroy();
 } else {
   var numberOfChecks:int = Math.ceil(Math.abs(enemy.speed)/
   enemyRect.width);
   for (var i:Number = 0; i <= numberOfChecks; i++) {</pre>
    var newRect:Rectangle = enemyRect.clone();
    newRect.x -= enemyRect.width*i;
```

```
for each (var projectile:Projectile in _
    projectileList) {
    projectileRect = projectile.getRect(this);
    if (newRect.intersects(projectileRect)) {
        removeProjectile(projectile);
        enemy.destroy();
    }
    }
}
```

In this modified example of the shooter collision check, if the width of the enemyRect is less than the speed it moved in a single frame, the check is performed as usual. However, if the speed exceeds the width of the rectangle, we determine how many checks we need to perform by dividing the speed by the width and rounding up. We add another *for* loop, this time counting the number of checks we need to perform and creating a new rectangle with a new position to test against. If this seems like a lot of looping, remember that the number of checks you're likely to have to perform is still pretty low unless the rectangle you're checking against is very small. Even then, AS3 should be able to handle it just fine. To be even more accurate, it would be wise to add the same iterative checking for the projectiles as well, but I'll leave this to you as an exercise to complete.

When All Else Fails, Mix 'n' Match

Sometimes any one approach to collision detection is not enough to get the job done effectively. That's when a combination of approaches can work, depending on the scenario. For example, in the previous example we saw how the distance detection method served well to determine collisions between two players; however, that method doesn't work as well to determine the overlap of the player Sprites on-screen. In addition to using distance for interaction, we can do a basic *hitTestObject* test to determine when they are overlapping and to adjust their indices in the display list. In that perspective skewed instance, when one player has a lower *y* value it should appear behind the other player.

The most important thing to keep in mind when applying collision detection techniques is to keep an open mind to different options. Just as in the case of physics simulation, pixel-perfect precision is rarely necessary and will end up costing you too much in performance. It is a balance of accuracy, speed, and flexibility that ultimately yields the best detection. We'll look at a more practical example of collision detection in Chapter 15.

I ALWAYS WANTED TO BE AN ARCHITECT

Ever since ActionScript 3 was introduced, there has been a flurry of interest regarding architecture and design patterns. If you read Chapter 1, you know that design patterns are basically a blueprint or template for solving development problems. They are meant to provide reusable architecture when building applications. In some areas of the programming community, design patterns are an essential part of application development. That said, more often than not design patterns implemented in ActionScript tend to hamper development because they work against the natural grain of the language. One reason for this is that AS3 is already somewhat designed as a language to work a certain way, specifically with *events*. In this chapter, we'll explore some of the basic fundamentals of object-oriented programming (OOP) to keep in mind as we develop, some programming styles and design patterns that work, and when you should ignore the hype.

OOP Concepts

As I mentioned in Chapter 1, object-oriented programming is a model of software design centered around the concept of objects interacting with each other. To put it into game terms, every character on the screen in a game would be an object, as well as the interactive elements around them. They would all have commands they accept and messages they can broadcast to each other. By having each object responsible for its own behavior, programming becomes much more modular and flexible. Abstractly, this is probably not too difficult a concept to grasp. In practice, it can be difficult to achieve without a certain amount of planning

and forethought. This is where design patterns arose; by using an approved style of software design, planning an application became easier because the template was already thought out. Notice I said *application*. Many of the accepted design patterns in the industry work extremely well for applications that perform specific tasks, like productivity apps, utilities, design software, etc. However, design patterns aren't always the answer for game development, because games are meant to feel more like experiences than rigid, predictable business software. The best solution to developing a game engine may not follow an accepted pattern at all, and that's perfectly okay. It is, however, important to follow some basic principles when using OOP so your code is modular and scalable.

Encapsulation

One of the most fundamental OOP concepts is that of encapsulation. Briefly, encapsulation is the notion that an object (or class, in ActionScript) should be entirely self-managed and contained. An object should not have to know anything about the environment in which it exists to carry out its functions, and it should have a prescribed list of functions (or interface) that other objects can use to tell it what to do. In order to send information to objects outside itself, it should send messages that can be "listened to" by other objects. You can think of a well-encapsulated object like a soda vending machine. All of the inner workings are hidden away from you, and its functionality is distilled down to the buttons you can press to select a drink and the bin in which you can "listen" to receive your purchase. There is no reason for you to know what is going on inside the machine; it might be a couple of gnomes brewing and canning the soda right there on the spot or it might just be a series of tubes. Either way, all you're interested in is getting your tasty sugar water through an interface that is easy to understand and use. If you look at any of the built-in classes in Flash, they follow this same pattern. The only information listed about a class in the documentation is its public methods, properties, and events. There is certainly more going on under the hood than what we're exposed to, but we don't need to know about all of it. Your goal should be the same in developing your classes for games.

Inheritance

Say we have two classes, Chair and Sofa. Each of these classes shares similar traits because they are both types of sitting furniture—weight, size, number of legs, number of people they can

seat, etc. Instead of defining all of these traits in both classes, we could save ourselves time by creating a class called Furniture and adding the common traits to those. We could then say that Chair and Sofa *inherit* those properties by being (or *extending*) Furniture. This is the concept of inheritance; all objects in the real and virtual worlds have a hierarchy. When programming in an object-oriented style, the key to maximizing efficiency is to recognize the relationships of one object to another and the features they share. Adding a property to both Chair and Sofa then becomes as simple as adding that property to Furniture. When you extend a class, the new class becomes its *subclass*, and the original is now referred to as the superclass; in the previous example, the Furniture is the superclass and the Chair and Sofa are subclasses. There are some practical limitations to pure inheritance (namely, that a class can only extend one other class) that we'll discuss shortly.

Polymorphism

Though it sounds like an affliction one might develop in a science fiction novel, polymorphism is basically the idea that one class can be substituted in code for another, and that certain behaviors or properties of inherited objects can be changed or *overridden*. ActionScript only allows for a basic type of polymorphism, so that's all we'll cover here. Take the Chair from the previous example on inheritance. Now let's say that we extend Chair to make a HighChair for an infant. Certain properties of the chair may not apply or behave differently in the HighChair vs. the normal Chair. We can override the features that are different in the HighChair but continue to inherit those that are similar. In practice this process is not as complicated as it sounds, and I will point it out when it is used.

Interfaces

A core principle of object-oriented programming is the separation between an *interface* and an *implementation*. An interface is simply a list of the public methods and properties, including their types. An implementation would be a class that uses that interface to define what methods and properties will be publicly available to other classes. This concept can be initially confusing, so let's look at an example. Note in this example (and throughout the rest of this book) that interface names in ActionScript start with a capital "I" by convention.

In the section on inheritance, we used an example of a Chair and Sofa extending from Furniture; however, if you were to introduce another piece of furniture—a Table, for example—you would now be presented with a problem. While all three of these objects are Furniture, they have very different uses. The Table has no need for methods that involve people sitting down, and the other two have no need for methods that set dishes on them. Theoretically, you could create a whole structure of inheritance, breaking down Furniture into SeatingFurniture, DisplayFurniture, SupportFurniture, etc., but you can see that this is becoming extremely unwieldy. Also, any changes that are made in large inheritance structures can ripple down to subclasses and create problems where none existed before. This is where interfaces come in very handy.

For these three classes, you can simply define distinct interfaces that support each one's specific needs. You could break down the interfaces as such:

- IFurniture contains move() method.
- ISeatedFurniture contains sitDown() method.
- ILayingFurniture contains layDown() method.
- ITableFurniture contains setDishes() method.

Unlike inheritance, where a class can only inherit directly from one other class, you can use however many interfaces you like with a single class. The Chair would implement IFurniture and ISeatedFurniture. The Sofa would contain those two as well as ILayingFurniture, and the Table would contain IFurniture and ITableFurniture. Also, because interfaces can also extend one another, the latter three interfaces could all extend the first one as well, making implementation even simpler. Now that you have some basic interfaces defined for different furniture purposes, you can mix and match them as needed to apply to a particular piece of furniture.

Don't worry if some of this abstract terminology gets confusing. When we build a full-scale game in Chapter 14 you'll be able to see these concepts in practice.

Practical OOP in Game Development

By default, AS3 supports OOP and good encapsulation through the use of events to send messages between objects. I've heard AS3's event model described as being akin to what is known as the *Observer* design pattern, but regardless of the niche it falls into it is the native way in which the language operates. It's important to remember that, despite the advantages other patterns may offer, all of them are altering the default behavior of the language if they deviate from this model. Figure 12.1 shows the relationship of objects to each other in AS3's hierarchy.

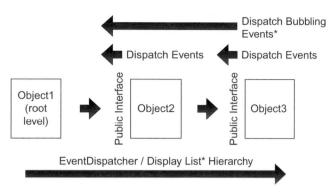

Figure 12.1 The basic event and communication model for AS3.

In this illustration, Object1 is at the top of the hierarchy, either as the root DisplayObject or just a generic data EventDispatcher. It has a reference to Object2 and can give it commands directly via its public interface because it knows Object2's type. Object2, however, has no way of knowing what its parent is without breaking encapsulation, but Object2 should be able to function regardless of what its parent object is. In order to send information out, it dispatches events. If Object1 adds itself as a listener to Object2, it will receive these events. The same is true between Object2 and Object3. If all of these are DisplayObjects, any events Object3 sets to bubble will eventually reach Object1 if it is listening for them. You can think of these objects as a line of people all facing one direction. The person at the back of the line can see all the other people and address each one directly, even if it has to go through the people directly in front of them. However, everyone else has no way of knowing whom, if anyone, is directly behind him or her or if they are even listening. All they can do is say something (dispatch an event); they don't have to care whether or not it is heard. By avoiding a reliance on knowing the hierarchy above any particular object, adding new objects to the hierarchy becomes relatively trivial.

In Figure 12.2, we have added Object4 to the second level of the hierarchy. All that has to change is that Object1 needs to know the correct type of Object4 to properly address its public interface, and Object4 needs to know the same information about Object2. Granted, this is a very abstract and simple example, but a well-thought out structure will allow you to make changes like this without dire consequences to the rest of your application. Because games can vary so widely in their mechanics and behavior, and because elements of gameplay tend to change throughout play testing, having a flexible system is a requirement when building a game engine.

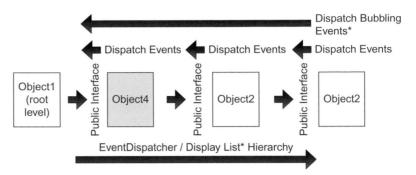

Figure 12.2 The same model as Figure 12.1 but with a new object inserted into the hierarchy.

The Singleton: A Good Document Pattern

Although I don't subscribe to any one design pattern for game development, I do like to use one particular pattern for the document class of my games. That pattern is known as the Singleton. The name sort of implies the concept behind it. A class that is a Singleton will only ever have one instance of itself in memory and provides a global point of access to that instance. In the context of a document or top-level class in a site, it ensures that there is always an easy way to get back to some basic core functionality. Say, for example, that all the text for my game is loaded in from an external XML file because it is being localized into other languages. I don't want to load the XML over and over again whenever I need it, so it makes sense for my document class to be responsible for loading it and then making it available to all the objects down the display list. The Singleton pattern provides a good way of doing this, because it essentially creates a global access point from anywhere, even non-DisplayObjects. This is a double-edged sword, however, because abuse of this pattern to store too much data or rely too heavily on references back to the main class will break your encapsulation. In practice, you should never put references to a Singleton class inside an engine component you intend to reuse, as this will make it too rigid. It should be reserved for classes that are being built for that specific game. Let's look at an example of a class set up as a Singleton. This file can be found in the Chapter 12 folder under Singleton Example.as.

```
package {
  import flash.display.MovieClip;
  public class SingletonExample extends MovieClip {
    static private var _instance:SingletonExample;
    public function SingletonExample(se:SingletonEnforcer) {
        if (!se) throw new Error("The SingletonExample class is
        Singleton. Access it via the static getInstance method.");
    }
}
```

```
static public function getInstance():SingletonExample {
   if (_instance) return _instance;
   _instance = new SingletonExample(new SingletonEnforcer());
   return _instance;
  }
}
internal class SingletonEnforcer {}
```

Traditionally, in other languages, a Singleton class would have a private constructor function, preventing you from calling it at all; however, in AS3, all constructors must be public, so we have to put in an error check to enforce proper use. The class keeps a static reference to its only instance, and the static getInstance method returns it. To prevent someone from arbitrarily instantiating the class, we create a secondary private class that is only accessible by the main document. Think of it like the secret password for the Singleton's constructor. Only the getInstance method knows how to properly create a new SingletonExample instance, as it will fail without this private class. This is a pretty commonly accepted way of dealing with basic Singleton classes in AS3, although this particular example will also break when used as a document class. This is because Flash will automatically try to instantiate the class to create the display list hierarchy. To get around this, we must modify the time of instantiation, alter the way the constructor works, and eliminate the private class. This new version can be found in SingletonExampleDocument.as.

```
package {
 import flash.display.MovieClip;
 public class SingletonExampleDocument extends MovieClip {
   static private var _instance:SingletonExampleDocument;
   public function SingletonExampleDocument() {
     if (_instance) throw new Error("This class is a
Singleton. Access it via the static SingletonExampleDocument.
getInstance method.");
     _instance = this;
    addEventListener(Event.REMOVED_FROM_STAGE, onRemove,
false, 0, true):
   private function onRemove(e:Event):void {
     _instance = null;
   static public function getInstance():SingletonExampleDocument {
    if (_instance) return _instance;
    _instance = new SingletonExampleDocument();
    return _instance;
```

As you can see in this modified version, we allow instantiation through the constructor once, relying on Flash to do it for us. When it is created, the constructor will throw an error from here on out. The one other addition we made is in case this document is loaded into another SWF. If this game is loaded into a container that has the ability to load and unload it multiple times, it's best to have the Singleton clean up after itself once it is removed from the Stage. This will prevent persistence of the Singleton in memory.

For another example of a Singleton in practice, refer back to Chapter 7 on audio. The SoundEngine class we created there followed the same pattern. These types of controllers, or "engines," are good candidates for Singletons because they need to be easily accessible from anywhere in your game.

Summary

If you are interested in learning more about design patterns to use in your game development, there are links to good articles and other books on this book's website, flashgamebook.com. The bottom line to remember is to always do what makes sense for your situation and don't go overboard with a solution that isn't applicable to what you are doing. Ultimately, if your game is no fun, no one will care that it is a perfectly implemented, flawlessly designed, model-view-controller pattern.

WE'VE ALL BEEN THERE

Now that we've just completed a chapter on best practices and ideal scenarios, it's only fair to cover some "worst practices" and basic pitfalls you should avoid. One of the most common phrases I hear developers (including myself from time to time) use to justify lackluster coding is "Well, this project just didn't afford me the time." The implication here is that if the developer had had more time to do the work it would have been done better. I certainly don't disagree with that premise. Before I worked at a game company, I was employed by an interactive ad agency. Anyone who has ever worked at an ad agency knows that there is never enough time on any project, ever. Forget formalized design patterns and wireframes; we're talking about timelines where it's hard to find time to use the bathroom. I have built the core mechanics for a game in less (but not much less) than 24 hours; it wasn't pretty, but it got the job done. I think most reasonable people could agree that a day or two turnaround for any game, regardless of complexity, is utterly absurd, and any project manager or account executive who agrees to such a timcline should be flogged publicly.

Despite all of this, I do think that abandoning all sense of standards, forward thinking, or just reasonable programming principles because you were given a ridiculous schedule is not a good practice. In my experience, coding a game rigidly and badly saves no more real time than coding it in a halfway decent way, so why not strive for the higher standard? In this chapter, I'll outline some examples of the least you can do, even when you don't have much time on your hands. If you follow these basic principles when you're in crunch time, you (and anyone else who has to look at your code) will be thanking yourself later on down the road.

Basic Encapsulation—Classes and Containers

I recently had to make edits to a game where the developer had, for the supposed sake of simplicity and speed, put virtually all of the code for the game, menu screens, and results screen in the same document class. Needless to say, it was an organizational nightmare. There was absolutely nothing separating game logic from the navigational structure or the leaderboard code. I'm sure at the time this kept the developer from having to switch between files, but it came with an ultimately very high cost. The code was one ugly step up from just having it all tossed on the first frame of the timeline. Here are the steps the developer should have taken to improve the readability and editability of his code, in order of importance:

- Move all game logic to its own class. At the bare minimum, any code that controls the mechanics of a game should be encapsulated by itself, away from irrelevant information. This is the core of the game and the most likely candidate for reuse; it should not be lumped in with everything else.
- Move code for each discrete screen or state of the game to its respective class. If the game has a title screen, rules screen, gameplay screen, and results screen, there should be a class for each. In addition, the document class should be used to move between them and manage which one is active.

This doesn't sound unreasonable, does it? It's hardly a formalized structure, but it can stand up to far more scrutiny than the previous "structure."

Store Relevant Values in Variables and Constants

If you work with string or numeric properties that represent a value in your code (such as the speed of a player, the value of gravity in a simulation, or the multiplier for a score bonus), store them in a variable or constant. "Well, duh," you're probably thinking right now, "Who wouldn't do that?!?" Sadly, I have to say I've seen a lot of code over the years that was hurriedly thrown together and the same numeric values were repeated all over the place instead of using a variable. Here's an example:

```
player.x += 10 * Math.cos(angle);
player.y += 10 * Math.sin(angle);
```

In their haste, a developer was probably testing values to determine the proper speed at which to move the player Sprite and just used the number directly in the equation. It would have taken

virtually no extra time to simply assign the number to a variable (speed) and then use the variable in the code instead:

```
var speed:Number = 10;
//
player.x += speed * Math.cos(angle);
player.y += speed * Math.sin(angle);
```

Now, if something changes in the game before it's finished that requires a change in player speed, it will require altering only a single line of code vs. however many places that value was used. While this seems like a shamefully simple exercise, a number of otherwise good developers have been guilty of this at one time or another because they were rushing. Although this example is obvious, there are other instances of this phenomenon that might not occur to developers immediately. One example that comes to mind is the names of event types. Many Flash developers with a background in ActionScript 2 are used to naming events with the use of raw strings:

```
addEventListener("init",initMethod);
```

In ActionScript 3, Adobe introduced constants: values that will never change but are helpful to have enumerated. One of the key uses of constants is in naming event types:

```
public static const INIT:String = "init";
addEventListener(INIT, initMethod);
```

There are a number of reasons for following this syntax. The first is that is follows the example from above. If you are going to use a value more than once *anywhere* in your code, it should be stored in memory to make changing it easier. The second reason is that by declaring event types and other constants in all capital letters, they stand out in your code if someone else is looking at them. Perhaps the most important reason, however, is compiletime checking. When Flash compiles your SWF, it runs through all the code to look for misuse of syntax and other errors.

```
addEventListener("init", method1);
addEventListener("inti", method2);
```

If I had the previous two lines of code in different parts of the same class, Flash would not throw an error when I compiled it.

```
public static const INIT:String = "init";
addEventLister(INIT, method1);
addEventLister(INTI, method2);
```

Had I used a constant value from above and misspelled the name of the constant, Flash would have warned me about my mistake when I tried to compile it. This type of checking is utterly invaluable at the 11th hour when you're trying to get a project out the door and don't have time to debug inexplicable errors.

Don't Rely on Your Stage

When developers are working on a game in a crunch, they are often doing so in a vacuum. They can take certain things for granted, like the size of the Stage of their SWF; however, if that SWF is loaded into another container of different dimensions, the game's mechanic can be adversely affected. For example, the following lines of code center an object horizontally and vertically on the Stage, assuming its container lines up with the upper-left-hand corner of the Stage and its registration point is in its center:

```
player.x = stage.stageWidth/2;
player.y = stage.stageHeight/2;
```

If the SWF containing this code is loaded into a larger SWF, it is unlikely it will still have the desired effect. The better option in this case is to use the less frequently known width and height values in the LoaderInfo object for the SWF. Every SWF knows what its intended Stage size should be, and that information is stored in an object that is accessible to every DisplayObject in the display list. The two lines above would simply become:

```
player.x = loaderInfo.width/2;
player.y = loaderInfo.height/2;
```

These values will stay consistent even if the Stage does not.

Don't Use Frameworks or Patterns That You Don't Understand or That Don't Apply

This may sound like an odd item in a list of bad practices to avoid when you're pressed for time, but it is yet another very real scenario I've witnessed with my own eyes. It is the opposite of gross underengineering—obscene overengineering—and it is every bit as much of a crime, as development crimes go. An example might be trying to apply a complex design pattern to a very simple execution. Some developers are tempted to rely on the many OOP frameworks that exist because of the generosity of the Flash community as a way to speed up development in a crunch. However, the developer who doesn't really understand the framework and how to implement it effectively will have essentially added an enormous amount of bulk to the project for no reason and will often end up "rewiring" how the framework is intended to function because it should never have been used in the first place.

Another project I recently had to make edits to was created with a model-view-controller (MVC) framework designed to force adherence to the design pattern of the same name. However, because of the architecture of the framework, related code was

scattered over at least 20 different class files. Some of the classes had only one or two methods or properties associated with them, making it a bread-crumb trail to attempt to debug. It was a classic example of overengineering; the game was not complicated or varied enough to warrant such a robust system, but the developer equated using an OOP framework with good programming so they used it anyway. As a result, it took probably twice as long to fix bugs in the game because it was hard to track down where the logic for different parts of the game was stored.

Know When It's Okay to Phone It in and When It Definitely *Isn't*

If you're producing games independently of an employer or client, either for profit or an experiment, the stakes are much lower. Fewer people, if any, are ever going to see your code, let alone have to work with it. You can get away with some sloppier standards or rushed programming. In fact, some of the best foundations for games I've seen have been born out of hastily thrown together code brainstorms. In experimentation, all you're interested in is the idea behind a mechanism. However, the moment you start having to answer to anyone else about your code, be it a client or a coworker, it is vital to take the time to do it right. No one is perfect, and no one's code is perfect, either, but there's a huge visible difference between someone who made a genuine effort and someone who did not. Even if you're independent now, don't turn a blind eye to your coding practices—you might want to get a job some day, and many employers like to see code samples.

Conclusion

Now that we've covered the least you can do, commit yourself to striving for the best you can do. Learning to program well and effectively is a journey, and given the ever-changing land-scape of new languages, technologies, and platforms, no one will ever reach a destination where they can say "I'm done!" Well, someone might, but they'll be left in the dust pretty quickly by everyone else.

MIXUP—A SIMPLE ENGINE

Up to this point, we've gone through many examples of different aspects of game development. Now let's pull them together to create a simple game from start to finish. In this chapter, we will cover how to create a basic image scramble game we'll call MixUp. This is a popular type of puzzle game where an image is broken into rectangles on a grid and reshuffled. Players must click on these pieces to interchange their positions and ultimately restore the original image. The difficulty of these puzzles is a combination of the number and size of the rectangles the image is broken into and the amount of detail in the imagery. We'll create an engine that will support any resolution of source image (within reason and memory restrictions) and divide it dynamically into any number of grid rectangles. We'll then see how this basic engine can be easily extended to support other source images like video or a live camera feed. Let's get started!

When defining the parameters for a game like this, it's important to lay out a basic rules set before starting to program. We won't do a full design document, as this is a simple game and that's not the point of this exercise. Instead, we'll just do a bullet-point list of the feature set and components so we know what we're dealing with:

Game screens and interface elements:

- Title screen
 - 1. Game logo
 - 2. Play button
 - 3. How to Play button
- How to Play popup
 - 1. Rules textfield
 - 2. Close button
- In-game screen
 - 1. Game status displays
 - 2. Quit button

- Results screen
 - 1. Game results textfields
 - 2. Play Again button
 - 3. Back to Title Screen button

In-game functionality and rules:

- Game will shuffle pieces on a grid, with no piece in its original position.
- Game will include timer that will count up from 0.
- Game will dispatch events when certain things happen, including:
 - 1. Player completing puzzle
 - 2. Player moving two pieces
 - 3. Player moving at least one piece to its correct position
- Game will be played with the mouse:
 - 1. Players will click on a piece to select it.
 - 2. If they click on the same piece again, they will de-select it.
 - **3.** If they click on another piece that is not locked down, the two selected pieces will trade positions and the game will check to see if either are now in the right place.
 - **4.** Players will not be able to move pieces that are correctly positioned.

We could go into even more detail, but this should be enough to get us started. Game design is an iterative process, meaning it grows and changes as it progresses. It is totally reasonable to change mechanics that don't make sense or prove not to work once in practice, but this initial layout allows us to try to predict potential problems and save time in the long run by anticipating trouble down the road.

Now that we have the basic guidelines for the game down, we can look at the file and class structure. In this case, we're going to work with one main FLA file that will house the game assets, and we'll use a number of classes and interfaces to control different aspects of the game functionality. Here's a quick breakdown of the classes we'll use and what each one is responsible for:

- MixUp—Document class; manages game state and screens, retains static game history, handles display of rules
- Title—Title/menu screen
- RulesPanel—Handles display and closure of the How to Play popup
- Game—Container; shows GameBoard, timer, and UI elements
- GameBoard—Creates puzzle from source image, shuffles pieces, and handles game logic
- IGamePiece—Interface that defines the methods for what constitutes a game piece:
 - 1. GamePiece—Implements IGamePiece and defines specific behavior for pieces (with regard to animation, mouse interaction, etc.)

- ISourceImage—Base interface for plugging in different image sets or video for use with the GameBoard:
 - SourceImageEmbedded—Uses images embedded in the SWF
 - 2. SourceImageCamera—Uses camera feed
- GameHistory—Simple data class containing static properties for the player's performance each time they play a round
- Results—Screen displaying game results when game is over

We'll work through each of these classes and the basic setup of the FLA one by one. So that we have some context for the code we'll be working with, we'll start with the structure of the MixUp .fla file. You can open it from the Chapter 14 Examples folder that you downloaded (or should download) from the book's website, flashgamebook.com.

The Main Document

When you open up MixUp.fla and look at the library and time-line, you'll notice a couple of things. First, they are very simple. The timeline has three labels and three matching pieces of content for each one: the title screen, the game screen, and the results screen. They are given their own discrete space on the timeline for organizational purposes and to simplify screen management. In the library, there are only a handful of items. Each screen is contained within its respective clip; there are a couple of different buttons and an image to be used as the source for the puzzle. Each of the screens is linked to a class with the same name. If you look at the document properties panel, you'll also see that the document is pointing to a class called MixUp. We'll start here first and work our way inward through the structure of the game.

The MixUp Class

This document class file controls the main logic for navigating between the screens in the game and displaying the rules panel. As the top level in our game, it is the one class that persists throughout the entire experience and is in the unique position of storing useful data such as the current session's game history (for showing best scores, average scores, etc.).

```
public class MixUp extends MovieClip {
  static public const FRAME_TITLE:String = "title";
  static public const FRAME_GAME:String = "game";
  static public const FRAME_RESULTS:String = "results";
  static public var gameHistory:Array = new Array();
```

```
protected var _imageNameList:Array = ["goldengate.jpg"];
protected var _imageList:Vector.<ISourceImage>;

public var title:Title;
public var game:Game;
public var results:Results;

public function MixUp() {
   enumerateFrameLabels();
   addEventListener(FRAME_TITLE, setupTitle, false, 0, true);
   addEventListener(FRAME_GAME, setupGame, false, 0, true);
   addEventListener(FRAME_RESULTS, setupResults, false, 0, true);
   createImagePool();
}

protected function createImagePool():void {
   _imageList = new Vector.<ISourceImage>();
   for each (var imageName:String in _imageNameList)
    _imageList.push(new SourceImageEmbedded(imageName));
}
```

There are only a few variables in this class: one for each of the main screens, an array for the game history, and a constant defining each of the frame labels. In addition to these public properties are two lists. One stores the list of available images to use for the puzzle (in this case, the one that is embedded in the library), and the other will store the list of image objects that will be used by the game. In the constructor for the class, <code>enumerateFrameLabels</code> is called and listeners are added to each of the frame names. It also calls <code>createImagePool</code>, which runs through the list of image names and creates new SourceImageEmbedded objects for each of them. More on this later when we get to the in-game classes.

```
private function dispatchFrameEvent():void {
   dispatchEvent(new Event(currentLabel));
}

private function enumerateFrameLabels():void {
   for each (var label:FrameLabel in currentLabels)
     addFrameScript(label.frame-1, dispatchFrameEvent);
}
```

These two functions use the addFrameScript method to dispatch events whenever a frame label is hit. Combined with the listeners in the constructor, events will be fired when the title screen, game screen, and results screen are reached.

```
protected function setupTitle(e:Event):void {
   stop();
   title.addEventListener(Title.PLAY_GAME, playGame, false, 0,
   true);
   title.addEventListener(Title.SHOW_RULES, showRules, false,
0, true);
}
protected function showRules(e:Event):void {
   var rules:RulesPanel = new RulesPanel():
```

```
rules.x = stage.stageWidth/2;
rules.y = stage.stageHeight/2;
addChild(rules);
}

protected function playGame(e:Event):void {
  gotoAndStop(FRAME_GAME);
}

protected function mainMenu(e:Event):void {
  gotoAndStop(FRAME_TITLE);
}
```

When the title screen is reached, we attach listeners to it for two events that are defined in the Title class: PLAY_GAME and SHOW_RULES. When showRules is called, it creates a new RulesPanel instance, positions it, and adds it to the Stage. The playGame method does exactly what you'd expect it to do—go to the frame with the game in it. The *mainMenu* method will be used later to return to the title screen, but it is included here for consistency.

```
protected function setupGame(e:Event):void {
 stop():
 game.init(_imageList[0], 3, 4);
 setTimeout(game.startGame, 1500);
 game.addEventListener(Game.GAME_OVER, gameOver, false, O,
true);
protected function gameOver(e:Event):void {
 var history: GameHistory = new GameHistory(true, e.target.
timeFlapsed, e.target.movesMade);
 history.formattedTime = e.target.timeElapsedText.text;
 gameHistory.unshift(history);
 gotoAndStop(FRAME_RESULTS);
protected function setupResults(e:Event):void {
 results.addEventListener(Results.PLAY_AGAIN, playGame,
false, 0, true);
 results.addEventListener(Results.MAIN_MENU, mainMenu,
false, 0, true);
```

These three methods follow much the same pattern of doing initialization when a frame label is reached. The *setupGame* method runs functions on the Game object and adds a listener for the GAME_OVER event. We'll return to the *gameOver* method later once we've progressed through the game logic that will get us there. Suffice it to say that we'll store stats about the player's most recent game in the history array. Now that the document class is defined, we're ready to delve into each of the individual screens.

The Title Class

Most games have some sort of main menu of options; few drop you directly into the action without explanation or pause. In this example, we have only two options on the title screen, which keeps it simple for explanation—a player can choose to start a game or first view the rules:

```
public class Title extends MovieClip {
 static public const PLAY_GAME:String = "playGame";
 static public const SHOW_RULES:String = "showRules":
 public var playButton: SimpleButton;
 public var rulesButton:SimpleButton;
 public function Title() {
   addEventListener(Event.ADDED_TO_STAGE, addedToStage.
false, 0, true):
 private function addedToStage(e:Event):void {
   playButton.addEventListener(MouseEvent.CLICK.
playButtonClick, false, 0, true);
   rulesButton.addEventListener(MouseEvent.CLICK.
rulesButtonClick, false, O, true):
 }
 private function playButtonClick(e:MouseEvent):void {
   dispatchEvent(new Event(PLAY_GAME));
 private function rulesButtonClick(e:MouseEvent):void {
   dispatchEvent(new Event(SHOW_RULES));
```

As you can see, the logic behind this screen is very simple. When either of the two buttons on the Title screen is clicked, events are dispatched with names corresponding to the listeners we saw in the MixUp class. Adding buttons to this screen is as simple as adding a constant for the event it generates, a variable for the DisplayObject, and a listener for button click.

The RulesPanel Class

From the Title screen, the player can choose to view the rules panel. In the MixUp class, we saw how this panel is instantiated and added to the Stage. Now we'll look at the internal logic behind it:

```
public class RulesPanel extends Sprite {
  public var closeButton:SimpleButton;
  public function RulesPanel() {
    addEventListener(Event.ADDED_TO_STAGE, addedToStage, false, 0, true);
  }
```

```
private function addedToStage(e:Event):void {
   TweenLite.from(this, .4, { y : -height } );
   closeButton.addEventListener(MouseEvent.CLICK,
closeButtonClick, false, 0, true);
}

private function closeButtonClick(e:MouseEvent):void {
   closeButton.removeEventListener(MouseEvent.CLICK,
closeButtonClick);
   TweenLite.to(this, .4, { y : -height, onComplete:parent.
removeChild, onCompleteParams:[this] } );
}
```

When the rules panel becomes part of the display list, it animates itself in from the top of the screen. It also adds a listener to the Close button that reverses this animation and upon completion removes the panel from the Stage. Because there are no references to the panel other than the display list, once it is removed from the Stage Flash will garbage collect it. Now we're ready to dive into the Game class and see the logic going on behind the scenes.

The Game Class

We've now reached the meat of the code, so to speak. The Game class is a composite of a few different components. The first and most important is the GameBoard class, which we will look at shortly. The GameBoard controls the actual logic that keeps track of each of the images, shuffles them, and determines whether or not the puzzle has been completed. In addition, the Game class stores an instance of whatever the source image is—in this case, a still image from the library. Finally, this class manages all of the user interface relevant to the game, like the Quit button and text fields. We'll start breaking it down with the variable declarations:

```
public class Game extends MovieClip {
  static public const GAME_OVER:String = "gameOver";
  public var piecesLeftText:TextField;
  public var movesMadeText:TextField;
  public var timeElapsedText:TextField;
  public var quitButton:SimpleButton;

  private var _sourceImage:ISourceImage;
  private var _gameBoard:GameBoard;
  private var _totalPieces:int;
  private var _piecesLeft:int;
  private var _movesMade:int;
  private var _timeElapsed:int;
  private var _timeTimer;
```

```
public function Game() {
   addEventListener(Event.ADDED_TO_STAGE, addedToStage,
false, 0, true);
   _timer = new Timer(1000);
   _timer.addEventListener(TimerEvent.TIMER, timerUpdate,
false, 0, true);
}

private function addedToStage(e:Event):void {
   quitButton.addEventListener(MouseEvent.CLICK, gameOver,
false, 0, true);
}
```

There are three TextField objects that display how many pieces are left, how many moves have been made, and how much time has elapsed, as well as a button the player can use to quit the game. Each of the private variables stores some piece of information related to gameplay, including the source image in the form of an interface (rather than a class). Along with the GameBoard, we'll cover this interface in a subsequent section. The constructor sets up the Quit button and also creates a Timer object. The Timer will fire every second (or 1000 milliseconds) once started, creating a very basic clock. Whenever a second passes, the Timer will call *timerUpdate*.

```
public function get movesMade():int { return _movesMade; }
public function set movesMade(value:int):void {
 _movesMade = value;
 movesMadeText.text = String(_movesMade);
public function get piecesLeft():int { return _piecesLeft; }
public function set piecesLeft(value:int):void {
 _piecesLeft = value:
 piecesLeftText.text = String(_piecesLeft);
public function get timeElapsed():int { return _timeElapsed: }
public function set timeElapsed(value:int):void {
 _timeElapsed = value;
 var timeString:String;
 if (_timeElapsed < 60) {
   timeString = "0:";
   timeString = String(Math.floor(_timeElapsed / 60)) + ":":
 var seconds:int = _timeElapsed % 60:
 if (seconds < 10) {
   timeString + = "0" + String(seconds);
 } else {
   timeString += String(seconds);
 timeElapsedText.text = timeString:
```

This set of six methods comprises the accessor, or getter/setter, methods we'll use for this class. The *get* function simply returns the value of the private variable. The *set* function sets the private variable and also updates the corresponding TextField object. In the case of the *timeElapsed* property, in particular, the time must be updated from just a number of seconds to a standard formatting of "mm:ss."

```
public function init(sourceImage:ISourceImage,
     rows:int.
     columns: int.
     imageWidth:int = 0,
     imageHeight:int = 0,
     boardPosition:Point = null):void {
  totalPieces = piecesLeft = rows * columns;
 movesMade = 0;
 sourceImage = sourceImage;
 gameBoard = new GameBoard(_sourceImage, GamePiece, rows,
columns, imageWidth, imageHeight);
 if (!boardPosition) boardPosition = new Point();
 _gameBoard.x = boardPosition.x;
 _gameBoard.y = boardPosition.y;
 _gameBoard.createBoard():
 addChildAt( gameBoard, 0);
 _gameBoard.shuffleBoard();
public function startGame():void {
 _gameBoard.activate();
 gameBoard.addEventListener(GameBoard.GAME_OVER.
pauseBeforeGameOver, false, 0, true);
  _gameBoard.addEventListener(GameBoard.PIECE_SWAP,
pieceSwap, false, 0, true);
  {\tt gameBoard.addEventListener} ({\tt GameBoard.PIECE\_LOCK},
pieceLock, false, 0, true);
 timeElapsed = 0:
 _timer.start():
```

You may have noticed that these two public methods are the same two called by the MixUp class earlier. The *init* function sets up the game for play, and *startGame* activates the GameBoard for mouse input and starts the Timer. There are a number of parameters for *init*, including the source image object to be used for the puzzle, the number of rows and columns the grid should be divided into, the width and height in pixels of the image that will be displayed, and the physical position of the GameBoard object in the form of a Point. Only the source image, rows, and columns are required. By default, we will use the native width and height of the image we're slicing up and set the board at (0,0). The total number of pieces for the puzzle is calculated as the number of rows multiplied by the number of columns. The *init* function is also where the GameBoard object is actually created. Most of the

same parameters that were passed into the function are similarly passed along to the GameBoard constructor, and it is subsequently added to the Stage. The GameBoard will dispatch a number of events as things occur in the game, so in *startGame* we add listeners for these events. We'll look at these listeners next:

```
private function pauseBeforeGameOver(e:Event):void {
   _timer.stop();
   setTimeout(gameOver, 2000, null);
}

private function pieceSwap(e:Event):void {
   movesMade++;
}

private function pieceLock(e:Event):void {
   piecesLeft--;
}

private function gameOver(e:Event):void {
   _timer.stop();
   _gameBoard.deactivate();
   _gameBoard.cleanUp();
   dispatchEvent(new Event(GAME_OVER));
}

private function timerUpdate(e:TimerEvent):void {
   timeElapsed = _timer.currentCount;
}
```

The method *pauseBeforeGameOver* merely stops gameplay and inserts a two second pause before calling the *gameOver* method so players have a moment to see the image they have completed. When a piece swap is made, the number of moves is incremented, and when a piece is locked into its correct position, the number of pieces is decremented. Finally, after the post-game pause is complete, *gameOver* deactivates the GameBoard, performs clean up, and dispatches the GAME_OVER event back up to the MixUp class.

The Interfaces

Before we proceed any further into the GameBoard engine, we need to look at the two interfaces that will be used in it, which we've already seen glimpses of in the MixUp and Game classes. As you'll recall from Chapter 4, an interface simply defines the names and parameters of public methods that will be used in a class. There is no actual logic performed in an interface. They are used to supply a common *interface* through which classes of disparate types can be used in the same context. The first is *ISourceImage*. It is this interface that must be implemented by any source of imagery the game will use for its puzzle,

regardless of whether it is still embedded photos, external photos, video, etc.:

```
package {
  import flash.display.BitmapData;
  public interface ISourceImage {
    function getImages(rows:int, columns:int, width:int = 0, height:int = 0):Vector.<BitmapData>;
    function cleanUp():void;
    function destroy():void;
}
```

Classes that implement this interface need only have three methods defined in them. The first method, <code>getImages</code>, is arguably the most important. It needs to return a vector list of BitmapData objects representing the sliced-up original image, based on the number of rows and columns. The next two, <code>cleanUp</code> and <code>destroy</code>, do pretty much what you would expect based on their names. The <code>cleanUp</code> method will be called when the GameBoard wants to dispose of the sliced-up images used to create the puzzle. The <code>destroy</code> method takes it one step further and also is intended to dispose of the original source image as well. Because BitmapData takes up a lot of space in memory, it is important to provide easy ways of freeing up that space.

The other interface used with the GameBoard class is called *IGamePiece*. It defines the methods that will be used by the clickable game pieces that will make up the game board. Each game piece will have a BitmapData object from the vector list returned by *ISourceImage.getImages()*:

```
package {
 import flash.display.BitmapData;
 import flash.events.IEventDispatcher;
 public interface IGamePiece extends IEventDispatcher {
   //DisplayObject Properties
   function get x(): Number;
   function set x(value:Number):void;
   function get y(): Number;
   function set y(value:Number):void;
   function get width(): Number;
   function set width(value:Number):void;
   function get height():Number;
   function set height(value:Number):void;
   //GamePiece-specific Methods
   function select():void;
   function deselect():void;
   function activate():void:
   function deactivate():void;
```

```
function movePiece(x:Number, y:Number):void;
function lock():void;

//GamePiece-specific Accessors
function get image():BitmapData;
function set image(value:BitmapData):void;
function get index():int;
function set index(value:int):void;
function get currentIndex():int;
function set currentIndex(value:int):void;
}
```

This interface has considerably more definitions in it, because unlike the source images, these game pieces will also need to be DisplayObjects. Since there is no common interface for DisplayObject classes to extend from, we'll need to define some of the basic properties that a game piece will need to have. These include *x* and *y* position, as well as width and height. For convenience, since the pieces will also need to dispatch events, we can extend IEventDispatcher to keep us from having to retype all those methods. For the game logic, every piece must have a way to be selected, deselected, activated, deactivated, moved, and locked. They must also have properties that define the BitmapData displayed inside them, and their original and current positions on the game board. We'll look at the classes that implement these interfaces shortly, but now that we at least know how these objects will be defined, we'll move on to the GameBoard class.

The GameBoard Class

This class is the engine at the heart of this entire game and where all the major logic happens. In order to be as flexible and reusable as possible, it refers to objects by their interfaces rather than by their specific class:

```
public class GameBoard extends Sprite {
 static public var GAME_READY:String = "gameReady":
 static public var GAME_OVER:String = "gameOver":
 static public var PIECE_SWAP:String = "pieceSwap":
 static public var PIECE_LOCK:String = "pieceLock":
 protected var _pieces:Vector.<IGamePiece>;
 protected var _rows:int, _columns:int;
 protected var _imageWidth:int, imageHeight:int:
 protected var _boardImage:ISourceImage;
 protected var _selectedPiece:IGamePiece:
 protected var _pieceClass:Class;
 public function GameBoard(boardImage: ISourceImage,
pieceClass:Class, rows:int, columns:int, imageWidth:int = 0.
imageHeight:int = 0) {
   _{rows} = rows;
   _columns = columns:
```

```
_imageWidth = imageWidth;
_imageHeight = imageHeight;
_boardImage = boardImage;
_pieceClass = pieceClass;
}
```

When a new GameBoard object is created, it looks for an image object to slice, the number of rows and columns to use, the width and height of the puzzle, and which class to use for the game piece (since it will be referred to generically as IGamePiece for the rest of the code). In addition to these properties, the class defines four different events that it will dispatch and a list object, _pieces, which will store a list of the game pieces in play.

```
public function createBoard():void {
 _pieces = new Vector.<IGamePiece>():
 var numPieces:int = _rows * _columns;
 var imageData:Vector.<BitmapData> = _boardImage.getImages(_rows,
columns):
 for (var i:int = 0; i < numPieces; i++) {</pre>
   var piece:IGamePiece = new pieceClass();
   piece.index = i;
   piece.image = imageData[i];
   piece.x = piece.width * (i % _columns);
   piece.y = piece.height * Math.floor(i / _columns);
   _pieces.push(piece);
   addChild(piece as DisplayObject);
public function shuffleBoard():void {
 randomize(_pieces);
  for (var i:int = 0; i < _pieces.length; i++) {
   movePiece(_pieces[i], i);
```

The *createBoard* function is the process by which the image data is pulled from its source and inserted into game pieces. For every piece of image data, a new game piece is created and added to the Stage. The result of *createBoard* is a reproduction of the original image, but in adjacent pieces rather than a single bitmap. The *shuffleBoard* method is used to mix up the images and move them from their original places. We'll look at the *randomize* and *movePiece* methods it calls shortly. The two methods above are separated to allow the game to display the original image for a period, if needed, before rearranging the board.

```
public function activate():void {
  for each (var piece:IGamePiece in _pieces) {
    piece.activate();
    piece.addEventListener(MouseEvent.CLICK, pieceClicked,
  false, 0, true);
  }
}
```

```
public function deactivate():void {
  for each (var piece:IGamePiece in _pieces) {
    piece.deactivate();
    piece.removeEventListener(MouseEvent.CLICK, pieceClicked);
  }
}
public function cleanUp():void {
  _boardImage.cleanUp();
  _pieces = null;
}
```

These methods are what are used upon beginning and completion of a game. Calling *activate* will enable each piece and make it clickable. The *deactivate* method reverses this action, and the *cleanUp* function calls the same method on the source image that we looked at earlier in the interface.

```
protected function pieceClicked(e:MouseEvent):void {
  var piece:IGamePiece = e.target as IGamePiece;
  if (!_selectedPiece) {
   _selectedPiece = piece:
  } else if (_selectedPiece == piece) {
   _selectedPiece.deselect();
   selectedPiece = null:
  } else {
   var index:int = _selectedPiece.currentIndex;
   dispatchEvent(new Event(PIECE_SWAP)):
   piece.deselect():
   _selectedPiece.deselect():
   movePiece(_selectedPiece, piece.currentIndex):
   checkPiece(_selectedPiece):
   movePiece(piece, index):
   checkPiece(piece):
   _selectedPiece = null:
   checkWin():
protected function checkPiece(piece:IGamePiece):Boolean {
 if (piece.currentIndex == piece.index) {
   piece.removeEventListener(MouseEvent.CLICK, pieceClicked);
   piece.lock();
   dispatchEvent(new Event(PIECE_LOCK));
   return true:
 }
 return false:
protected function checkWin():void {
 var won:Boolean = true;
 for each (var piece:IGamePiece in _pieces) {
   if (piece.currentIndex != piece.index) won = false:
 if (won) {
   deactivate():
   dispatchEvent(new Event(GAME_OVER));
```

```
protected function movePiece(piece:IGamePiece, newIndex:int):void {
  piece.movePiece(piece.width * (newIndex % _columns), piece.
height * Math.floor(newIndex / _columns));
  piece.currentIndex = newIndex;
}
```

I have grouped these methods together because they are all interrelated and easier to look at in the context of each other. The pieceClicked method is called when, you guessed it, a piece is clicked. It looks to see if another piece has already been selected. If not, this piece becomes the currently selected piece. If this piece is already selected, it will be deselected. If a different piece has already been selected, the game dispatches a PIECE_SWAP event and proceeds to exchange the two pieces' positions. The movePiece function calls the same method on the corresponding piece and updates its *currentIndex* property. Once moved, the piece's position is evaluated by the *checkPiece* method. If the piece's currentIndex matches its original index, the piece is in place and is locked. Finally, once the two pieces have been moved and checked, *checkWin* is called to determine if all the pieces are now in their correct positions. If they are, the game deactivates itself and dispatches the GAME OVER event.

```
protected function randomize(vector:Vector.<IGamePiece>):
Vector.<IGamePiece> {
  for (var i:int = 0; i < vector.length-1; i++) {
    var randomIndex:int = Math.round(Math.random()*(vector.
length-1 i)) + i;
    swapElements(vector, i, randomIndex);
  }
  return vector;
}

protected function swapElements(vector:Vector.<IGamePiece>.in
dex1:int,index2:int):void {
  var temp:IGamePiece=vector[index1];
  vector[index1]=vector[index2];
  vector[index2]=temp;
  temp=null;
}
```

These two final methods of the GameBoard class are not specific to the game logic but are actually generic utility functions that I wrote originally to manipulate arrays. Here, they have been modified to do the same with vectors of a specific type. The *randomize* method shuffles the vector so all of the elements are in new positions. By swapping each index with a random one after it, we ensure that we get a unique order every time. This method makes direct use of the *swapElements* function to move the elements in the list.

Now we'll look at the GamePiece class that is used for the implementation of the IGamePiece interface. Remember how the GameBoard class only referenced pieces via the IGamePiece

interface? Because of this the GamePiece class has the luxury of having whatever internal mechanisms we want, as long as it correctly implements all of the methods of the interface. As a result, this class has a fair amount of hard-coded values, such as the color, size, and speed of animations. To make a different type of game piece, you could use this class as a starting point and then modify any of the functionality inside it or start from scratch. Ultimately, all that matters in this case is that the interface methods are defined and that the game piece in some way extends from DisplayObject or preferably InteractiveObject. This is because in the GameBoard class, pieces are added to the Stage and a non-DisplayObject descendent will throw an error.

```
public class GamePiece extends Sprite implements IGamePiece {
  protected var _image:Bitmap;
  protected var _index:int;
  protected var _currentIndex:int;
  protected var _culloverHighlight:Shape;
  protected var _clickHighlight:Shape;
  public function GamePiece() {
  }
}
```

For this implementation, GamePiece will extend Sprite and contains a Bitmap variable to store its image slice, two int variables to store its current and original index, and two Shape variables that will be used for rollover and click states.

```
protected function createRolloverHighlight():void {
 _rolloverHighlight = new Shape();
 _rolloverHighlight.graphics.lineStyle(1, 0xFFFFFF, 1);
 _rolloverHighlight.graphics.beginFill(0xFFFFFF, .3);
 _rolloverHighlight.graphics.drawRect(.5, .5, _image.width-1,
image.height-1);
 _rolloverHighlight.graphics.endFill();
 addChild(_rolloverHighlight);
 _rolloverHighlight.visible = false;
protected function createClickHighlight():void {
 _clickHighlight = new Shape();
 _clickHighlight.graphics.lineStyle(2, 0, 1);
 _clickHighlight.graphics.beginFill(0xFFFFFF, .2);
  _clickHighlight.graphics.drawRect(1, 1, _image.width-2,
_image.height-2);
 _clickHighlight.graphics.endFill();
 addChild(_clickHighlight);
 _clickHighlight.visible = false;
```

These two methods create the aforementioned Shape instances that will constitute the piece's alternative states. Both of them are arbitrarily defined and could be styled any number of ways or even make reference to clips in the FLA library.

```
public function get index():int { return _index; }
public function set index(value:int):void {
    _index = value;
}
public function get currentIndex():int { return _currentIndex; }
public function set currentIndex(value:int):void {
    _currentIndex = value;
}
public function get image():BitmapData { return _image.
bitmapData; }
public function set image(value:BitmapData):void {
    if (!_image) {
        _image = new Bitmap(value);
        addChild(_image);
        createRolloverHighlight();
        createClickHighlight();
    }
    else _image.bitmapData = value;
}
```

These accessor methods are implementations from the interface. The only one that requires a little extra explanation is the set function for the *image* property. If the image already exists, it is assigned directly to the Bitmap instance. If not, it creates the Bitmap and the highlighted states.

```
protected function onClick(e:MouseEvent):void {
 select():
protected function onRollOver(e:MouseEvent):void {
  _rolloverHighlight.visible = true;
protected function onRollOut(e:MouseEvent):void {
  _rolloverHighlight.visible = false;
public function select():void {
 _clickHighlight.visible = true;
public function deselect():void {
 _clickHighlight.visible = false;
public function activate():void {
 addEventListener(MouseEvent.CLICK, onClick, false, 1, true);
 addEventListener(MouseEvent.ROLL_OVER, onRollOver, false,
0, true);
 addEventListener(MouseEvent.ROLL_OUT, onRollOut, false, 0, true);
 buttonMode = true;
```

```
public function deactivate():void {
  removeEventListener(MouseEvent.CLICK, onClick);
  removeEventListener(MouseEvent.ROLL_OVER, onRollOver);
  removeEventListener(MouseEvent.ROLL_OUT, onRollOut);
  buttonMode = false;
  _rolloverHighlight.visible = false;
  deselect();
}
```

The first three methods are triggered by mouse events and toggle the rollover state and select method. The next four are more implementations from the interface, all of which affect the different states and mouse input.

```
public function lock():void {
 deactivate():
 setTimeout(pieceLockAnimation, 500);
public function movePiece(newX:Number, newY:Number):void {
 TweenLite.to(this, .5, { x:newX, y:newY, ease:Expo.easeOut } );
protected function pieceLockAnimation():void {
 var shape:Shape = new Shape();
 shape.graphics.beginFill(0 \times 00CC00, .5):
 shape.graphics.drawCircle(0, 0, Math.max(width, height) / 2);
 shape.graphics.endFill();
 shape.x = width / 2;
 shape.y = height / 2;
 addChild(shape);
 TweenLite.to(shape, 1, { scaleX:2, scaleY:2, alpha:0,
onComplete:removeChild, onCompleteParams:[shape]} );
 parent.setChildIndex(this, parent.numChildren-1);
override public function toString():String {
 return "GamePiece: index = " + index + "
currentIndex = " + currentIndex;
```

Finally, wrapping up the class are the methods to lock the piece in place and also to move it. The *pieceLockAnimation* method is another custom animation function that could be substituted for just about any other treatment. In this case, when a piece is locked, it flashes a green (usually the color associated with a positive move) square over the piece and fades it out.

Techie Note. Shapes

Shape objects are a low-impact form of DisplayObject that are great to use when all you need is something to draw in using the Graphics API or to use as an overlay. Because they don't extend InteractiveObject, you don't have to worry about them receiving or blocking mouse or keyboard events that you need your container to get. Because they're so simple they also consume fewer resources, so if you did a puzzle with 100+ pieces you wouldn't be consuming nearly as much in memory or rendering power.

The SourceImageEmbedded Class

Now that we have all the logic for the game itself and functional pieces, the last component to this puzzle is the image itself. We've seen the ISourceImage interface that is used by the GameBoard class to pull in a list of BitmapData objects. But, how does the original BitmapData get pulled in and then sliced? The answer is "depends." It depends on the source of the image. If the images are embedded in the FLA library, as in our example, the BitmapData is just waiting there for us to instantiate. But, for other sources, such as external image files or a camera feed, it's a little more complicated. We'll start out by seeing how to use an embedded image. You may have noticed an image in the MixUp.fla library that was set to export as "goldengate." This image of the Golden Gate Bridge in San Francisco (taken by yours truly circa 2003) will be available to us as raw BitmapData when the SWF is exported. Back in the MixUp.as document class, we also defined a list of image names (in this case, just one image) that would be used to load in the data. Those names were then used to create instances of a class called SourceImageEmbedded. We'll look at that class now:

```
public class SourceImageEmbedded implements ISourceImage {
   private var _imageClass:Class:
   private var _sourceBitmap:BitmapData;
   private var _pieceList:Vector.<BitmapData>;
   public function SourceImageEmbedded(linkageName:String) {
      _imageClass = getDefinitionByName(linkageName) as Class;
}
```

When a new SourceImageEmbedded object is created, the linkage name in the library for the image we want to use is passed into the constructor. That name is then used to look up and retrieve the actual class that name is associated with. If you recall, there were three required methods of the ISourceImage interface. We'll now look at this class's implementation of those functions:

```
public function getImages(rows:int,
               columns:int.
               width: int = 0,
               height:int = 0):Vector. <BitmapData> {
 if (_pieceList) return _pieceList;
 _sourceBitmap = new _imageClass(width, height):
 var pieceBitmap:BitmapData;
 var pieceWidth:int = Math.floor(_sourceBitmap.width / columns);
 var pieceHeight:int = Math.floor(_sourceBitmap.height / rows);
 _pieceList = new Vector.<BitmapData>();
 for (var j:int = 0; j < rows; j++) {
   for (var i:int = 0; i < columns; i++) {
     pieceBitmap = new BitmapData(pieceWidth, pieceHeight);
     var rect:Rectangle = new Rectangle(i * pieceWidth, j *
pieceHeight, pieceWidth, pieceHeight);
     pieceBitmap.copyPixels(_sourceBitmap, rect, new Point());
```

```
_pieceList.push(pieceBitmap);
}
return _pieceList;
}

public function cleanUp():void {
  for each (var bmd:BitmapData in _pieceList) {
    bmd.dispose();
}
  _pieceList = null;
}

public function destroy():void {
  cleanUp();
  _sourceBitmap.dispose();
  _imageClass = null;
}
```

The *getImages* method is definitely the heavy-lifter of this class. If the list of BitmapData objects already exists (in other words, the image has already been cut up), the function simply returns that list again. This is to prevent destruction of still usable objects and creation of unnecessary new objects, as BitmapData can be costly to create and destroy repeatedly. For each rectangle on the grid, a new BitmapData object is created in fixed dimensions and has the pixel data from the original image copied to it. The cleanUp and destroy functions, as mentioned earlier in the section on the interface, are there to properly dispose of the references to BitmapData when the game is through with them. While not particularly crucial with only one image, if you had a game with 10, 50, or 100 images, you would not want to keep all of them in memory at once—just the one you're working with at any given moment. Now we have all the classes we need to make the game work, but we have no measure of skill or statistics to associate with the player's performance. From here we switch gears to what happens when the game is over.

The GameHistory and Results Classes

While it sounds like a cool course you'd take at a college, the GameHistory class simply contains a few pieces of data about how the player did in a particular round of MixUp:

```
public class GameHistory {
  public var won:Boolean;
  public var time:int;
  public var formattedTime:String;
  public var movesMade:int;
  public function GameHistory(won:Boolean, time:int,
  movesMade:int) {
    this.won = won;
```

```
this.time = time;
this.movesMade = movesMade;
}
```

That's it. As you can see, there's not much to this class. This is just the most basic set of data. You could feasibly store all sorts of information about how the player performed, but for this example we're limiting it to whether or not they won (as opposed to quitting prematurely), how much time it took them, and the number of moves they made. This information is stored in the MixUp *gameHistory* array and used by the Results class:

```
public class Results extends MovieClip {
 static public const PLAY_AGAIN: String = "playAgain";
 static public const MAIN_MENU:String = "mainMenu";
  public var movesMadeText:TextField:
 public var finalTimeText:TextField;
 public var playAgainButton: SimpleButton;
 public var mainMenuButton:SimpleButton;
 public function Results() {
   addEventListener(Event.ADDED_TO_STAGE, addcdToStage,
false. O. true):
 private function addedToStage(e:Event):void {
   var history;GameHistory = MixUp.gameHistory[0];
   movesMadeText.text = String(history.movesMade);
   finalTimelext.text = history.formattedTime;
   playAgainButton.addEventListener(MouseEvent.CLICK,
playAgain, false, 0, true);
   mainMenuButton.addEventListener(MouseEvent.CLICK,
mainMenu, false, 0, true);
 private function playAgain(e:MouseEvent):void {
   dispatchEvent(new Event(PLAY_AGAIN));
 private function mainMenu(e:MouseEvent):void {
   dispatchEvent(new Event(MAIN_MENU));
```

Like the Title class, this screen is pretty minimal in its current form, but it could support many other pieces of information or options. Because GameHistory objects are added to the beginning of the array in the MixUp class, to get the latest object the Results class simply looks at the first element.

At this point, we at last have a game that can be played start to finish and has multiple screens. If you publish the SWF and test it you will see how the game works, as in Figure 14.1.

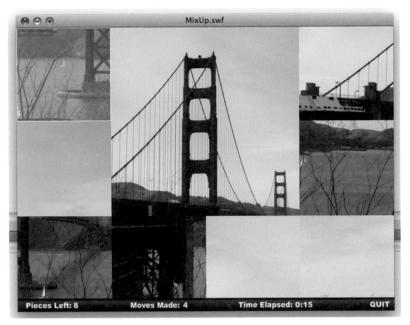

Figure 14.1 The MixUp game, in action.

Before we end this chapter, however, we have one more class to look at. It is an alternative class to use for the ISourceImage implementation. It is called SourceImageCamera, and it will use a live feed for the grid instead. If you don't have any kind of webcam, you can either skip to the next chapter or you can read on for enlightenment.

The SourcelmageCamera Class

Our previous implementation, the SourceImageEmbedded class, was simply a generic object. It only ran code when it was requested and was silent the rest of the time. For this next example, we'll need to be able to continually update the BitmapData in the pieces after they're cut up in order for a camera feed to be worthwhile:

```
public class SourceImageCamera extends Sprite implements
ISourceImage {
  protected var _rows:int, _columns:int;
  protected var _video:Video;
  protected var _camera:Camera;
  protected var _sourceBitmap:BitmapData;
  protected var _pieceList:Vector.<BitmapData>;
  public function SourceImageCamera(width:int, height:int, fps:int = 15) {
    _camera = Camera.getCamera();
    _video = new Video (width, height);
```

```
_camera.setMode(width, height, fps);
_video.attachCamera(_camera);
}
```

You'll notice a number of similarities between this class and the one for embedded images. In this version, we create variables to store the number of rows and columns for later use, as well as references to use with the Video and Camera classes. For more information on using the Camera class, go to Appendix A at the end of this book. When this class is constructed, new Camera and Video objects are created to match the desired dimensions and frame rate.

```
public function getImages(rows:int, columns:int, width:
int = 0, height:int = 0):Vector.<BitmapData> {
 if (_pieceList) return _pieceList;
 if (width == 0) width = _video.width;
 if (height == 0) height = _video.height;
 _{rows} = rows;
 _{columns} = columns;
 _sourceBitmap = new BitmapData(width, height);
 _sourceBitmap.draw(_video, new Matrix()):
 var pieceBitmap:BitmapData;
 var pieceWidth:int = Math.floor(_sourceBitmap.width / _columns);
 var pieceHeight:int = Math.floor(_sourceBitmap.height / _rows);
 _pieceList = new Vector.<BitmapData>();
 for (var j:int = 0; j < rows; j++) {
   for (var i:int = 0; i < \_columns; i++) {
    pieceBitmap = new BitmapData(pieceWidth, pieceHeight);
    var rect:Rectangle = new Rectangle(i * pieceWidth, j *
piccoHoight, pieceWidth, pieceHeight);
     pieceBitmap.copyPixels( sourceBitmap, rect, new
Point()):
    _pieceList.push(pieceBitmap);
 addEventListoner(Event.ENTER_FRAMF, updateImages, false, 0,
true);
 return _pieceList;
```

Once again, you probably notice a number of similarities to the image version of this class, except for two main differences. The first is that, instead of simply instantiating a new BitmapData object from a class, we have to create an empty one and draw the video into it. The second is that when the list is done being created an ENTER_FRAME listener is added to call a method called *updateImages*, which we'll look at next:

```
protected function updateImages(e:Event):void {
    _sourceBitmap.dispose();
    _sourceBitmap = new BitmapData(_video.width, _video.
height);
    _sourceBitmap.draw(_video);
    var pieceBitmap:BitmapData;
    var pieceWidth:int = Math.floor(_sourceBitmap.width /
    _columns);
    var pieceHeight:int = Math.floor(_sourceBitmap.height /
    _rows);
```

```
for (var j:int = 0; j < _rows; j++) {
  for (var i:int = 0; i < _columns; i++) {
    pieceBitmap = _pieceList[i + (j * _columns)];
    var rect:Rectangle = new Rectangle(i * pieceWidth, j *
pieceHeight, pieceWidth, pieceHeight);
    pieceBitmap.copyPixels(_sourceBitmap, rect, new
Point());
  }
}</pre>
```

Most of this function mirrors the same process we did in *getI-mages*, except that we now dispose of the original source image and draw a new one on every frame loop (to keep up with the changing camera image). Also, instead of creating a new list of BitmapData objects, we simply update the images we've already created. Because these objects are associated with the bitmaps inside of the game pieces, those bitmaps will automatically be updated when the pixel data inside their BitmapData changes.

```
public function cleanUp():void {
  for each (var bmd:BitmapData in _pieceList) {
    bmd.dispose();
  }
  removeEventListener(Event.ENTER_FRAME, updateImages);
  _pieceList = null;
}
public function destroy():void {
  cleanUp();
  _sourceBitmap.dispose();
  _video = null;
  _camera = null;
}
```

Finally, only minor changes are needed to the *cleanUp* and *destroy* methods. The frame loop must be removed and the video and camera objects nulled. Back in the MixUp class, you only need to change one line to change the game from using a static image to using this new source. On the game.init line in the *set-upGame* method, change the line to look like this:

```
game.init(new SourceImageCamera(640, 480, 24), 3, 4);
```

The game will now use a live feed in all the rectangles, which makes the game even more interesting if there is much motion in the background behind you. You can apply these same techniques to create new SourceImage classes that pull in imagery.

Review

In this chapter, we took a simple game from basic concept and rule set to completion using interfaces to keep it modular. In the next chapter, we will apply these concepts further on a much larger, more complicated game.

BRINGING IT ALL TOGETHER: A PLATFORMER

In the process of deciding what game I should walk through the creation of in this chapter, I asked a lot of my developer friends what they would find most useful. I even posted a public survey for people to cast votes on a variety of game types. I was impressed that, by a huge margin (the runner-up had about half as many votes), the winner was a platformer-style game. When I asked other devs why they thought this was the case, the answer was simple, albeit daunting: The platformer is an example of many different game design and development principles all working together at once—level design, animation, keyboard input, physics, collision detection, and basic AI. So, in the name of democracy, that's the type of game we will create in this chapter.

The Platformer Genre

If you've played very many games in your life, particularly on a console, odds are you've probably played a platformer game at one point. In fact, if you've played almost any of Nintendo's popular line of *Mario* games, you've played a platformer. While that famous Italian plumber tends to be the iconic representation of platformer games, this subgenre of action/adventure games is actually much broader than squashing enemies from above and collecting oversized mushrooms. Some might take place in a single screen while others scroll horizontally or vertically. Some might focus on solving a puzzle by moving objects around, collecting keys, or manipulating the game environment to allow the player to escape.

Despite all of the variations and possible styles of platformer games, they all tend to follow a few core tenets:

- The user controls some kind of protagonist, generally just referred to as a player.
- The player can move left and right and can almost always jump or use ladders.
- Some basic rules of physics usually apply, like gravity and basic collisions with solid objects; some games employ other forces like wind, buoyancy, or rubbery surfaces that cause the player to bounce.
- Gameplay is level based; each level has a start and an endpoint or ends based on accomplishing a particular objective (collecting certain items, destroying all enemies, etc.).
- There is a backstory, however brief, explaining what the player is doing and why.

Next, we'll define the rule set for our game based on these fundamental ideas.

Data Flow

It's important to outline the responsibilities of the different components of the game before going any further. In Figure 15.1, I've outlined what each component of our game is responsible for controlling. When I talk about the "engine," I'm referring to the set of classes that make up the core mechanics of a platformer game.

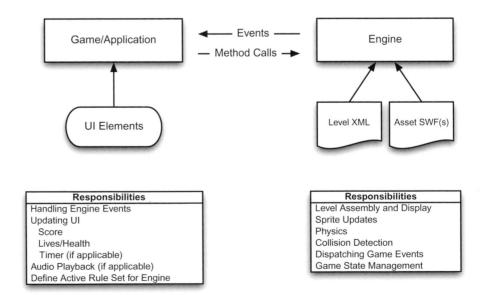

Figure 15.1 The application and the engine have different responsibilities that work in tandem with each other.

This engine is game-agnostic—it is the code that is meant to be reused later. When I talk about the game- or application-level code, I'm referring to the current *implementation* of the engine. Let's say I wanted to build two different platformer games with different art sets and basic behaviors (modified physics, for example). The engine code should remain unchanged from one game to the next (other than to add or fix features that affect all games), while the game code and art are unique to each implementation.

We applied a similar process with MixUp in Chapter 14, just not as explicitly outlined; the GameBoard class and the accompanying interfaces were the engine and the other classes were the implementation. It is important to delineate each component's jurisdiction ahead of time; it is easier than separating code into different classes later. When we look at the code for this game later on in the chapter, it will be split into these two categories.

The Game Flow and Features

Because a platformer is more complicated than the simple puzzler in the last chapter, it requires even better definition of scope and mechanics. This rule applies to game development across the board—an increase in complexity necessitates an increase in documentation. There are so many possible feature sets that can be included in a platformer it is important to narrow them down to just what we will implement in this version of the engine; otherwise, this chapter would engulf an entire book, and it would take you weeks to build it. It is important to remember that most well-written applications start out with a basic feature set and are modular enough to add feature sets over time. Take any given professional level app, even Flash itself; we are now on version 10, and it *still* does not have all the features we might want it to. Instead, Adobe has chosen to focus on certain feature sets and fine tune them so they work reliably and consistently. We must remember to give ourselves this same breathing room. No one developer is going to create the next World of Warcraft by him- or herself; it takes hundreds of people and thousands of hours of work.

The Setting

For the purposes of this book and learning the mechanics of a platformer, we don't really need a backstory. Suffice it to say that for this game the player will be exploring dungeon-like mazes, avoiding enemies, and collecting treasure for points. Although this may sound simple and familiar, it is intentional. Ultimately, we want to create a generic engine that can be reused for any number of implementations and environments.

The Level Design and Walls

The levels for this platformer will be based around a grid design of squares. This helps simplify level creation and enforces a standard for asset artwork. Any given grid square can be solid or empty, either blocking the player or allowing the player to pass through it. Going forward we will refer to solid grid squares as *walls*. We will examine how a sample level layout will look on paper momentarily. If there are no walls along the bottom of the level, it will be possible for the player to fall off the map. This would cause the level to end and the player to lose a life.

Portals

Every level will have an exit point that will signify completion of the level when the player passes through it. We'll call this exit a *portal*, as it transports the player somewhere else. You may be wondering why we're not simply calling it an exit. While this implementation of the game and engine may only ever have one exit, future iterations might span a level over a series of screens, and these portals would actually be a means of moving between them.

The Player Character

In this game, the arrow keys will control the player. The left and right arrow keys will move him in those directions, respectively. The up arrow will make the player jump, and the down arrow will be used to enter portals. The player's jump height is equal to 1.5 times the height of a grid square. This allows for the player to clear gaps one grid space in width and to easily jump onto grid squares one unit above. Additionally, the player has the ability to carry items in an inventory. In our iteration, these items will primarily consist of treasure and keys for unlocking doors but could include other pickups, such as health, in the future.

Items

Both keys for unlocking portals and treasure are classified as *items*. They share a similar relationship in that they both disappear and are added to the player's inventory when the player moves over them. The game will define certain special types of items (such as keys), which will be used by the game engine in a particular way. Items not predefined by the engine will simply accumulate in the inventory, and it will be up to the particular implementation of the game as to how to handle them when they are picked up.

Enemies

An enemy in this game will be defined as any entity that is toxic to the player. Coming into contact with an enemy will damage the player, by either taking a life or eating away at the player's health. By using this more general definition, an enemy could be a sharp inanimate object or a moving creature with basic AI. As such, enemies can either process physics such as gravity or choose to ignore them (imagine stalactites in a cave).

In Figure 15.2, you'll see a level design for the platformer based around a 10×10 grid. As the key in the figure shows, black squares represent walls and white squares are movable areas for the player. The dollar signs are treasure that can be picked up

Sample Platformer Level Lavout \$ \$ = Treasure = Wall = Enemy = Player Start = Portal

Figure 15.2 Because of the grid design of the levels, it is easy to map out a potential level design on "paper" first.

for points, and the key icon represents the key required to exit through the portal at the top of the level. There is also one enemy along the bottom of the level that will move back and forth. The player must jump over the enemy to avoid it. The player will start the level at the top, in the one notch cut out of the border wall surrounding the level. All of the levels for the game can (and probably should) be mapped out this way. This type of system is also very handy because it can translate into a standardized format like XML (which we will look at momentarily), and it is relatively straightforward to create an editor app for building levels.

The Level File Format and Asset Structure

It is a good idea to keep all of the data for each level in external files. This allows you to load new levels at runtime, as well as create your own in a standardized format, either by hand or (preferably) using a custom editor. Much like in Chapter 9, we'll store this level data in XML. This keeps the data modular and flexible, making it easy to add or remove elements from a level. It also enforces a level of organization on the data, keeping it readable if you needed to make edits by hand.

In addition to the level data living outside the final game SWF, it's a good idea with a game like this to externalize as many assets as possible. As such, we'll look at maintaining separate SWF files for the different art assets used in the game. Each level XML file will include the asset SWFs it uses, and the engine will handle loading those files prior to assembling the level. Keeping these assets in separate SWFs also allows for other developers or artists to work on different aspects of the game without stepping on each other's toes. When we get to the code behind the engine, we'll define the rules that asset files must follow in order to work properly with the engine.

The Level XML

Here is what Figure 15.2 looks like represented as XML. Note that to make the wall nodes more readable I have inserted carriage returns between each column. In the final format, there is no reason to have these and it is a non-standard XML practice.

```
<enemies>
   \langle enemy \ spriteClass = "Enemy1" \ name = "enemy1" \ x = "5" \ y = "8" />
 </enemies>
 <items>
   <item spriteClass = "Key" type = "key" name = "key1"</pre>
x = "1" y = "5" points = "0"/>
   <item spriteClass = "Treasure" type = "treasure"</pre>
name = "treasure1" x = "2" y = "3" points = "100"/>
   <item spriteClass = "Treasure" type = "treasure"</pre>
name = "treasure2" x = "1" y = "8" points = "100"/>
   <item spriteClass = "Treasure" type = "treasure"</pre>
name = "treasure3" x = "6" y = "6" points = "100"/>
 </items>
 <portals>
   <portal spriteClass = "LevelEndDoor"</pre>
destination = "nextLevel" x = "5" y = "1"
   <requirement type = "inventory" name = "key1"/>
   </portal>
 </portals>
 <walls>
   <wall spriteClass = "StandardWall" x = "0" y = "0"/>
   <wall spriteClass = "StandardWall" x = "0" y = "1"/>
   <wall spriteClass = "StandardWall" x = "0" y = "2"/>
   <wall spriteClass = "StandardWall" x = "0" y = "3"/>
   <wall spriteClass = "StandardWall" x = "0" y = "4"/>
   <wall spriteClass = "StandardWall" x = "0" y = "5"/>
   <wall spriteClass = "StandardWall" x = "0" y = "6"/>
   <wall spriteClass = "StandardWall" x = "0" y = "7"/>
   <wall spriteClass = "StandardWall" x = "0" y = "8"/>
   <wall spriteClass = "StandardWall" x = "0" y = "9"/>
   <wall spriteClass = "StandardWall" x = "1" y = "0"/>
   <wall spriteClass = "StandardWall" x = "1" y = "4"/>
   <wall spriteClass = "StandardWall" x = "1" y = "6"/>
   <wall spriteClass = "StandardWall" x = "1" y = "7"/>
   <wall sprite() ass = "StandardWall" x = "1" y = "9"/>
   <wall spriteClass = "StandardWall" x = "2" y - "2"/>
   <wall spriteClass = "StandardWall" x = "2" y = "4"/>
   <wall spriteClass = "StandardWall" x = "2" y = "7"/>
   <wall spriteClass = "StandardWall" x = "2" y = "9"/>
   <wall spriteClass = "StandardWall" x = "3" y = "0"/>
   <wall spriteClass = "StandardWall" x = "3" y = "2"/>
   <wall spriteClass = "StandardWall" x = "3" y = "9"/>
   <wall spriteClass = "StandardWall" x = "4" y = "0"/>
   <wall spriteClass = "StandardWall" x = "4" y = "1"/>
   <wall spriteClass = "StandardWall" x = "4" y = "2"/>
   <wall spriteClass = "StandardWall" x = "4" y = "3"/>
   <wall spriteClass = "StandardWall" x = "4" y = "5"/>
   <wall spriteClass = "StandardWall" x = "4" y = "9"/>
   <wall spriteClass = "StandardWall" x = "5" y = "0"/>
   <wall spriteClass = "StandardWall" x = "5" y = "2"/>
   <wall spriteClass = "StandardWall" x = "5" y = "3"/>
   <wall spriteClass = "StandardWall" x = "5" y = "6"/>
   <wall spriteClass = "StandardWall" x = "5" y = "9"/>
```

```
<wall spriteClass = "StandardWall" x = "6" y = "0"/>
   <wall spriteClass = "StandardWall" x = "6" v = "3"/>
   <wall spriteClass = "StandardWall" x = "6" y = "7"/>
   <wall spriteClass = "StandardWall" x = "6" v = "9"/>
   <wall spriteClass = "StandardWall" x = "7" y = "0"/>
   <wall spriteClass = "StandardWall" x = "7" y = "5"/>
   <wall spriteClass = "StandardWall" x = "7" v = "9"/>
   <wall spriteClass = "StandardWall" x = "8" y = "0"/>
   <wall spriteClass = "StandardWall" x = "8" y = "4"/>
   <wall spriteClass = "StandardWall" x = "8" y = "5"/>
   <wall spriteClass = "StandardWall" x = "8" v = "8"/>
   <wall spriteClass = "StandardWall" x = "8" v = "9"/>
   <wall spriteClass = "StandardWall" x = "9" y = "0"/>
   <wall spriteClass = "StandardWall" x = "9" y = "1"/>
   <wall spriteClass = "StandardWall" x = "9" v = "2"/>
   <wall spriteClass = "StandardWall" x = "9" y = "3"/>
   <wall spriteClass = "StandardWall" x = "9" y = "4"/>
   <wall spriteClass = "StandardWall" x = "9" y = "5"/>
   <wall spriteClass = "StandardWall" x = "9" y = "6"/>
   <wall spriteClass = "StandardWall" x = "9" v = "7"/>
   <wall spriteClass = "StandardWall" x = "9" y = "8"/>
   <wall spriteClass = "StandardWall" x = "9" y = "9"/>
 </walls>
</level>
```

In the opening tag of the XML, the width and height of the level, and the pixel size of each grid square are set. In this case, the level is 10×10 , with a square size of 50 pixels. This gameboard will ultimately be 500×500 pixels. In the first set of nodes, I define which asset SWFs the level will use. The engine will load these files before parsing the rest of the level. Whenever a node makes reference to a class, it will be defined and contained within one of the asset SWFs. I will outline the creation of these asset SWFs shortly.

The next individual node defines the player class and start position. Note that this x and y will not translate directly to an x and y on the Stage, but rather the corresponding grid reference in the level. To match the arrays that will eventually exist to house the grid, the x and y coordinates are 0 based. Thus, the player's start position of (2,0) will actually be in the third column at the top. The next two sets of nodes follow the same pattern, just with enemies and items. Items have a couple of extra attributes, including the type (so the engine knows how to use the item), a unique name (so the item can be tied to functionality in the game), and a point value. Note that the key is not worth any points but will be a requirement to exit the level.

Next in the file are any portal nodes. This level has only one, and its destination attribute designates that it will go to the next level. Portals also have optional requirement nodes; these are things that must be done for the portal to be active. In this case, the item tagged with the name "key1" is required to have been

picked up in order for the portal to be used. With this structure, you could theoretically have multiple requirements, such as destroying all enemies on a level or gathering all the treasure.

Finally, the file ends with the wall definitions. Each of these nodes defines a grid square that holds a wall. The player will not be able to move into these squares. Every one of these wall squares will look the same, but you could in fact define a different asset class for each of them. This would allow you to create grid squares that seam together to form larger images.

Asset SWFs

To keep the game as modular as possible and load times low, the various art assets for the game will be stored in external SWFs and loaded in at runtime. This will provide a few benefits:

- Assets will only be loaded when needed, meaning the main game SWF will not be weighted down with a ton of art in its initial load should an implementation of this game have many levels.
- Multiple developers and artists are capable of working on specific assets in tandem without needing access to the core FLA file.
- Adding new character and scenery art will be as simple as dropping in new SWFs and referencing them in the level XML.

This structure is similar to how many commercial games work; the EXE or main application file is the engine and is accompanied by one or more resource files (PAK, WAD, and RSC are some common extensions).

The asset files will have no active timeline. Each will consist merely of library items with class linkages. Once the assets are loaded into the game, they will be stored in memory and then accessed by instantiating new copies of the assets. When a level is complete, the assets will be purged from memory, but if they need to be loaded again they should already be cached in the user's browser, preventing a repeat download.

The Game Outline

Before we dig into the code behind this game, I'll outline all the classes that will come into play. The classes are divided into three categories, each with a specific purpose:

• Engine code—These files are at the heart of the game mechanic and are where the core feature set of the engine is implemented; in addition to classes, this code also contains interfaces for creating the different game components. These files are all within the com.flashgamebook .engines.platformer package.

- Game code—These classes control how this specific instance
 of the engine looks and behaves and other logic like switching between levels and creation of all the engine instances.
- Asset classes—For each of the asset SWFs in use, we'll specify
 unique class names for each individual asset, but we won't
 actually create AS files for any of them (more on this shortly).

We'll now look at all the classes involved, in the aforementioned order. It's important to note that unlike the MixUp game in Chapter 14, this example does not include multiple screens with navigation; we will focus on the game only. There is already enough code at work here and I did not want to bog you down with information not directly pertinent to the tasks at hand. I'm nice like that.

The Engine Classes

In this section, I will outline each of the classes involved in the core engine of this platformer and walk through the code of each. This is where the bulk of the code for this game resides, and it's important to understand all the components at play:

- PlatformerEngine.as—This is the big one. All of the core functionality of the game is run here; all the other classes in the package act as support for the engine.
- CollisionGrid.as—To efficiently store information about the game grid, we will use this custom data structure, which relies on multidimensional arrays and vectors to keep track of everything going on in the game.
- GridReference.as—Each grid square has an accompanying GridReference object that stores which enemies, items, walls, and portals are in a given slot on the grid.
- PlatformerConfig.as—This is a data class that allows for easy configuration of different aspects of the engine and makes it easier to change the behavior of the engine properties from level to level by storing preconfigured instances of this class.
- PortalRequirement.as—Each portal instance has an array of these objects, which define what requirements must be met in order to finish a level.
- PortalDestination.as—An enumeration class, this file simply contains preapproved destinations for portals (which map to those mentioned earlier in the XML) and makes it easy to add new ones.
- PlatformerEvent.as—Tucked inside the *events* subpackage, this class extends a normal DataEvent that the PlatformerEngine can dispatch when certain things happen inside the game; it also stores enumerations for all of the different game events.

• ISprite.as, IPlayer.as, IEnemy.as, IItem.as, IPortal.as, IWall .as—This set of interfaces in the *sprites* subpackage defines the necessary methods required for Sprites that wish to act as the player, enemies, etc., in the game.

We'll work through these classes in reverse order, so the main engine class will make more sense in context.

The ISprite Interface

This interface is the foundation for all of the other types of Sprites, except walls. It extends IEventDispatcher so that if at some point we need the Sprites to be able to easily dispatch events there will be no interface conflicts:

```
package com.flashgamebook.engines.platformer.sprites {
 import flash.display.Sprite;
 import flash.display.DisplayObject;
 import flash.events.IEventDispatcher;
 import flash.geom.Rectangle;
 public interface ISprite extends IEventDispatcher {
   function get x(): Number;
   function set x(value:Number):void;
   function get y():Number;
   function set y(value: Number): void;
   function get width():Number;
   function set width(value:Number):void;
   function yet height(): Number;
   function set height(value:Number):void;
   function get rotation(): Number;
   function set rotation(value:Number):void;
   function get hitArea():Sprite;
   function gctRect(coordinateSpace:DisplayObject):Rectangle;
   function get name():Slring;
   function set name(value:String):void;
```

You probably noted that all of these methods and accessors are included in DisplayObjects, specifically Sprites. Implementing this interface on a Sprite-based class will require no extra functionality but makes it more flexible in the engine by referring to this interface rather than any particular DisplayObject type.

The IPlayer Interface

Wherever the engine refers to the character the user controls in the game, it is done through the IPlayer interface, which extends ISprite:

```
package com.flashgamebook.engines.platformer.sprites {
  import flash.geom.Vector3D;
```

```
public interface IPlayer extends ISprite {
  function get netForce():Vector3D;
  function set netForce(value:Vector3D):void;
  function get isJumping():Boolean;
  function set isJumping(value:Boolean):void;
  function get isFalling():Boolean;
  function set isFalling(value:Boolean):void;
  function update():void;
  function get tempX():Number;
  function set tempX(value:Number):void;
  function get tempY():Number;
  function set tempY(value:Number):void;
}
```

Note the use of Vector3D objects, much like in the examples of Chapter 10.

The IEnemy Interface

Similar to the IPlayer interface, IEnemy also extends ISprite. In fact, it repeats a couple of the accessors from IPlayer, but it didn't make sense to make them part of ISprite just so they would be inherited:

```
package com.flashgamebook.engines.platformer.sprites {
  import flash.geom.Vector3D;
  import com.flashgamebook.engines.platformer.GridReference;
  public interface IEnemy extends ISprite {
    function update():void;
    function get tempX():Number;
    function set tempX(value:Number):void;
    function get tempY():Number;
    function set tempY(value:Number):void;
    function get receivesForces():Boolean;
    function get motion():Vector3D;
    function get gridReference():GridReference;
    function set gridReference(value:GridReference):void;
  }
}
```

One unique aspect of this interface is that enemies must keep track of where they currently are on the collision grid, since they are the only type of entity besides the player that can move. As such, implementers of this interface have an accessor for a GridReference object, which we'll look at soon.

The Iltem Interface

Though admittedly an awkward name for an interface, IItem is used for any items the player can pick up:

```
package com.flashgamebook.engines.platformer.sprites {
  public interface IItem extends ISprite {
    function get points():Number;
    function set points(value:Number):void;
    function get type():String;
    function set type(value:String):void;
    function pickUp():void;
}
```

The IPortal Interface

As I mentioned earlier in the chapter, portals are the devices that players make use of to move between levels:

```
package com.flashgamebook.engines.platformer.sprites {
  public interface IPortal extends ISprite {
    function get requirements():Array;
    function set requirements(value:Array):void;
    function get destination():String;
    function set destination(value:String):void;
  }
}
```

The IWall Interface

The final interface, and the only one that doesn't extend from something else, is the one used for instances of walls. While all of these functions are defined in ISprite, IWall intentionally has a smaller subset to keep it separate from that hierarchy. Collision detection with walls is handled differently than with other objects, so this gives us room to expand this interface without ramifications for other parts of the engine:

```
package com.flashgamebook.engines.platformer.sprites {
  import flash.display.DisplayObject;
  import flash.geom.Rectangle;

public interface IWall {
    //DISPLAY OBJECT PROPERTIES AND METHODS
    function get x():Number;
    function set x(value:Number):void;
    function get y():Number;
    function set y(value:Number):void;
    function set y(value:Number):void;
    function get width():Number;
    function set width(value:Number):void;
```

```
function get height():Number;
function set height(value:Number):void;
function getRect(targetCoordinateSpace:DisplayObject):
Rectangle;
}
}
```

The PlatformerEvent Class

All the messages dispatched by the PlatformerEngine, with the exception of progress messages during loading, are in the form of a PlatformerEvent object:

```
package com.flashgamebook.engines.platformer.events {
 import flash.events.DataEvent;
 public class PlatformerEvent extends DataEvent {
   public static const LEVEL LOAD COMPLETE:
String = "levelLoadComplete";
   public static const ASSET_LOAD_COMPLETE:
String = "assetLoadComplete";
   public static const GAME_START:String = "gameStart";
   public static const PLAYER_DIE:String = "playerDie";
   public static const INVENTORY_UPDATE:
String = "inventoryUpdate":
   public static const ENTER_PORTAL:String = "enterPortal";
   public function PlatformerEvent(type:String, data:
String = null, bubbles:Boolean = false, cancelable:
Boolean = false) {
     super(type, bubbles, cancelable, data):
```

As it becomes necessary to dispatch events about additional functionality, those event enumerations will easily be added here.

The PortalDestinations and PortalRequirement Classes

Because they're both very short, we'll now look at the two classes related to portal behavior:

```
package com.flashgamebook.engines.platformer {
  public class PortalDestinations {
   public static const NEXT_LEVEL:String = "nextLevel";
   public static const PREV_LEVEL:String = "prevLevel";
  }
}
```

While these two enumerations could have potentially been tucked away into the PlatformerEngine class, it makes more sense for them to be singled out. This is because there may be more functionality to add to portal behavior, such as the ability to move between two different portals on a single map. This framework allows for that extensibility.

```
package com.flashgamebook.engines.platformer {
  public class PortalRequirement {
    public static const INVENTORY:String = "inventory";
    public static const ENEMY_KILLED:String = "enemyKilled";
    public var type:String;
    public var name:String;
    public function PortalRequirement(type:String, name:String) {
        this.type = type;
        this.name = name;
    }
    }
}
```

PortalRequirement objects are also very simple and could have their limited functionality handled by a generic object, but it's better practice to statically type it and create a space for future functionality.

The PlatformerConfig Class

This class exposes certain properties of the engine by allowing you to preconfigure the behavior of the engine before even creating it. It is prepopulated with values that work well for our purposes, but these are all easily changed later:

```
package com.flashgamebook.engines.platformer {
 import Nash.geom.Rectangle;
 import flash.geom.Vector3D;
 import flash.ui.Keyboard;
 public class PlatformerConfig {
   public var gravity: Vector3D = new Vector3D(0,25);
   public var friction: Number = .75;
   public var drag:Number = .92;
   //INPUT
   public var keyJump:int = Keyboard.UP;
   public var keyUse:int = Keyboard.DOWN;
   public var keyLeft:int = Keyboard.LEFT;
   public var keyRight:int = Keyboard.RIGHT;
   //PLAYER PROPERTIES
   public var playerMovement:Vector3D = new Vector3D(30);
   public var playerJump: Vector3D = new Vector3D(0, -10);
```

Notice that this is a good way of creating and assigning input schemes, as well as defining things like the effects of gravity and friction.

The GridReference Class

As stated earlier, every square on the game grid has an associated GridReference object. It stores information about which walls, enemies, items, and portals are in a given square:

```
package com.flashgamebook.engines.platformer {
 import com.flashgamebook.engines.platformer.sprites.*:
 public class GridReference {
   public var walls:Vector.<IWall>=new Vector.<IWall>():
   public var items:Vector.<IItem>=new Vector.<IItem>();
   public var enemies:Vector.<IEnemy>=new Vector.<IEnemy>():
   public var portals:Vector.<!Portal>=new Vector.<!Portal>():
   public function hasEnemy(sprite:IEnemy):Boolean {
     return (enemies.indexOf(sprite) > -1):
   public function removeEnemy(sprite:IEnemy):void {
     if (enemies.indexOf(sprite) > -1) {
       enemies.splice(enemies.indexOf(sprite).1):
   public function hasItem(sprite:IItem):Boolean {
     return (items.indexOf(sprite) > -1);
   public function removeItem(sprite:IItem):void {
     if (items.index0f(sprite) > -1) {
       items.splice(items.indexOf(sprite),1);
     }
   public function concat(gridReference:GridReference):void {
     if (!gridReference) return;
     walls = walls.concat(gridReference.walls);
     itcms = items.concat(gridReference.items):
     enemies = enemies.concat(gridReference.enemies):
     portals = portals.concat(gridReference.portals);
   public function toString():String {
     var str:String = "GRID REFERENCE:\n";
     str += "WALLS: " + walls + "\n";
     str += "ITEMS: " + items + "\n":
     str += " ENEMIES: " + enemies + "\n";
     str += " PORTALS: " + portals;
     return str:
```

```
public function clear():void {
   walls = null;
   items = null;
   enemies = null;
   portals = null;
}
}
```

Every type of object a grid reference can store has a vector created just for it. Many of these vectors may stay empty, but they consume very little memory by themselves, so it is a small price to pay for such flexibility. Similar to an array, GridReference objects have a *concat* method, which allows you to merge one grid reference with another. With this functionality, it is possible to combine multiple grid references into one for easy checking.

There are also convenient methods for removing enemies and items from a grid reference and a custom *toString* method that allows you to easily see what's in a grid reference with a simple trace statement. Finally, there is also a *clear* method that can be called during engine cleanup.

The CollisionGrid Class

To store all of the GridReference objects in a cohesive structure, we need a container. We could use a simple array or vector to keep track of all of them, but in our case it makes more sense to create a custom data structure—enter the CollisionGrid. This class makes use of both an array and multiple vectors to create a multidimensional grid:

```
package com.flashgamebook.engines.platformer {
  import flash.geom.Point;
  public class CollisionGrid {
    private var _width:int;
    private var _height:int;
    private var _grid:Array;

  public function CollisionGrid(width:int, height:int) {
      _width = width;
      _height = height;
      _grid = new Array(_width, true);
      for (var i:int = 0; i < _width; i++) {
            _grid[i] = new Vector.<GridReference>(_height, true);
            for (var j:int = 0; j < _height; j++) {
                 _grid[i][j] = new GridReference();
            }
      }
    }
}</pre>
```

```
public function getGridReference(x:int, y:int):GridReference {
    if (x < 0 || y < 0) return null;
    if (x >= _width || y >= _height) return null;
    return _grid[x][y];
}

public function clear():void {
    for (var i:int = 0; i < _grid.length; i++) {
        for each (var gridReference:GridReference in _grid[i]) {
            gridReference.clear();
        }
        _grid[i] = null;
    }
    _grid = null;
}</pre>
```

When a new CollisionGrid object is created, it needs a width and a height. It constructs all of the necessary containers and fills them with empty GridReference objects. Because the structure and dimensions of a level can't change on the fly, the vector containers have a fixed length. This improves speed and memory usage.

Getting at a specific GridReference object is as simple as calling the *getGridReference* method and passing it *x* and *y* values. If a grid square outside the range of the grid is requested, the method returns null. Like a GridReference object, the grid created by this class also has a *clear* method that performs clean-up and disposal of all the objects.

The PlatformerEngine Class

Now we've reached the heart of the entire game. This class is very large (500+ lines), so I will break it up into discrete pieces. The class is divided logically into different sets of tasks, so it's easier to find what you're looking for. These tasks are:

- · Level XML load handling
- Asset load handling
- · Level creation
- Game loop functionality (what is run every frame)
- Helper methods
- Input handlers

This largely maps to the order of events that occur when using the engine as well, so it is straightforward to follow. This class also uses a ton of imports, which I'll skip here in the text (you can find them in the source files for this chapter). We'll start by looking at all the properties defined in the class:

```
public class PlatformerEngine extends Sprite {
  protected var _gravity:Vector3D;
  protected var _friction:Number;
  protected var _config:PlatformerConfig;
```

```
protected var _currentLevel:XML;
protected var previousTime:int;
protected var _deltaTime:Number;
protected var _keyLeftPressed:Boolean;
protected var _keyRightPressed:Boolean;
protected var walls:Array;
protected var _items:Array;
protected var _enemies:Array;
protected var _portals:Array;
protected var _player:IPlayer;
protected var _collisionGrid:CollisionGrid;
protected var _gameRunning:Boolean = false;
protected var _inventory:Vector.<IItem>;
protected var _assetDomain:ApplicationDomain;
protected var _assetPath:String = "";
protected var _assetQueue:Vector.<String> = new Vector.<String>();
protected var _assets:Vector.<Loader> = new Vector.<Loader>();
public function PlatformEngine() {
```

The properties listed here mostly consist of containers for different types of objects. A couple of important things to note are the container for the player's inventory and the <code>_assetDomain</code> property. The latter is used to store all of the class definitions for the assets the engine will load. This will keep those definitions from overriding any that might exist in the engine and will keep them from being separated from each other. Note that the constructor does nothing—it is there merely as an acknowledgment. Initialization is handled through the <code>init</code> method, which we will look at next:

```
public function init(config:PlatformerConfig):void {
   _config = config;
   _gravity = _config.gravity;
   _friction = _config.friction;
   _assetDomain = new ApplicationDomain(ApplicationDomain.currenlDomain);
   _inventory = new Vector.<IItem>();
}
```

This method handles creation of a number of basic engine properties. It is the first of a handful of public-facing methods. The majority of the functionality of this engine is protected and inaccessible from the outside.

```
public function startGame():void {
  if (!stage) throw new Error("PlatformEngine instance must
be added to stage before startGame() is called.");
  stage.addEventListener(KeyboardEvent.KEY_DOWN, onKeyDown,
false, 0, true);
  stage.addEventListener(KeyboardEvent.KEY_UP, onKeyUp,
false, 0, true);
  addEventListener(Event.ENTER_FRAME, update, false, 0, true);
  _previousTime = getTimer();
  _gameRunning = true;
}
```

```
public function stopGame():void {
  if (!stage) throw new Error("PlatformEngine instance must
be added to stage before stopGame() is called.");
stage.removeEventListener(KeyboardEvent.KEY_DOWN, onKeyDown);
  stage.removeEventListener(KeyboardEvent.KEY_UP, onKeyUp);
  removeEventListener(Event.ENTER_FRAME, update);
  _gameRunning = false;
}
```

Once the game is added to the Stage and has had all of its data loaded, the *startGame* and *stopGame* methods can be called. They handle the enterFrame and keyboard listener attachment, and also toggle a Boolean value called *_gameRunning*. This will be used later in case the game is stopped and disposed of before all the game loop code has finished running.

```
public function get inventory():Vector.<IItem> {
  return _inventory.slice();
}
```

A facet that the game does expose is a copy of the inventory vector. This allows the user interface to display information about what is in the player's inventory. Storing everything the player picks up allows us to tie portal requirements to specific items later on.

```
public function get inventoryWorth():Number {
  var worth:Number = 0;
  for each (var item:IItem in _inventory) {
    worth += item.points;
  }
  return worth;
}
```

In addition to the list of inventory items, there's a helpful method for retrieving the total worth of the inventory in points. If you recall from the level XML, every item has a point attribute; in some cases, that value is 0, but all of them have it.

```
public function destroy():void {
  clearReferences();
  for (var i:int = numChildren - 1; i >= 0; i--) {
     removeChildAt(i);
  }
}

protected function clearReferences():void {
  _collisionGrid.clear();
  _inventory = null;
  _walls = null;
  _items = null;
  _enemies = null;
  _portals = null;
  _portals = null;
  _player = null;
  for each(var loader:Loader in _assets) {
    loader.unload();
}
```

```
_assets = null;
_assetQueue = null;
}
```

Both of these methods are used to perform clean-up on the engine. Because there are so many pieces of data in so many containers, it is important to null them all out. Note also that each of the Loader objects in the asset list call the *unload* method on themselves. We'll look at level and asset loading next:

```
//LEVEL MANAGEMENT
public function loadLevel(uri:String):void {
 var request:URLRequest = new URLRequest(uri);
 var levelLoader:URLLoader = new URLLoader(request);
 levelLoader.addEventListener(Event.COMPLETE, levelLoaded,
false, 0, true);
 levelLoader.addEventListener(IOErrorEvent.IO ERROR,
levelError, false, 0, true);
 levelLoader.addEventListener(SecurityErrorEvent.SECURITY_
ERROR, securityError, false, 0, true);
protected function levelLoaded(e:Event):void {
 _currentlevel = XML(e.target.data);
  _collisionGrid = new CollisionGrid(Number(_currentLevel.@
width), Number(_currentLevel.@height));
 var assets:XMLList = _currentLevel.assets.children();
 for (var \ i:int = 0: i < assets.length(); i++) {
   _assetQueue.push(assets[i].@file);
 var pe:PlatformerEvent = new
PlatformerEvent(PlatformerEvent.LEVEL LOAD COMPLETE);
 dispatchEvent(pe);
 loadNextAsset():
protected function levelError(e:IOErrorEvent):void {
 trace("PlatformEngine: Error Loading Level: ".e.text):
protected function securityError(e:SecurityErrorEvent):void {
 trace("SecurityError:",e.text);
//END LEVEL MANAGEMENT
```

When the engine has been created and initialized, it is ready to load a level XML file. As such, there is a public method called *loadLevel* that does just this. When the level data is loaded and converted to an XML object, a new CollisionGrid object is created, as well as a list of all the necessary assets needed to play the level. Once this list is complete, asset loading begins.

```
//ASSET MANAGEMENT
protected function loadNextAsset(e:Event = null):void {
  var loader:Loader = new Loader();
  var nextAsset:String = _assetQueue[_assets.length];
```

```
var context:LoaderContext = new LoaderContext(false,
   _assetDomain);
  loader.load(new URLRequest(_assetPath + nextAsset),
  context);
  loader.contentLoaderInfo.addEventListener(Event.COMPLETE,
  assetsLoaded, false, 0, true);
  loader.contentLoaderInfo.addEventListener(ProgressEvent.
  PROGRESS, assetLoadProgress, false, 0, true);
  loader.contentLoaderInfo.addEventListener(IOErrorEvent.
  IO_ERROR, assetLoadError, false, 0, true);
  loader.contentLoaderInfo.addEventListener(SecurityErrorEvent.
  SECURITY_ERROR, securityError, false, 0, true);
  _assets.push(loader);
}
```

The *loadNextAsset* method is called each time one asset finishes loading, until the entire manifest has been pulled into the engine. Note that the Loader has a specific LoaderContext object created for it, which directs it to place the Loader's class definitions in a common ApplicationDomain. Each Loader also has a progress event linked to it, which we will look at next:

```
protected function assetLoadProgress(e:ProgressEvent):void {
  var baseCompletion:Number = 100 * (_assets.length-
1)/_assetQueue.length;
  var currentProgress:Number = (100/_assetQueue.length) *
(e.bytesLoaded/e.bytesTotal);
  var bytesLoaded:int = Math.
round(baseCompletion + currentProgress);
  var pe:ProgressEvent = new ProgressEvent(ProgressEvent.
PROGRESS, false, false, bytesLoaded, 100);
  dispatchEvent(pe);
}
```

To create an accurate percentage of how much of the level assets have loaded (without knowing the file size of each one), we have to create a custom ProgressEvent. It takes into account the number of items to load and the individual progress of each asset to create an event with somewhere between 0 and 100 bytes loaded, which represents the percent loaded. Naturally, if the asset files are dramatically different in size, this means of measuring completion will seem a little erratic, but it will be as accurate as we can get without loading all of the files at once (which can choke on some Internet connections).

```
protected function assetsLoaded(e:Event):void {
  if (_assets.length < _assetQueue.length) {
    loadNextAsset();
    return;
  }
  var pe:PlatformerEvent = new PlatformerEvent(PlatformerEvent.ASSET_LOAD_COMPLETE);
  dispatchEvent(pe);
  createLevel();
}</pre>
```

```
protected function assetLoadError(e:IOErrorEvent):void {
   trace("PlatformEngine: Error Loading Asset:
",_assetQueue[_assets.length - 1]);
}

protected function getAssetClass(assetName:String):Class {
   if (_assetDomain.hasDefinition(assetName)) {
     return _assetDomain.getDefinition(assetName) as Class;
   }
   throw new ArgumentError("Asset Class " +assetName+ "
   cannot be found in loaded asset files.");
}
//END ASSET MANAGEMENT
```

Once all of the assets are loaded successfully, the level is ready to be created via *createLevel*. To link up the classes referenced in the XML, there is one helper function called *getAssetClass* that accepts a class name as a string. It looks up the class definition in the common asset ApplicationDomain and returns it as a Class object or throws an error if the asset does not exist.

```
//BEGIN LEVEL CREATION
protected function createLevel():void {
  createWalls();
  createPortals();
  createEnemies();
  createItems();
  //CREATE PLAYER
  var playerClass:Class = getAssetClass(_currentLevel.
player.@spriteClass);
  _player = new playerClass();
  _player.x = Number(_currentLevel.player.@x) *
Number(_currentLevel.@gridSquareSize);
  _player.y = Number(_currentLevel.player.@y) *
Number(_currentLevel.@gridSquareSize);
  addChild(_player as DisplayObject);
}
```

There is a lot going on in this method; it calls individual methods for creating each type of core object and then creates the player Sprite. I'll show all of the creation methods back to back, as they are largely similar in structure:

```
protected function createWalls():void {
   _walls = new Array();
   var walls:XMLList = _currentLevel.walls.children();
   for (var i:int = 0; i < walls.length(); i++) {
     var wallClass:Class = getAssetClass(walls[i].@
   spriteClass);
   var wallSprite:IWall = new wallClass();
   wallSprite.x = Number(walls[i].@x) *
Number(_currentLevel.@gridSquareSize);
   wallSprite.y = Number(walls[i].@y) *
Number(_currentLevel.@gridSquareSize);
   _walls.push(wallSprite);</pre>
```

```
var gridReference:GridReference = _collisionGrid.getGridRe
ference(Number(walls[i].@x), Number(walls[i].@y));
   gridReference.walls.push(wallSprite);
   addChild(wallSprite as DisplayObject);
protected function createEnemies():void {
 enemies = new Array();
 var enemies:XMLList = _currentLevel.enemies.children();
 for (var i:int = 0: i < enemies.length(): i++) {</pre>
   var enemyClass:Class = getAssetClass(enemies[i].@
spriteClass):
   var enemySprite:IEnemy = new enemyClass();
   enemySprite.x = Number(enemies[i].@x)
Number( currentLevel.@gridSquareSize);
   enemySprite.y = Number(enemies[i].@y)
Number( currentLevel.@gridSquareSize);
   enemySprite.name = enemies[i].@name;
   _enemies.push(enemySprite):
   var gridReference:GridReference =
collisionGrid.getGridReference(Number(enemies[i].@x),
Number(enemies[i].@y));
   gridReference.enemies.push(enemySprite);
   enemySprite.gridReference = gridReference:
   addChild(enemySprite as DisplayObject);
protected function createItems():void {
 _items = new Array();
 var items:XMLList = _currentLevel.items.children():
 for (var i:int = 0; i < items.length(); i++) {
   var itemClass:Class = getAssetClass(items[i].@
spriteClass):
   var itemSprite:IItem = new itemClass();
   itemSprite.x = Number(items[i].@x)
Number( currentLevel.@gridSquareSize):
   itemSprite.y = Number(items[i].@y)
Number(_currentLevel.@gridSquareSize);
   itemSprite.points = Number(items[i].@points);
   itemSprite.name = items[i].@name;
   itemSprite.type = items[i].@type;
   _items.push(itemSprite);
   var gridReference:GridReference =
_collisionGrid.getGridReference(Number(items[i].@x),
Number(items[i].@y));
   gridReference.items.push(itemSprite);
   addChild(itemSprite as DisplayObject);
protected function createPortals():void {
  _portals = new Array();
  var portals:XMLList = _currentLevel.portals.children();
  for (var i:int = 0; i < portals.length(); i++) {</pre>
   var portalClass:Class = getAssetClass(portals[i].@
spriteClass);
```

```
var portalSprite:IPortal = new portalClass();
   portalSprite.x = Number(portals[i].@x)
Number(_currentLevel.@gridSquareSize);
   portalSprite.y = Number(portals[i].@y) *
Number(_currentLevel.@gridSquareSize);
   portalSprite.destination = portals[i].@destination:
   for each (var requirement:XML in portals[i].requirement) {
     portalSprite.requirements.push(new
PortalRequirement(requirement.@type, requirement.@name)):
   _portals.push(portalSprite);
   var gridReference:GridReference =
_collisionGrid.getGridReference(Number(portals[i].@x).
Number(portals[i].@y));
   gridReference.portals.push(portalSprite);
   addChild(portalSprite as DisplayObject);
//END LEVEL CREATION
```

Because there is so much code to digest here, I've bolded the most significant areas. Each of the types of Sprites adds itself to the appropriate GridReference object, and each enemy Sprite stores a reference to its respective GridReference. In *createPortals*, each portal defines a new PortalRequirement object for every requirement necessary to use that portal. Every type of Sprite is added both to an engine-level list as well as to a grid reference and then added to the Stage at its specified position from the XML.

The level has now been created and is in the display list. From this point forward, *startGame* and *stopGame* can be called on the engine, and the player Sprite is ready to receive input. However, we're going to jump slightly out of order in the file for a moment to outline the helper methods before we dive into the main game loop. Then we'll examine the keyboard input handlers the game uses, as well.

```
//BEGIN UTILITY
protected function getGridPosition(sprite:ISprite):Point {
 var spriteRect:Rectangle = sprite.getRect(this):
 var centerX:Number = spriteRect.x + (spriteRect.width/2);
 var xPos:int = Math.floor(centerX /
Number(_currentLevel.@gridSquareSize));
 var centerY:Number = spriteRect.y + (spriteRect.height/2);
 var yPos:int = Math.floor(centerY /
Number(_currentLevel.@gridSquareSize));
 return new Point(xPos, yPos);
protected function updateGridReference(sprite:IEnemy):void {
 var position:Point = getGridPosition(sprite);
 var newGridReference =
_collisionGrid.getGridReference(position.x, position.y);
 if (newGridReference == sprite.gridReference) return;
 sprite.gridReference.removeEnemy(sprite);
```

```
sprite.gridReference = newGridReference;
 newGridReference.enemies.push(sprite):
protected function getCollisionReference(sprite:ISprite):
GridReference {
 var testPoint:Point = getGridPosition(sprite);
 var testReference:GridReference = new GridReference();
 //CHECK THE CURRENT GRID REFERENCE, AND THE EIGHT
SURROUNDING
 testReference.concat( collisionGrid.getGridReference
(testPoint.x-1, testPoint.y-1));
 testReference.concat( collisionGrid.getGridReference
(testPoint.x, testPoint.y-1));
 testReference.concat(\_collisionGrid.getGridReference)\\
(testPoint.x+1, testPoint.y-1));
 testReference.concat(_collisionGrid.getGridReference
(testPoint.x-1, testPoint.y));
 testReference.concat(_collisionGrid.getGridReference
(testPoint.x, testPoint.y));
 testReference.concat(_collisionGrid.getGridReference
(testPoint.x+1, testPoint.y));
 testReference.concat(_collisionGrid.getGridReference
(testPoint.x-1, testPoint.y+1));
 testReference.concat( collisionGrid.getGridReference
(testPoint.x, testPoint.y+1));
 testReference.concat( collisionGrid.getGridReference
(testPoint.x+1, testPoint.y+1));
 return testReference;
//END UTILITY
```

To make it easy to determine the grid space for any given Sprite in the game, there is a single method that returns a Point object. Any given Sprite is measured from the center point of its Stage rectangle to determine the grid space in which is resides.

As I mentioned earlier, enemies are capable of moving between grid squares, so they must have the ability to update the GridReference objects to which they are linked. This is where the *updateGridReference* method comes in handy—it handles removing an enemy from one reference and into another with a single command.

The final, and perhaps most important, helper method is <code>getCollisionReference</code>. This method assembles an entirely new GridReference object concatenated from the eight grid squares surrounding a Sprite, plus the square in which the Sprite currently exists. This is important because it ensures that we only test for collisions in <code>nearby</code> grid references. There is no need to test the player against another Sprite on the other side of the level. This ensures that there will be no more and no less than nine checks per cycle, which means that the level size can scale almost indefinitely without a performance drop. This method will be called at the onset of every collision detection check.

```
//BEGIN INPUT MANAGEMENT
protected function onKeyDown(e:KeyboardEvent):void {
 switch (e.keyCode) {
   case _config.keyLeft: _keyLeftPressed = true;
   break;
   case _config.keyRight: _keyRightPressed = true;
   break:
   case _config.keyJump: playerJump();
   break;
   case _config.keyUse: checkPortals();
   break:
protected function onKeyUp(e:KeyboardEvent):void {
 switch (e.keyCode) {
   case _config.keyLeft: _keyLeftPressed = false;
   break:
   case _config.keyRight: _keyRightPressed = false;
   break:
//END INPUT MANAGEMENT
```

The key input for this platformer is very simple. The left and right keys (regardless of the actual key they're assigned to in the Config class) act as toggles, while the jump and use keys (Up and Down arrows, by default) perform one-time actions.

On every frame update, the game will call the *update* method. This function determines the amount of time that has elapsed since it was last called and then calls a number of other methods:

```
//BEGIN GAME LOOP LOGIC
protected function update(e:Event):void {
   _deltaTime = (getTimer() - _previousTime)/1000;
   _previousTime = getTimer();
   readKeyInput();
   applyForces();
   movePlayer();
   moveEnemies();
   checkPlayerCollisions();
   render();
}
```

As a top-level summary before we dig into each method individually, here is the process that takes place in the course of an *update*:

- The game checks to see which keys are pressed so it can apply player forces if necessary.
- Physics forces are applied to the player.
- The player's cumulative forces are used to update the player's position in the form of temporary properties (*tempX* and *tempY*).

- All of the enemies in the game are moved according to their motion parameter; they are also checked for collisions against walls.
- The player is collision-checked against different kinds of Sprites, depending on the player's position in the grid; portals are not checked until the "use" key is pressed.
 - 1. If the player is colliding with a wall, the player's temp position is updated to adjust for the wall.
 - **2.** If the player is colliding with an enemy, a death event is dispatched.
 - **3.** If the player is colliding with an item, the item is added to the inventory and an inventory update event is dispatched.
- The player's and enemies' temporary positions are assigned to their respective x and y values, having been correctly adjusted for collisions.

```
protected function readKeyInput():void {
  var movement:Vector3D = _config.playerMovement.clone();
  movement.scaleBy(_deltaTime);
  if (_keyLeftPressed) {
    _player.netForce.decrementBy(movement);
  }
  if (_keyRightPressed) {
    _player.netForce.incrementBy(movement);
  }
}
```

In *readKeyInput*, the player's horizontal movement is applied as a force (scaled by the amount of time that has passed) to the player's physics object.

```
protected function playerJump():void {
  if (_player.isJumping || _player.isFalling) return;
  _player.isJumping = true;
  var jump:Vector3D = _config.playerJump.clone();
  _player.netForce.incrementBy(jump);
}
```

When the user presses the jump key, it triggers the *playerJump* method. If the player is already jumping or is falling through the air, the jump command is ignored. The jump is applied directly one time, rather than being scaled over time; gravity will eventually overcome the force of the jump.

```
protected function applyForces():void {
  var gravity:Vector3D = _config.gravity.clone();
  gravity.scaleBy(_deltaTime);
  _player.netForce.incrementBy(gravity);
  if (_player.isJumping) {
    _player.netForce.x *= _config. drag;
  } else {
    _player.netForce.x *= _config.friction;
  }
}
```

```
protected function movePlayer():void {
    _player.tempX = _player.x + _player.netForce.x;
    _player.tempY = _player.y + _player.netForce.y;
}
```

Next, the forces of gravity, drag, and friction are all applied to the player's force object. Then the player's position is updated to its *tempX* and *tempY* properties based on the current amount of force being applied. Before checking for collisions, however, we need to update the positions of all enemies in the game:

```
protected function moveEnemies():void {
 for each (var enemy:IEnemy in _enemies) {
   var motion:Vector3D = enemy.motion.clone();
   motion.scaleBy(_deltaTime);
   enemy.tempX = enemy.x + motion.x;
   enemy.tempY = enemy.y + motion.y;
   //CHECK WALL COLLISIONS
   var testReference:GridReference = getCollisionReference(enemy);
   var enemyRect:Rectangle = enemy.hitΛrea.getRect(this);
   var oldRect:Rectangle = enemyRect.clone();
   enemyRect.offset(enemy.tempX-enemy.x, enemy.tempY-enemy.y);
   for each (var wall:IWall in testReference.walls) {
     var wallRect:Rectangle = wall.getRect(this);
     var intersection:Rectangle =
wallRect.intersection(enemyRect):
     if (!intersection.width | | !intersection.height) continue;
     if (wallRect.right >= oldRect.left) { //WALL IS TO THE LEFT
       enemyRect.x -= intersection.width:
       enemy.motion.x *=-1;
     if (wallRect.left >= oldRect.right) { //WALL IS TO THE RIGHT
       enemyRect.x -= intersection.width:
       enemy.motion.x *=-1:
   enemy.tempX = enemy.x + cncmyRect.x oldRect.x;
   enemy.tempY = enemy.y + enemyRect.y-oldRect.y;
```

Each enemy can have its own motion force defined individually, and each one is applied separately. In the same process, since we're already looping through the list of enemies, we test for wall collisions using the <code>getCollisionReference</code> method we looked at earlier. If an enemy is hitting a wall, its direction is reversed. For this example, there is no accounting for physics on enemies, so gravity would not affect them; however, it would not be terribly difficult to add support for forces to be applied to enemies as well as the player.

```
protected function checkPlayerCollisions():void {
  var testReference:GridReference = getCollisionReference(_player);
  //CHECK INDIVIDUAL SPRITES
  checkWalls(testReference);
```

```
checkItems(testReference);
checkEnemies(testReference);
```

The *checkPlayerCollisions* method is actually comprised of several methods that test against individual kinds of Sprites. The tests for each are very similar, but the results are handled differently in each case.

```
protected function checkWalls(testReference:GridReference):
void {
 var testRect:Rectangle = _player.hitArea.getRect(this);
 var oldRect:Rectangle = testRect.clone();
 testRect.x += _player.tempX-_player.x:
 testRect.y += _player.tempY-_player.y;
 for each (var wall: IWall in testReference.walls) {
   var wallRect:Rectangle = wall.getRect(this);
   var intersection: Rectangle =
wallRect.intersection(testRect):
   if (!intersection.width || !intersection.height)
continue:
   if (wallRect.top >= oldRect.bottom) { //WALL IS BELOW
     testRect.y -= intersection.height; //OFFSET BY
INTERSECTION HEIGHT
     _{player.netForce.y} = 0;
   intersection = wallRect.intersection(testRect);
   if (wallRect.right <= oldRect.left) { //WALL IS TO THE LEFT
    testRect.x += intersection.width:
     if (intersection.width) _player.netForce.x = 0;
   intersection = wallRect.intersection(testRect);
   if (wallRect.left >= oldRect.right) { //WALL IS TO THE RIGHT
     testRect.x -= intersection.width;
     if (intersection.width) _player.netForce.x = 0;
   intersection = wallRect.intersection(testRect);
   if (wallRect.bottom <= oldRect.top) { //WALL IS ABOVE
    testRect.y += intersection.height; //OFFSET BY
INTERSECTION HEIGHT
    if (intersection.height) _player.netForce.y = 0;
   }
   //ADJUST VALUES TO MATCH NEW RECT
   _player.tempX = _player.x + (testRect.x - oldRect.x);
   _player.tempY = _player.y + (testRect.y - oldRect.y);
```

The wall collision check is the most involved, as it requires the most calculation and action on the engine's part. If the player is overlapping into a wall, its position must be corrected relative to the wall. If no overlap occurs, the full check and adjustment step is skipped to minimize calculations.

```
protected function checkItems(testReference:GridReference):
void {
 var testRect:Rectangle = _player.hitArea.getRect(this):
 for each (var item:IItem in testReference.items) {
   var itemRect:Rectangle = item.hitArea.getRect(this):
   if (testRect.intersects(itemRect)) {
    var itemPoint:Point = getGridPosition(item);
    var gridReference:GridReference =
_collisionGrid.getGridReference(itemPoint.x, itemPoint.y);
    gridReference.removeItem(item):
    _inventory.push(item);
     _items.splice(_items.indexOf(item),1);
    removeChild(item as DisplayObject);
    var pe:PlatformerEvent = new PlatformerEvent(Platformer
Event.INVENTORY_UPDATE,item.name);
    dispatchEvent(pe):
```

The next type of Sprite to check against is items. A similar rectangle intersection test is performed, but no position adjustments are needed. If the player collides with an item, it should simply be removed from the screen and all collision lists, and it should then be added to the player's inventory.

```
protected function checkEnemies(testReference:GridReference):
void {
 var testRect:Rectangle = _player.hitArea.getRect(this);
 for each (var enemy:IEnemy in testReference.enemies) {
   var enemyRect:Rectangle = enemy.hitArea.getRect(this);
   if (testRect.intersects(enemyRect)) {
     var enemyPoint:Point = getGridPosition(cncmy):
     var gridKeterence:GridReference =
_collisionGrid.getGridReference(enemyPoint.x, enemyPoint.y):
     gridReference.removeEnemy(enemy):
     _enemies.splice(_enemies.indexOf(enemy).1):
     removeChild(enemy as DisplayObject):
     var pe:PlatformerEvent = new
PlatformerEvent(PlatformerEvent.PLAYER_DIE, enemy.name);
    dispatchEvent(pe);
   }
```

The *checkEnemies* method is very similar to the item check, except that a different outcome occurs in the form of a PLAYER_DIE event. The enemy is also removed from all lists.

```
protected function checkPortals():void {
  var testPoint:Point = getGridPosition(_player);
  var testReference:GridReference =
  _collisionGrid.getGridReference(testPoint.x, testPoint.y);
```

```
if (testReference.portals.length) {
   var portal:IPortal = testReference.portals[0];
   var portalRect:Rectangle = portal.hitArea.getRect(this);
   if (_player.hitArea.getRect(this).intersects(portalRect)) {
     var metRequirements:Boolean = true;
     for each (var requirement:PortalRequirement in
portal.requirements) {
       if (requirement.type == PortalRequirement.INVENTORY) {
          if (!checkInventory(requirement.name)) {
             metRequirements = false;
             break:
     if (metRequirements) {
       var pe:PlatformerEvent = new
PlatformerEvent(PlatformerEvent.ENTER_PORTAL, portal.destination);
       dispatchEvent(pe);
protected function checkInventory(name:String):Boolean {
 var found:Boolean = false;
 for (var i:int = 0; i < _inventory.length; i++) {
   if ( inventory[i].name == name) {
     found = true;
     break:
 return found;
```

When the use key is pressed, the engine runs the *checkPortals* method. This not only tests to see if the player is colliding with a portal but also checks the portal's requirement list to make sure the player has completed the requirements for passing through the portal. The one type of requirement the engine currently accounts for is an inventory item. The *checkInventory* method is called to see if an item with the specified name is in the player's inventory. If it is, the requirement is met and the player is allowed access to the portal.

```
protected function render():void {
  if (!_gameRunning) return;
  _player.x = _player.tempX;
  _player.y = _player.tempY;
  _player.update();
  for each (var enemy:IEnemy in _enemies) {
    enemy.x = enemy.tempX;
    enemy.y = enemy.tempY;
    updateGridReference(enemy);
    enemy.update();
  }
}
//END GAME LOOP LOGIC
```

The final method of the engine class updates the player's and all enemies' x and y positions to their corrected temp values. It also calls the update method on both of these types of objects. This allows animation/graphic updates in those types of Sprites to occur regularly and without having to call any specific code. Now we've covered the entire engine package—next we'll cover the game and asset classes that put this engine into action.

The Game Class

For this example, all of the classes associated with game code are in the "example" package, differentiating them from the engine classes. One of these classes is tied to the PlatformerExample.fla file, found with the Chapter 15 support files. The other classes are related to the assets, which we will examine shortly.

The PlatformerExample Class

The document class used for this example handles creation of the engine instances, as well as notification and progress messaging:

```
package example {
 import flash.display.Sprite:
 import flash.events.ProgressEvent;
 import flash.text.TextField:
 import com.flashgamebook.engines.platformer.*:
 import com.flashgamebook.engines.platformer.events.
PlatformerEvent:
 public class PlatformerExample extends Sprite(
   public var pointsText:TextField:
   public var loadingText:TextField;
   public var percentlext:lextField:
   public var gameOverText:TextField;
   private var _platformer:PlatformerEngine;
   private var _config:PlatformerConfig;
   private var _level:int = 0;
   private var _score:Number = 0;
   private var _previousScore:Number = 0;
   public function PlatformerExample() {
    nextLevel();
   public function nextLevel() {
     level++:
    loadingText.visible = true;
    percentText.text = "0%":
    percentText.visible = true:
    gameOverText.visible = false;
    _platformer = new PlatformerEngine();
    _config = new PlatformerConfig();
    _platformer.init(_config);
```

```
platformer.loadLevel("level"+_level+".xml");
    platformer.addEventListener(ProgressEvent.PROGRESS,
loadProgress, false, 0, true);
 platformer.addEventListener(PlatformerEvent.ASSET_LOAD_
COMPLETE, loadComplete, false, 0, true);
     _platformer.addEventListener(PlatformerEvent.ENTER_
PORTAL, levelComplete, false, 0, true);
     platformer.addEventListener(PlatformerEvent.PLAYER DIE,
playerDied, false, 0, true);
 _platformer.addEventListener(PlatformerEvent.INVENTORY_
UPDATE, inventoryUpdate, false, 0, true);
   private function loadProgress(e:ProgressEvent):void {
     percentText.text = Math.round(100
(e.bytesLoaded/e.bytesTotal)) + "%";
   private function loadComplete(e:PlatformerEvent):void {
     loadingText.visible = false;
     percentText.visible = false;
     addChild(_platformer);
     platformer.startGame();
   private function levelComplete(e:PlatformerEvent) {
     if (e.data = PortalDestinations.NEXT_LEVEL) {
       _platformer.stopGame();
       trace("GAME OVER:",_platformer.inventoryWorth,"points");
       _previousScore = _platformer.inventoryWorth;
       _platformer.destroy();
       removeChild( platformer);
       nextLevel():
   private function playerDied(e:PlatformerEvent) {
     platformer.stopGame();
     trace("GAME OVER: Player killed by", e.data);
     _platformer.destroy();
     removeChild(_platformer);
     gameOverText.visible = true;
   private function inventoryUpdate(e:PlatformerEvent) {
     _score = _previousScore + _platformer.inventoryWorth;
     pointsText.text = _score.toString();
}
```

The primary method behind this class is *nextLevel*. It creates the objects necessary to instantiate the game engine and start the loading process. If you test this SWF using the bandwidth profiler inside of Flash, you'll see that it accurately moves from 0 to 100% over the course of loading all the assets. The method also sets up listeners for the major game events, like the player dying, picking up items, or going through the end portal. Overall, this class

is pretty bare bones—this is only slightly more than the bare minimum code required to get an instance of the PlatformerEngine up and running. Next, we'll look at the different asset classes and how each one is tied to specific game assets.

The Asset Classes

The PlatformerEngine only makes use of interfaces to manipulate the Sprites used in the game. To build assets for the game, we must create classes that implement those interfaces for each type of object. If you look in the example package, you'll notice that each of the classes, besides the main document file, map to one of the five types of interfaces in the engine: player, enemy, item, wall, or portal. Let's examine how each of these classes implements the appropriate interface. Since we're going for a minimalist implementation here, these classes are pretty simple and only include the bare essentials to meet the requirements of the interfaces.

The Player Class

This class will be used to implement the IPlayer interface:

```
package example {
 import com.flashgamebook.engines.platformer.sprites.IPlayer:
 import flash.display.Sprite;
 import flash.geom.Vector3D;
 public class Player extends Sprite implements IPlayer {
   private var _netForce:Vector3D = new Vector3D();
   private var _tempX:Number = 0;
   private var _tempY:Number = 0;
   public function get netForce():Vector3D {
    return _netForce;
   public function set netForce(value:Vector3D):void {
    _netForce = value:
   public function get isJumping():Boolean {
    if (_netForce.y < 0) return true;
    return false:
   public function set isJumping(value:Boolean):void {
   public function get isFalling():Boolean {
    if (_netForce.y > 0) return true;
    return false:
   public function set isFalling(value:Boolean):void {
```

```
public function get tempX():Number {
    return _tempX;
}

public function set tempX(value:Number):void {
    _tempX = value;
}

public function get tempY():Number {
    return _tempY;
}

public function set tempY(value:Number):void {
    _tempY = value;
}

public function update():void {
}

override public function get hitArea():Sprite {
    return this;
}
```

Note that the hitArea accessor can be overridden to return any Sprite you wanted to use as the rectangle for collision testing. In this case, we're just using the bounding box of the Sprite itself.

The Enemy Class

This class implements the IEnemy interface:

```
package example {
 import com.flashgamebook.engines.platformer.sprites.IEnemy;
 import com.flashgamebook.engines.platformer.GridReference;
 import flash.display.Sprite;
 import flash.geom.Vector3D;
 public class Enemy extends Sprite implements IEnemy {
   private var \_motion:Vector3D = new Vector3D(-20);
   private var _tempX:Number;
   private var _tempY:Number;
   private var _gridReference:GridReference;
   public function get tempX():Number {
     return _tempX;
   public function set tempX(value:Number):void {
     _tempX = value;
   public function get tempY():Number {
    return _tempY;
   public function set tempY(value:Number):void {
     _tempY = value;
```

```
public function get motion():Vector3D {
   return _motion;
}

public function get receivesForces():Boolean {
   return false;
}

public function get gridReference():GridReference {
   return _gridReference;
}

public function set gridReference(value:GridReference):void {
   _gridReference = value;
}

public function update():void {
}

override public function get hitArea():Sprite {
   return this;
}
}
```

There is one aspect of note in this implementation; the motion vector is entirely arbitrary. Because this does not affect the engine code, we can make the enemy's speed any value we want.

The Item Class

This class implements the IItem interface:

```
package example {
  import com.flashgamebook.engines.platformer.sprites.IItem;
  import lash.display.Sprite;
  public class Item extends Sprite implements IItem {
    private var _points:Number;
    private var _type:String;
    public function get points():Number {
        return _points;
    }
    public function set points(value:Number):void {
        _points = value;
    }
    public function get type():String {
        return _type;
    }
    public function set type(value:String):void {
        _type = value;
    }
    public function pickUp():void {
    }
}
```

```
override public function get hitArea():Sprite {
  return this;
  }
}
```

In another implementation of this engine, the *pickUp* method could be used to play some type of animation or play a sound.

The Portal Class and Wall Class

These classes implement the IPortal and IWall interfaces:

```
package example {
 import com.flashgamebook.engines.platformer.sprites.IPortal;
 import flash.display.Sprite;
 public class Portal extends Sprite implements IPortal {
   private var _requirements:Array = new Array();
   private var _destination:String;
   public function get requirements():Array {
     if (!_requirements) _requirements = new Array();
     return _requirements;
   public function set requirements(value:Array):void {
    requirements = value;
   public function get destination():String {
     return _destination;
   public function set destination(value:String):void {
     _destination = value;
   override public function get hitArea():Sprite {
     return this;
package example {
  import com.flashgamebook.engines.platformer.sprites.IWall;
  import flash.display.Sprite;
  public class Wall extends Sprite implements IWall {
   public function Wall() {
```

Even though it does nothing, the Wall class exists to fulfill the requirement of an IWall implementation. Without it, we could not substitute this class for instances where an IWall was required.

The Assets

We've now covered every class in play throughout this game. Whew! Give yourself a pat on the back for having slogged through it all. Now crack open the player.fla file in the main Chapter 15 examples folder. We'll see how these classes are implemented.

Once you open the FLA file (and any of the other asset FLAs, for that matter), you'll notice one thing right off the bat: There is nothing on the Stage. All of these assets are being exported directly from the library with linkages. If you right-click on the player Sprite in the library and select properties, you'll see a dialogue like that shown in Figure 15.3.

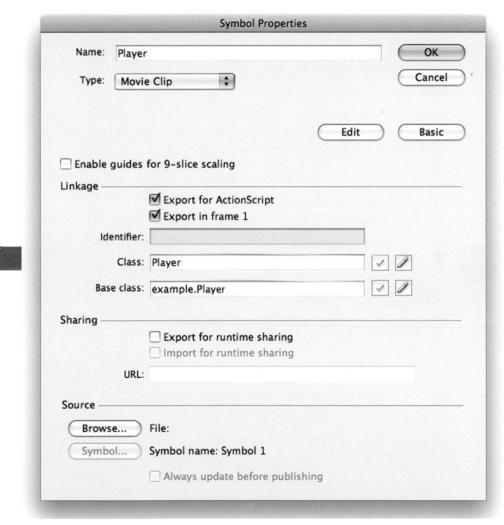

Figure 15.3 For each asset, the base class points to the actual code implementation, and the class field points to a unique, unpackaged name that matches the level XML.

This player Sprite is nothing more than a green square, and it uses the Player class file in the example package as its *base* class from which it derives a new class, simply called "Player" (with no package association). The reason for this structure is so the level XML does not have to directly associate itself with a particular package implementation. If you open any of the other asset files—environment.fla, for example—you'll see that each asset is set up in a similar fashion. Figure 15.4 reflects this.

	Symbol Properties	
Name: Level	EndDoor	OK
Type: Movi	e Clip 💠	Cancel
		Edit Basic
□ Enable quides	for 9-slice scaling	
Linkage —	for 9-slice scaling	
Linkage	Export for ActionScript	
	Export in frame 1	
Identifier:		
Class:	LevelEndDoor	V 0
Base class:	example.Portal	V D
Sharing —		
	Export for runtime sharing	
	Import for runtime sharing	
URL:		
Source —		
Browse	File:	
Symbol	Symbol name: Symbol 1	
	Always update before publishir	10

Figure 15.4 The level-end portal has the name LevelEndDoor but is an instance of the Portal class.

Once each of these individual SWFs is compiled, they can be loaded into the engine and have all their class definitions recognized. Running the main PlatformerExample SWF should look like Figure 15.5. Doesn't it bring back that classic NES nostalgia?

Figure 15.5 The completed engine implementation, running level1.xml.

Taking It Further

A lot more is possible with this game engine, from making it scroll to adding a second player to creating more types of enemies and items. Platformers can have an obscene number of features, and it's important to remember that high-end platformers like *Little Big Planet* for the PlayStation 3 or any of the recent *Mario* games by Nintendo have set the bar very high. If you build a platformer in Flash, make sure it differentiates itself in some way from the pack.

DON'T PLAY BY YOURSELF: MULTIPLAYER DEVELOPMENT

As the Internet continues to blossom as a tool of social interaction, games are just one type of application that is increasingly demanded in a multiple-user format. Many games are simply more fun when played with others. In this chapter we are going to look at a very basic multiplayer game and how it works under the hood. Robust multiplayer games are extremely time consuming to produce because of the nature of real-time changing data, so for this example we will revisit the MixUp game from Chapter 14. In that chapter, we demonstrated how the use of interfaces allowed for a "plug-in" system of sorts to be used for the puzzle image data. Once the different classes were created, it was a trivial task to change the game from a static image puzzle to a constantly updating camera feed. Now we will utilize that interface once again to build a class where the puzzle image constantly updates with your *opponent's* camera.

RTMFP

In Flash Player 10, Adobe introduced a new protocol for multiple-user communication called Real-Time Media Flow Protocol (RTMFP). It is meant to complement the protocol already used by the Flash Media Server (FMS) called Real-Time Messaging Protocol (RTMP). RTMFP is peer based, meaning it does not require a server and users connect directly to each other's machines via the Flash Player. Because of this, it is very fast and can send considerably more information in a shorter time than RTMP. This makes it an ideal protocol to use for multiplayer games, where response time is critical for a good game experience.

Stratus

In addition to upcoming support for RTMFP in Flash Media Server, Adobe has created a service called Stratus (in Beta as of this writing) that provides users with a unique 64-character ID—called a peer ID—that allows any two Flash 10 clients to connect over the web. Because it is not a multiple-user server in the sense of FMS, no communication is routed through Stratus. It simply provides the unique identifier and the information on how to connect to other machines of any connected client. Once a client has an ID, it is up to the user to spread that ID to others, either through a back-end service or some other more direct form of communication. We will be doing the latter, in order to focus as much as possible on the Flash portion and not the other components involved.

MixUp Multiplayer

As I stated previously, we will be modifying MixUp to become a multiplayer-capable game. For this to work, we need to iron out the flow of operations so we know what order the code has to execute in for it to work. Here's an outline of the process of creating a multiplayer connection through Stratus (we'll look at the code momentarily):

- Each user connects to the Stratus service with a developer key (mine is provided with the code on the website—if you develop your own games to use Stratus, please sign up for your own free key).
- Both users receive a peerID back from the service in the form of a 64-character alphanumeric string.
- Both users publish NetStream objects (more on this soon), which will act as their outgoing channels of communication; when clients want to send data, this is the stream they will use.
- One user chooses to be the host for the game and is shown their peerID to share with others—they can simply send this string via e-mail or instant messaging (as I did while testing this app).
- The other user gets the host's peerID and uses it to subscribe to the host's outgoing stream with a new, incoming stream.
- The host receives notification that a user has connected, retrieves their peerID, and sets up an incoming stream connected to the new guest.
- Both clients now have an outgoing and an incoming stream to send and receive data—the game can begin!

If this looks like a lot of steps, you're right. Network communication is not a trivial matter, although Adobe has made it pretty straightforward to implement. Now let's dig into the code.

The Classes

This chapter assumes you've looked at Chapter 14 already and are familiar with how the MixUp engine works. We will be looking at the classes that have changed for this version of the game, as well as the entirely new classes that must be created.

Updated classes:

- MixUp.as—The document class must change to support additional functionality required by the multiplayer communication.
- Title.as—There are now options for hosting or joining a game, rather than just simply starting a game.
- Results.as—The results for both players are now displayed at the end of the game.

New classes:

- ConnectionPanel.as—This class manages establishing the connection between the two players.
- SourceImageWebCamera.as—The meat of this implementation, this class manages the streams between the users and channels all communication, as well as updating the puzzle pieces with the latest opponent camera data.

We'll look at the new classes first, so the updates to the older classes make more sense.

The SourceImageWebCamera Class

As before, this class implements the ISourceImage interface, which is used by the game engine. It also contains a number of other methods and properties used by other classes. I based it off of the original SourceImageCamera class for consistency and because a fair amount of the logic won't change much.

```
public class SourceImageWebCamera extends Sprite implements
ISourceImage {
  protected var _rows:int, _columns:int;
  protected var _video:Video;
  protected var _camera:Camera;
  protected var _sourceBitmap:BitmapData;
  protected var _pieceList:Vector.<BitmapData>;

  protected var _netConnection:NetConnection;
  protected var _streamOutgoing:NetStream;
  protected var _streamIncoming:NetStream;
  protected var _endPoint:String = "rtmfp://stratus.adobe.com/";
  protected var _devKey:
String = "60b54df7bbb0449f247c6b8d-e1074fcae0b3";
```

```
protected var _gameIsOver:Boolean = false;
public var opponentHistory:Object;
```

The first five properties are all the same from the regular camera class. After that, we will need variables to store references to our NetConnection object (which stays connected to Stratus), the incoming and outgoing NetStream objects, a flag for whether or not the game is over, and a public-facing history object for the opponent.

```
public function SourceImageWebCamera(width:int, height:int,
fps:int = 15, endPoint:String = null, devKey:String = null) {
    _camera = Camera.getCamera();
    _video = new Video (width, height);
    _camera.setMode(width, height, fps);
    if (endPoint) _endPoint = endPoint;
    if (devKey) _devKey = devKey;
    setupConnection();
}
```

In the constructor function, we create the same Camera and Video objects as before, as well as a BitmapData object for the opponent. After that, we call *setupConnection*:

```
protected function setupConnection():void {
   //SETUP CONNECTION TO STRATUS
   _netConnection = new NetConnection();
   _netConnection.connect(_endPoint + _devKey + "/");
   _netConnection.addEventListener(NetStatusEvent.NET_STATUS,
netConnectionHandler);
}
```

This method simply starts the NetConnection and makes a connection to Stratus. It also adds a listener for a special type of event known as a NetStatusEvent. Whenever the service sends information back to the client, it will come in the form of this type of event.

```
protected function netConnectionHandler(e:NetStatusEvent):
void {
  if (e.info.code == "NetConnection.Connect.Success") {
    setupOutgoingStream();
  }
}
```

When the client receives server messages, they are in the form of a dot-delimited string named "code" and are part of an *info* object. In this case, the only message we're interested in is a successful connection notification. Once we receive this, we set up the outgoing stream object:

```
protected function setupOutgoingStream():void {
   _streamOutgoing = new NetStream(_netConnection, NetStream.
DIRECT_CONNECTIONS);
   _streamOutgoing.addEventListener(NetStatusEvent.NET_STATUS,
netStreamHandler, false, 0, true);
```

```
var out:Object = new Object();
out.parent = this;
out.onPeerConnect = function (subscriber:NetStream):Boolean {
   this.parent.setupIncomingStream(subscriber.farID);
   return true;
}
_streamOutgoing.client = out;
_streamOutgoing.publish("MixUp");
_streamOutgoing.attachCamera(_camera);
}
```

When you set up a NetStream object, you must supply it with a NetConnection object and the type of connection you want to make. In this case, since we're using RTMFP, we want to use the DIRECT_CONNECTIONS type. Once the stream is created and has a status listener attached, we create an additional object called *out*. The purpose of this object is to act as the recipient of a special kind of message from the NetStream, which will tell us when another client has subscribed to the stream. This method is called *onPeerConnect* and passes the subscriber's incoming NetStream object. By using this stream's *farID* property (simply their peerID from Stratus), we can now set up the host's incoming stream. Now that this method is handled, we will publish this stream under the name "MixUp" and attach the camera object to it. The outgoing stream is now ready to accept connections.

```
public function setupIncomingStream(id:String):void {
   if (id.length! = 64) throw new Error("peer ID is
incorrect!");
   if (_streamIncoming) return;
   _streamIncoming = new NetStream(_netConnection, id);
   _streamIncoming.client = this;
   _streamIncoming.addEventListener(NetStatusEvent.NET_STATUS,
netStreamHandler, false, 0, true);
   _streamIncoming.play("MixUp");
   _video.attachNetStream(_streamIncoming);
}
```

When one client has a peerID to connect to, the public-facing *setupIncomingStream* method is called. It receives this ID as a parameter and throws an error if it is anything other than 64 characters in length. The method also exits if the incoming stream already exists, so as not to create it twice. We assign the *client* property of the incoming stream to this main class, so that when messages are sent through the stream they will be intercepted by methods of the class. Finally, we activate the stream with the *play* command and attach it to our video object.

Keep in mind that at this point we've only established the streams. The camera feeds will automatically send data to each other, but other than that no data has passed between players.

```
protected function netStreamHandler(e:NetStatusEvent):void {
  if (e.info.code == "NetStream.Play.Start") {
```

```
if (e.target == _streamOutgoing) {
    _streamOutgoing.send("|RtmpSampleAccess", true, true);
    setTimeout(dispatchEvent, 1000, new Event(Event.CONNECT));
}
}
```

Much like the NetConnection object, we also attached a NetStatusEvent listener to both NetStreams. When we are certain one user has connected to the outgoing stream and begun to play it, the class sends a message to the connected client and broadcasts a CONNECT event to the main MixUp class. As of this writing, there is a bug in the Flash Player that is currently being addressed by Adobe. This is the reason for the rather odd-seeming command that we send through the stream called "|RtmpSampleAccess" with two parameters, both true. It sets the permissions of the outgoing stream so the opponent will be able to draw his camera object into BitmapData without causing a security error. Adobe states that eventually this will simply be a permission that can be set as part of the stream. In the meantime, this message takes care of that problem for us. We include a one-second delay to make sure this message is received by the other client before proceeding. Next we'll look at a few public methods that are used by classes outside this one, as well as those used by the NetStream objects:

```
public function get myID():String {
  return _netConnection.nearID;
}

public function get gameIsOver():Boolean {
  return _gameIsOver;
}

public function sendGameOver(history:GameHistory):void {
  _streamOutgoing.send("gameOver",history);
}

public function gameOver(history:Object):void {
  _gameIsOver = true:
  opponentHistory = history;
  dispatchEvent(new Event(Event.COMPLETE));
}
```

The *myID* accessor function simply returns the client's peerID for display elsewhere. The *gameIsOver* performs a similar function, allowing read-only access of the game state. The *send-GameOver* method is used when a player finishes the game, and it sends their stats history to the other user. By specifying "gameOver" as the first parameter of the *NetStream.send()* command, the incoming NetStream knows to call the method of the same name. When *gameOver* is called, it sets the flag to true, assigns the opponent's game history object, and dispatches a COMPLETE event to let the main class know the game is done.

The *getImages* and *updateImages* methods haven't had to change from the SourceImageCamera class, as they reference the same Video and BitmapData objects as before. However, the *destroy* method now has some additional functionality due to the communication objects now being used. Both streams and the NetConnection must be closed to fully end communication between Stratus and any peers:

```
public function destroy():void {
    _streamOutgoing.close();
    _streamIncoming.close();
    _netConnection.close();
    cleanUp();
    _sourceBitmap.dispose();
    _video.clear();
    _video = null;
    _camera = null;
}
```

The ConnectionPanel Class

The other new class in this version of MixUp handles the visual display of the two clients connecting to each other. You can find the assets for this class in the accompanying MixUp.fla file.

```
public class ConnectionPanel extends MovieClip {
 public static const HOST:String = "host";
 public static const JOIN:String = "join";
 public var submitButton: SimpleButton;
 public var cancelButton:SimpleButton;
 public var peerID: TextField;
 public var myID:TextField;
 private var _myID:String;
 public function (connectionPanel(id:String, Lype:String) {
   addEventListener(Event.ADDED_TO_STAGE, addedToStage,
false, 0, true);
    gotoAndStop(type);
   _{myID} = id:
 private function addedToStage(e:Event):void {
   TweenLite.from(this, .4, { y : -height } );
   if (submitButton) submitButton.addEventListener
(MouseEvent.CLICK, submitButtonClick, false, 0, true);
   if (cancelButton) cancelButton.addEventListener
(MouseEvent.CLICK, cancelButtonClick, false, 0, true);
   if (myID) myID.text = _myID;
 }
 private function submitButtonClick(e:MouseEvent):void {
   submitButton.removeEventListener(MouseEvent.CLICK.
submitButtonClick);
   dispatchEvent(new DataEvent(Event.CLOSE, false, false,
peerID.text.substr(0,64)));
   close();
```

```
private function cancelButtonClick(e:MouseEvent):void {
   cancelButton.removeEventListener(MouseEvent.CLICK,
   cancelButtonClick);
   close();
}

public function close():void {
   TweenLite.to(this, .4, { y : -height, onComplete:parent.
   removeChild, onCompleteParams:[this] } );
}
```

When a ConnectionPanel object is created, it expects to receive the client's peerID, as well as whether it should display the hosting panel or the join panel. If it is the join panel, clicking the submit button will dispatch a DataEvent with the inputted peerID. Figure 16.1 shows what the hosting panel will look like, and Figure 16.2 shows the join panel.

Figure 16.1 The MixUp hosting panel.

Figure 16.2 The MixUp join panel.

The Title Class

Only menu options have changed for the Title class:

```
public class Title extends MovieClip {
  static public const PLAY_GAME:String = "playGame";
```

```
static public const HOST_GAME:String = "hostGame";
 static public const SHOW_RULES:String = "showRules";
 public var playButton: SimpleButton;
 public var hostButton: SimpleButton:
 public var rulesButton:SimpleButton;
 public function Title() {
   addEventListener(Event.ADDED_TO_STAGE, addedToStage,
false, 0, true);
 private function addedToStage(e:Event):void {
   playButton.addEventListener(MouseEvent.CLICK;
playButtonClick, false, 0, true);
   hostButton.addEventListener(MouseEvent.CLICK,
hostButtonClick, false, 0, true);
   rulesButton.addEventListener(MouseEvent.CLICK,
rulesButtonClick, false, 0, true);
 private function playButtonClick(e:MouseEvent):void {
   dispatchEvent(new Event(PLAY_GAME));
 private function hostButtonClick(e:MouseEvent):void {
   dispatchEvent(new Event(HOST_GAME));
 private function rulesButtonClick(e:MouseEvent):void {
   dispatchEvent(new Event(SHOW_RULES));
```

The Results Class

This class now accepts both the player's game history object as well as the opponent's. It also has an extra frame at the beginning that acts as a waiting screen if one player finishes before the other:

```
public class Results extends MovieClip {
  static public const PLAY_AGAIN:String = "playAgain";
  static public const MAIN_MENU:String = "mainMenu";

public var movesMadeText:TextField;
  public var inalTimeText:TextField;
  public var opponentMovesMadeText:TextField;
  public var opponentFinalTimeText:TextField;
  public var mainMenuButton:SimpleButton;

public function Results() {
    stop();
  }

  public function setup(playerHistory:GameHistory,
  opponentHistory:Object):void {
    mainMenuButton.addEventListener(MouseEvent.CLICK,
  mainMenu, false, 0, true);
```

```
movesMadeText.text = String(playerHistory.movesMade);
finalTimeText.text = playerHistory.formattedTime;
opponentMovesMadeText.text = String(opponentHistory.movesMade);
opponentFinalTimeText.text = opponentHistory.formattedTime;
}
private function mainMenu(e:MouseEvent):void {
   dispatchEvent(new Event(MAIN_MENU));
}
```

Note that the opponent's game history object is treated as a generic object. This is because, in the process of getting sent through the NetStream, it lost its custom object typing. While it does not affect functionality, it unfortunately means that you lose compile-time error checking for any objects sent through NetStreams, unless they are native ActionScript objects like arrays, dictionaries, or byte arrays.

The MixUp Class

To wrap up our code changes, the MixUp class must alter its behavior to accommodate the new multiplayer functionality. Since the class is large, I will first outline just those sections that have changed, to make it easier to read.

```
protected var _webCam:SourceImageWebCamera;
protected var _hostPanel:ConnectionPanel;

//INITIALIZATION METHODS
public function MixUp() {
   enumerateFrameLabels();
   addEventListener(FRAME_TITLE, setupTitle, false, 0, true);
   addEventListener(FRAME_GAME, setupGame, false, 0, true);
   addEventListener(FRAME_RESULTS, setupResults, false, 0, true);
   _webCam = new SourceImageWebCamera(640, 480);
}
```

The SourceImageWebCamera class is now instantiated immediately to allow it to begin setting up the NetConnection objects. This will ensure that the game is connected to Stratus by the time the user can click to play.

```
protected function setupTitle(e:Event):void {
  stop();
  title.addEventListener(Title.PLAY_GAME, showJoinPanel,
false, 0, true);
  title.addEventListener(Title.SHOW_RULES, showRules, false,
0, true);
  title.addEventListener(Title.HOST_GAME, showHostPanel,
false, 0, true);
}
```

```
protected function connectToGame(e:DataEvent):void {
 if (!e.data dpipe;dpipe; e.data = = "") return:
 _webCam.addEventListener(Event.CONNECT, playGame, false, 0,
 webCam.setupIncomingStream(e.data);
protected function showJoinPanel(e:Event):void {
 var connectionPanel:ConnectionPanel = new
ConnectionPanel(_wcbCam.myID,ConnectionPanel.JOIN);
 connectionPanel.x = stage.stageWidth/2;
 connectionPanel.y = stage.stageHeight/2;
 addChild(connectionPanel);
 connectionPanel.addEventListener(Event.CLOSE,
connectToGame, false, 0, true);
protected function showHostPanel(e:Event):void {
 var connectionPanel:ConnectionPanel = new
ConnectionPanel(_webCam.myID,ConnectionPanel.HOST);
 connectionPanel.x = stage.stageWidth/2;
 connectionPanel.y = stage.stageHeight/2;
 addChild(connectionPanel);
 _hostPanel = connectionPanel;
  _webCam.addEventListener(Event.CONNECT, playGame, false, 0,
true):
```

When the Host a Game button is clicked, the *showHostPanel* method is called. It creates the panel and adds a listener to the SourceImageWebCam instance for a CONNECT event. If you recall from earlier, this event is dispatched when the game is ready to play. If the user opts to Join a Game, a listener is added to the panel to listen for the DataEvent with the host's peerID. This ID is then passed to the *setupIncomingStream* method we looked at previously.

```
protected function playGame(e:Event):void {
    _webCam.removeEventListener(Event.CONNECT, playGame);
    if (_hostPanel) {
        _hostPanel.close();
        _hostPanel = null;
    }
    gotoAndStop(FRAME_GAME);
}

protected function setupGame(e:Event):void {
    stop();
    game.init(_webCam, 3, 4);
    setTimeout(game.startGame, 1500);
    game.addEventListener(Game.GAME_OVER, gameOver, false, 0, true);
}
```

When the *playGame* method is called, the Host a Game panel is closed (if it existed), and the game is directed to begin.

When the game is initialized, the SourceImageWebCamera instance is passed to the engine.

```
protected function gameOver(e:Event):void {
 var history: GameHistory = new GameHistory(true.
e.target.timeElapsed, e.target.movesMade):
 history.formattedTime = e.target.timeElapsedText.text;
 gameHistory.unshift(history);
 _webCam.sendGameOver(history):
 gotoAndStop(FRAME RESULTS):
protected function setupResults(e:Event):void {
 if (_webCam.gameIsOver) {
   results.nextFrame():
   results.setup(gameHistory[0], _webCam.opponentHistory):
   results.addEventListener(Results.PLAY_AGAIN, playGame,
false, 0, true):
   results.addEventListener(Results.MAIN_MENU, mainMenu,
false, 0, true):
   _webCam.removeEventListener(Event.COMPLETE, setupResults);
 } else {
   trace("I AM THE FIRST TO WIN-I MUST WAIT"):
   _webCam.addEventListener(Event.COMPLETE, setupResults,
false, 0, true);
```

When a player finishes the game, the *gameOver* method is called, and the game's history object is sent to the other player. If the player is the first to arrive at the results screen, the class simply listens for a COMPLETE event from the webcam class. Once it receives this event, the *setupResults* method is simply called again and the results screen is configured.

Conclusion

That's it! That is what it takes to build a basic multiplayer game using RTMFP in Flash. Obviously there is lots of room for improvement in how *fun* this game could be, with features like microphone support, the option to mess with two of your opponents' placed pieces as a reward for getting a series of pieces in a row, etc. There's also the issue of user-friendly matchmaking. The current system of having to copy and paste a 64-character string is pretty arcane and not really approachable outside of a development and testing environment. Adobe offers an example project to show how you can set up a simple web service to handle simple matchmaking and user logging. I recommend downloading this example and exploring the protocol further.

SQUASH 'EM IF YOU'VE GOT 'EM: THE BUG HUNT

As you get close to completing a project, whether on your own or with a team, it will usually (and should *always*) go through some form of quality assurance, or QA. During this process, those testing the game should look for bugs, performance issues (both CPU and network related), and general playability. Playtesting a game to refine a mechanic and make it more fun is an entire process unto itself, which we will not cover in this chapter. What we *will* cover are ways to speed up the process of debugging code and tools to help you optimize your code for better performance.

Bugs

Unless you are a programming wunderkind (in which case, why are you reading this book?), you're going to have bugs crop up in your work from time to time. Flash's compiler and runtime engine will catch a lot of errors caused by incorrect syntax, misspellings, and a host of other common coding mistakes. These are the bugs that give you immediate feedback and are usually very simple to correct. It's the bugs where nothing is *technically* wrong with the code but your game behaves incorrectly that programmers never want to encounter. Examples of these types of bugs might be degrading performance over time, memory leak/bloat issues, or even simply unexpected output from your game engine. To address these kinds of issues, Flash has a set of tools we can use—and expand upon—to speed up debugging. We'll look at a number of these tools and how to use them in your work.

Traces

The most basic form of displaying information from your code is through the use of a *trace* statement. It prints any arguments you give it to the Output window in Flash. Any objects that are passed to the method have their *toString* method called to determine how to display them. This is why generic objects will trace [object Object]. Arrays will trace their contents as a commadelimited string (as though the *join* method had been called). When creating custom game objects, it's not a bad idea to override the *toString* method and display custom returns, as well. For example, if you have a player Sprite on the screen, a helpful *toString* return might be a list of its vital stats:

```
Player <name> - Health: 90%, Ammo: 30
```

Similarly, the main game engine object might list out important information:

```
Game Status - Time: 2:49, Enemies: 5, Projectiles: 2, Score: 1200
```

All objects have a *toString* method available to them for overriding. Here's how you might write such an override:

```
override public function toString():String {
  var status:String = "Game Status-";
  status + = "Time: " + gameTime + ", ";
  status + = "Enemies: " + enemyList.length + ", ";
  status + = "Projetiles: " + projectileList.length + ", ";
  status + = "Score: " + score;
  return status;
}
```

Defining these *toString* substitutions makes the information coming back from a trace much more relevant when you're trying to solve a problem. However, once you get a bunch of traces on objects going (which happens very quickly if you don't comment out a trace after you're done with it), it can be a mess to try to sort through the very limited Output window to find what you're looking for. This is where extending the trace functionality to a new class makes sense. Because trace is a top-level function, there's no way to override or extend it in the same way we might do with a class; however, we can create a class of static methods and properties that will increase the usefulness of traces. We'll call the class TraceUtil:

```
package {
  public class TraceUtil {
    public static const INFO:String = "info";
    public static const WARNING:String = "warning";
    public static const ERROR:String = "error";

    public static var throwErrors:Boolean = false;
    public static var filter:Array = [INFO, WARNING, ERROR];
```

```
public function TraceUtil() {
    throw new Error("TraceUtil class cannot be instantiated.");
}

public static function Trace(message:String, category:
String = INFO):void {
    if (category == ERROR && throwErrors)
        throw new Error(message);
    if (!filter || !filter.length || filter.indexOf(category)
> -1)
        trace(message);
}

public static function TraceObject(message:String,
object:Object, category:String = INFO):void {
    Trace(message, category);
    Trace(" " + object, category);
    for (var i:String in object) {
        Trace(" " + i + ":" + object[i], category);
    }
}
}
```

This class will allow us to attach a filter to our traces as we perform them so we can later cull out less important ones. I have predefined three different levels of priority in this class: INFO traces are those that are purely informational and less crucial (like a notification that a file has finished loading), WARNING traces are for situations that the game knows how to deal with but shouldn't have gotten into for one reason or another, and ERROR traces should be used to track down errors inside of try/catch blocks or in places where you don't want to actually throw an error but you do want to be notified of a problem. By adding these strings (or any others you wanted to create) to the filter array, only messages that correspond to these trace types will be displayed.

The first method in TraceUtil is one called *Trace*, capitalized because of the name conflict with the trace statement itself. It simply traces out the given message, assuming that the category matches what's in the filter array. Additionally, if you're in the throes of debugging a serious issue, you can set the *throwErrors* flag to true and the method will throw an actual error when a message with that type is sent. When you're done testing and don't want runtime errors thrown, you can turn this flag back off.

The other method in this class is called *TraceObject*. It is intended for use with dynamic objects; it relies on a *for...in* loop to iterate through the given object and trace out its properties on individual lines. In addition to normal dynamic objects, this will also work for arrays and vectors. It will format the properties so they are indented slightly. This simple formatting will make scrubbing through the Output window considerably easier.

FlashTracer

Unfortunately, as useful as traces can be, they're technically only available inside of Flash. Luckily, a savvy programmer and Flash user named Alessandro Crugnola created an extension for Firefox that works in conjunction with the Flash debug player to display traces in a handy window side-by-side with your content. It works on both Mac and Windows and is an excellent tool for debugging once you've left Flash and are in the browser. You can find a link to download FlashTracer on this book's website, flashgamebook.com. Figure 17.1 shows a shot of FlashTracer displaying the traces from the TraceUtil.fla example.

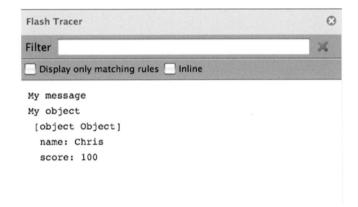

Figure 17.1 FlashTracer allows you to view all of your Flash traces inside of Firefox using the debug player.

The Debugger

Sometimes traces are insufficient or too time consuming to implement for solving a particular issue. Perhaps you want to view a number of values in an object at once or watch an object change as it is processed by a method. Traces will work here but are a brute-force and messy solution. This is where Flash's debugger comes in very handy. If you've used the debugger in Flash versions prior to CS3, you probably just rolled your eyes. This is because the debugger in older versions of Flash was, sadly, buggy. It would not always activate correctly, it was hard to track down values, and it had a very poor user interface for navigating the information when you could get it to work. For AS3, Adobe reworked the debugger, and it is a much more useful tool now. If you're unfamiliar with the debugger, it allows you to step through your code line by line as it is running to see exactly where a problem starts or an error occurs. You can define the point at which your code stops running automatically and switches to line-byline mode. This is known as a *break point*. You add it to your code

in Flash by simply clicking to the left of a line number. You will see a red dot appear next to the line. This indicates that when the Flash Player reaches this line it will turn over control to you. Figure 17.2 shows how this break point looks inside of Flash.

```
public function TraceUtil() {
    throw new Error("TraceUtil class cannot be instantiated.");
}

public static function Trace(message:String, category:String = INFO):void {
    if (category == ERROR && throwErrors)
        throw new Error(message);
    if (!filter !! !filter.length !! filter.indexOf(category) > -1)
        trace(message);
}
```

Figure 17.2 When you click to the left of a line number in the Flash code editor, it adds a break point that will be caught by the debugger.

Once you've set a break point, you can run your SWF in debug mode by selecting Debug \rightarrow Debug Movie from the main toolbar (Figure 17.3).

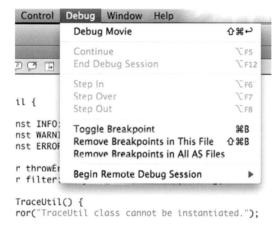

Figure 17.3 Start a SWF in debug mode by selecting the Debug menu from the main toolbar.

Once you've started the debug player, it will run until it encounters an error or a break point. It will then show the current stack of methods, as well as any variables relevant to the scope of the break point. In Figure 17.4, you can see how this information looks inside the *Trace* method from earlier in the chapter. We can see the values in the TraceUtil class, such as the filter array and *throwErrors* flag, as well as values in the method we're currently inside (the message and category). Now try setting a break point in a piece of code and explore the debugger further on your own.

Figure 17.4 The method stack in the debugger, and the variable browser.

Like traces, debugging is very useful inside of Flash, but often errors and problems don't crop up until you're in the final phases of a project and a game is in the browser. If you have the Flash debug player installed in your browser (as any self-respecting Flash developer should), you can debug a SWF remotely with Flash open in the background. To do this, you must first compile the SWF in debug mode; this includes some extra data (such as break points) that the debugger can pick up. You may have noticed that the size of a SWF in debug mode is larger than one in normal mode. Next deploy your SWF on a remote server to test. Go into Flash and select Debug → Begin Remote Debug Session → ActionScript 3.0. You'll notice at this point that the Output window goes into an idle mode, waiting for a connection. Finally, load the SWF in a browser, and Flash will connect to it automatically. While this can be a tedious series of steps to follow every time you deploy new builds to a server, it is invaluable when a bug occurs in the browser but not inside Flash.

Performance/Optimization

In addition to traditional debugging (fixing errors), an important component of game quality assurance (QA) is performance testing. This includes simply playing the game on a variety of different machines to determine the lowest threshold for your system requirements. If your game is going to be in front of a wide audience or kids (who often have older, hand-me-down computers), it needs to be able to hold up on even modest machines. Every game's needs are different—a puzzle game is likely going to need less CPU power and memory than a side-scrolling action game.

The catch to performance testing is that on the surface all you have is a "feeling" for how the game is supposed to play. Obviously, if a game is maxing out your CPU usage every moment it's running, you have a problem, but usually the differences are subtler. You can only eyeball the frame rate, and most system memory viewers don't separate browsers into discrete threads, so it can be difficult to get an accurate gauge of just how the game is performing. In this section, we'll create a couple of tools you can use to add basic frame rate and memory monitoring to your game. We'll combine both classes into an FLA called PerformanceProfiler, which you can open from the Chapter 17 examples folder.

The FrameRateProfiler Class

Most Flash games don't consistently run at a perfect fixed frame rate. The rate fluctuates based on how much information the Flash Player is trying to process at that moment, and what else is going on in the browser (and the rest of the system, for that matter). When you profile a game for frame rate performance, you want to take a sample over a period of time and average it. To do this, we will create a simple Sprite-based component that will allow us to monitor the frame rate right on the Stage.

```
package {
  import flash.display.Sprite;
  import flash.events.Event;
  import flash.utils.getTimer;
  import flash.text.TextField;

public class FrameRateProfiler extends Sprite {
    private var _previousTime:int;
    private var _sampleSize:int = 30;
    private var _sample:Vector.<Number>;

    [Inspectable(defaultValue = 1,name = "Decimal Precision")]
    public var precision:uint = 1;
    public var textField:TextField;
```

To start out the class, we set up variables to store the number of samples we'll collect, as well as a Vector object to keep track of them and the level of decimal precision we want to display when viewing the frame rate. Since this is going to be a component, we'll expose the precision variable so this can be set from

inside the Flash component inspector. We expose it using the Inspectable metadata tag.

```
public function FrameRateProfiler() {
   addEventListener(Event.ADDED_TO_STAGE, addedToStage, false,
0, true);
   addEventListener(Event.REMOVED_FROM_STAGE,
removedFromStage, false, 0, true);
   _sample = new Vector.<Number>();
}

[Inspectable(defaultValue = 30, name = "Sample Size")]
public function set sampleSize(value:int):void {
   _sampleSize = Math.max(1, value);
}

public function get sampleSize():int { return _sampleSize; }

[Inspectable(defaultValue = 0 × 000000, type = "Color",
name = "Text Color")]
public function set color(value:uint):void {
   textField.textColor = value;
}

public function get color():uint { return textField.
textColor; }
```

In the constructor, we simply initialize the vector and assign listeners so the component knows when it is added to and removed from the Stage. Next we expose two other accessor methods for defining the sample size (number of frames we'll use to get our average) and the color of the text field. This way the same component can be used on a variety of different backgrounds and still be readable.

```
private function addedToStage(e:Event):void {
 addEventListener(Event.ENTER_FRAME, onEnterFrame, false, 0,
 _previousTime = getTimer();
private function removedFromStage(e:Event):void {
 removeEventListener(Event.ENTER_FRAME, onEnterFrame);
private function onEnterFrame(e:Event):void {
 var newTime:int = getTimer();
 var rate:Number = 1000/(newTime-_previousTime);
 _sample.push(rate);
 if (_sample.length > _sampleSize) _sample.shift();
 _previousTime = newTime;
 var avg:Number = 0;
  for each (var value: Number in _sample)
     avg += value;
 avg /= _sample.length;
  textField.text = avg.toFixed(precision);
```

When the component is added to the stage, the onEnterFrame script starts getting called on every frame cycle. Each time it fires, we determine the amount of time between frames and divide it into 1000 milliseconds to determine the frame rate. This rate is then added to the samples vector. Once the vector has exceeded the sample size we specified earlier, older elements at the front are removed. The text field is then updated with an average of the sample.

If you open the PerformanceProfiler.fla file, you can see how this class is attached to a clip in the library called FrameRate Profiler, as well as in the component definition for that same clip. Once on the Stage, you can set the three exposed properties in the Component Inspector panel, which is accessible from the Window toolbar. Next we'll look at a similar class for profiling memory usage.

The MemoryProfiler Class

In this class, we'll create a component much like our FrameRateProfiler, which will simply monitor the amount of memory the Flash Player is using over time. This will allow you to see any large spikes in memory usage that are directly caused by Flash or your game.

```
package {
 import flash.display.Sprite;
 import flash.events.Event;
 import flash.events.TimerEvent;
 import flash.utils.Timer:
  import flash.system.System:
 import flash.text.TextField;
 public class MemoryProfiler extends Sprite {
     private var _timer:Timer;
     privale var _interval:Number = 5:
     public var textField:TextField;
     public function MemoryProfiler() {
       addEventListener(Event.ADDED_TO_STAGE, addedToStage,
false, O. true):
       addEventListener(Event.REMOVED FROM STAGE.
removedFromStage, false, 0, true);
       _timer = new Timer(interval * 1000);
```

Because memory does not fluctuate at the same frequency as frame rate, we only need to check the memory usage every few seconds. Check much more often than that and you'll be taxing the processor more than you need to for the same result. By default, this component checks every five seconds.

```
[Inspectable(defaultValue = 5,name = "Sample Interval")]
public function set interval(value:Number):void {
    _interval = Math.max(1, value);
    _timer.delay = _interval * 1000;
}
```

```
public function get interval():Number { return _interval; }
[Inspectable(defaultValue = 0 × 000000, type = "Color",
name = "Text Color")]
public function set color(value:uint):void {
  textField.textColor = value;
}
public function get color():uint { return textField.
textColor; }
```

Like the previous class, we expose two values to the Component Inspector—the interval at which we want to check the system memory and the color of the text field.

```
private function addedToStage(e:Event):void {
    _timer.addEventListener(TimerEvent.TIMER, onTimer, false,
0, true);
    _timer.start();
    onTimer(null);
}

private function removedFromStage(e:Event):void {
    _timer.stop();
}

private function onTimer(e:TimerEvent):void {
    var memoryUsed:Number = System.totalMemory/1024;
    var memoryUnit:String = "k";
    if (memoryUsed > 1024) {
        memoryUsed /= 1024;
        memoryUnit = "mb";
    }
    textField.text = "Memory Used: " + memoryUsed.
toFixed(1) + memoryUnit;
}
```

As before, adding and removing the component starts and stops the Timer, respectively. Every time the Timer object runs, it converts the amount of system memory used to kilobytes. If the amount of memory used is about 1024k (1 MB), we use megabytes instead.

Together in the PerformanceProfiler document, these components provide a lot of useful information. You could even convert them to precompiled clips (by right-clicking on them in the library and selecting Covert to Compiled Clip), at which point they would be entirely self-contained and portable to any file, regardless of where the class AS files are. When combined with the Activity Monitor on a Mac or the Task Manager on Windows, you can use these two components to easily do real-time, statistical monitoring of your game on multiple machines.

The Sample Package

Sometimes in the process of debugging and optimization you're able to narrow down the source of a performance drain to

a handful of culprits. Game engines that manage a lot of data (like a large action game) often generate a lot of hefty objects in memory to store all the data. Prior to Flash CS4, it was not possible to get information about how much memory objects actually consumed, other than as a sum total. In CS4, Adobe introduced a set of classes that were originally part of the Flex Builder debugging set. This package and its primary class are known as the Sampler. This is because its primary function is to take samples of memory data to determine which methods are called the most and which objects are eating the most resources. It's worth noting that these classes and methods only function as expected within the debugged Flash Player, and they are also compatible with certain versions of Flash Player 9, if you are still targeting that platform.

Sampling memory can become complicated, and the Sampler package is capable of being used to write a full in-Flash debugging tool for monitoring performance. That said, we'll just be taking a quick look at a couple of the more useful "quick" methods that can be used when trying to track down memory leaks.

The *getSize* method at the root level of the Sampler package accepts any object as a parameter and returns the amount of memory that object consumes in bytes. In the Chapter 17 examples folder, you can find a file called getSizeExample.fla. All it has is a little code on the first frame to demonstrate memory usage:

```
import flash.sampler.*;
var arr1:Array = new Array(1, 2, 3, 4, 5);
var arr2:Array = new Array(1, 2, 3, 4, 5, 6, 7, 8, 9, 10);
var arr3:Array = new Array();

trace("Array 1:",getSize(arr1),"bytes");
trace("Array 2:",getSize(arr2),"bytes");
trace("Array 3:",getSize(arr3),"bytes");
```

In this example, there are three different arrays, each with a different number of values in them. The traces output the following:

```
Array 1: 60 bytes
Array 2: 80 bytes
Array 3: 40 bytes
```

As you might expect, Array 2 has twice as many elements as Array 1 and takes up twice as much space over the empty Array 3. This is also helpful because it shows the cost of an object before it has even been populated with any data. Doing a little bit of math reveals that each number (or int, in this case) consumes 4 bytes of memory. This number may be small on its own, but consider that most objects are far more complicated and contain many numbers, strings, Booleans, and other objects. Every little piece of data adds up, and being conscientious of it at the onset of development will help prevent problems later. To put it in perspective,

refer back to the MixUp game from Chapter 14. The main game object was around 500 bytes, but each individual square of bitmap data was 100k (12 for a total of 1.2 MB). Code will almost always be less than raw assets, like sounds or images. Look to Chapters 5 and 7 for tips on how best to optimize these assets.

Another useful set of methods in the Sampler package are getInvocationCount, getSetterInvocationCount, and getGetterInvocationCount. These three return the number of times a method (or getter/setter) has been called on an object. This information can be helpful because it acts as an indicator for where your time optimizing code should be spent. Say you have a game that involves artificial intelligence (AI) making decisions about where enemy players move during gameplay. The logic involved is likely going to poll a number of methods frequently. Taking a measurement of the frequency with which these methods are called at the end of a game will give you a summary you can use to determine where to focus your time. I've created a SamplerUtil class, similar to TraceUtil, which provides a static method for getting this information easily. It also makes use of an overridden toString method to make the returned data easily readable. Before we look at the function for polling, however, we should look at a helper class I also created to store the information retrieved about the methods:

```
internal class MethodObject extends Object{
 public var name: String;
 public var count:int;
 public var getCount:int;
 public var setCount:int;
 public function MethodObject(name:String,
               count:int = 0,
               getCount:int = 0.
               setCount:int = 0) {
   this.name = name;
   this.count = count;
   this.getCount = getCount;
   this.setCount = setCount;
 public function toString():String {
     if (count > 0) {
       return "Method " + name + " called " + count +
" times.";
    } else {
      return "Accessor " + name + " set " + setCount +
 times and gotten " + getCount + " times.";
    }
}
```

The MethodObject class is simply a data container. We could have also used a generic object, but because we'll be creating a bunch of these it is better to statically type the properties we will be using. The *toString* method is also easier to add in this format. Each of these objects keeps track of how many times a method or getter/setter is called. The *toString* method checks to see what type of function it is based on the number of types of calls and returns an appropriately formatted string. It's worth noting at this point that if an accessor function is read-only (just a *get*, no *set*), the setCount will be –1. Now we'll look at the method that uses these objects:

```
package {
 import flash.sampler.*;
 public class SamplerUtil {
   public static function pollMethods(obj:Object):Array {
     var methods:Array = new Array();
     for each (var name:QName in getMemberNames(obj)) {
        var methodObject:MethodObject;
        if (isGetterSetter(obj, name)) {
            methodObject = new MethodObject(name.localName, 0.
 getGetterInvocationCount(obj, name),
 getSetterInvocationCount(obj, name));
       } else {
          methodObject = new MethodObject(name.localName.
 getInvocationCount(obj, name));
      if (methodObject.count > 0 ||
methodObject.getCount > 0 || methodObject.setCount > 0)
          methods.push(methodObject);
      methods.toString - function () {
        return this.join("\n");
      return methods;
```

When the *pollMethods* function is called, it creates an array and then iterates through the passed object with the *getMember-Names* method of the Sampler package. This method will return all public and private member variables of a class object. What is returned is a list of QName objects.

Techie Note. QName?

The QName (or Qualified Name) class is usually associated with XML, as it is part of the E4X standard. We won't cover its use with XML, but in regular ActionScript it stores a properly packaged reference to the name of a specific member variable. To get the name of the variable as we're used to looking at it, you simply specify the localName property of a QName object. Most of the time you likely won't deal with QNames, unless you're working very heavily with XML.

A new MethodObject is created for each QName object returned, storing its localName property and the number of times it was invoked, either as a method or as a getter/setter. Since we're only interested in methods, not just plain properties, we don't bother to add to the array any objects that don't have at least one invocation. When the loop is finished running, we have an array of only those methods that were called at least once, and it can easily be sorted based on the "count," "getCount," or "setCount" properties of each MethodObject. As a last step before returning the array, we format the *toString* method of the array to use line breaks to separate each element (as opposed to the default commas). This will make any trace statements with the array automatically formatted for readability.

I encourage you to continue exploring the rest of the Sampler package and use it to create helpful debugging tools. I hope that Adobe will continue to provide us with more information we can use in future versions of the Flash Player. My fingers are crossed for CPU and GPU usage polling ...

Summary

Debugging and optimization are extremely important tasks in game development that should never be omitted because of lack of time (or any other reason, for that matter). If your game is buggy or sluggish, people won't want to play it.

ON YOUR GUARD

No matter where your game is hosted on the Internet, if people come and play it, someone will invariably attempt to hack it. Don't take it personally; some people are just jerks. Hacking can include everything from abuse (like jamming the game with input all at once in the hopes of crashing it), to botting (where someone writes a program to play your game for them), to harvesting or changing data in memory and information sent over the Internet. These jerk people are motivated by a variety of factors. Perhaps you are giving away some prize and they want to cheat to win it. Maybe there is a scoreboard associated with your game and they want to be number one. Sometimes, they just want to prove to their other hacker jerk friends that they can do it. The hacker community doesn't let you rest on your laurels; if you haven't hacked something *today*, you're not worth the smelly couch you sleep on in your mother's basement. Sorry, I digress.

There are a number of strategies you can use to make it very difficult for someone to hack your game. Notice I did not say you could prevent it 100%. Let me stress this point: *No* game is unhackable. To make such a claim would be to invite a whole host of the best jerks to prove you wrong. The goal with these strategies is that, with every roadblock you introduce, a few less people will be willing to try. The techniques I will outline in this chapter cover two main areas: malicious use (which includes abusive behavior and botting) and data protection.

Malicious Use

Some games are more susceptible to abuse by players than others. Games that rely heavily on keyboard input, like many puzzle games, are particularly prone to being attacked. This is because it

tends to be easier for hackers to write bots (programs to do work for them) and other scripts for keyboard-driven games. It's harder to track where the mouse is on a screen because that can vary from machine to machine depending on resolution, position of buttons, etc. Here are some tips to help block keyboard hacking.

Turn Off Listeners When You Don't Need Them Anymore

It's often very tempting when developing, particularly under a deadline, to just add listeners to things like keyboard input at the onset of a game and then just remove them at the very end. Unfortunately, giving people uncontrolled input can open you up to tampering by bots and other scripts. If you're expecting input from a user, add a listener only when you're ready to receive it, and turn it off after you've received your first piece of input. This allows you to analyze the data you've been given before opening the pipe again. This is another place where weakly referenced listeners are very important. When objects that weak listeners are attached to are tagged for garbage collection, the listeners will get removed automatically. Refer back to Chapter 4 to learn how to use weakly referenced listeners.

Set a Minimum Delay for Accepting Input

Often bots are used to speed up the progress of a game faster than a human would be able to accomplish it. If you define an interval (which depends heavily on the style of game in question) during which the listener ignores input, you can force hackers to slow down their bots to a human rate of speed. Here is what code for this might look like:

```
import flash.utils.getTimer;
private const MINIMUM_INPUT_DELAY:int = 150; //milliseconds
private var _timeOfLastInput;
private function onKeyDown(e:KeyboardEvent):void {
  if (getTimer()-_timeOfLastInput < MINIMUM_INPUT_DELAY)
    return;
  _timeOfLastInput = getTimer();
  //OTHER INPUT-RELATED CODE
}</pre>
```

Detect Malicious Use and Shut Down the Game

This is a more drastic measure and probably only worth implementing if: (1) you have a legal obligation to other users to prevent hacking (because of prizes or money), or (2) you are certain people are hacking your game in a particular, consistent way. The second of these two criteria is harder to define and can lead to

nonoffending users reaping a consequence designed to catch hackers. There is a balance to be struck with this approach, particularly if you have less than adequate data to prove when someone is hacking your game. Occasional rapid input on a keyboard-driven game could just mean the player is genuinely skilled. You don't want innocent players to have a lousy experience just because you were trying to stop the jerks.

Data Protection

While bots and malicious users are certainly a concern, they tend to be less of a problem than players who attempt to manipulate the data inside, being received, or being sent from the game. This next section discusses ways to protect your game data, both in memory and over the wire.

Memory Hacking

Writing a bot for a specific game can be a time-consuming effort, and, like I mentioned above, bots cater more toward a specific type of game. It would be extremely difficult to bot a sidescrolling action game, because the bot would have to know a lot more about the changing game screen than is probably possible. In these cases, hackers are more likely to just try to manipulate a few values in their computer's memory in the hopes of giving themselves a high score. There are several utilities that exist that will allow people to modify memory addresses, and a decent hacker won't have any trouble finding them. It would be dangerous to just start changing memory values blindly, so the way these programs tend to work is by analyzing which memory addresses have changed over a period of time and telling the user what is in each one. If a hacker starts the utility and then plays a couple of turns in the game, they will probably be able to narrow down relatively quickly where data like their score or progress are kept. They then use the same utility to change the value in their favor. At this point you may be saying, "Well, how am I going to combat that?" Don't worry; there are a few things you can do that will make the jerks' jobs a lot harder.

Hash Data

One way around memory hacks is to hide vital data you're storing. You can do this any number of ways, but one effective method is to use a technique known as *hashing*. A hash is a form of cryptography intended to validate a piece of data by running a series of procedures on it. Depending on the hash algorithm you're using, the result of a hash function will be a string of the

same length every time. If you're scratching your head right now, don't fret; we're about to look at some examples. For instance, a common hashing algorithm is known as MD5. When given data of any length, it will return a 32-character series of letters and numbers. Think of this as that piece of data's *signature*—every time an MD5 hash is run on that data it will produce the same result. As an example, the string "Real World Game Development with Flash CS4" will always output:

ac0c8d53e3a5ba2670126be815219c78

My name will always result with:

e640754e479fa16c1320c97e65ccdb13

It's important to note that these hash results are not guaranteed to be unique; that is, two different pieces of data could feasibly result in the same 32-character string. This phenomenon is known as *collision*, and some hash algorithms are more susceptible to it than others. MD5 has some weaknesses where this is concerned, but it is also very fast, so if you are changing values regularly over a period of time it is probably worth the decreased security. Another method, known as SHA-256, is known to have a lower collision probability, but it is slower to process. It is more suited to data being sent outside of Flash, which we will discuss shortly. Now let's look at a practical example of how you could use a hash to protect a game's score.

Consider the following very simple class that stores a number in a private variable through public accessors:

```
package {
  public class Game {
    private var _score:Number;
    public function set score(value:Number):void {
      _score = value;
    }
    public function get score():Number {
      return _score;
    }
}
```

This code contains no protection from hacking and the *_score* property is very susceptible to having its value changed. We'll now introduce an MD5 algorithm. You can find many different implementations of MD5 on the web; most that are in ActionScript started as JavaScript. I have included one in the Examples folder for this chapter. You can use it along with the sample Game.as file:

```
package {
  public class Game {
```

```
private var _score:Number;
private var _scoreHash:String;
private var _scoreDate:Date;

public function set score(value:Number):void {
    _score = value;
    _scoreDate = new Date();
    _scoreHash = MD5.hash(_score + _scoreDate.toDateString());
}

public function get score():Number {
    if (_scoreHash != MD5.hash(_score +
    _scoreDate.toDateString())) return 0;
    return _score;
}
}
```

Now we're getting somewhere. Each time the score property is set, it will not only store the actual value but also a hash of the score to check against when reading the value back out. MD5 and similar hash algorithms work better when you have more data to encrypt as that makes it less likely that a matching string can be generated by something else. Since a score is likely to be only a handful of characters, we also generate a timestamp from a Date object (yet another way to try to make the sequence unique) and append it to the score. In this instance, the date is what is known as the *salt* of the hash. It is the piece of data that is irrelevant to what you're trying to protect but is used to further obfuscate it. This way, when the score is set, three different values have been written to memory. If any one of them changes, the score will be invalid when it is read back out. In this case, if the hash doesn't match, I return 0 instead of the actual score value. You could even throw an error if you wanted to, instead of returning anything, but it's important to consider how you want the game to behave once illegal activity is detected. A big advantage of this method is that it is highly customizable. There are any number of properties you could use as the salt, and they need not be the same per game or even the same per class. In fact, the more you vary your use of them, the harder it will be for a hacker to determine how you're generating the hash at any given moment. Another unique identifier you could use as a salt is the server string for the user's computer. It is a property of the Capabilities class and produces a nice long string of many values for that machine:

```
import flash.system.Capabilities;
//
_scoreSystem = Capabilities.serverString;
_scoreHash = MD5.hash(_score + _scoreDate.toDateString() + _scoreSystem);
```

Once again, this does not eliminate the possibility of someone still managing to hack your game, but it does make it a bigger pain for a hacker than moving on to a game that is an easier target. You also need to weigh performance against how many values you want to hash. Usually a couple of main values is enough. Values that change very frequently (like every frame) will be harder for hackers to target anyway, and the added processing required to run MD5 multiple times a frame could get heavy on slower machines.

Break Up Data

Another way to help obfuscate data is to break it into pieces and reassemble it only when you need it. This method is particularly helpful if you have strings in your code that contain important information, like a key or passwords for levels. By breaking up the string into single characters in an array, for example, you help obscure your data from memory readers. Any single piece of the data is likely to be useless on its own, and assembling it only when you need it (and subsequently discarding the assembled version) ensures that the value can't simply be fished out of memory:

```
private const PASSWORD_LEVEL_1:Array = ["H","A","C","K","E", "R","S","S","U","C","K"]
```

With the above example, a simple toString() call on the array will return you the reassembled value, but in memory it will store 11 different values.

Insert Red Herrings

This method can kind of go off the deep end if you're not careful, but another avenue to take is to insert meaningless data along with the data you care about. The idea here is to have so much data moving around and changing at any given moment that a memory utility can't differentiate between the real values and the "noise." The catch is that unless you have a solid strategy for making this distinction yourself you run the risk of falling victim to your own defenses. This also involves quite a bit more hassle to implement, so it should be reserved only for information that is extremely critical. If we were to build on the previous example, we could store random numbers in among the real data and then store a separate array of values that map to the correct indices in the first array:

```
private const PASSWORD_LEVEL_2:Array = ["H", 1,"A", new Object(), "C","K", new Date(), "E","R","S", .5,"S","U", new Object(), "C","K"]; private const PASSWORD_LEVEL_2_MAP:Array = [0, 2, 4, 5, 7, 8, 9, 11, 12, 14, 15];
```

```
public function getMappedValue(name:String):String {
  var str:String = "";
  var stringArray:Array = this[name];
  var mapArray:Array = this[name + "_MAP"];
  for (var i:int = 0; i < mapArray.length; i++) {
    str += stringArray[mapArray[i]];
  }
  return str;
}
//
var password:String = getMappedValue("PASSWORD_LEVEL_2");</pre>
```

As you can see, this is quite a bit of trouble to go to for very many values and also begins to eat a considerable amount of memory to store just a simple 11-character string. Ultimately you must weigh the cost of protecting your data.

Protecting Sent and Received Data

More and more Flash games out today are making use of external data, both for loading content and for posting data (like leaderboards). I discussed some of these techniques back in Chapter 9 using XML. This data is very vulnerable to tampering, even more so than that in memory. Anyone with a basic type of HTTP activity monitor can see the data in plain sight coming in and going back out. The best method for protecting this data is encryption, and there are a few different approaches for encrypting data.

Hashing

Much like the previous memory examples, using a hash algorithm to validate data that is sent to a server from Flash is a great way to secure it. Depending on the nature of the data, you may want to use an even more robust hash, like SHA-256. It is slower to process than MD5, but usually data transactions are things like score postings or saving profile information: events that do not repeat rapidly in succession. When you use a hash to send data to a server, both Flash and the server need to have two things:

- · The salt for the hash
- The order of operations to recreate the hash

Here is an example of how you might send out a score to a server:

```
private const LEADERBOARD_URL:String =
"http://www.flashgamebook.com/savescore.php";
private const LEADERBOARD_SALT:String = "hackerjerks";
public function saveScoreToServer():void {
  var urlVars:URLVariables = new URLVariables();
  urlVars.score = score;
  urlVars.date = new Date().toDateString();
```

```
urlVars.checksum = MD5.hash(score + date + LEADERBOARD_SALT);
var urlRequest:URLRequest = new URLRequest(LEADERBOARD_URL);
urlRequest.method = URLRequestMethod.POST;
urlRequest.data = urlVars;
var urlLoader:URLLoader = new URLLoader(urlRequest);
```

This method would send the score and timestamp, along with the hash to check against. The server would need to know that the salt is "hackerjerks" and that the three properties must be concatenated together and hashed to match. This works well for data that you don't mind people seeing but want to validate as legitimate once it arrives at its destination. This isn't a solution for loading data that you don't want to be seen at all, like solutions to a puzzle or sensitive user data being loaded from a database. For these instances, we turn to a method known as *ciphering*.

Ciphering

Unlike a hash, which is a one-way encryption (there is no way to get back to the original value from a hash), ciphering is two-way encryption. It turns the data in question into different data and then back to its original state. Most ciphers (the worthwhile ones, anyway) have a key associated with them that both sides must have when working with the data. A particularly popular and powerful encryption cipher is the Advanced Encryption Standard (AES). Ciphering is even slower than hashing, and results in a string longer than the data initially inputted. Here is what the name of this book would look like encrypted in AES with my first name as the key:

/pv/JFamBEGYRkrA8J8aIpceB+IqUb6XC11UPR8v1SNe7bugwDNtMhqD4J0LWP8g

As you can see, it is totally unintelligible from the original data. Without the key, it would take a *long* time for even the best applications to crack the encryption. For games with external puzzle or other textual content, running the data through a cipher like this before putting it on a public server is a very good idea. Other ciphers are less heavy on the processor than AES. Algorithms like the Extended Tiny Encryption Algorithm (XTEA) or RC4 are suitable for encrypting noncritical data and are much faster. I have posted a link to a free encryption library for AS3 on flashgame-book.com. It includes all of the popular hash and cipher methods you probably ever need to use.

SWF Protection

The last item we'll look at in this chapter is probably the one most out of our collective control—protecting the code inside your SWFs. A number of utilities exist to extract ActionScript from a SWF, making it plainly readable, albeit without comments. Adobe has yet to seriously tackle the issue of SWF security, and as a result just about every SWF is vulnerable, regardless of Flash version. A few companies have written software that obfuscates the data inside a SWF to make it harder to extract. One such program is called SWF Encrypt by Amayeta Software. While far from perfect, it does an admirable job of at least making hacker's jobs harder by turning the output of most extraction utilities to garbage. In the end, running a program like this and selecting "Protect from Import" in the publish settings of your SWF are the best options if you have sensitive data inside your game. I hope Adobe will work to remedy this lack of security in future versions of Flash. Until then, you can at least lower your likelihood of being hacked. You have to remember that these jerks are usually lazy and will go for the low-hanging fruit. If someone else's work is less protected than yours, they are a more likely target than you.

Summary

Now you have a number of new methods in your arsenal for protecting your work. Hacking and security on the Internet are a continual arms race. As one company finds a new way of securing data, another individual will find a way to expose it. The best you can do is to protect yourself as much as possible. Well, that and if you ever meet someone who you discover is a hacker in their spare time, break their hands.

AFTERWORD: IT'S ALL BEEN DONE, SO DO SOMETHING DIFFERENT

You made it to the end of this book—give yourself a pat on the back! We've covered a lot about the process of game development, not to mention a *lot* of code. Now, like a public service announcement at the end of a kid's cartoon, I want to leave you with a few parting thoughts on where Flash games are going and

how you can affect it.

With the advent of ActionScript 3, Flash has started to attract a lot of attention among developers from more traditional programming backgrounds as a viable game platform. The rapid development cycle, ubiquity of the Flash Player, and the variety of tools that work seamlessly with Flash are all appealing to game developers. However, like Hollywood and the mainstream console game industry, there's the ever-looming possibility of stagnation. For every original, interesting Flash game on the Internet, there are a dozen Sudoku, Bejeweled, or Tetris clones taking up way more of the spotlight. They're cheap and quick to produce, and many interactive marketing agencies see them as easy filler to sell their clients. I know—I used to work at agencies like that. Those games have their place, but we as a development community can do better.

I challenge you to take the knowledge you gain from this book and strive to do something different and original. Every new, fun, and inventive game released in Flash further legitimizes and empowers the platform, as well as its community. As part of this challenge, there will be an area on flashgamebook.com where I will happily feature anyone's work that is new and different. Thank you for reading this book, and good luck with your

creations!

WEBCAMS AND MICROPHONES

Ever since Flash 6, users have been able to make use (to a limited extent) of the cameras and microphones connected to their computers. The original purpose of these features was for use with the Flash Media Server, a multi-user platform for streaming media between users. Because Adobe has not added much functionality to these components since their creation, little more can be done with them today than when they were first released. In fact, one might wonder why they're being brought up in a book about game development at all.

There are actually more applications for these devices than you might think. More and more computer users are purchasing machines with built-in cameras and mics (including close to every Mac for the past several years), making content that uses them more relevant to the general public. Even though the feature set is limited, each device has some unique methods to it that can be used as a controller, or in conjunction with interface elements. We'll start out by looking at microphones first.

Testing 1, 2, 3: The Microphone Object

When not connected to the Flash Media Server (FMS), the microphone can really only perform one function: It can route back out to your speakers. This in and of itself is not useful except perhaps for testing; you cannot perform any operations on the sound data going out, and if your speakers are very loud you'll experience some echo feedback. However, you can read the activity level of the microphone while it is being processed. That level is anywhere from 0 to 100, representing a range from quiet to loud. Let's look at an example of how to set up a microphone for input and use the activity level for a real purpose. You can follow along with the Microphone Example. fla file in the Appendix A folder.

The MicrophoneExample file uses a single document class for the functionality we'll explore. The class extends MovieClip since it is purely a wrapper for the document:

```
public class MicrophoneExample extends MovieClip {
  private var _mic:Microphone;
  public var microphoneLevel:MovieClip;
```

This class will keep two persistent variables. One is a reference to the Microphone object and the other is a vertical bar inside a clip called *microphoneLevel*. This clip will ultimately reflect the activity level of the microphone. Now we'll take a look at the class constructor:

```
public function MicrophoneExample() {
   _mic = Microphone.getMicrophone();
   _mic.setLoopBack(true);
   _mic.soundTransform = new SoundTransform(0);
   _mic.addEventListener(ActivityEvent.ACTIVITY, micActivity, false, 0, true);
}
```

Microphone instances aren't created using the *new* keyword; Flash has a list of all available microphones for the computer and will return the default device by calling *getMicrophone*. Once the instance is created, the microphone is activated by calling *setLoopBack* and passing it a parameter of *true*. Since we're not using FMS with this file, Flash needs a place to route the audio from the microphone to make it available to us. Until this method is called again with a parameter of false, any sound the mic picks up will be passed through to the speakers. For this example, we don't want the sound to come back through, so we set the *soundTransform* of the object to a volume of 0. The microphone will still reflect its current activity level in code, but we won't hear anything. Finally, we add a listener for any *ActivityEvents* that the mic generates:

```
private function micActivity(e:ActivityEvent):void {
  if (e.activating) {
    micUpdate(null);
    addEventListener(Event.ENTER_FRAME, micUpdate, false, 0, true);
  } else {
    removeEventListener(Event.ENTER_FRAME, micUpdate);
  }
}
```

ActivityEvent objects are a derivative of normal events, with an additional property that tells whether the device dispatching the event is in the process of activating or deactivating. In this case, if the microphone registers anything more than a negligible amount of sound data, it will dispatch this event with the activating property set to *true*. If the mic has gone a specific amount of

time (which can be set per Microphone object) without detecting any audio, it will dispatch this same event with activating set to *false*. When the microphone becomes active, we attach a frame listener that will be called the *micUpdate* method. Likewise, when the microphone goes dormant, we'll remove the listener to clean up after ourselves:

```
private function micUpdate(e:Event):void {
  microphoneLevel.scaleY = Math.max(.01, _mic.
activityLevel/100);
}
```

Though it is the code at the heart of this exercise, the *micUpdate* method is only one line. It sets the *scaleY* value of the microphoneLevel clip to the value of the microphone's activity level (with a minimum value of .01 to prevent it from disappearing altogether). This is the extent of the functionality we will include. When this SWF is exported, Flash should prompt you to allow it access to your microphone (assuming you have one). After agreeing, you should see a bar on the screen that raises and lowers with the amount of sound it picks up.

Applications

Like I mentioned before, this is obviously very simplistic functionality but it has a number of potential applications in games. For example, in a game where a character slowly falls down the screen, the activity level could be used as a boost to keep the character afloat. Since it does not discriminate between the tones it receives, you could tell the player to blow into the microphone to produce the noise level required. Another possibility is a timing game where you must create a loud noise in conjunction with some rhythmic activity on the screen. Along those same lines, you could make players create softer or louder sounds to navigate their characters through a series of obstacles.

Considerations

For the purposes of the previous example, we applied no smoothing whatsoever to the data being received from the microphone. As a result, the bar jumped rather violently from one position to the next. To account for this and make the data less erratic when displaying it on-screen, we can take a *sampling* of the data over time and average it. This will smooth out any sudden peaks or drops. Here is a quick example of how the previous class could be modified to do this. First, we'd need to add two properties to the class:

```
private var _micLevels:Vector.<Number> = new Vector.<Number>();
private const _sampleSize:int = 5;
```

The first is a vector (typed array) that will hold the sample values we pull from the microphone. The second is a constant defining how many samples the vector should contain before pushing older values out. We'll need to now make some additions to the *micUpdate* method and include a new method to average the values:

```
private function micUpdate(e:Event):void {
   _micLevels.push(Math.max(.01, _mic.activityLevel/100));
   if (_micLevels.length > _sampleSize) _micLevels.shift();
   microphoneLevel.scaleY = getAverage(_micLevels);
}

private function getAverage(values:Vector.<Number>):Number {
   var avg:Number = 0;
   for each (var value:Number in values) avg += value;
   return avg/values.length;
}
```

Now, instead of assigning the microphone level directly to the clip's scaleY value, we push it into the vector and remove any samples over the max of 5. We then assign the scale value with the new *getAverage* method. This method simply adds all the values of the vector and returns the average. When the example is exported, you'll notice the activity bar raises and lowers much more smoothly without the twitchiness it had before. You can make it even smoother by increasing the sample size, but you'll start losing accuracy for very short sounds. If you were measuring the activity level over a longer duration of time (like the example I gave earlier of having someone blow continuously into the microphone), a larger sample size would work fine. For shorter, more punctuated sounds, keeping the sample size low will get you closer to the true values.

Where do you go from here? Come up with your own unique application for how this simple functionality can play into a game mechanic. Flash applications that make use of the microphone are still pretty few and far between, so a fun game will stand out from the crowd if it makes savvy use of the device. As we explore the Camera object next, you'll notice some similarities in syntax and implementation.

Lights, Camera Object, ActionScript!

The ability to grab a live feed from a connected camera is a very nice feature of Flash, even in its limited state. To see the image from a camera, it must be attached to a Video object. Like the Microphone class, all Camera objects have an *activityLevel*, which represents the amount of motion in the video feed. When the image is very still, the value is close to 0; when the entire image is changing every frame, the activity level approaches 100. Now we'll

look at how to set up a Camera object and display the feed on the Stage. The associated file for this example is CameraExample.fla in the Appendix A folder.

```
public class CameraExample extends MovieClip {
  private var _cam:Camera;
  private var _video:Video;
  public var activityLevel:MovieClip;
```

We'll need to store references to both the Camera object we've created as well as the Video object that will be added to the Stage. Like the Microphone example, there is a clip on the Stage already called *activityLevel* that will be scaled to represent the motion rate of the Camera.

```
public function CameraExample() {
    _cam = Camera.getCamera();
    _cam.setMode(stage.stageWidth, stage.stageHeight, 30);
    _cam.addEventListener(ActivityEvent.ACTIVITY,
cameraActivity, false, 0, true);
    _cam.addEventListener(StatusEvent.STATUS, cameraStatus,
false, 0, true);
    _video = new Video (stage.stageWidth, stage.stageHeight);
    _video.attachCamera(_cam);
}
```

As with Microphone objects, Camera instances are returned by the *getCamera* method. To define the dimensions and frame rate of the video fccd, we call the *setMode* method of the object and use the values of the Stage dimensions. Next we create two listeners. One is for ActivityEvents, similar to the Microphone. The other is for StatusEvents, which represents changes in the camera's operating state. In this case, we're interested in knowing when the camera is activated after the user grants permission to Flash to access the device. Finally, we create a new Video instance with the same dimensions as the camera and attach it.

```
private function cameraStatus(e:StatusEvent):void {
  if (e.code == "Camera.Unmuted") {
    if (!_video.stage) addChildAt(_video, 0);
  }
}
```

To ensure the camera is initialized correctly, the *cameraStatus* method adds the Video object to the Stage (underneath the bar showing activity) when a status of Camera.Unmuted is sent. This message is delivered when a user agrees to let Flash have access to their camera.

```
private function cameraActivity(e:ActivityEvent):void {
   //CAMERA WAS ACTIVATED
   if (e.activating) {
```

```
addEventListener(Event.ENTER_FRAME, updateCamera, false, 0,
true);
} else {
   removeEventListener(Event.ENTER_FRAME, updateCamera);
}
```

When the camera is activated by motion, it creates a frame listener that will call the *updateCamera* method.

```
public function updateCamera(e:Event):void {
  activityLevel.scaleY = Math.max(0, _cam.activityLevel/100);
}
```

Once again, just like the Microphone example, the camera's activity level is translated to the *scaleY* property of the clip on the Stage. When this SWF is exported, it will show a full-stage video feed from your camera (if you have one attached).

Because the video feed is linked to a DisplayObject, it can be captured and manipulated into BitmapData. To change this functionality, we can simply add some code to the existing example. A new file exists for this change in the Appendix A folder: CameraBitmapDataExample.fla. The two major changes are to the *cameraStatus* and *updateCamera* methods.

```
private var _currentImage:BitmapData;
private var _stageImage:Bitmap;

private function cameraStatus(e:StatusEvent):void {
  if (e.code == "Camera.Unmuted") {
    _stageImage = new Bitmap();
   addChildAt(_stageImage, 0);
  }
}
```

Two additional properties have been created in this example, each storing related information about the image being captured from the video. When the camera is activated, it instantiates and adds a new Bitmap object to the Stage.

```
private function updateCamera(e:Event):void {
  activityLevel.scaleY = Math.max(0,_cam.activityLevel/100);
  if (_currentImage) _currentImage.dispose();
  _currentImage = new BitmapData(_video.width, _video.height);
  _currentImage.draw(_video);
  _stageImage.bitmapData = _currentImage;
}
```

The *updateCamera* method has some additional functionality, as well. It checks to see if any residual image data exists, disposes of it to free up memory, and then draws a new Bitmap from the video feed. Upon viewing this example next to the last one, there would appear to be no difference in the output, except that because *updateCamera* is only called when the camera detects significant motion the image will freeze when still for too

long. This can be adjusted by either setting the motion threshold for the camera much lower or by running the function every frame whether or not the camera is detecting motion. Regardless, it is very powerful to now have live bitmap data that can be used for any number of different tasks and manipulated using any of the filters available in the display package.

Applications

Where the Microphone class relies on changes in sound to be of any real use in game development, the Camera class's reaction to motion can be put to similar use. A game could require that a player is alternately active and inactive in their motions to manipulate gameplay. Additionally, any puzzle games that make use of static imagery could employ a live camera image to offer a different experience.

Conclusion

Outside of their use with FMS, microphones and cameras can be valuable input devices that can complement or even replace the keyboard and mouse in certain instances. I hope that the more developers make use of these tools, the more attention Adobe will pay to making them even more robust and useful.

INDEX

Note: Page numbers with "f" refer to figures.

3D in Flash Adventure games, 1-5 basics, 161-164 **AES** (Advanced Encryption perspective projection, Standard), 314 163-164 AI (artificial intelligence), 8-9 position, 161-162 AIFF format, 97-98 otation, 162-163 Algorithms, 6 x,y,z system, 161–164 alive value and destruction see also Tunnel shooter animation, 197 8-bit PNG with alpha channel, 79 Alpha-channel video, 115-116, 125 - 127Amadeus Pro (HairerSoft), 101 Ambient sound, 98 Absolute-value function, 159 Acceleration/deceleration, AMFPHP, 32 176 - 177Angels and trig functions, direction of acceleration, 184 154-155 Accessor methods, 39-40 _angle variable, 179 Action games, 2 Animation ActionScript easing, 86 code editors, 15-17 vs. games, 21-22 familiarity with, 35 projectile class, 87-88 history of/versions, 13-14 sequencing, 86 idiosyncrasies, 65-66 simple scripted shooter, see also Flash development. 87-90 OOP (object-oriented timeline vs. ActionScript, programming) 85 - 86activate method, 136, 169-170, tweens, 86-87 appendChild method, 148-149 Activity Monitor (Mac), 17-18 ApplicationDomain, 70 activityLevel Camera object, A3, Arrays A4-A5 basics, 60-61 addEnemy method, 172, 173 three dot syntax, 38 addEventListener method. Vector class, 176 50-53, 72 ASDoc formatting, 64–65 addFrameScript method, 66-69 Asset list, 28-30 Adjacent side of right triangle, Assets 154-155 _assetDomain property, 257 Adobe Flash building asset list, 28-30 see Flash development external SWFs, 244-248 ADPCM (Adaptive Differential getAssetClass function, 261

Linkage (Symbol Properties),

277-279

Pulse Code Modulation),

99f, 100

linking classes to, 45-46 loadNextAsset method, 260 managing, 75-76, 259 Attributes class, 8, 40-41 XML, 131-132 Audio/sound export settings to use, 98-100 formats, 97-98 pausing/muting, 108, 112 planning, 28-30 playing/stopping, 106, 109 Publish Settings window, quality adjustments, 100 scripting sounds, 101-114 setting up, for export, 112-113 Sound class, 102 sound effects, 97-98 Sound Properties window, 99f SoundChannel object, 102 SoundEngine class, 65, 103-112, 208 SoundEngineEvent, 103, 112 soundEvent method, 109 SoundMixer class, 113-114 SoundTransform class, 102 speech settings, 98, 100 testing sound, 112-113 tools for working with sounds, 101 using external files, 101 volume/pan, 107 Author-time events, 12 Axes perspective projection, 163 - 164rotation, 162-163 x,y coordinate systems, 154 x,y,z system and 3D, 161 - 164

В	Card-based games, 5	public attributes, 8, 40–41
Background/foreground	Memory Card game, 90–95	subclasses/superclasses, 41,
objects, 10, 88	Cartesian coordinate system,	202–203
Backstories, 240, 241	153–154	UML diagrams, 32–33
Barriers and <i>hitTestPoint</i>	Casting, 48–49	versions, 8
method, 190–194	catch statement block, 56–57	See also specific class name
Base class, 46	Catching errors, 56–57	Classical mechanics, 175
Begin Remote Debug Session	Character Embedding panel, B5f	<i>cleanUp</i> method, 72, 225, 228
command, 298	checkCards method, 94	clear method, 255, 256
Bitmap Properties panel, 81f	checkCollisions method, 198-199	clearSelection method, 144–145
Bitmaps	checkEnemies method, 269	<i>client</i> property, 285
IBitmapDrawable	checkInventory method, 270	Code editors, 15–17
interface, 43	checkItems method, 269	Codecs, video, 115–116
smoothing, 82–83	checkPlayerCollisions method,	Coefficient of friction, 177
see also Graphics	268	Collision detection
Blur, motion, 124–125	checkPortals method, 270	<i>alive</i> value, 197
Board-based games, 5	checkWin method, 229	checkCollisions method,
Bots, 307–308, 309	Ciphering, 314	198–199
Bounce easing, 94	Circular objects and collisions,	check Player Collisions
Bounding boxes	194–195	method, 268
hitTestObject method,	Classes	CollisionGrid class, 249
189–190, 194, 195–196	attributes, 8, 40–41	combining approaches to, 200
rect testing, 195–200	vs. base class, 46	createEnemy method, 198–199
Break points, 296–298	basics, 7–8, 35–36	design basics, 189
Breaking up data, 312	code organization	destroy method, 197, 198-199
Bubbling phase of events, 50–51	recommendations, 210	Enemy class, 196–197
Bugs, 293–298	constants, variables, and	enterFrame method, 194
Buttons	methods, 37–39	getCollisionReference method,
as display objects, 11	constructors, 37	264, 267
event propagation/	dynamic attributes, 40–41	<i>hitTestObject</i> method,
cancellation, 53–54	exported symbols with no	189–190, 194, 195–196
planning use of, 26f, 26–27,	class file, 48	hitTestPoint method, 190–194
28–30	extending, 201–202	iterative testing, 199
ByteArray class, 63	as files, 36–37	localToGlobal method, 191
Dyterming endes, se	final attributes, 40–41	loops for, 194, 199, 200
	getDefinitionByName	predictive testing, 195–196
C	method, 48–49	radius/distance testing,
CameraBitmapDataExample.	getter/setter methods, 39-40	194–195
fla, A6	identifiers, 40–41	rect testing, 195–200
CameraExample.fla, A4–A5	inheritance and	SimpleShooterCollisions
Cameras	polymorphism, 8, 41–42,	class, 197–199
applications, A7	202-203	tempPoint object, 194
basics, A4–A7	instances/instantiation, 35-36	wall collision check, 268–269
SourceImageCamera class,	vs. interfaces, 42–45	weaknesses of, 199-200
236–238	internal attributes, 8, 40–41	Collision of hash results, 310
SourceImageWebCamera	linking to assets, 45–46	CollisionGrid.as, 248
class, 283–287, 290	naming conventions, 36	Color
cameraStatus method, A5, A6	packages, 11–12, 36	ColorTransform class, 140,
Cancellation of event	private attributes, 8, 40–41	168
propagation, 53–54	Project window, 46f	getRandomColor method, 170
Capture phase of events, 50–51	protected attributes, 8, 40–41	Commenting code, 64–65

Compacting, Save and Compact *content* container, 148–149 arrays, 60-61 operation, 75-76 createPuzzle method, 142 basics, 58 Compile-time errors, 56 crossword builder, 148-149 ByteArrays, 63 Compile-time events, 12 CrosswordClue class, custom, 64 Component Inspector, 299-300, 138 - 139dictionaries, 62-63 301, 302 CrosswordPuzzle class, iteration, 58 Compression 139 - 148objects, 59–60 audio, 99f, 100 CrosswordTile class, 134–137 vectors, 62 graphics, 81-82 CrosswordTile symbol, 137 Database structure for video codecs, 115-116 init method, 137 scores, 27, 31 concat method, 60, 255 keyDown method, 146 deactivate method, 136, Connection speed, system for loops, 142, 145 169-170, 228 requirements, 30-32 MouseEvent, 146 Deblocking, 83 ConnectionPanel class, 287-288 savePuzzle method, 148 Debug menu, 297, 298 ConnectionPanel.as, 283 selectTile method, 144-145 Debug Movie command, 297 Connections setAnswer method, 136, 146 Debugger, 296-298 ConnectionPanel class, structure in XML, 131-148 Debugging content 287-288 switch statement, 146 basics, 18-19 onPeerConnect method, 285 wordIndex, 145 Begin Remote Debug Session setupConnection method, 284 CrosswordPuzzle.fla, 137, 138, command, 298 see also Multiplayer 146 - 147break points, 296-297 development Crugnola, Alessandro, 296 debugger, 296-298 Constants, 37–39, 210–211 currentIndex property, 229 ERROR traces, 295 Constructors, 37 currentLabel property, 67 Flash debug player, 296, Containers, 210 currentTarget object, 11, 49 297, 298 _content container, 148–149 Customizing FlashTracer, 18–19, 296 contentLoaderInfo object, 69–70 data structures, 64 INFO traces, 295 Conventions error classes, 54-55 throwErrors flag, 295 see Naming conventions event classes, 54-55 TraceObject method, 295 Convert to Compiled Clip Media Encoder presets, 118f, traces, 294-295 command, 302 118 - 119WARNING traces, 295 Coordinates/coordinate system, Cutscenes Deceleration/acceleration, 153 - 154CutsceneManager, 119–123 176 - 177Cosine (cos) and trig functions, encoding, 117-119 direction of acceleration, 184 153 - 157external video uses, 116-119 Degrees and trig functions, CPU speed, 30–32 154-155 createBoard function, 227 Deleting D createEnemy method, 198-199 delete command, 59, 63 createHighlight method, 170 Data protection, 309–314 dictionaries, 63 createImagePool method, 218 break up data, 312 objects, 59 createLevel method, 261 ciphering, 314 Delta time 180–181 createPortals method, 263 collision, 310 Description of game, 25-26 createProjectile method, 89 Design patterns, 7, 201 hash data/hashing, createPuzzle method, 142 309-314 poor programming practices, createTunnel method, 166 insert red herrings, 312-313 212 - 213Crossword puzzle memory hacking, 309 Singleton design pattern, 103, appendChild method, protecting sent/received data, 148 - 149149, 313 Singleton document pattern, clearSelection method. Data signature, 309-310 206-208 144-145 Data structures destroy method, 197, 198–199,

alternatives for lists, 63

225, 238, 287

ColorTransform class, 140

Dictionaries, 62–63	<i>IEnemy</i> interface, 249, 250, 274	Extending classes, 201–202
disableTextFields method, B8	in platformer games, 243–244	External image tools, 83
Dispatching events	Engine	
dispatchEvent method, 49–50	data flow from application to,	
dispatchFrameEvent function,	240f	F
68	game outline, 247	farID property, 285
event flow, 66	MixUp game, 241	Features, planning, 27–28
Displacement, 176	platformer games, 240–241	Fieworks (Adobe), 79, 81f, 83
Display objects, 11	enterFrame event, 172–173	File size
Distance formula, 160	enterFrame method, 194	audio formats, 97–98
collision detection, 195	enumerateFrameLabels method,	compression
Doyle, Jack, 87	68, 218	see Compression
Drift, driving game with,	Enumerations, 49–50	graphics, 77–78
184–186	Environment.fla, 279	managing assets, 75–76
Driving game	Errors	PNG sequence vs. video,
_angle variable, 179	basics, 55–56	127f, 127–128
classes, 178–184	catching, 56–57	video on timeline, 123–124
delta time 180–181	compile-time, 56	FileReference <i>save</i> method,
direction of acceleration, 184	ERROR traces, 295	148–149 Files
with drift, 184–186	runtime, 56	classes as, 36–37
Game class, 181–184	throwErrors flag, 295	external, for sound, 101
getTimer method, 180	throwing your own, 57–58 try, catch, finally, 56–57	managing assets, 75–76
<i>moveVehicle</i> function, 182–183	type checking, 38	organization of, 76
readInput function, 182–183	see also Quality assurance	reducing filesize, 75–76
stoppingThreshold constant,	(QA)	working with multiple,
179	event type parameter, 51–52	69–70
Time class, 180–181, 192	Events	Final attributes, 40–41
Vehicle class, 179–180	addEventListener, 50-53, 72	finally statement block,
DrivingSimDrift.fla, 184	basics, 11, 12, 49, 201	56–57
Dynamic attributes, 40–41	custom, 54–55	Firefox, Flash Tracer extension,
Dynamic classes, 64	dispatching, 49-50, 66	18–19, 296
•	enumerations, 49–50	Flash debug player, 296–298
	event/communication model,	Flash development
E	205f	animation vs. games, 21
E4X (ECMAScript for XML),	flow of, 66	application vs. games,
130–131	phases, 50–53	21–22
easeIn function, 173	propagation and cancellation,	code editors, 15–17
Easing, 86	53–54	coordinate system, 154
Elastic easing, 94	removeEventListener, 50–53	debugging content, 18–19
Encapsulation, 202, 210	Exceptions, 55–56	display objects, 11
Enemies	see also Errors	events and listeners, 11, 12 Flash vs. Flex, 22
addEnemy method, 172, 173	Expectations vs. reality, 178	flaws, 15–20
<pre>checkEnemies method, 269 createEnemy method, 198–199</pre>	Export setting up sound for,	flexibility of, 14
Enemy class, 171, 196–197,	112–113	for games, 14–15
274–275	settings for audio, 98–100	history of/versions, 13–14
Enemy.as, 165	video, 125–128	libraries, 19, 20
enemyFrequency variable,	Exported symbols with no class	performance/memory
171–172	file, 48	management, 17–18
enemy Movement Finished	Extended Tiny Encryption	player penetration, 14
function, 173	Algorithm (XTEA), 314	RIAs, 21–22

updateImages method, 237

working with, 77–78

speed to market, 14–15	MixUp, 221–224	Geometry, 153–154
Stage, 11	SimpleTunnelShooter, 171	getAssetClass function, 261
vs. traditional game	Game development	getAverage method, A4
development, 20–21, 23	AI, 8–9	getCamera method, A5
visual appeal of games, 15	algorithms, 6	getCollisionReference method,
websites vs. games, 22–23	attributes, 8, 40–41	264, 267
Flash idiosyncrasies	design patterns, 7, 201	getDefinitionByName method,
basics, 65–66	main loops, 6, 9	48-49
event flow, 66	OOP, 6–7, 201–204	getDistance function, 160
frame scripts, 66–69	poor programming practices,	getGetterInvocationCount
garbage collection, 71–73	209	method, 304
working with multiple SWF	procedural languages/	getGridReference method, 256
files, 69–70	programming, 6	getImages method, 225, 234,
Flash Media Server (FMS), 281	pseudo-code, 5–6	238, 287
Flash Player	scrolling, 10	getInvocationCount method,
penetration, 14	state machine, 9	304
system requirements, 30–32	tile-based games, 10	getMemberNames method, 305
version 9, 62, 68–69, 73,	traditional vs. Flash,	getMicrophone method, A2
302–303	20–21, 23	getRandomColor method, 170
Flash Professional 8 Game	views, game, 9–10	get Setter Invocation Count
Graphics (Firebaugh), 77	see also Flash development	method, 304
Flash Tracer, 18–19, 296	Game planning, steps for	getSize method, 303
Flash Vars vs. XML, 149–151	asset list (step 4), 28–30	GetSizeExample.fla, 303
FlashDevelop, 16–17, 45–46	game description (step 1),	getter function, 169
flashgamebook.com, 33	25–26	Getter/setter methods, 39-40
Flex Builder, 16–17, 22, 302–303	game mechanics (step 3),	MixUp game, 223
flipCard method, 93–94	27–28	getTimer method, 180
Flow	game screen wireframe/flow	gModeler, 32
event, 66	(step 2), 26–27	Golden Gate Bridge source
game planning, 26–27	technical requirements (step	image, 233
Font selection, B1	5), 30–32	Graphics
for each loops, 63	UML class diagrams (step 6),	compression, 81–82
for loops, 59, 142, 145	32–33	createImagePool method,
forin loops, 59, 295	Game types	218
Foreground/background	action games, 2	deblocking, 83
objects, 10, 88	adventure games, 1–5	external image tools, 83
Frame scripts	board- and card-based	getImages method, 225, 234,
addFrameScript, 66–69	games, 5	238, 287
basics, 66–69	puzzle games, 3	<i>image</i> property, 231
frameScript function, 89	RPGs, 4	ISourceImage interface,
frameScript method,	strategy/simulation, 3–4	224–225, 233–234
172–173	vehicle games, 4–5	key points to remember, 84
FrameRateProfiler class,	word games, 3	raster formats, 78–83
299–301	GameBoard class, 226–232	smoothing, 82–83
Framework, Flex, 14–15	gameHistory array, 235	SourceImageCamera class,
Friction, 177	GameHistory class, 234–236	236–238
from method, 93–94	gameOver method, 219, 224,	SourceImageEmbedded class,
	286, 292	233–234
G	Games.as, 164, 310	SourceImageWebCamera
u	Garbage collection (GC),	class, 283–287, 290

71 - 73

Genres, 1-5, 239-240

Game class

DrivingSim, 181–184

240-241

ioError method, 109 Gravity and physics forces, 177, import command, 11–12, 36 IPlayer interface, 249-250, 273 266, 267 GridReference class, 254-255 currentIndex property, 229 IPlayer.as, 249 _highlightIndex property, 165, IPortal interface, 249, 251, 276 GridReference.as, 248 169-170 IPortal.as, 249 Grids isMuted method, 112 index property, 171 designing levels, 243f getGridReference method, 256 wordIndex, 145 ISourceImage interface, 224-225, 233-234 updateGridReference method, Indexing arrays ISprite interface, 249 indexOf method, 61 ISprite.as, 249 lastIndexOf method, 61 Items Inertia, 177 Н basics, 242 info object, 284 H.264 (MPEG-4-based) video, checkItems method, 269 INFO traces, 295 Inheritance and polymorphism, IItem interface, 249, 115 - 118251, 275 Hackers/hacking, 307 8,41-42Item class, 275-276 bots, 307-308, 309 classes vs. interfaces, 42-45 Iteration, 58 memory hacking, 309 OOP concepts, 202-203 init method, 137, 223-224, 257 IWall interface, 249, 251-252, Hash data, 309-312 Hashing, 309-310, 313-314 276 Input hide method, 91 IWall.as, 249 key input for platformer History panel, C2-C3 game, 265, 266 Hits readInput function, 182–183 J see Collision detection readKeyInput method, 266 JavaScript Flash (JSFL) HitTestCoordinate.as, 191-192 setting minimum delay for, commands, C1-C3 hitTestObject method, 189-190, 308 custom panels and 194, 195–196 Instances/instantiation, 35–36 MMExecute, C3-C7 hitTestPoint method, 190-194 interestDistance variable, 160 History panel, C2–C3 HitTestPoint.as, 191-192 Interfaces JSFLConverter, C4-C5 HitTestPoint.fla, 191-192 vs. classes, 42-45 Move Items panel, C5–C7 Hypotenuse (hyp), 154-155 IBitmapDrawable, 43 **IPEG** format IEnemy, 249, 250, 274 basics, 78-83 IEventDispatcher, 44, 49-50, compression, 81–82 226, 249 JSFLConverter, C4–C5 IGamePiece, 225 IBitmapDrawable interface, 43 Icons vs. text, B2 IItem, 249, 251, 275 IPlayer, 249-250, 273 Identifiers, class, 40-41 K IPortal, 249, 251, 276 IEnemy interface, 249, 250, 274 Key input for platformer game, ISourceImage, 224-225, IEnemy.as, 249 265, 266 233-234 IEventDispatcher interface, 44, Keyboard hacking, 307-309 ISprite, 249 49-50, 226, 249 IWall, 249, 251-252, 276 keyDown method, 146 IGamePiece interface, 225 for MixUp game, 224-226 IItem interface, 249, 251, 275 OOP concepts, 203-204 IItem.as, 249 L Illusion vs. simulation, 177-178 sprites subpackage, 249 Internal attributes, 8, 40-41 Labels Illustrator (Adobe), 77, 83 International development currentLabel property, 67 image property, 231 enumerateFrameLabels see Localization **Images** method, 68 see Graphics Inventory, 242, 257, 258 timeline, 67, 67f ImageSequence.fla, 125 checkInventory method, 270 Language selection, B3-B9 Implementation of engine, checkItems method, 269 Inverse trig functions, 156 see also Localization

languageLoaded function, B8	for collision detection, 194,	Vector3D class, 175-176
lastIndexOf method, 61	199, 200	xSpeed variable, 159
Length, array, 60	for each loops, 63	ySpeed variable, 159
Levels	forin loops, 59, 295	Math class, 153
basics, 240, 242	frame scripts, 66–69	Mechanics
createLevel method, 261	for loops, 59, 142, 145	see Physics/mechanics
grid design of, 243f		Media Encoder (Adobe)
loadLevel method, 259		customizing presets, 118f,
managing, 259	M	118–119
nextLevel method, 272-273	Main loops, 6, 9	encoding cutscenes, 117–119
XML representation, 244–247	mainMenu method, 219	126-127
Libraries	Mark sweeping, 71–73	Memory card game
custom/open source, 19, 20	Math	bounce easing, 94
linking classes to assets,	3D in Flash, 161–164	cardNumber function, 91
45–46	absolute-value function,	checkCards method, 94
organized by use, 76f	159	elastic easing, 94
tweening, 87	angels and trigonometric	flipCard method, 93-94
video on timeline, 124	functions, 154–155	Memory class, 92-95
Linkage properties, 113f	arc functions, 157	MemoryCard class, 91
Linking classes to assets, 45–46	coordinates/coordinate	rotationX/Y properties, 94
Listeners	system, 153–154	selectCard method, 93-94
addEventListener method,	degrees and trig functions,	_selectedCards list, 94
50–53, 72	154–155	show/hide methods, 91
basics, 11, 12, 49	distance formula, 160, 195	shuffledCards method, 93
event phases, 50–53	geometry, 153–154	to/from methods, 93–94
listener priority parameter,	getDistance function, 160	tweening animation, 90–95
51–52	hypotenuse (hyp), 154–155	Memory management
removeEventListener method,	interestDistance variable, 160	getSize method, 303
50–53	inverse trig functions, 156	memory hacking, 309
turning off, for security, 308	mouse pointer math,	monitoring, 17–18
useCapture parameter,	156–161	optimization, 298–306
51–52	MouseFollowDistance.fla,	system requirements, 30–32
useWeakReference parameter,	159–160	Memory.as, 90–91
52 Lists C2 50	MousePointer.fla, 156–158	MemoryCard class, 91
Lists, 63, 58	opposite/adjacent sides	MemoryCard.as, 90–91
LoaderInfo object, 212	of right triangle,	Memory.fla, 90–91
Loading SWF files, 69–70	154–155	MemoryProfiler class, 301–302
loadLevel method, 259	physics see Physics/	method parameter, 51–52
loadNextAsset method, 260	mechanics	Methods
loadResources method, 69–70	pi and radians, 158–161	constants, variables, and,
Localization	Pythagorean theorem,	37–39
in Flash CS4, B2–B9	156	getter/setter, 39–40
font selection, B1	right triangles and	identifiers, 40–41
icons vs. text, B2	trigonometric functions,	naming conventions, 40
MixUp game, B2–B9	153–157	MicrophoneExample.fla, A1
scrollbars for lengthy text, B2	SimpleTunnelShooter,	Microphones
Strings panel, B3–B9 text field length, B2	164–175 unsigned value of number,	applications, A3
localToGlobal method, 191	159	basics, A1–A4 considerations, A3–A4
Loops	updatePointer function,	micUpdate method,
basics, 6, 9	156–160	A3, A4
240100, 0, 0	130-100	$\Lambda J, \Lambda H$

MixUp game activate/deactivate methods, 228 checkWin method, 229 cleanUp method, 225, 228 createBoard function, 227 createImagePool method, 218 currentIndex property, 229 design basics, 215-216 destroy method, 225, 238 engine, 241 enumerateFrameLabels method, 218 file/class structure. 216 - 217Game class, 221-224 GameBoard class, 226-232 gameHistory array, 235 GameHistory class, 234-236 gameOver method, 219, 224 getImages method, 225, 234, 238 getter/setter methods, 223 *IEventDispatcher* interface, 226 IGamePiece interface, 225 image property, 231 init method, 223-224 ISourceImage interface, 224-225, 233-234 localization of, B2-B9 main document, 217 mainMenu method, 219 MixUp class, 217-219 mouse rollover/click states, 230, 232 movePiece method, 227, 229 multiplayer see Multiplayer development pauseBeforeGameOver method, 224 pieceClicked method, 229 *pieceLockAnimation* method, 232 pieces list, 227 playGame method, 219 randomize method, 227, 229 Results class, 234-236 RulesPanel class, 220-221 setupGame method, 219, 238 shuffleBoard method, 227

SourceImageEmbedded class, 233-234 startGame method, 223-224 swapElements function, 229 timerUpdate method, 222 Title class, 220 updateImages method, 237 MixUp.as, 233, 283 MixUp.fla, 217, 287, B7 MMExecute method, C3-C7 MMORPGs (massively multiplayer online RPGs), 4 see also Multiplayer development Mouse pointer math, 156-161 Mouse rollover/click states, 230, 232 mouseEnabled property, B8 MouseEvent, 146 MouseFollowDistance.fla, 159 - 160MousePointer.fla, 156-157 Move Items panel, C5–C7 Move Items.fla, C5, C6 moveEnemies method, 173 moveItems method, C6 movePiece method, 227, 229 movePlayer function, 89, 172 - 173moveProjectiles method, 89 moveVehicle function, 182 - 183MovieClip.as, 36 MovieClips as display objects, 11 safe casting, 49 MP3 format, 97-98 Multiplayer development classes, 283 client property, 285 ConnectionPanel class, 287-288 destroy method, 287 farID property, 285 gameOver method, 286, 292 getImages method, 287 hosting panel, 288f info object, 284 join panel, 288f

SourceImageCamera class,

236-238

MixUp class, 290-292 MixUp multiplayer, 282-292 mvID function, 286 NetStatusEvent, 284, 286 onPeerConnect method, 285 out object, 285 peerIDs, 282-292 play method, 285 playGame method, 291–292 **RTMFP, 281** sendGameOver method, 286 setupConnection method, 284 *setupIncomingStream* method, 285, 291 setupResults method, 292 showHostPanel method, 291 SourceImageWebCamera class, 283-287, 290 Stratus, 282 Title class, 288-289 updateImages method, 287 Music audio formats, 98 planning, 28-30 Mute sound, 108, 112 myID function, 286

N

Names
getDefinitionByName
method, 48–49
getMemberNames method,
305
QName (Qualified Name)
class, 305
Naming conventions
classes, 36
interface, 203
using underscore ("_"), 40
variables/methods, 40
netStatus method, 122
NetStatusEvent, 284, 286
NetStream objects, 282
nextLevel method, 272–273

0

Objects, 59–60 Observer design pattern, 204–205

On2 VP6 codec, 115-116 system requirements, 30-32 engine code, 247 One-point projection, 163 testing/optimization, features of genre, 239-240 onPeerConnect method, 285 298-306 game code, 248 OOP (object-oriented video on timeline, 124 game flow and features, programming) PerformanceProfiler.fla, 301 241 - 244basics, 6-7, 201-204 Perspective projection, 163–164 *_gameRunning* value, 258 encapsulation, 202, 210 Phases, event, 50–53 getAssetClass function, 261 event/communication model, Photoshop (Adobe), 83 getCollisionReference method, 205f PHP, 31, 149, 150 264, 267 inheritance, 8, 41–42, 202–203 Physics/mechanics getGridReference method, 256 interfaces, 203-204 acceleration/deceleration. grid design of levels, 243f polymorphism, 8, 41-42, 203 176 - 177GridReference class. practical, in game basics, 175 254-255 development, 204–205 displacement, 176 GridReference.as, 248 Singleton document pattern, friction, 177 IEnemy interface, 249, 206-208 inertia, 177 250, 274 storing values in variables/ in platformer games, 240 IItem interface, 249, 251, 275 constants, 210-211 reality vs. expectations, 178 init method, 257 Opposite side of right triangle, scalars, 175 inventory, 242, 257, 258 154 - 155simulation vs. illusion, IPlayer interface, 249–250, 273 Optimizing performance, 177 - 178IPortal interface, 249, 298-306 top-down driving engine, 251, 276 out object, 285 178 - 186ISprite interface, 249 Outline, game, 26–27, 247–248 vectors, 175 Item class, 275–276 Overengineering, 212-213 velocity, 176 items, 242 Overridden behaviors/ Pi and radians, 158-161 IWall interface, 249, properties, 203 pieceClicked method, 229 251-252, 276 override keyword, 41–42 Planning key input, 265, 266 Overriding toString method, see Game planning, steps for level creation, 261 294, 304 Platformer game level design and walls, 242 asset classes, 248, 273-279 level file format, 244-248 asset linkages, 277–279 level management, 259 P asset management 259-261 loadLevel method, 259 **Packages** asset SWFs, 244-248 loadNextAsset method, 260 basics, 11-12, 36 _assetDomain property, 257 nextLevel method, 272-273 import command, 11-12, 36 checkEnemies method, 269 outline, 247-248 Pac-Man checkInventory method, 270 PlatformerConfig class, asset list, 28–30 checkItems method, 269 253-254 game description, 25-26 checkPlayerCollisions PlatformerConfig.as, 248 Parallax scrolling, 10, 88 method, 268 PlatformerEngine class, **Patterns** checkPortals method, 270 256-271 see Design patterns clear method, 255, 256 PlatformerEngine.as, 248 Pause sound, 108, 112 CollisionGrid class, 249 PlatformerEvent class, 252 pauseBeforeGameOver method, CollisionGrid.as, 248 PlatformerEvent.as, 248 224 concat method, 255 PlatformerExample Peer ID, Stratus, 282-292 createPortals method, 263 class, 271-273 Performance data flow, 240-241 player character, 242 monitoring, 17–18 enemies, 243-244 Player class, 273–274 Sampler package, 302–306 Enemy class, 274–275 player position update, streaming silence for older engine, 240-241 267, 271

engine classes, 248-271

playerJump method, 266

machines, 114

Platformer game (<i>Continued</i>) Portal class, 276	inheritance and, 8, 41–42 OOP concepts, 203	FlashTracer, 18–19, 296 FrameRateProfiler class,
Portal Class, 276 PortalDestination.as, 248	pop command, 60	299–301
PortalDestinations class,	PortalDestination.as, 248	MemoryProfiler class,
252–253	PortalRequirement.as, 248	301–302
PortalRequirement class,	Portals	performance/optimization,
252–253	basics, 242	298–306
PortalRequirement.as, 248	checkPortals method, 270	Sampler package, 302–306
portals, 242	createPortals method, 263	traces, 294–295
readKeyInput method, 266	<i>IPortal</i> interface, 249, 251, 276	TraceUtil class, 294-295
setting, 241	Portal class, 276	QuickTime, 115-116, 125-126
startGame method, 258, 263	PortalDestinations class,	Quit button, 27
stopGame method, 258, 263	252–253	
toString method, 255	PortalRequirement class,	
unload method, 259	252–253	R
update method, 265	Position, 3D, 161–162	Radians
update task summary,	Predictive testing and collisions,	arc function measurement,
265–266	195–196	157
updateGridReference	Priority, listener, 51–52	pi and, 158–161
method, 264	Private attributes, 8, 40–41	Radius/distance testing and
Wall class, 276	Procedural languages/	collisions, 194–195
wall collision check, 268–269	programming, 6	Randomizing
PlatformerConfig.as, 248	Programming	getRandomColor method, 170
PlatformerEngine.as, 248	see Game development	randomize method, 227, 229
PlatformerEvent.as, 248	Projectile class, 87–88	Raster formats, 77–83
PlatformerExample.fla, 271	Projectile.as, 87	R00004 algorithm, 314
play method	Propagation of events, 53	readInput function, 182–183
for incoming streams, 285	stopImmediatePropagation	readKeyInput method, 266
for sounds, 106	method, 53–54	Reality vs. expectations, 178
playCutscene method, 122	stopPropagation method,	Real-Time Media Flow Protocol
Player characters	53–54	(RTMFP), 281
<i>IPlayer</i> interface,	Protect from Import commands,	Real-Time Messaging Protocol
249–250, 273	314–315	(RTMP), 281
in platformer games, 240, 242	Protected attributes, 8, 40–41	Received/sent data, protecting,
Player class, 273–274	Pseudo-code, 5–6	149, 313
position update, 267, 271	Public attributes, 8, 40–41	Rect testing, 195–200
Player.as, 165, 191–192	Publish Settings window	Reference counting, 71–73
Player.fla, 277	audio settings, 100f	removeEventListener method,
playGame method, 219,	image settings, 81–82, 82f	50–53
291–292	push command, 60	Requirements, technical, 30–32
playSound method, 109	Puzzle games, 3	Resolution, screen, 30–32 Resources
PNG (portable network	Pythagorean theorem, 156	loadResources, 69–70
graphics) format		unloadResources, 69–70
8-bit with alpha channel, 79	Q	working with multiple SWF
basics, 78–83	QName (Qualified Name) class,	files, 69–70
compression, 81–82	305	Results class, 234–236, 289–290
file size compared to video, 127–128, 127f	Quality assurance (QA)	Results.as, 283
vs. video on timeline, 123–125	bugs, 293–298	RIAs (rich Internet
pollMethods function, 305	coding effort/improvement,	applications), 21–22
Polymorphism	213	Right triangles and
classes vs. interfaces, 42–45	debugger, 296–298	trigonometric functions

basics, 154–155 turning off listeners, 308 SimpleTunnelShooter tunnelshooter example, Security hash, 31 see Tunnel shooter 166 - 168selectCard method, 93-94 SimpleTunnelShooter.fla, Rollover/click states, 230, 232 _selectedCards list, 94 164, 173-174 Root node, 131-132 selectTile method, 144–145 Simulation games, 3-4 Rotation, 3D, 162-163 sendGameOver method, 286 Simulation vs. illusion, rotationX/Y properties, 94 Sent/received data, protecting, 177 - 178rotationX/Y/Z properties, 162–163 149, 313 Sine (sin) and trig functions, RPGs (role-playing games), 4 Sequencing, 86 153 - 157RTMFP (Real-Time Media Flow Servers, 30-32 Singleton design pattern, Protocol), 281 setAnswer method, 136, 146 103, 105 RTMP (Real-Time Messaging setLoopBack parameter, A2 Singleton document pattern, Protocol), 281 setMode method, A5 206-208 RulesPanel class, 220-221 Setter/getter methods, 39–40 SingletonExample.as, 206 Runtime errors, 56 MixUp game, 223 SingletonExampleDocument. Runtime events, 12 Settings, game, 241 as, 207 setupConnection method, 284 Size setupGame method, 219, 238 of files, 75–76 S setupIncomingStream method, of stage, 212 Safe casting, 49 285, 291 Smoothing, 82-83 Salt for hash, 311, 313–314 setupResults method, 292 Sorenson Spark codec, 115-116 Sampler package, 302–306 Shape objects, 232 sort command, 60 SamplerUtil class, 304 shift command, 60 Sorting arrays, 60 Sampling data, A3 Shooter animation sortOn command, 60 Save and Compact operation, see Simple shooter Sound 75-76 show method, 91 see Audio/Sound Saving files showHostPanel method, 291 Sound Studio (Freeverse), 101 FileReference save method, shuffleBoard method, 227 SoundBooth (Adobe), 101 148-149 shuffledCards method, 93 SoundEngine class, 65, 103–112, Save and Compact operation, Shut down on malicious use. 208 75 - 76308-309 SoundEngine.as, 103, 105 Scalars, 175 Signature, data, 309 310 SoundEngineEvent.as, 103 Scores Simple shooter SoundForge (Sony), 101 database structure for, 27, 31 background/foreground soundTransform value, A2 hashing, 309-312 objects, 88 SourceImageCamera class, technical requirements, createEnemy method, 198–199 236-238 27, 31 createProjectile method, 89 SourceImageEmbedded class, Scrolling Enemy class, 196-197 233-234 basics, 10 frameScript function, 89 SourceImageWebCamera class, parallax, 10, 88 movePlayer function, 89, 283-287, 290 scrollbars for lengthy text, B2 172 - 173SourceImageWebCamera.as, Security moveProjectiles method, 89 283 bots, 307-309 Projectile class, 87–88 **Specifications** data protection, 309-314 simple scripted shooter, 87-90 core mechanics of game, detecting malicious use SimpleShooter class, 88-90 27 - 28and game shut down, SimpleShooterCollisions planning technical 308-309 class, 197-199 requirements, 30-32 hackers/hacking, 307 weaknesses of collision Speech settings, 98, 100 malicious use, 307-309 detection, 199-200 Speed and velocity setting min delay for SimpleShooter.as, 87 formula, 176

SimpleShooterCollisions.fla, 196

SimpleShooter.fla, 87-90

Speed to market, 14–15

splice command, 60

input, 308

SWF protection, 314–315

Sprites	T	trace statement, 18-19, 294
as display objects, 11	Tangent (tan) and trig functions,	TraceObject method, 295
ISprite interface, 249	153–157	Traces, 294–295
safe casting, 49	Target phase of events, 50–51	TraceUtil class, 294–295
Stage (Flash), 11	Targets, 11	TraceUtil.fla, 296
size changes, 212	Task Manager (Windows),	Triangles and trigonometric
startGame method, 172–173,	17–18	functions
223–224, 258, 263	Technical requirements, 30–32	basics, 154–155
StarUML, 33	Technie Notes	tunnelshooter example,
State machine, 9	8-bit PNG with alpha channel,	166–168
Static methods/variables, 8, 41	79	Trigonometric functions, 153–157
stop method for sounds, 106	AMFPHP, 32	tunnelshooter example,
stopCutscene method, 122 stopGame method, 258, 263	format for animation	166–168
stopImmediatePropagation	sequences, 125	Trigonometry, 154
method, 53–54	getRandomColor method, 170	try statement block, 56–57
stoppingThreshold constant, 179	getters/setters, 135	Tunnel class, 165–175
stopPropagation method, 53–54	getTimer method, 180	Tunnel shooter
stopSound method, 109	QName (Qualified Name) class, 305	(SimpleTunnelShooter)
Strategy games, 3–4	shape objects, 232	activate/deactivate methods,
Stratus, 282	sound quality, 100	169-170
MixUp multiplayer, 282–292	static attributes, 8	addEnemy method, 172, 173
Streams	streaming silence, 114	basic mechanics, 164
audio stream setting, 100f,	Vector class, 176	classes, overview, 164–165
100	tempPoint object, 194	ColorTransform class, 168
NetStream objects, 282	Text field length, B2	createHighlight method, 170
play method for incoming,	TextFieldUtil.as, B8	createTunnel method, 166
285	throwErrors flag, 295	easIn function, 173
setupIncomingStream	Throwing errors, 57–58	Enemy class, 171
method, 285, 291	Tile-based games, 10	Enemy.as, 165
streaming silence, 114	Tiles, tunnelshoter example, 164	enemyFrequency variable,
Strings panel, B3–B9	Time class, 180–181, 192	171–172
Stub code, 33	Timelines	enemyMovementFinished
Subclasses, 41, 202–203	vs. ActionScript, 85–86	function, 173
super keyword, 42	animation vs. games, 21	enterFrame event, 172–173
Superclasses, 41, 202–203	labels, 67, 67f	frameScript method, 172–173 Game class, 164, 171
swapElements function, 229	setting up internal video,	Games.as, 164, 310
SWF Encrypt (Amayeta	125–128	getter function, 169
Software), 314–315	sound via, 101, 103	_highlightIndex property, 165,
SWF files data protection, 314–315	video on, 123–125	169–170
working with multiple,	Timers	index property, 171
69–70	getTimer method, 180	moveEnemies method, 173
switch statement, 146	timerUpdate method, 222	movePlayer function, 172–173
Symbol Properties	tunnelshooter, 172–173 timerUpdate method, 222	Player.as, 165, 191–192
Base class assignment, 47f	Title class, 220, 288–289	startGame method, 172-173
CrosswordClue class, 139f	Title.as, 283	tiles, 164
CrosswordTile symbol, 137f	to method, 93–94	timer, 172–173
Symbols, exported with no class	<i>toString</i> method, 255, 304–305	Tunnel class, 165–175
file, 48	overriding, 294, 304	Tunnel.as, 165
System requirements, 30–32	Trace method, 295	tunnelshooter package, 164

TunnelTile.as, 165 _tunnelTiles array, 165, 167 Tunnel.as, 165 TunnelTile.as, 165 _tunnelTiles array, 165, 167 TweenLite, 173 TweenMax (Doyle), 87, 90, 92–95 Tweens, 86–87, 173 Type checking, 38 Types for constants/variables, 37–39 event type parameter, 51–52 events and listeners, 11	VBR (variable bit rate), 118–119, 123–124 Vector class, 176 Vector graphic formats, 77–78 Vector3D and <i>IPlayer</i> interface, 249–250 Vector3D class, 175–176 Vectors basics, 175 data structures, 62 length/magnitude, 185 Vehicle class, 179–180 Vehicle games, 4–5 Velocity, 176 Versions, class, 8	useWeakReference parameter, 52 weakKeys parameter, 62 Webcams see Cameras Websites vs. games, 22–23 Windows Media Player, 115–116 Wireframe, game, 26–27 Word games, 3 wordIndex, 145 X XML activate/deactivate
U	Video	methods, 136
UML (Unified Modeling Language) class diagrams, 32–33 Underscore ("_") naming convention, 40 unload method, 69–70, 259 unloadAndStop method, 69–70 unloadResources method, 69–70 unshift command, 60 Unsigned value of number, 159 update method, 265 updateCamera method, A6, A6–A7 updateGridReference method, 264 updateImages method, 237, 287 updatePointer function, 156–160	alpha-channel, 115–116, 125–127 codecs, 115–116 CutsceneManager, 119–123 encoding cutscenes, 117–119 external, via cutscenes/ menus, 116–119 internal, setting up, 125–128 playCutscene method, 122 on timeline, 123–125 using CutsceneManager, 122–123 Views, game, 9–10 Visual appeal of games, 15 void keyword, 39 Voidce-over audio, 98, 100 Volume/pan control, 107	attributes, 131–132 basics, 130 bringing data in, 129 crossword builder and content, 148–149 crossword puzzle structure, 131–148 CrosswordClue class, 138–139 CrosswordPuzzle class, 139–148 CrosswordTile class, 134–137 E4X, 130–131 features, 129 vs. Flash Vars, 149–151 levels represented as, 244–248 root node, 131–132 saving, 148–149 sending data back out, 149
URLLoader class, 129, 149, 150–151		URLLoader class, 129, 149,
useCapture parameter, 51–52 useWeakReference parameter, 52	W w values and Vector3D class, 175–176 Walls	150–151 xSpeed variable, 159 x,y coordinate system, 153–154
V	basics, 242	
Vanishing points, 163–164 Variables constants, methods, and, 37–39 getter/setter methods, 39–40 identifiers, 40–41	collision check, 268–269 <i>IWall</i> interface, 249, 251–252, 276 Wall class, 276 WARNING traces, 295 WAV format, 97–98	Y ySpeed variable, 159 Z
naming conventions, 40	Weak reference	z-axis and 3D in Flash, 161f,

garbage collection, 72

161 - 164

storing values in, 210–211